Edited by Peter Sachs Collopy
and Claudia Bohn-Spector

CROSSING OVER
ART AND SCIENCE AT CALTECH 1920–2020

Caltech Library, Pasadena
Published with the assistance of the Getty Foundation

CROSSING OVER

7
FOREWORD
Kara Whatley

8
PREFACE
True Confessions
of an Aging Archivist
Judith Goodstein

14
INTRODUCTION
Peter Sachs Collopy
and Claudia Bohn-Spector

21
THE INFINITE LAWN

46
BETWEEN SCIENCE
AND FICTION
NASA's Voyager Missions
and the Visualization
of the Space Environment
Lois Rosson

54
THE UNIVERSE IN PIXELS
The Creation of Charge-
Coupled Devices and the
Dawn of Big Data
Astronomy
David Zierler

71
TIME STREAM

95
POWERS OF TEN

110
"OF MEN AND MOLDS"
Neurospora and the
Illustration of Nature's
Molecular Order
Charles A. Kollmer

126
RENDERING THE
MOLECULAR WORLD
Soraya de Chadarevian

154
GOLDEN EVENT SCIENCE
IN THE GOLDEN AGE
OF TELEVISION
Brian R. Jacobson

194
THINKING WITH ART
AND ENGINEERING
AT THE JET PROPULSION
LABORATORY
Learning from JPL's Visual
Strategists
Talia Shabtay Filip

230
JPL'S *VISIONS OF THE
FUTURE* POSTERS
AND THE IMAGINED
FRONTIER
Anne Sullivan

247
AESTHETIC VIRTUE

260
FIGURES AND GROUNDS
A Critical History
of the Caltech Campus
and Its Architecture
Christopher Hawthorne

268
ARCHITECTURES
OF EPISTEMIC MASTERY
ON THE CALTECH
CAMPUS, 1915–1930
J. V. Decemvirale

288
PASSING IN THE
HALLWAY
Art and Technology
at Caltech, 1968–1972
Peter Sachs Collopy

294
AN EXPERIMENT IN ART
Baxter Gallery at Caltech
Jennifer A. Watts

302
A CONSPIRACY OF
BACHELORS
Caltech and the Visual Arts
at Mid-Century
Claudia Bohn-Spector

312
EXHIBITS A & B
Notes for an Exhibition
of Science and Art
Tim Durfee

314
CALTECH ART EXHIBITIONS,
1968–1985

316
CONTRIBUTORS

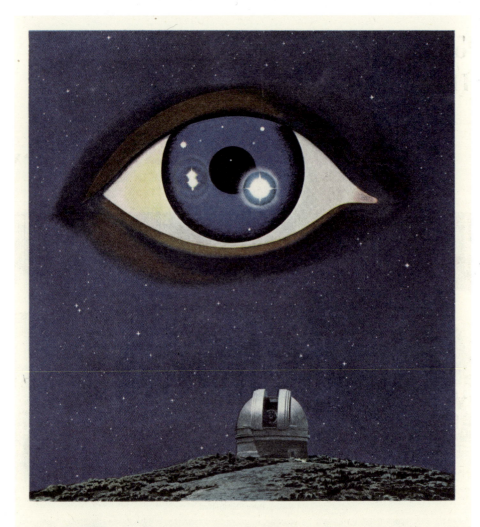

What makes the "Big Eye" see?

There is a thin coating of *aluminum* on the 200-inch mirror which is part of the world's largest telescope at Palomar Mountain. This aluminum surface enables the "big eye" to reflect the light from heavenly bodies billions of miles away.

Aluminum's exceptional ability to reflect light—and heat as well—is another reason why you find it in products you see every day. But it's *only one* reason...

For no other metal possesses aluminum's unique *combination of advantages*. Aluminum offers you lightness, strength, economy, freedom from rust, permanent beauty.

As a major supplier to the manufacturers of the products shown at the right, and thousands of others, Kaiser Aluminum has built an unsurpassed reputation for quality and service.

Kaiser Aluminum is produced by Kaiser Aluminum & Chemical Corporation, Oakland, California. 63 sales offices and warehouse distributors in principal cities.

Kaiser Aluminum

A major producer in a growing industry

FOREWORD

As a librarian who has spent my career at scientific institutions, it gives me particular pleasure to welcome readers to this unique volume, which combines original essays and remarkable images to explore, illustrate, and critique the interplay of science and the visual arts at Caltech and the Jet Propulsion Laboratory over the last century. It may come as a surprise to some that such a relationship even exists, synonymous as the names Caltech and JPL are with science and technology. I first became aware of this rich history not long after I became Caltech's University Librarian in 2019, when one of the earliest decisions I faced was whether we should apply to be part of the Getty Foundation's 2024 PST ART exhibition program on art and science. Being new to California, I had not previously attended PST exhibitions, but what little I knew about them certainly inspired me to learn more.

As it turns out, my decision was an easy one—any exhibition program focusing on how art and science have intertwined in the Los Angeles area would surely be incomplete without taking into account Caltech's role and impact in this arena. Most of the organizations participating in PST this year are art museums building connections with science and its influence in the art world. Caltech, in contrast, is a science institution finding art in its past and present.

Early research by our team of collaborators, centering on the exceptional resources in the Caltech Archives and Special Collections, led us to a theme for our PST contribution. That theme is "crossing over"—a term coined by Caltech biologist Thomas Hunt Morgan and technician Eleth Cattell. It describes how parental genes combine to produce new offspring and, in quite another context, refers to how different academic and creative disciplines can cross-pollinate to create new ones. Such "crossing over" has long defined Caltech's multidisciplinary approach to scientific teaching and research, and, as this catalog will show, equally characterizes the Institute's intriguing and complicated history of engagement with the arts.

One of the principal, indeed iconic, roles of a university is to foster the free expression and exchange of innovative and unconventional ideas, including those that may strike some as controversial. This we do to inspire and create meaningful, thought-provoking dialogue and to open the mind to new avenues of thought. The essays in this catalog are no exception. In multiple, sometimes provocative ways, they encourage and inspire us to think about the artistry in scientific images and the complex interaction between art and science in ways that many of us have not previously considered. Welcome to *Crossing Over*!

Kara Whatley
University Librarian, Caltech

Kaiser Aluminum,
in *Saturday Evening Post*
"What Makes the 'Big Eye' See?"
March 3, 1951
Magazine advertisement
Caltech Archives and Special Collections

Judith Goodstein

PREFACE
True Confessions of an Aging Archivist

In 1968, when I was offered—and promptly accepted—a position as Caltech's first archivist, I had heard of the physicist Richard Feynman, but pretty much nothing else. To develop a sense of history about a place takes time and when people on campus began to call me "the school historian," I felt embarrassed by the title—I didn't feel ready to accept that designation. After all, many renowned faculty members had spent their entire careers at Caltech. They had all known Millikan, Hale, and Noyes, Caltech's founding trio, personally. If I am often consulted as the "school's memory," for lack of a better phrase, it's because the faculty ranks of my generation have thinned, while I remain. In any event, I am no longer embarrassed.

To cast back several decades, 1979 was a banner year for Einstein celebrations. It seemed that everyone in Los Angeles wanted to share in his hundredth birthday, including KCET, the local public television station, which asked that Caltech's archivist come down to its Hollywood studio for a live interview about the iconic scientist, who had spent a couple of winters at the campus in the early 1930s. "Remember to tell them what an archivist does," my teenage daughter suggested. As a graduate student, I had written my dissertation on Sir Humphry Davy, a chemist who came to prominence at the beginning of the nineteenth century. However, starting out as an archivist in 1968, I had only a foggy idea what such a person was supposed to do. One of the more distinguished historians on the faculty had suggested that an archivist could spend their days preparing brief biographies of other faculty members. After due consideration, I have decided not to reveal who proposed that job description.

By Einstein's centennial year, I figured I had the job of being the Institute's archivist more or less down to a science—after all, I was at a premier science institution. The formula was simple: first, you need to decide what should be preserved, and second, you need to do whatever it takes to preserve it. When my KCET host began the interview by asking what an archivist does all day, I was ready with that answer.

The Caltech Archives today is the culmination of that simple but far from simple-minded approach to assembling, classifying, and curating the wealth of historic Caltech material featured in curator Claudia Bohn-Spector and project director Peter Sachs Collopy's lavish exhibition on display at a select number of sites on campus. With more than 500,000 objects dating from antiquity to the present day to choose from, they have mined the Archives' substantial holdings of scientific instruments, models, paintings, rare books and prints, drawings, seals, and photographs to highlight the role and function of art in areas that the Institute's founders saw, and what continues to be seen, as the most important fields at the frontiers of science and technology.

The records of the Human Betterment Foundation, perhaps the most controversial and, in recent years, among the Archives' most consulted research collections, were transferred from the Institute's Waverly warehouse to the Archives in 1968, shortly after I was told that inactive records and files were routinely sent there for further retention or destruction. The papers of Ezra S. Gosney, the HBF founder and principal donor, were either strewn across the floor or stored in dozens of boxes, and they were clearly marked "destroy." Given the recent controversy surrounding Robert Millikan's membership on the foundation's board in the late 1930s, perhaps it would have been better to have left them there. But I knew that the records would provide historians with essential source material for examining the eugenics movement in America, starting with the personal and social impact of sterilization carried out under California's first sterilization law in 1909 and its revision in 1913. Beyond those records, I found nothing else of interest in the Waverly warehouse.

As late as the mid-1950s the majority of Caltech's library holdings were clearly geared toward meeting the contemporary needs of its science and engineering faculty and students, although I can remember checking out a well-thumbed English-language copy, published in 1790, of eighteenth-century French chemist Antoine Lavoisier's *Elementary Treatise on Chemistry*, which had sat on the open shelves in the school's chemistry library for decades. Then, like a sudden downpour in summer, rare first editions of landmark texts in the history of science began raining down on the campus. Collectively, these priceless volumes are among the Archives'—and Caltech's—crown jewels. They were assembled early in the twentieth century, in Florence, Italy, by Giampaolo Rocco, a prince with an engineering degree.

Mostly rebound in blue morocco leather and embossed with his family's coat of arms on the cover, Rocco's holdings—consisting primarily of astronomy and physics texts published in the sixteenth and seventeenth centuries—arrived at Caltech in 1955. It may have been the only time in the school's history that a trustee was persuaded to write a check, sight unseen, for 202 books, based solely on a published list prepared by a prince's private librarian.[1]

Ostensibly, the Rocco collection was intended for Earnest C. Watson, a long-time member of Caltech's physics faculty, whose deep interest in books, manuscripts, pictures, and instruments relating to the history of science had by the mid-1930s turned him into an avid collector. Shortly after the volumes arrived, Watson turned them over to Caltech, not simply because they represented, in his eyes, a good investment, but also as a reminder that the pursuit of science is far older than the institution that stands today at the pinnacle of scientific achievement. He would go on to supplement the Rocco collection with many of his own rare first editions.

The designers and publishers of these works were not themselves scientists, but they were craftspeople, artisans, and illustrators of the highest order, who, like many of the works' authors, clearly had a keen appreciation of the value of art in illuminating scientific concepts.[2]

One of these volumes, by the first chancellor of Oxford University and bishop of Lincoln and one of the medieval world's most celebrated thinkers, Robert Grosseteste (ca. 1168–1253), is Caltech's oldest dated book, published in 1503 in Nuremberg. This short work, *Concerning Lines, Angles, and Figures, and the Refraction and Reflection of Rays*, is the first printed edition of his geometrical analysis of light. The woodcut frontispiece shows a tree in a tub of water to demonstrate refraction. Meanwhile, reflected rays of the sun shining into a mirror cause a tree in the distance to burst into flame (page 10). (Like the four volumes described below, this exceedingly rare first edition was gifted to Caltech by Earnest Watson.)

Three centuries after Grosseteste, the seeds of modern science began to blossom. Even a modest tour of the scientific and visual gems in Caltech's rare book collection must include the Polish astronomer (and Catholic canon) Nicholas Copernicus's earth-shattering view of the solar system. In his book *On the Revolutions of the Heavenly Spheres* (Nuremberg, 1543), which he saw in published form and handled shortly before he died, Copernicus placed the sun rather than the earth at the center of the natural order. His description of the heliocentric solar system is accompanied by one of the most famous illustrations in the history of science: a drawing of the six known planets orbiting the sun (page 74). Overthrowing fourteen centuries of traditional thought, Copernicus's revolutionary model, based on literal revolutions in the sky, launched the scientific revolution that would lead, some 150 years later, to the publication of Isaac Newton's *Principia* and the dawn of the Age of Enlightenment. (A rare second edition of this pivotal work in the history of science is also part of the Caltech collection.)

Born not long after Copernicus's death, the Danish nobleman Tycho Brahe (1546–1601), the last dedicated astronomer not to use a telescope, spent much of his life carrying out the most detailed observations then possible of the heavens, largely with instruments of his own invention. He accomplished all this at observatories he had constructed on the island

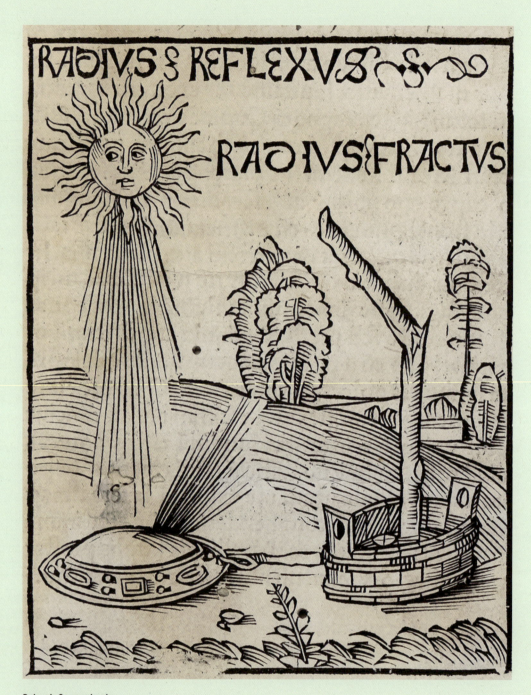

Robert Grosseteste
Libellus lincolniensis de phisicis lineis angulis et figuris..., 1503
Book (detail)
Caltech Archives and Special Collections

of Ven, which King Frederick II of Denmark gave him in 1576. A stunning series of color illustrations in cartographer Joan Blaeu's *Atlas Maior* (Amsterdam, 1662) offers a panoramic view of Tycho's astronomical kingdom. One picture shows *Uraniborg*—named for Urania, the muse of astronomy—a complex of buildings that included observatories, a laboratory, a printing shop for publications, and living quarters, all enclosed within an elaborate wall. Another hand-colored print in the same volume depicts Tycho's observatory *Stellaborg*, situated outside the walls of *Uraniborg* and, as its name implies, designed for stargazing. Partially constructed underground to protect its astronomical instruments from wind and other disturbances, the building's occupants can be observed in the lower right using a sextant (a type of navigational instrument) to measure the distances between celestial bodies (below).

A contemporary of Tycho, Johann Bayer (1572–1625) published *Uranometria*, the first true star atlas, in 1603. The most famous of all celestial atlases, it consists of 51 constellation maps of the night sky engraved on copper plates. Recognized for their outstanding beauty to this day, the maps remained a popular guide to the constellations for more than two hundred years.

German astronomer and mathematician Johannes Kepler (1571–1630) and his Italian counterpart Galileo Galilei (1564–1642) were both staunch Copernicans. In an early bid to unmask the hidden design of the universe, Kepler devised a model demonstrating how each of the five "perfect solids" of antiquity could be neatly interposed between the spheres of the six planets then known in the Copernican system. A famous drawing of these nested solids (the outermost sphere is Saturn's) appears in his book *The Secret of the Universe*, published in 1596 (page 74). Thirteen years later, Kepler abandoned this idea with his discovery that the orbit of Mars was elliptical. *The New Astronomy* (1609) sets forth his thesis that the orbits of all the planets are ellipses with the sun at one focus, a proposition now known as Kepler's first law of planetary motion (page 75). (This work, like the astronomy volumes discussed below, came to Caltech with the Rocco collection.)

In 1627, under the patronage of Holy Roman Emperor Rudolph II, Kepler published the *Rudolphine Tables* (cultivating benefactors was as essential to scientists in those days as it is today, if not more so), a set of planetary tables and star charts. Kepler himself designed the book's frontispiece, an elaborate engraving depicting those he considered the giants of astronomy, both ancient and among his contemporaries, gathered in the temple of Urania. He placed himself and the titles of four of his books in the left panel on the base of the temple.

Caltech's copy of the *Rudolphine Tables* also includes a fine seventeenth-century map of the world, prepared by Kepler and cartographers Eckebrecht and Walch, and dated Nuremberg 1630. As with other maps of that era, California is drawn as an island.

The invention of the telescope in 1610 marked the end of the era of naked-eye astronomy. The first to grasp that the telescopic lens might be used to study the night sky was Galileo, and *Starry Messenger*—the book in which he published his findings—marked the birth of telescopic

Tycho Brahe
Astronomiae instauratae mechanica, 1602
Book (detail)
Caltech Archives and Special Collections

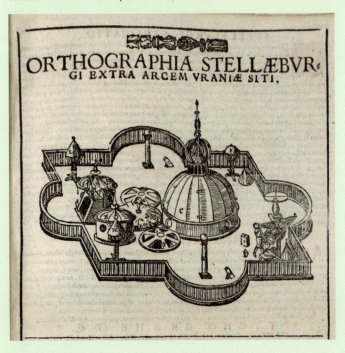

observations of the heavens. One of Galileo's earliest discoveries was of the craters and mountains on the moon, and *Starry Messenger* contains his hand-drawn pictures of them (page 76). But if the moon had mountains, like the earth, then the Aristotelian view of corrupt bodies on the earth and perfect, unchanging celestial bodies fell apart. There were other spectacular discoveries: Venus exhibited phases like the moon; Jupiter had four moons. Their existence lent weight to the Copernican theory by providing indisputable visual evidence of satellites moving around a planet as the planets moved around the sun.

There are important books in the history of science canon, and then there is Galileo's *Dialogue Concerning the Two Chief World Systems*, one of the great masterpieces of the scientific revolution. His defense of the Copernican theory in this book (and his sarcastic treatment of its critics, which included a number of influential Roman Catholic clergy) resulted in a summons to Rome, where Galileo was brought to trial before the Inquisition and sentenced to permanent house arrest. The edition in the Archives, published in Florence in 1632, is exceedingly rare and contains both the proof and the final version of the book's frontispiece. The elegant engraving by Stefano della Bella depicts Aristotle, Ptolemy, and Copernicus debating their respective theories of Earth's position in the cosmos.

In 2000, the late Caltech Professor George Housner, a pioneering earthquake engineer, donated his extensive collection of historical books and prints relating to earthquakes to the Archives. Among them are a series of exquisite woodblock prints created after the great Tokyo quake of 1855. They depict scenes in the life of *namazu*—the giant catfish whose unpredictable actions Japanese folklore held to be the cause of earthquakes (page 98).

Some decades before the Archives began acquiring its rare book collection, physicist Robert Millikan, who had recently become the de facto head of Caltech, made his own effort to enlist art in the service of science. In 1923 he commissioned Belgian artist Godefroid Devreese to create a representational work that, in Millikan's words, would serve "for a thousand years to come ... [as] the symbol by which the California Institute will be most widely known." According to various archival records, Millikan asked Devreese to design a seal that would show an older man passing the torch to a younger one. He wanted the figures to symbolize the spirit of research being passed from one generation to the next, from maturity to youth. Devreese duly produced a design depicting the older torch-bearing male sprinting toward the younger as in a relay race, both unclad in the manner of antiquity and floating in the clouds (page 256).

Appearing above these two figures, the seal's motto "The truth shall make you free," also chosen by Millikan, comes from the New Testament's Gospel of John. Taken in the context of the emblem—the passing on of knowledge—Caltech's first Nobel laureate seemed to be endorsing scientific truth. Moreover, as a minister's son and an ardent proponent of the idea that science and religion need not be in conflict, the biblical excerpt probably struck him as appropriate.

Millikan evidently liked the emblem, referring to it as Caltech's official seal. In 1925, Caltech's executive council, which he headed, authorized its use on diplomas, where it remained for many years.

The Devreese design was considered the official seal until the 1960s, when there were calls to update it. In 1969, with Harold Brown's inauguration as president and the imminent admission of female undergraduates, Caltech's administration looked at two "new and improved" renderings. Apparently, they couldn't decide which one to use: both versions appeared on Brown's inauguration publications.

Brown thought the original Devreese seal didn't help Caltech's public image or its fund-raising efforts. He solicited the opinion of trustee Henry Dreyfuss, a well-known industrial designer, on a possible revamp. Dreyfuss promptly submitted his own hand-drawn sketch, just after Caltech started admitting undergraduate women. Above it, he wrote, "Instead of boys chasing one another, we have a boy chasing a girl, or vice versa." In a memo to an intermediary, Brown wrote "I like this seal."

Meanwhile, with surprisingly little discussion, the trustees officially adopted a design consisting

of a torch held by a single hand. Members of the student body, however, took exception, and suddenly everyone on campus had an opinion. To complicate matters further, when Caltech trustees started delving into the Devreese seal's actual history, it was discovered that it had never been officially approved by anyone in a position to do so. It had merely served as the de facto official seal for those many decades.

There matters rested until 1984, when the issue of the Institute seal resurfaced. Caltech's trustees rescinded the board's 1969 approval of the one-handed seal. The Devreese design was adopted as the official seal retroactively to 1925 but was taken out of circulation except for its use on diplomas, while the motif Millikan originally favored of a torch being passed—with just the hands this time—went into general usage on all campus publications, souvenirs, and memorabilia. In the early 2000s it supplanted the Devreese seal on the diplomas as well.

What I can tell you, as one of Caltech's storytellers, holds true for others who have, and will, in the future, depict this little school in Pasadena with its outsized ambition and aspirations. Without exception, their works will reflect the perspectives, agendas, and quirks of their creators. Mine included. We all come to our task, to our tales, and to our art, with a point of view. That said, all of what I have written here comes directly out of the Archives, Caltech's memory vault. It's only a sample of what lies there still, waiting to be explored.[3]

1—Dino Cinti, *Biblioteca Galileiana: Raccolta dal Principe Giampaolo Rocco di Torrepadula* (Florence: Sansoni, 1958). Issued in a limited edition of 666 numbered copies, the Cinti bibliography opens with an essay describing the history of astronomy from antiquity to the time of Galileo. This is followed by a chronological listing of the individual works collected by Prince Rocco, including many black and white images of the texts.

2—The Rocco and Watson first editions I describe were all published in Latin, with the exception of Galileo's *Dialogue*, which was originally written in Italian. With one or two exceptions, their titles are translated here into English.

3—Portions of this work appeared in somewhat different form in *Caltech News* (1992), *Caltech 336* (2001), and "Earnest Watson and the Amazing Liquid Air Show," in the Earnest C. Watson Caltech Lecture Series, October 29, 1997. I would like to thank Heidi Aspaturian and Elisa Piccio of the Caltech Archives; Loma Karklins, now retired from the Caltech Archives; and Caltech registrar Christy Salinas for their help in preparing this preface.

Peter Sachs Collopy and Claudia Bohn-Spector

Introduction

When architects Elmer Grey and Bertram Goodhue each drew up plans for the Throop College of Technology's new campus in the 1910s, they included both a science museum and—surprisingly—an art museum (pages 16–17). This college, which became the California Institute of Technology in 1920, was to be devoted first to engineering and then to science as well, and museums were to be key spaces for education. In these plans, they sat at the western edge of the campus, at its entrance on Wilson Avenue, forming a bridge between the new college and the surrounding community.

Caltech never built either of these museums. Compared to other leading science and engineering schools in the United States, the Institute has historically been tentative in embracing the unique contributions that art has made to the generation, visualization, and communication of scientific thought. But while art has often stood in science's shadow, eclipsed by the far greater institutional priority given to scientific and technological research, it has also *been* science's shadow, produced as a consequence of science's presence and scale, but disappearing and reappearing as the sun disappears behind clouds and reappears again. If the history of science and engineering at Caltech has been one of steady growth, the history of art has been episodic and uneven, filled with inconspicuous starts and untimely endings.

How, we have asked in this exhibition and book, have scientists and engineers used images and collaborated with artists to discover, invent, and communicate? How have science and engineering institutions used visual culture to construct their built environments and shape the identities of those who occupy them? How have the arts fared at Caltech as a formerly all-male institution? *Crossing Over* probes the rich pictorial record of a single institution, over a century of tremendous change, to propose some answers to these questions. The exhibition draws extensively from the Caltech Archives and Special Collections, augmenting those holdings with images from other repositories and contemporary artworks.

Images, as this book and exhibition show, are vehicles to convey information. They embody arguments, theories, and worldviews and seek to persuade viewers of their truth and significance. Starting in the sixteenth century, actual images, not just imagined ones, became increasingly central to scientific arguments with the global spread of the printed book. Ever since, our notion of science as objective has drawn authority from illustration, photography, and film, blending phenomena in nature with their visual interpretation. Today, historians of science and, indeed, scientists themselves increasingly see laboratories as sites for the creation of images, bringing numerous disciplines, including art history and art itself, into closer conversation with science.

As part of PST ART's region-wide exploration of the interface between art and science, *Crossing Over* reveals new facets of life and work at Caltech as they informed, and were informed by, the vibrant visual culture of Southern California, including the two industries that most defined this region, Hollywood and aerospace. Bookended by two global pandemics, *Crossing Over* spans one hundred years. It unfolds in four independent but interconnected movements—*The Infinite Lawn*, *Time Stream*, *Powers of Ten*, and *Aesthetic Virtue*—taking viewers from the "universe without" (suns, moons, planets, and galaxies) to the "universe within" (cells, genes, molecules, atoms, and subatomic particles) and the evolving ecology of Caltech itself.

As Grey and Goodhue planned for Caltech's architectural future, biologist Thomas Hunt Morgan led a laboratory of scientists at Columbia University experimenting with heredity using

Drosophila melanogaster, or fruit flies. They found that some traits that a fly inherited from each parent were correlated or linked, suggesting that genes for them were physically located near each other on a chromosome. Sometimes, though, traits that typically appeared together instead appeared separately. One explanation was that the chromosomal structure was twisted or flipped between these two genes so that the mother and father's contributions were reversed. Morgan and Eleth Cattell—one of several women who worked for him as technicians—termed this phenomenon "crossing over," and it was an essential part of how genes from two parents combined to produce offspring that differed from each. (The brilliant illustrations drawn by another of these technicians, Edith Wallace, are featured in the *Powers of Ten* section of this catalog.) In 1928, Morgan and his lab moved to Caltech, founding its Division of Biology.

"Crossing over" serves as a potent metaphor for the complex interchange between science and the visual arts at this influential institution—in a process that has been both fertile and fraught with difficulty. Throughout Caltech's history, art and science have crossed over like the chromosomes of two parents, producing new hybrids with some of the traits of each. The same can be said about many images in this exhibition and book. Neither exclusively scientific nor strictly fine art, the images on view straddle a divide, often blurring the lines between the disciplines from which they sprang. Like all images, they are dependent on the conditions of their creation and reception, shifting their meanings when contemplated from new perspectives.

Both the exhibition *Crossing Over* and this book begin with pictorial hybrids in astronomy and planetary science. *The Infinite Lawn* focuses on astronomers' efforts to expand human vision farther and deeper into space, particularly through the construction of Palomar Observatory in the 1930s and 1940s. In those same decades, Caltech engineers began a rocketry research program that evolved into the Jet Propulsion Laboratory. In 1958, Caltech began operating JPL for the newly founded NASA, a relationship that continues to this day. When JPL's Voyager spacecraft produced new data on Jupiter and Saturn in the 1970s, writes Lois Rosson, astronomical illustrators merged these findings with their artistic knowledge of Earth's landscapes to produce images of alien worlds for the wide audiences of both *Star Trek: The Motion Picture* and astronomer Carl Sagan's nonfiction television series *Cosmos*. During the same period, David Zierler writes, astronomers at Palomar Observatory and JPL adopted the electronic charge-coupled device, or CCD, as a new technology for astrophotography, facilitating new forms of computational analysis.

Time Stream continues to gaze to the heavens as it looks back to the sixteenth and seventeenth centuries through Caltech's collection of rare first-edition books in the history of astronomy, juxtaposing them with more recent ways of imagining the universe. This second section also includes artist Lita Albuquerque's ephemeral installation *This Moment in Time,* covering a bridge across Caltech Hall's reflecting pool with small sheets of fluttering gold leaf, a precious material of profound significance in both science and the arts.

Powers of Ten explores how artists, scientists, and engineers produced new images across myriad scales and Caltech's many disciplines. Beginning in the 1930s, writes Soraya de Chadarevian, chemist Linus Pauling formed a close collaboration with architect Roger Hayward to translate the three-dimensional molecular models that he and colleagues developed into a two-dimensional "architecture of molecules." In the 1960s, his successor Richard Dickerson formed a similar collaboration with artist Irving Geis. Biologist George Beadle's own 1948 collaboration with Hayward, writes Charles Kollmer, shows how life scientists—in this case using the bread mold *Neurospora* to study heredity—used drawings and photographs to convey their findings to both colleagues and the general public. Brian Jacobson turns our attention to Caltech physicist Carl Anderson's 1932 discovery and photograph of the

Elmer Grey
*Birdseye View: Music Hall & Art Museum
for Throop College of Technology*, c. 1910
Watercolor and ink on cardstock
Caltech Archives and Special Collections

positron and 1957 collaboration with filmmaker Frank Capra, a Throop alumnus, to bring this "image tradition" of physics to television.

Talia Shabtay Filip takes us back to JPL to visit The Studio, where visual strategists have brought the skills of art and design to space exploration missions for the last twenty years. Among The Studio's creations is *Visions of the Future*, a 2016 series of posters visualizing travel to moons and exoplanets which, Anne Sullivan explains, take their inspiration from associations between space exploration and the American frontier.

Aesthetic Virtue is not part of the *Crossing Over* exhibition, but it occupies a prominent place in this catalog. It explores efforts to bring art to Caltech not only in the direct service of science, but for its own sake, and the influence of Caltech's architecture on its scientific community. Christopher Hawthorne traces how architect Bertram Goodhue, chemist and donor Arnold Beckman, and biologist and Caltech president David Baltimore each expressed ideas about the role of science in society through campus buildings. Goodhue and other designers of Caltech's early campus, writes J. V. Decemvirale, used Spanish Colonial Revival architecture both to present a narrative of European progress and to incorporate iconography from other parts of the world.

Art formed part of Throop's early curriculum, but mostly vanished as the institution narrowed its focus in 1910. In 1941, Pasadena's California Graduate School of Design merged with Caltech to become its Industrial Design Section, one of several new academic programs in the field—but the department lasted only eight years. In 1969, writes Peter Collopy, Caltech invited artists to campus to teach and make art in new media, but the goals of the artists and their host institution seldom aligned. Caltech's experiments in art and technology evolved into Baxter Art Gallery, which, as Jennifer Watts writes, hosted dozens of innovative exhibitions from 1971 to 1985 and persistently raised questions about the role of art at a technical institute. Even as

Caltech embraced coeducation in the early 1970s, writes Claudia Bohn-Spector, the relationship between art and science was shaped by firm disciplinary boundaries and the patriarchal legacies of single-sex education and "Bachelordom," reflected in artist Marcel Duchamp's enigmatic and allegorical *Large Glass*, shown in an exhibition just blocks away from the campus in 1963.

Tim Durfee, the architect of *Crossing Over* as an exhibition, closes our catalog with a visual essay on the philosophy of its presentation.

If art is a shadow that expands and contracts at Caltech, today that shadow is relatively large. Since 2019, the Caltech-Huntington Program in Visual Culture has brought artists-in-residence to campus and incubated a new undergraduate minor in visual culture. Science and engineering disciplines like neuroscience and machine learning have increasingly turned their attention to vision. Artists and scientists collaborate in Caltech's influential Data to Discovery program. The art curriculum begun in 1969 survives in the cozy Art Chateau. And exhibitions and catalogs like this one attest to the bridges that Caltech has built between art and science for the benefit of both.

...

Crossing Over is a collaborative historical research and exhibition project that would never have been possible without the generous support of many individuals and institutions. At the Getty Foundation, we thank Joan Weinstein, Heather MacDonald, Melissa Lo, Lu Spriggs, Zachary Kaplan, and Selene Preciado for their formative work on the PST ART initiative, their generous support of our exhibition, and their unfailing advice in developing it. We so much appreciate the additional support of Caltech trustees David Lee and Maria Hummer-Tuttle, and of the Keck Foundation, the Pasadena Art Alliance, and Sebastien Montabonel and The Island, for generously providing funding that has made this exhibition and catalog possible.

An exhibition of this magnitude would be impossible without the contribution of many artists and lenders. We extend our heartfelt thanks to all who engaged their creative energies and generously contributed to our efforts by making or loaning works.

Thank you to University Librarian Kara Whatley for her visionary leadership in the project, without which it would not exist. Thank you to our collaborators in the research component of the project: in addition to all the authors of essays here, those include Jed Buchwald, Dehn Gilmore, David Kremers, Melissa Lo, Patrick McCray, Hillary Mushkin, Joanna Radin, Chitra Ramalingam, and Caltech archivists Loma Karklins, Penny Neder-Muro, Elisa Piccio, Mariella Soprano, and Richard Thai. We and several of our contributors want to extend additional thanks to Loma for her exceptional research support and her knowledge of art and architecture in Caltech's history. Special thanks also go to our exhibition coordinator Bailey Westerhoff, whose brilliant organizational skills and unstinting efforts helped make the book and exhibition a reality. The Caltech Archives and Special Collections would not exist if not for the decades-long work of University Archivist Emerita Judith Goodstein, whom we thank for her generous preface.

The development of the exhibition and catalog have also involved many collaborations across Caltech and beyond. Thank you to Thomas Rosenbaum; to David Tirrell, Kaushik Bhattacharya, Stacey Scoville, and Regina Colombo in the Office of the Provost; and to Catherine Geard, Chris Daley, Mitchel Del Rio, Jocelyn Yamasaki, and Ling Lim at Caltech Library for their unfailing support of our efforts. We are equally indebted to colleagues across

Caltech, including Dexter Bailey, Nicole Weaver-Goller, Maria Sturges, Lauren Limbert, Polly Carrico, Santiago Lombeyda, Chiemi Suzuki, Shayna Chabner, Michael Alexander, Julia Ehlert, Jean Mueller, and Lawrence Henling. At JPL we would like to thank Michael Greene, Dan Goods, and David Delgado.

An essential part of mounting an exhibition of this scale at Caltech was borrowing space from academic divisions. Thank you to Paul Wennberg, Andrew Thompson, and Nora Oshima at the Linde Center; Dennis Dougherty, Grace Liang-Franco, Joseph Drew, Anya Janowski, and Paolina Martinez in Chemistry and Chemical Engineering; Tracy Dennison, Candace Younger, and Victoria Cruz in Humanities and Social Sciences; and Richard Murray, David Warren, and Jesse Flores in Biology and Biological Engineering for loaning us beautiful spaces. Thank you to Tim Durfee and Jennifer Rider for designing the exhibition and filling these spaces with equally beautiful graphics and exhibition furniture.

Thank you to Thomas Hunt Morgan and Eleth Cattell for inspiring the title of our exhibition and to Italo Calvino, Eric Temple Bell, Charles and Ray Eames, and Matthew Wisnioski for those of each of its four sections.

We owe a debt of thanks to Heidi Aspaturian, who brought a seasoned editorial eye and deep knowledge of Caltech to her role as copy editor. Our proofreader, Hillary Bhaskaran, worked diligently to correct errant typos. Many thanks also to Lorraine Wild and Ching Wang at Green Dragon Office for designing this book and making it a work of art. Kara Kirk, Maureen Winter, and Leslie Rollins at Getty Publications provided extraordinary assistance in getting this book distributed worldwide.

It's been a real pleasure and privilege to work with all of you.

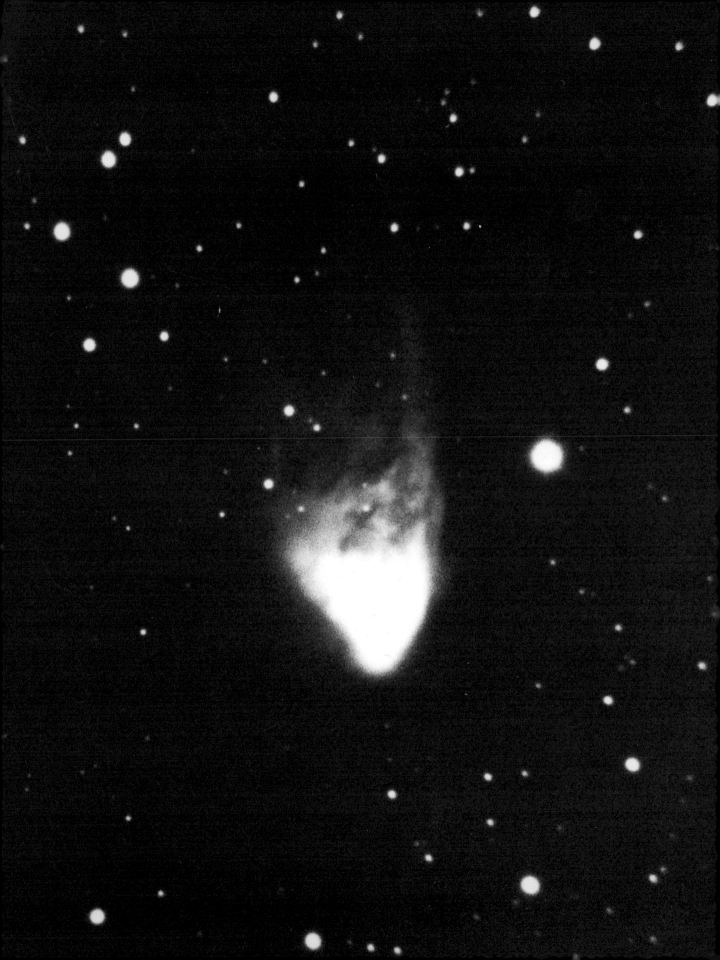

THE INFINITE LAWN

Mr. Palomar's mind has wandered, he has stopped pulling up weeds. He no longer thinks of the lawn: he thinks of the universe. He is trying to apply to the universe everything he has thought about the lawn. The universe as a regular and ordered cosmos or as a chaotic proliferation. The universe is perhaps finite but countless, unstable within its borders, which discloses other universes within itself. The universe, collection of celestial bodies, nebulas, fine dust, force fields, intersections of fields, collections of collections…
—Italo Calvino, "The Infinite Lawn," *Mr. Palomar*

Named after a chapter in Italo Calvino's 1983 novel *Mr. Palomar*, about a pensive man contemplating the universe, this exhibition's first section explores images of the cosmos. It is located at the Linde Laboratory for Global Environmental Science, formerly the Robinson Laboratory of Astrophysics. Completed in 1928 by the architectural firm of Goodhue Associates, it is one of the oldest buildings on campus, blending elements of the Spanish Colonial Revival style with astronomical motifs. Linde Laboratory still operates a small solar observatory with a telescope dome, Cassegrain mirror, and shaft extending 120 feet into the ground, projecting a small live image of the sun that welcomes visitors to the exhibition.

The sun played a pivotal role in the life and work of George Ellery Hale, who led the development of Caltech into a scientific research institution. Between 1903 and 1905, he envisioned and built Mount Wilson Observatory, where in 1923, astronomer Edwin Hubble discovered that our Milky Way was just one of many galaxies in an expanding universe, forever changing our view of the cosmos. Later, Hale collaborated with the architect Russell Porter to develop the Mount Palomar 200-inch telescope, which opened in 1948 as the largest on Earth. Built on an ancient Indigenous site for starwatching, Palomar has become one of the world's most recognizable scientific facilities, symbolic of the best of Caltech's research traditions. Astronomers—exclusively male, until Vera Rubin became the first woman to gain access to the observatory in 1965—have used its telescopes to map the night sky, discover distant stars and galaxies, measure cosmic distances, and uncover the nature of quasars, the most luminous and energetic objects in the universe—all the while creating magnificent images of space that continue to fuel not only science but art and the popular imagination as well.

Edwin Hubble
Variable nebula, 1949
Photograph
Caltech Archives and Special Collections

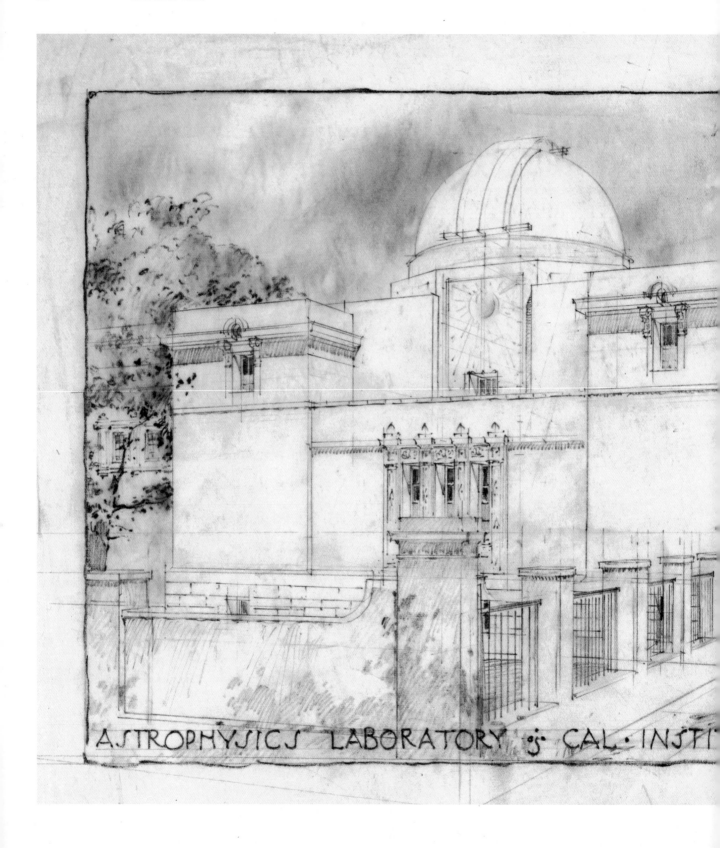

Russell Porter
Astrophysics Laboratory, 1929
Pencil on sketch paper
Caltech Archives and Special Collections

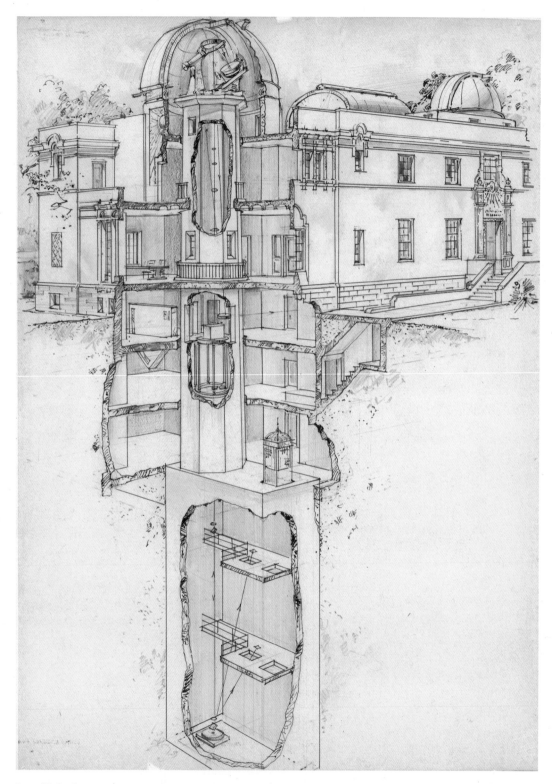

Russell Porter
Coelostat, 1929
Ink and pencil on sketch paper
Caltech Archives and Special Collections

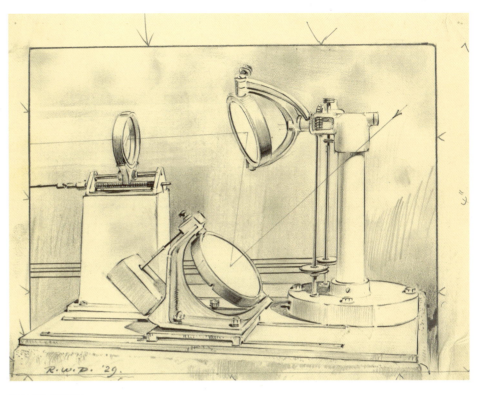

Russell Porter
Untitled (Spectrohelioscope Mirrors), 1929
Pencil and ink on sketch paper
Caltech Archives and Special Collections

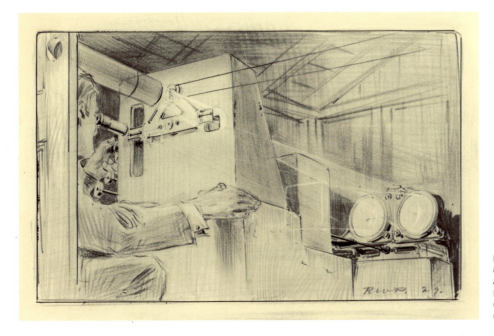

Russell Porter
Untitled (Operation of Spectrohelioscope), 1929
Pencil and ink on sketch paper
Caltech Archives and Special Collections

James Sebastian Fassero
Russell Porter at the drawing board, 1938
Photograph
Caltech Archives and Special Collections

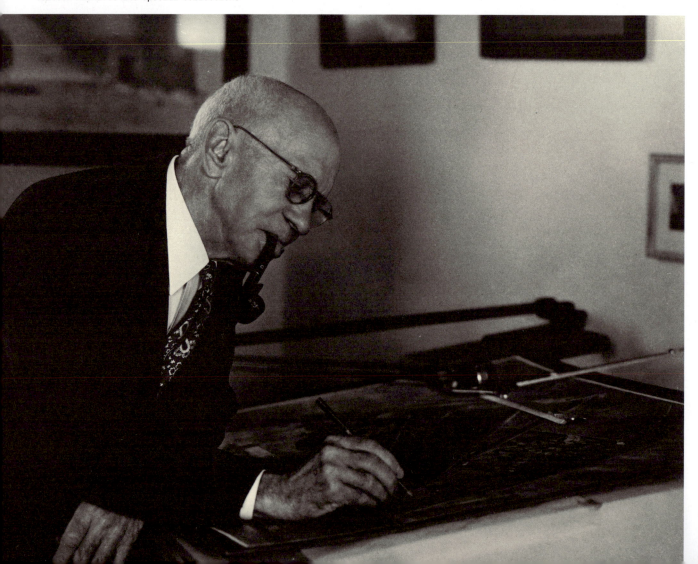

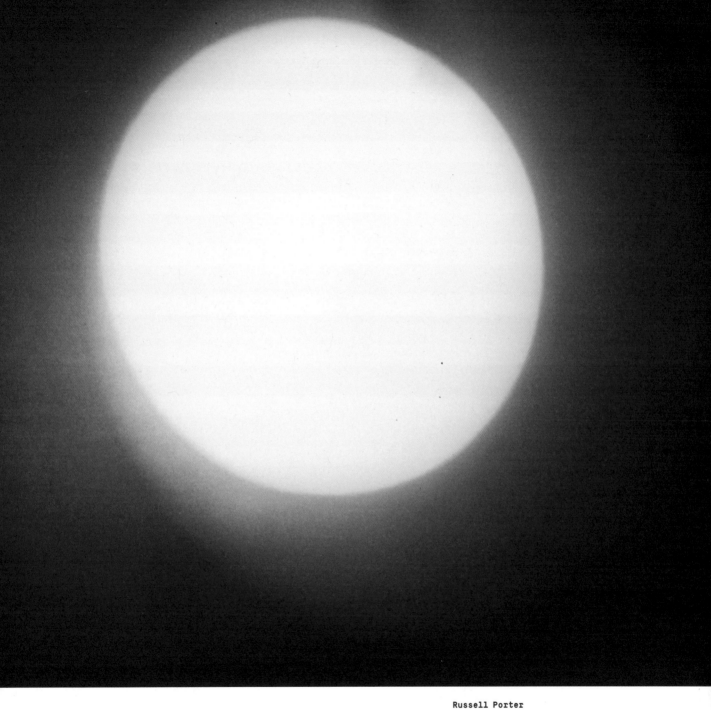

Russell Porter
Coelostat in Ronald and Maxine Linde
Center for Global Environmental Science, 1932
Projecting solar telescope
Caltech Archives and Special Collections

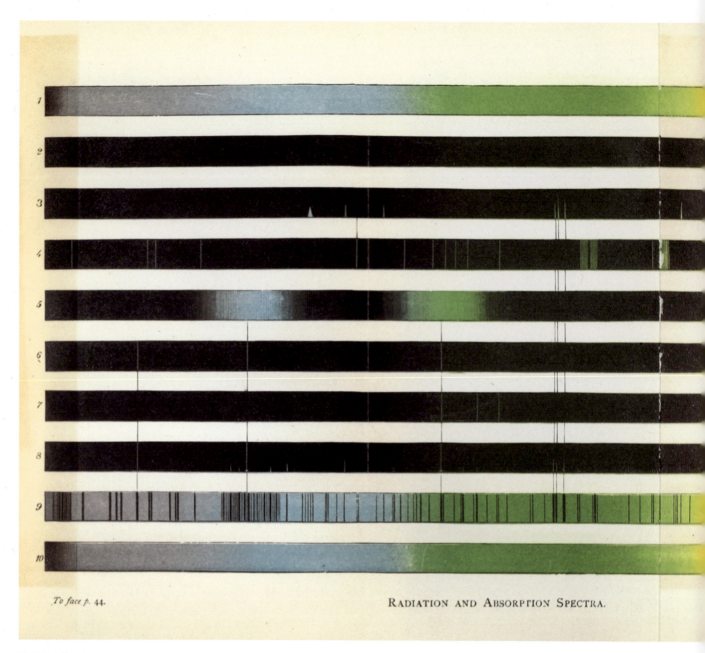

Norman Lockyer
Studies in Spectrum Analysis, 1878
Book
Caltech Archives and Special Collections

Unknown Photographer
George Ellery Hale at the National Academy of Sciences, c. 1930
Photograph
Caltech Archives and Special Collections

Unknown Photographer
George Ellery Hale and Ferdinand
Ellerman on Mount Wilson, c. 1905
Photograph
Huntington Library

Unknown Photographer
Staff and researchers at
the Monastery, Mount
Wilson Observatory, 1905
Photograph
Huntington Library

Unknown Photographer
Margaret Harwood, 1907
Photograph
Smithsonian Institution Archives

Unknown Photographer
"Four Friends" (astronomer
Phoebe Waterman Haas, left), 1910
Photograph
National Air and Space Museum,
Smithsonian Institution

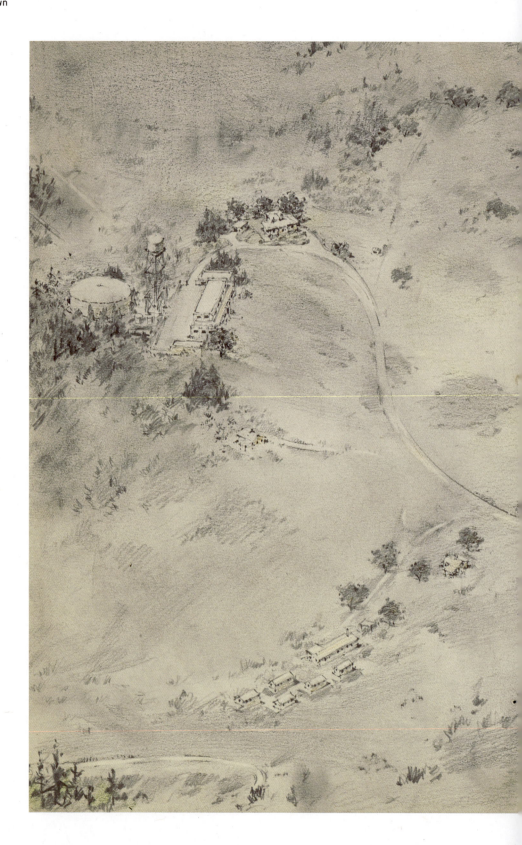

Russell Porter
Untitled (Palomar Observatory Site), 1937
Pencil on sketch paper
Caltech Archives and Special Collections

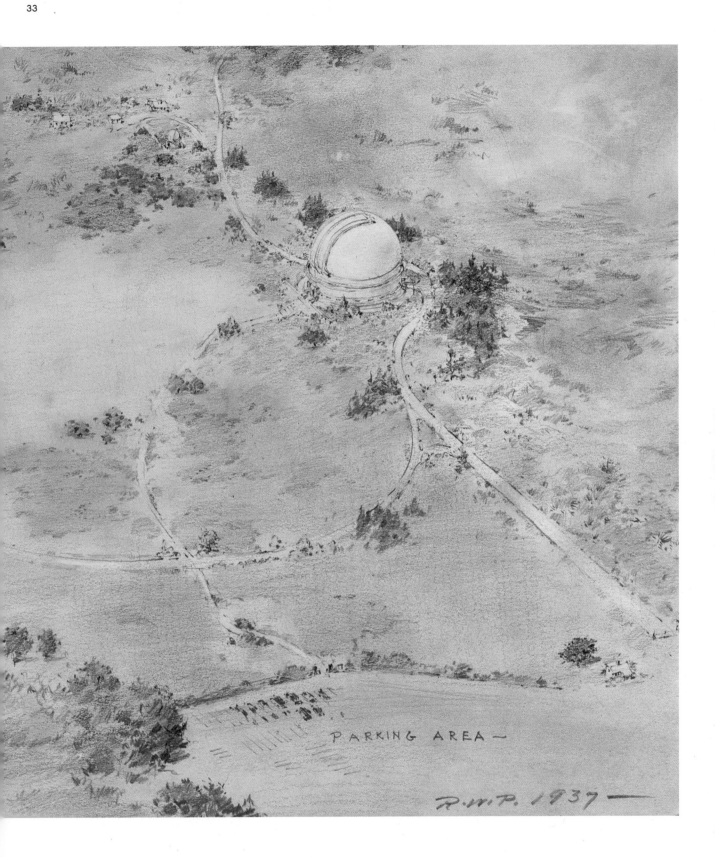

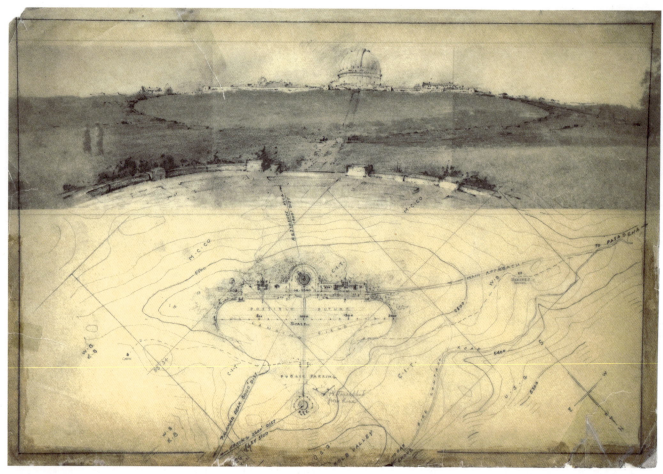

Russell Porter
Untitled (Palomar Observatory Site), 1935
Pencil on sketch paper over photograph
Caltech Archives and Special Collections

Unknown Photographer
200-inch Hale Telescope
site, c. 1935
Photograph
Caltech Archives and
Special Collections

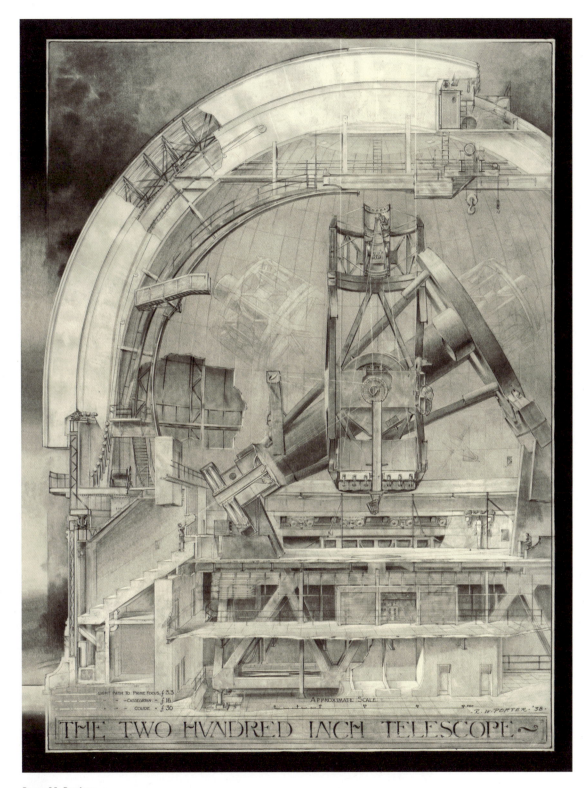

Russell Porter
The Two Hundred Inch Telescope, 1938
Pencil, ink, charcoal, and gouache on board
Caltech Archives and Special Collections

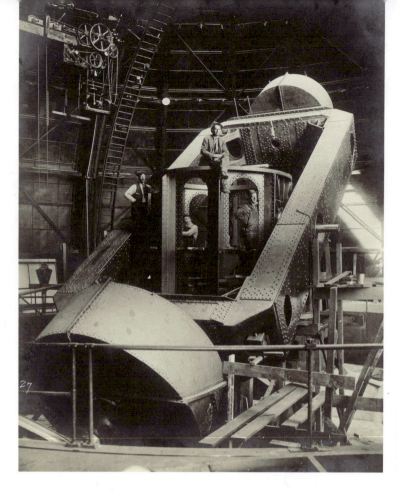

Unknown Photographer
Section of Mount Wilson
Observatory Hooker Telescope, 1916
Photograph
Caltech Archives and Special
Collections

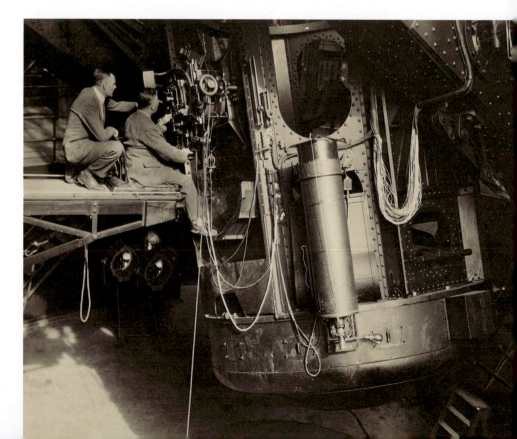

Wide World Photos
Edwin Hubble and James Jeans look
through Hooker Telescope, 1931
Photograph
Caltech Archives and Special
Collections

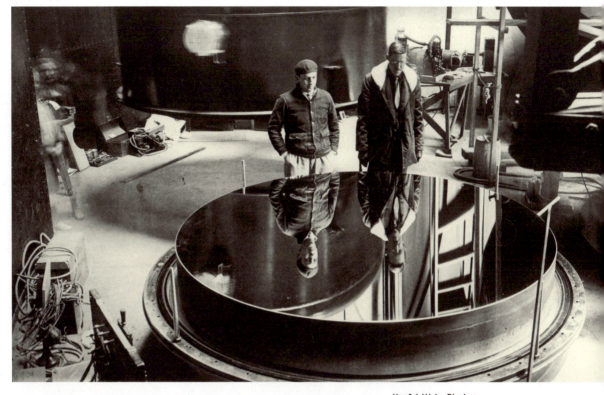

World Wide Photos
John D. Strong and Enrique Gaviola
look into aluminized Hale
Telescope mirror, 1947
Photograph
Caltech Archives and Special
Collections

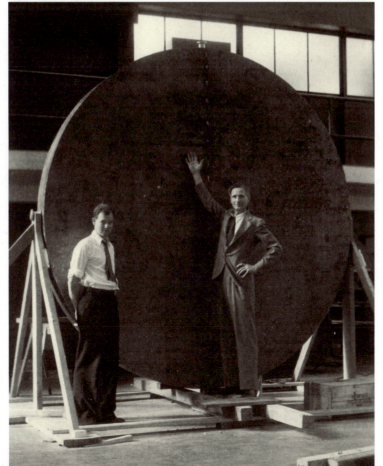

Unknown Photographer
200-inch Hale Telescope mirror
blank, c. 1936
Photograph
Caltech Archives and Special
Collections

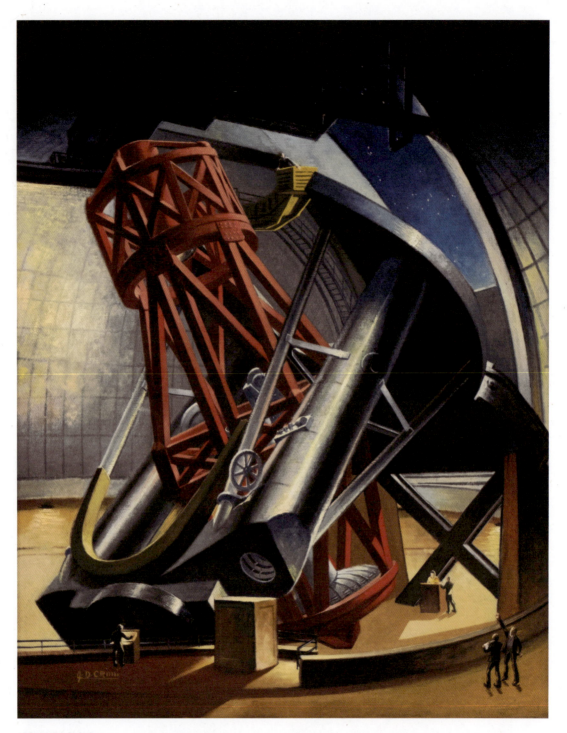

Alfred D. Crimi
The Hale Telescope at Palomar Observatory, 1945
Oil on canvas
Caltech Archives and Special Collections

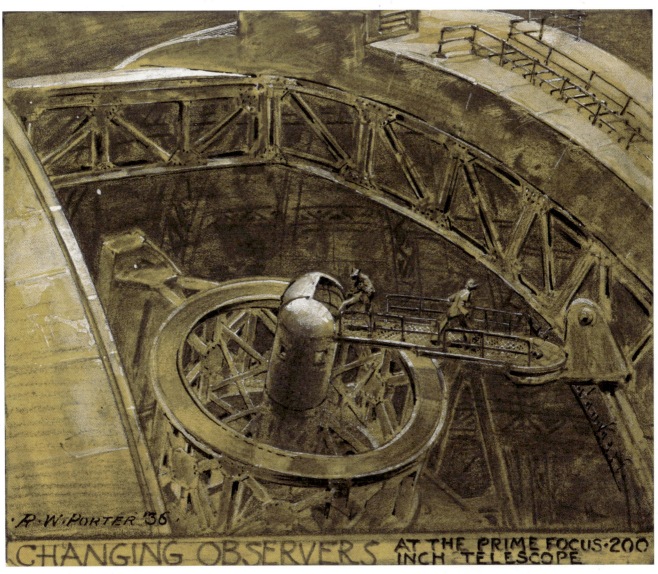

Russell Porter
Changing Observers, 1936
Pastel on cardstock
Caltech Archives and Special Collections

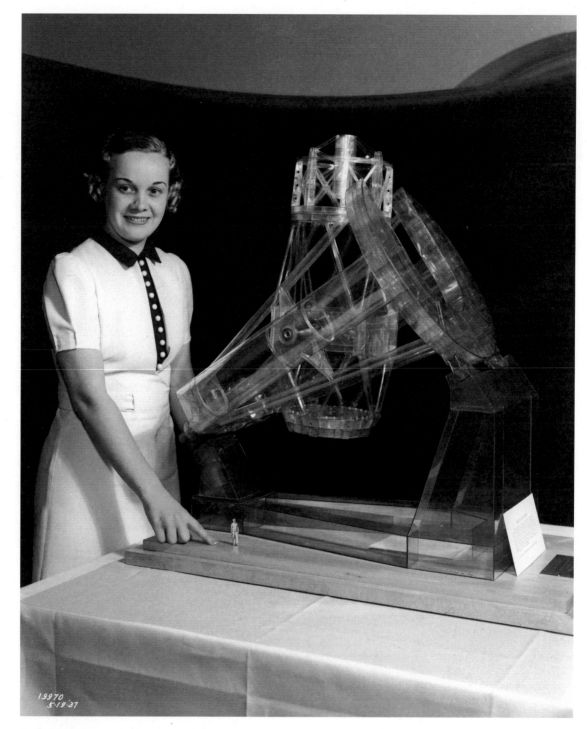

G. Haven Bishop
Marie Johnson exhibits Hale Telescope model, 1937
Photograph
Huntington Library

O. K. Harter
Hale Telescope dome, 1941
Photograph
Caltech Archives and Special Collections

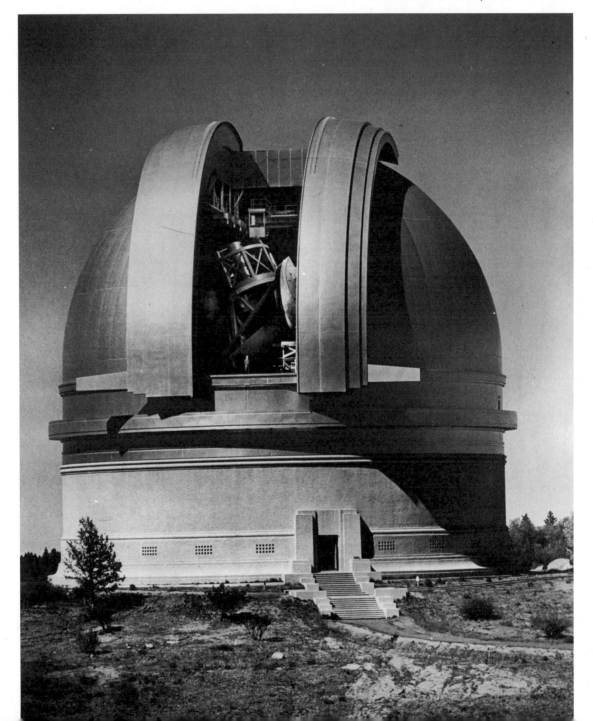

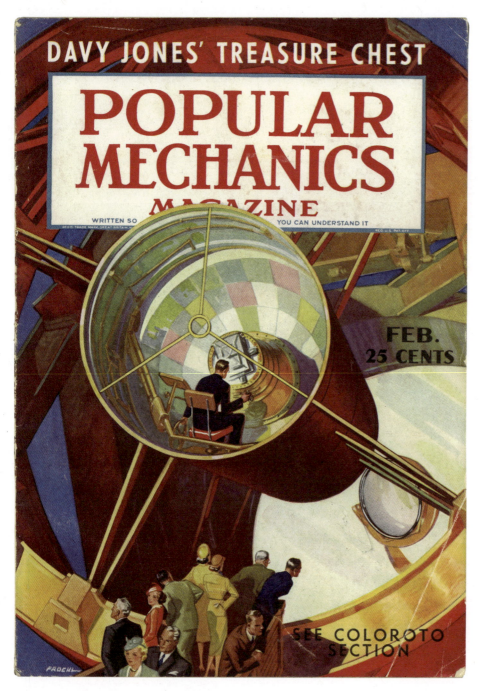

Unknown Artist
Popular Mechanics Magazine, February 1939
Magazine
Caltech Archives and Special Collections

J. R. Eyerman
Edwin Hubble inside
the 200-inch Hale
Telescope, 1950
Photograph
Huntington Library

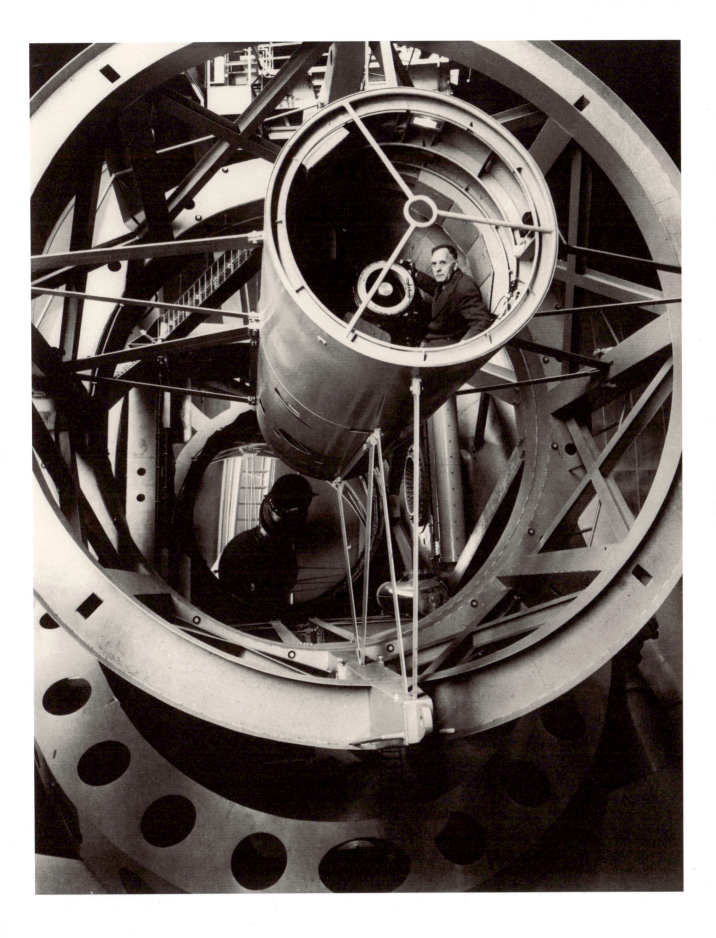

Arax Photo Studio
Vera Rubin as an undergraduate at Vassar, c. 1948
Photograph
Archives and Special Collections, Vassar College
Library

John Anderson
Triangulum Galaxy seen from
Mount Wilson Observatory, 1910
Photograph
Caltech Archives and Special
Collections

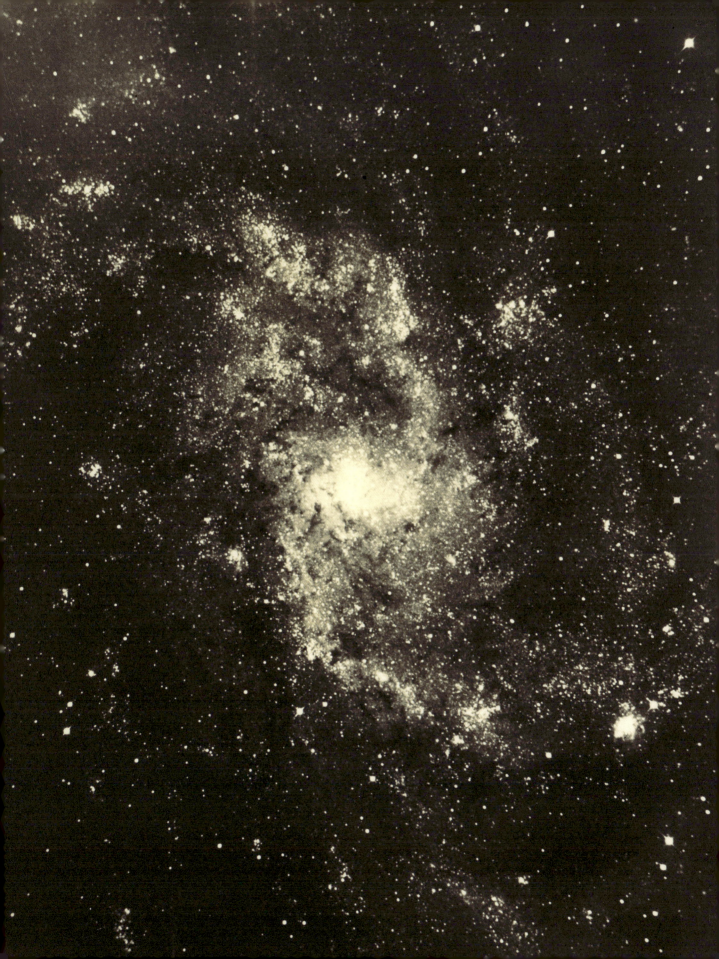

Lois Rosson

BETWEEN SCIENCE AND FICTION:
NASA's Voyager Missions and the Visualization of the Space Environment

Seeing Space in the 1970s

The look of outer space in the public imagination is an image that changes alongside history, but certain moments have shaped the appearance of this remote landscape more than others. While Project Apollo transmitted the lunar surface in human terms via astronaut intermediaries, NASA's push into the outer solar system in the 1970s was characterized by the robotic exploration of alien environments. Voyagers 1 and 2 drove the pictorialization of these places, a process greatly influenced by the geographic proximity of NASA's Jet Propulsion Laboratory (JPL) in Pasadena, California, to the Hollywood film industry. The first film in the *Star Wars* franchise was released in May of 1977; *Star Trek: The Motion Picture* entered production shortly thereafter; and by September of the same year, engineers at JPL watched both Voyagers launch from Cape Canaveral. In 1979, Carl Sagan's *Cosmos: A Personal Voyage* introduced television audiences to the Voyager encounters via the Public Broadcasting System. Rather than characterizing this moment as one where new science informed the look of a given subject in popular media, JPL's exchanges with the entertainment industry highlight the professional agency of trained artists in the production of scientifically accurate images.

The case of the astronomical illustrator is an instructive one for demonstrating the sheer difficulty of seeing space, and the amount of extrapolation needed to coax a coherent picture of an alien environment from remotely collected data. But what does it mean for an image to be scientific? And if an image is determined to be accurate with respect to scientific criteria, where in the image is the science transmuted into visual information? JPL's impact on the look of outer space is rightfully celebrated, but the visually interpretive scaffolding that helped incorporate its scientific work into the popular imagination is often overlooked entirely. This essay focuses on the work of three astronomical illustrators—Rick Sternbach, Don Davis, and Jon Lomberg—and the construction of their professional identities.

Astronomical illustration was seen by its practitioners as a form of scientific image making, a genre that typically subverts the artist's identity into the anonymity of objective representation.[1] Collaborations with scientific authorities obscured the role of artists as authors of images, subsuming their individual perspectives into the generic category of "artist's rendition." Rather than treating artists as passive vessels that simply rework scientific information into visual forms, recognizing their anonymity as a feature of the genre reasserts the agency of individual artists and helps demonstrate how the visual culture of science intersects with culture at large.

The historical contingencies of the late 1970s produced a viable market for illustrators to craft images they could bill as scientifically authoritative. Planetary science in the post-Apollo period was characterized by unmanned satellite and probe missions sent to neighboring planets and their moons. These missions sent back data that needed to be reconstituted into coherent images. Artists gave visual form to this information, participating in an exchange of tools, data, and expertise that to this day remains underexamined in historical scholarship.

Popular Science and Science Fiction: A Conceptual Symbiosis

The rise of the melodramatic space opera genre, exemplified by the groundbreaking success of George Lucas's *Star Wars* in 1977, had a profound influence on Rick Sternbach's artistic trajectory. The previous year, he had attended a science

fiction convention in Kansas City, where he encountered Ralph McQuarrie's preproduction paintings for *Star Wars: A New Hope*. In addition to a personal appearance by 24-year-old Mark Hamill, the convention featured a room full of prints of McQuarrie's work as well as several costumes designed for the film.[2] McQuarrie had spent time as an artist at Boeing, and Sternbach was deeply impressed by the attention to plausible engineering and pictorial realism reflected in his spacecraft designs.[3]

In this story, science and science fiction are mutually constitutive. Rick Sternbach's early career was characterized by an interest in scientific accuracy exemplified by technically dense works of science fiction popular in the early 1970s. His first *Analog* magazine cover illustration depicted an Enzmann starship for an article by G. Harry Stine, a former White Sands missile engineer, on a plan for transgenerational travel between star systems.[4] As with the "hard" science fiction writing of the 1950s, technical accuracy was a metric by which quality illustrations were judged in the publishing industry. Rather than treating accompanying artwork as fanciful ornamentation, these images were meant to visualize futuristic principles in plausible, if speculative, ways (right).

Sternbach's illustrations were popular because they mirrored the technical validity of the text he worked with. In his case, science and science fiction were both rooted in a desire to maximize fidelity. The artist's work was soon in considerable demand; after his cover for *Analog*, he cultivated a reputation as a successful illustrator for both popular science and science fiction magazines. Accuracy was the core of his professional identity, and his process was one that collaborators trusted as sufficiently rigorous. In order to create an image, Sternbach would make two or three rough paintings about the size of the magazine itself, shoot several Ektachrome photographs, mail the film into the publisher, and wait for feedback. After making its selection, the magazine would give him two weeks to produce a final draft.[5]

Rick Sternbach
Untitled (Cover Painting for Analog *Magazine)*, 1973
Oil on canvas
© 2023 Rick Sternbach

By 1977, prompted by the McQuarrie paintings he saw in Kansas City, Sternbach left the magazine jobs he'd found on the East Coast to try his hand in the film industry. After relocating to Los Angeles, he met a production designer at Paramount working on a television revamp of the show *Star Trek*. Originally aired in 1966, *Star Trek* was cancelled after three seasons, prompting Paramount to license the broadcast syndication rights to help mitigate the show's financial losses. Reruns started almost immediately, airing in over 150 domestic and 60 international markets. As a result, *Star Trek* grew more popular over the 1970s than it had been during its original run. The 1977 release of *Star Wars* prompted executives at Paramount to rethink the viability of a revamped *Star Trek* universe.[6] Fortuitously, Sternbach's entry into the film industry coincided with Paramount's decision to upgrade *Star Trek: Phase II*, originally conceived as a television show, into a film, later titled *Star Trek: The Motion Picture*.

Sternbach was especially interested in plausible depictions of space hardware, which made *Star Trek: The Motion Picture* an attractive project. Both Matt Jefferies and Gene Roddenberry had experience working with real aircraft, which Sternbach considered a sort of qualification for representing feasible spacecraft. Jefferies, the designer of the original starship *USS Enterprise,* had worked inside several American bomber planes during World War II. Roddenberry, *Star Trek's* creator, had studied aeronautical engineering before enlisting as a bomber pilot in 1942.

The production of *Star Trek: The Motion Picture* coincided with a particularly visible moment in the history of JPL. Taking cues from private industry and responding to growing popular interest in the Voyager mission to the outer planets, JPL had begun to cultivate a public image by deploying public affairs specialists, as well as Voyager mission team members, on behalf of science.[7] Rather than waiting to publish in scientific journals, JPL held press conferences to share immediate discoveries with science writers and journalists. The trajectory of the Voyager spacecraft was typically publicized in advance, so the media could time its inquiries around planned encounters.[8] The findings were also novel, showcasing never-before-seen images of Jupiter and Saturn.[9]

This was a boon for *Star Trek* and other forms of popular media that were interested in using Voyager's discoveries to make their depictions of space more sophisticated. There was an unforeseen technical dimension as well; data coming in from the Voyager mission prompted the development of new and better computer animation techniques. Though computer graphics was still in its early stages, its creations looked cutting-edge compared to hand-made effects, and *Star Trek* managed to poach some of the vector animations Jim Blinn and his team were developing at JPL's Computer Graphics Lab. In *Star Trek: The Motion Picture,* these graphics can be seen on the video monitors onboard the *Enterprise*.[10]

Rick Sternbach functioned as a liaison between the lab and studio, sourcing reference material that could help make the film appear more technologically sophisticated. In addition to the animations displayed on the *Enterprise* monitors, he was also charged with overseeing the look of one the film's major props— the mysterious V'ger. In the film, the *Enterprise* is dispatched to investigate V'ger, an enigmatic and menacing force moving toward Earth. Toward the end of the movie, this being is revealed to be Voyager 6, which was intercepted by sentient deep-space robots and developed both a consciousness and a yearning to meet its creator.

Though the film never clarified where on Earth V'ger anticipated having this reunion, both Pasadena and Hollywood would have been strong contenders. To physically create V'ger, Sternbach and his collaborators went directly to JPL's Public Affairs Office for blueprints of the spacecraft's nonfiction counterpart.[11] Voyager 6 was modeled on the real Voyager spacecraft design, which by this time had acquired enough media visibility for the studio to believe that audiences would recognize it. The admiration between JPL and the original *Star Trek's* creators

was mutual; when the lab's project managers were weighing new names for MJS77—Mariner Jupiter-Saturn '77, the mission hardware that would become Voyager—"Planet Trek" and "Trekker" were both considered.[12]

Cosmos, Voyager, and the Visual Campaign for Space Science

Released in 1979, *Star Trek: The Motion Picture* was met with mixed reviews. Though one critic dubbed it "*2001: A Space Odyssey* for slow learners," the film emerged as a box office success, showcasing the public's fascination with space and extraterrestrial encounters.[13] The *Star Trek* franchise emerged amidst a period of burgeoning interest in space exploration and science advocacy, amplifying the need for compelling visualizations of the cosmos.

Shortly after the film's release, Rick Sternbach shifted his focus to a new venture under way at KCET, a PBS television station in Hollywood. *Cosmos: A Personal Voyage*, spearheaded by planetary scientist Carl Sagan, astrophysicist Steven Soter, and writer Ann Druyan, was a television program meant to inspire continued support for the scientific exploration of space by presenting audiences with the mysteries of the universe in a visually compelling format. The program pitched outer space as a realm worthy of investigation for investigation's sake, situating humanity and Earth as continuous with the rest of the solar system, and suggesting to viewers that answers to questions about life on Earth might be found in outer space.

Cosmos embraced an approach to representation akin to Sternbach's prior experiences with science fiction, prioritizing accuracy and up-to-date reference material. Sagan, together with Soter and Druyan, had access to an extensive network of expertise in both astronomy and science writing, amplified through close ties with JPL. Unlike *Star Trek*, which used the appearance of technical accuracy to create an immersive environment for the sake of entertainment, *Cosmos* was envisioned as a pedagogical program that would use the realities of alien environments to inspire curiosity in its audience.

The show's educational goals further underscored the need for accuracy with respect to visualization, coinciding with the arrival of Voyager at the Jovian system in March 1979 (page 226).[14]

That *Cosmos* entered production alongside the arrival of Voyager data from Jupiter and Saturn had a profound impact on the show's development. The program's art department was charged with rendering the landscapes of space as new information unfolded in real time. While the team had access to JPL's library of cutting-edge visual references, many of these views needed to be elaborated on to create a fully immersive environment sufficiently compelling for television audiences. Hiring artists with professional experience in astronomical illustration was a way to ensure accuracy alongside pictorial craftsmanship. The program's art department had a concentration of this type of talent. Don Davis, one of Sternbach's artistic contemporaries, had trained at the astrogeology branch of the US Geological Survey in the early 1970s and illustrated Gerard O'Neill's 1975 *Space Settlement Design Study*, produced in conjunction with Stanford University and NASA's Ames Research Center.[15]

Attempting to visualize the solar system at this point in time felt experimental in its own right. There was a tacit understanding amongst the staff that whatever work was done to visually represent the solar system might soon be rendered obsolete. There were upsides, however—Don Davis recalled with satisfaction being able to use fresh Voyager 1 images to inform the color of the globes he constructed for the show.[16] The head of *Cosmos*'s art department, Jon Lomberg, was a former science journalist who led the artistic direction on Voyager's Golden Record. (The conceptual successor to the Pioneer Plaque, the Golden Record was mounted aboard both Voyagers and designed to carry information about the cultures of Earth out into the solar system for hypothetical extraterrestrial viewers.) Lomberg was a long-time Sagan collaborator, and while working on the set of *Cosmos*, he would wait at JPL for new pictures from the

Voyager spacecraft to reach the lab. "We'd get the picture, and I'd hop in the car and drive at high speed from Pasadena back to Hollywood and literally would revise the paintings—the models—as new data was coming in."[17]

Cosmos: A Personal Voyage was a breakthrough in how artistic expertise could further visualization in the sciences. The series entered production just as JPL was pioneering new developments in computer graphics. The *Cosmos* production team contracted with JPL to help produce animation sequences for the series and gave Jim Blinn and his Computer Graphics Lab new funding for software development. These collaborations resulted in several usable sequences for both entities; imagery of the Voyager spacecraft flying past Jupiter shown in *Cosmos* was also circulated in official JPL press releases. When Blinn couldn't get the money from JPL to do his Voyager fly-by, he got the money from *Cosmos* (page 51).[18]

Cosmos's art department also made substantive contributions to the 3D computer mapping techniques Blinn had developed. In fact, Blinn hired Don Davis and Rick Sternbach to produce some of the first planetary texture maps ever created. Davis worked on three-dimensional maps of Saturn and its various satellites, as well as Uranus and Neptune. He viewed these computational tools as perfectly continuous with methods developed by earlier astronomical illustrators and likened the CGL planetary texture maps to cylindrical Mercator projections of the sixteenth century. These projections presented north and south as up and down but in a way that preserved local directions and shapes.

The idea for the CGL maps was similar—rectangular planetary texture maps were wrapped digitally around a virtual globe, so they could be examined from any angle.[19] Accounting for distortion with this method was tricky, because round craters shown anywhere near poles on a planet's surface would stretch into long ellipses. After hand-painting the textures themselves, Davis and Sternbach solved the distortion problem by using the stamp tool Blinn and his team had created as a visual guide.

The collaboration was a fruitful one for both teams—while the visualization tools Blinn developed for scientific inquiry helped Davis and Sternbach overcome the challenges of visually designing the look of outer space for television, the artists reciprocated by helping plot information received from spacecraft according to the visual technique of linear perspective.[20]

Cosmos: A Personal Voyage aired in 1980 and remains one of the most successful television series ever produced by the Public Broadcasting System.[21] Carl Sagan's desire to educate audiences about "real science" in a visually striking way directly benefited from the artistic ethos cultivated over the late 1970s. The visuals for which the show was celebrated appeared on screen as a simple 1:1 index of outer space. For this to work, the artist's interpretive judgement needed to be subsumed into the clarity of the image; what viewers saw was a visualization of the cosmos, mediated through a trained artist who functioned only as a temporary vessel. The appearance of scientific neutrality, however, was quite literally constructed by a group of people with a distinct form of professional expertise.

Conclusion—The Space Environment as Cultural Artifact

By examining the ways in which professional illustrators legitimated their work as scientifically plausible—and tracing the types of terrestrial reference material they used to bolster the clarity of their images—we can start to understand their influence on the "look" of outer space in the popular imagination. By recentering the narratives of individual illustrators, we can examine their agency in this process.

The production of *Cosmos* carried significant political implications. Carl Sagan, in his commitment to science education, emphasized the importance of public investment in the dissemination of scientific knowledge. He believed that education played a pivotal role in maintaining momentum for scientific initiatives. *Cosmos* aimed to inspire curiosity and interest in space exploration by positioning humanity and Earth as integral components of the cosmic realm. The show's visual style, exemplified by the work

Unknown Photographer
Don Davis working on a model of Venus
for *Cosmos* TV show, 1980
Photograph
Courtesy of Don Davis

of Jon Lomberg, signaled continuity between outer space and the terrestrial landscape, bolstering Sagan's advocacy for continued exploration. Lomberg's art blended interpretive symbols of earthly biology with images of space, portraying humanity as an integral part of the cosmos rather than suspended within it. Space, in this framework, was not the absence of natural landscapes, but an extension of the landscapes that humans and other terrestrial organisms could one day inhabit.

The political and moral concerns of the 1970s reverberated throughout representations of outer space, embedding the visual culture of space science in this period with historically specific cultural signifiers. Missions to the outer solar system resulted in a deluge of new visual information about alien worlds that coincided with widespread anxieties about the exhaustion of natural resources on Earth. Some illustrations repeated much older visual tropes that cast the cosmos as a type of unsettled western frontier, but they did so in a way that gestured to the environmental concerns of the moment, framing space as an extension of the natural world. This was true also of illustrations that imagined humanity's future beyond Earth's borders—space station design from this period emphasized the possibility of pastoral living in a way that mirrored suburban white flight out of American cities throughout the 1970s.

We know that the visual arts can transmute scientific knowledge into broadly legible images, but how do we parse the push and pull of culture and science within individual images? Scholarship around science communication has long pushed back against the center-out model of dissemination, which dictates that scientific knowledge permeates outward from scientific institutions into culture at large. Models that describe coproductive knowledge making, which see scientific institutions as sites of both input and output, leave more room for evaluating the ways science functions as a social product.

1—"Art" and "illustration" are used indistinguishably over the course of this essay. The actors in this story were paid *illustrators*, but they evaluated their contributions to astronomical illustration in terms of their *artistic* dexterity. Some of them described the act of scientific visualization as a type of high realism consistent with the history of Western art, even though they weren't producing what galleries or museums considered art objects.

2—Rick Sternbach, author interview, May 26, 2020, 3.

3—McQuarrie illustrated one of the Apollo animations for the CBS news broadcast of the Apollo Moon Landing. Bob Rehak, "Remembering Ralph McQuarrie," *Graphic Engine* (blog), March 6, 2012, https://graphic-engine.swarthmore.edu/remembering-ralph-mcquarrie/.

4—Sternbach illustrated the Enzmann starships Stine identified as the most likely transit vehicle. Adam Crowl, K. F. Long, and R. K. Obousy, "The Enzmann Starship: History and Engineering Appraisal," *Journal of the British Interplanetary Society* 65, no. 6 (2012): 185.

5—Sternbach, interview, 3.

6—Doug Schult, "Cult Fans, Reruns Give Star Trek an Out of This World Popularity," Green Sheet, *Milwaukee Journal*, July 5, 1972.

7—The process of debuting science at the press conference was known as "instant science" at JPL. See Peter Westwick, *Into the Black: JPL and the American Space Program, 1976–2004* (New Haven: Yale University Press, 2011), 33.

8—Westwick, *Into the Black*, 33.

9—The Voyager projects turned Jupiter and Saturn from "blurry smears on astronomer's plates" to material topographies with knowable features. "Voyager rewrote the textbooks—or, perhaps more accurately, drafted them from scratch, since knowledge of some of Jupiter's and Saturn's satellites and features was previously too scant to support detailed description." Westwick, *Into the Black*, 31–32.

10—Sternbach, interview, 3.

11—Sternbach, interview, 4.

12—Westwick, *Into the Black*, 38.

13—Ed Power, "A Troubled Enterprise: How *Star Trek: The Motion Picture* Flirted with Disaster Only to Become a Surprise Smash," *Independent* (US edition), December 6, 2019.

14—For the timeline of the Voyager mission to the four giant outer planets, see the interactive mission timeline at "A Once-in-a-Lifetime Alignment," Voyager, NASA/JPL, https://voyager.jpl.nasa.gov/mission/timeline/#event-a-once-in-a-lifetime-alignment.

15—Lois Rosson, "The Astronomical Realists: The Social Mechanics of Visual Documentation, Art, and the American Space Age, 1944–1987" (doctoral dissertation, UC Berkeley, 2022), 96–100, https://escholarship.org/uc/item/0xt9j667.

16—Don Davis, author interview, May 26, 2020, 6.

17—Jon Lomberg, author interview, May 18, 2020, 12.

18—Lomberg, interview, 10.

19—Davis, interview, 8.

20—Davis, interview, 18.

21—J. Kelly Beatty, "The Return of Cosmos," *Sky & Telescope*, August 9, 2011, https://skyandtelescope.org/astronomy-news/the-return-of-cosmos/.

Josef J. Johnson
Palomar Mountain landscape seen through the 18-inch Schmidt Telescope, 1938
Photograph
Caltech Archives and Special Collections

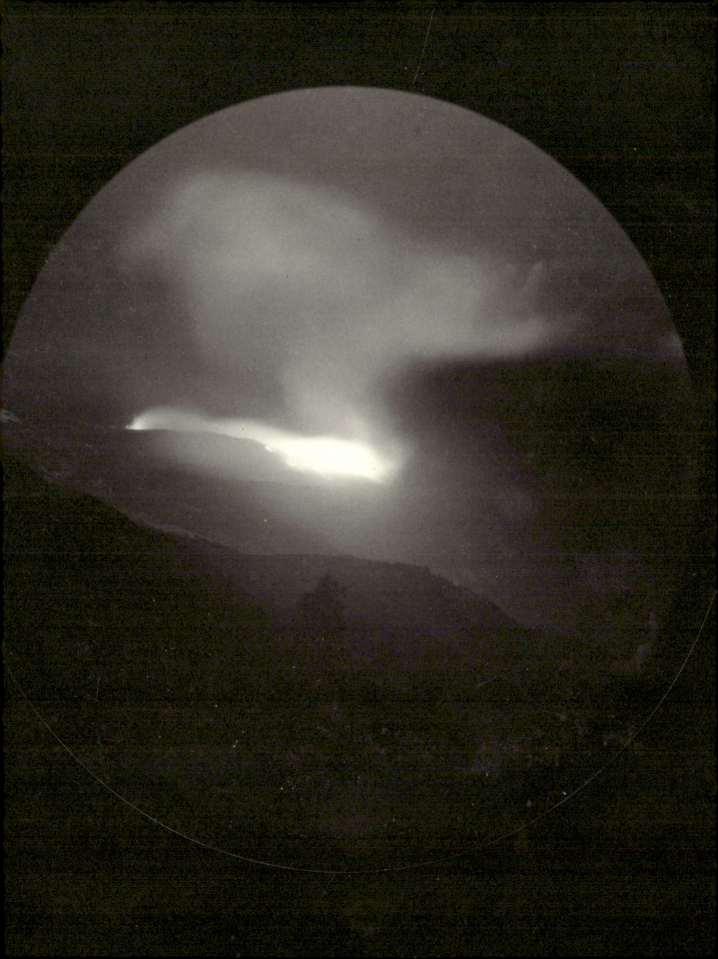

David Zierler

THE UNIVERSE IN PIXELS:
The Creation of Charge-Coupled Devices and the Dawn of Big Data Astronomy

The most significant technical advance in twentieth-century astronomy originated in the quest to improve computational memory. The technology originated at Bell Labs in Murray Hill, New Jersey, and it translated most spectacularly into astronomical applications, with advances in camera design at the Jet Propulsion Laboratory (JPL) and with the inception of data-driven astronomy at Caltech. The resulting shifts in imaging from analog to digital instrumentation, and the consequent revolutions in our capacity to image the universe, have made astronomical discovery at once more exciting, more accessible, and essentially as limitless as the universe itself. Thanks to digital detectors and their evolution from the charge-coupled device (CCD), astronomers can now peer deeper into the great beyond with ultra-high resolution, and they can survey the night sky to detect changes over cosmic time, creating in the process vast amounts of data to be interpreted through the aid of computational analysis and machine learning.[1]

Today, virtually every important astronomical event and intriguing cosmic object is captured and studied by these means, all thanks to an industry-relevant technological motivation that had nothing to do with astronomy and, initially, had nothing to do with imaging. The following account illustrates a grand theme in the modern interplay of technology and science: discovery is often the happy result of unintended consequences and misguided initial motivations.

A CCD is an array of light-sensitive semiconductors that capture particles of light, or photons, and convert them to electrons. The electric charge at any single point—a pixel in a digital device—is correlated with the luminosity hitting the CCD.

In mosaic form, these pixels form a digital image. Invented at Bell Labs in 1969 by George Smith and Willard Boyle—an achievement for which they would receive the 2009 Nobel Prize in physics—the CCD was the result of a one-afternoon brainstorming session, in pursuit of a silicon-based version of magnetic bubble devices. At the time considered to be one of the most promising digital memory technologies, bubble memory, also a Bell Labs innovation, never found widespread application. Jack Morton, a technical leader at Bell Labs, saw it as a concept that would be much enhanced by recent developments in semiconductor technology. Of specific relevance was Bell Labs' development of silicon-diode-array camera tubes for the much-anticipated Picturephone, which, as its name suggested, combined telephone and television technologies. Adding a visual element to telephony had been a conceptual goal dating back decades, and Bell Labs was convinced there was a huge market for the Picturephone to be exploited in the early 1970s. As Smith later recalled, the Picturephone provided a conceptual impetus to create a silicon-based solid-state device that eliminated the need for an electron beam, which Smith described as being notoriously unreliable in communications applications.[2]

During this time, Bell Labs also resumed basic research in metal oxide semiconductor (MOS) technology, which it pioneered in the 1950s and then largely ignored as the lab's competitors, including RCA and Fairchild Semiconductor, pursued MOS capabilities. With most of the issues in reliably transferring electrons resolved over the previous decade, MOS capacitors proved to be the linchpin that combined the conceptual promise of bubble memory with the technical superiority of silicon.

Acting on Morton's charge to create a new memory device that used semiconductor chips, Smith and Boyle stood at a blackboard and sketched out a device featuring a layer of "doped" silicon. They surmised that the electrodes in the device, serving as "gates" to which applied voltage blocks silicon's positive charge, would create an accumulation of electrons that would flow in a sequence, akin to filling a row of buckets, until the last gate, at which point the charge level could be measured as a unit of light.[3] Smith later explained that the idea of direct application of voltage was the deciding factor in making the CCD a viable technology.[4]

The prototype model worked exactly as its creators envisioned. They had managed to combine the promise of bubble memory with the silicon proof-of-concept of the Picturephone, while utilizing the principles and advantages of semiconductor technology. While the motivation at Bell Labs was to push forward next-generation memory capabilities, it soon became apparent that the CCD would have a singular impact on imaging technology.

Realizing this potential required a flash of insight to reimagine CCDs as the basis for a new era in digital imaging. Bell Labs was lucky in its timing when it hired Michael Tompsett in 1969. At English Electric Valve, Tompsett had invented the pyroelectric camera tube, for which the solid-state version remains the standard in thermal imaging applications. Recognizing that the future of the industry was in silicon, Tompsett recalled his motivation to transfer to Bell as an effort to "get away from the tube business." As an "image guy" who had followed the progress of Boyle and Smith's CCD collaboration, his "immediate reaction was to make [the CCD] into an imaging device."[5]

Upon examining the new device, Tompsett was immediately struck by its imaging area, significantly smaller than camera tubes, which offered obvious advantages. He later explained, "the signal-to-noise ratio of CCDs was going to be much better than in existing camera tubes," owing to a combination of the efficient and rapid transfer of electric charges within the device.

The CCD setup allowed for optimal conditions of the photoelectric effect—the transformation of photons into electric signals when they contact the silicon chip.

With the device configured with electrodes polarized with negative voltage to confine and control photons, Tompsett grasped that a CCD could feature geometric arrays of light-sensitive elements capable of capturing and storing electric charge as information correlated with the intensity of incoming light. The corresponding variability of the incoming light and the electric charge it produced from each picture element ("pixel") could be digitized and reproduced on an external display.

To test this idea, Tompsett built an 8-bit shift register, consisting of two MOS capacitors featuring diodes at both ends. When he applied a charge at the diode boundary point between the diode and the capacitor, he and his team observed the rapid charge transfer from the first capacitor through the array at near 100 percent efficiency between the capacitors, thereby demonstrating the feasibility of charge-coupled devices for optical imaging capabilities.

Tompsett's work heralded an industry-wide shift from tube-based imaging to a new world of solid-state capabilities. With proof-of-concept firmly established, companies with experience in semiconductor technologies set out to expand the potential of the first 8-bit CCD design. At Bell Labs, Tompsett's team employed "full-frame architecture" whereby the CCD operates both as a photodetector and manager of charge transfer from one pixel to the next. This innovation allowed for a more compact chip design that would prove vital for the rapidly expanding electronics consumer market.

With marketplace competition in full swing, Tompsett created the world's first color digital camera, which used a prism to project colors onto a 106-128 pixelated array. Marking this great milestone, *International Electronics* magazine featured the first digital color photograph of Tompsett's wife, Margaret (page 56).

Together, these developments signaled to Tompsett, and eventually the entire solid-state

56 The Universe in Pixels

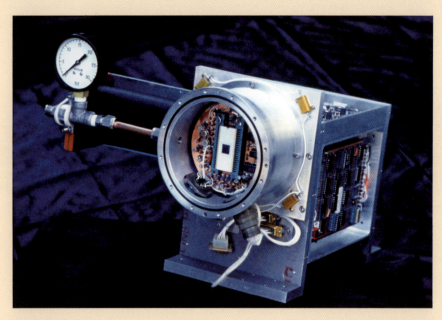

Jim Janesick
Traveling CCD Camera System, c. 1975
Photograph
Courtesy of Jim Janesick

Michael F. Tompsett
International Electronics
cover, January 1972
Magazine

field, that the greatest utilization potential of CCD technology lay not in memory but in imaging, and that with steady improvements in size, efficiency, and resolution, there was virtually no industry or application using film that would not stand to benefit by embracing digital capabilities. Throughout the semiconductor industry, and especially as Japanese companies entered the market, the race was on to develop digital consumer products, thereby completing the long journey of semiconductor advances, all originating in the postwar impetus of "fundamental undirected academic research" as epitomized by the research culture at Bell Labs.[6]

As this narrative suggests, even when progress in basic science yields promising results in a particular application, serendipity and inspiration can steer the technology in unforeseen directions. One of the earliest fields to embrace CCDs was astronomy, which up to that point had only the faintest connections to the world of semiconductors. In 1976, Jim Janesick of JPL and Brad Smith of the University of Arizona partnered to create the first CCD-derived astronomical images with the 60-inch Mt. Lemmon telescope. Most notably, the pair imaged Uranus, and they were amazed at the results. Janesick later explained how CCDs allowed astronomers to determine the diameter of Uranus and detect the presence of methane gas on the planet, findings that later proved crucial in the calibration of the Voyager mission and its encounters with the outer planets.[7]

The astronomy community's profound appreciation of CCD capabilities and potential from its very beginning is striking. As Janesick indicates, the imaging of Uranus (and then Jupiter and Saturn) was more than a proof-of-concept achievement. Even as a prototype in a brand-new application, the CCD provided data and allowed scientific discovery that had not previously been possible. As astronomers embraced CCDs as their imaging technology of choice by the 1980s—moving away from the glass plate emulsions in use for over a century—they teamed up with engineers to modify detector architecture and capabilities to meet the unique needs of astronomical applications.

More than any other project, NASA's Large Space Telescope (LST) provided the impetus to tailor CCDs for space-based astronomy. The developments driving the LST program (a sprawling enterprise involving NASA facilities, including JPL, and eventually the European Space Agency), closely tracked the development of CCDs. First seriously theorized by the astrophysicist Lyman Spitzer in 1946, a year before he joined the faculty at Princeton, the self-evident advantages of carrying out astronomical observations from space required advances in rocket propulsion to launch a telescope beyond Earth's orbit.[8] By 1969, with the publication of the National Academy of Sciences' report *Scientific Uses of the Large Space Telescope,* the scientific community had lent its full support to the LST project. The report cited image-tube technology and television cameras as the presumed devices of choice for the telescope—unlike film, these would not be vulnerable to space radiation.[9]

But subsequent analyses of image tubes revealed two major shortcomings: The tubes demonstrated poor capacity to capture images over long exposures, and the fast degradation of tube components would outpace the planned lifespan of the telescope![10] This left program managers questioning the wisdom of launching a telescope that would likely lose the ability to capture images well before other systems began to break down.

As early as 1972, staff scientists from Bell Labs introduced the LST project team to CCDs as an alternative to the image tube. The focus of those early discussions was on the device's own limitations, including its storage requirement at ultracool temperatures, its inefficiency in transferring charges and consequent limited field of view, and its non-responsiveness to ultraviolet light.[11] But the obvious benefits of CCDs, and the achievable mitigating solutions for storage, efficiency, and ability to shield the device from space radiation, convinced the LST team to move away from image tubes.

Meanwhile at JPL, researchers partnered with industry to increase the device's number of pixels and optimize its quantum efficiency—the effectiveness of turning photons into electrons—

and they evangelized these improvements with the Traveling CCD Camera System, which embarked on a worldwide tour of astronomical facilities to herald CCD capabilities. The upgraded system featured 400 × 400 pixel resolution with back-sided illumination, cooled by liquid nitrogen under vacuum seal. Astronomers at Kitt Peak, Palomar, and Lick Observatories were the first to experiment with it and were uniformly impressed (page 56).

James Westphal, a professor of planetary science at Caltech who built scientific instruments for a wide range of applications, recognized early on that CCDs were poised to launch astronomy into the digital era. His own Silicon Intensified Light Camera, built for the Caltech Palomar Observatory's 200-inch Hale Telescope—then the world's premier astronomical instrument—is considered a "transitional device" between glass plate emulsions and the first astronomical CCDs for its extreme sensitivity to light, being twenty times more sensitive than film.[12] He partnered with fellow Caltech professor Jim Gunn on a CCD camera proposal for the LST. Gunn's achievements across theory, observation, and instrumentation make him arguably peerless in modern astronomy, and his contributions to the instrument that would officially be renamed the Hubble Space Telescope in 1977 are testaments to his versatility.

Gunn and Westphal's design, built and tested at JPL, was called the Wide Field/Planetary Camera; it featured two discrete cameras at 800 × 800 pixel resolution, with one optimized for panoramic imaging and the other for imaging specific objects at high resolution. Perhaps their greatest innovation was in devising a special coating to absorb ultraviolet photons, which solved the problem of earlier CCDs' non-responsiveness to UV light.

By the time Westphal and Gunn formalized their proposal in 1976, the proof of concept of CCDs for astronomy was just beginning to gain traction; it was a bold proposal for the risk-averse NASA and its flagship telescope project. The choice NASA faced for Hubble's imaging technology pitted the cutting-edge CCD against the established vidicon image tube, in use since the 1950s, with demonstrated success on NASA's Orbiting Astronomical Observatory 2 in 1968.[13] The latter's design proposal, known as the SED Vidicon, was led by Spitzer at Princeton, then at a senior stage of his career, for which the Hubble would be a capstone. NASA's decision to approve the Caltech/JPL CCD over the vidicon was overlaid with emotional considerations, given Spitzer's singular legacy in bringing the Hubble to life.[14]

The proliferation of CCDs in astronomy in the 1980s, and the attendant maturation of digital imaging technology, offered astronomers greater opportunity to adapt CCD architecture and function according to their specific needs. The most significant developments in astronomical CCDs during this period included larger pixel arrays for greater dynamic range; ultra-cold storage to capture small amounts of photons over long periods of exposure; and the quest to achieve total quantum efficiency and low noise levels.

In this early period, one drawback of CCDs that had no immediate technological fix was their inability to view and image large expanses, or fields, of sky. One response, which would presage the coming era of big data astronomy, pioneered by Caltech professor George Djorgovski, was to embrace depth over breadth in the analysis of the small fields of view generated by CCD images. In an astronomical context, "depth" is akin to looking back in time to understand the evolution of stars and galaxies, and even to gain insight into the structure of the universe. As Djorgovski later explained, this "required astronomers to develop image-processing tools and measurement tools to extract quantitative information from those relatively small images."[15]

Djorgovski's insight, informed by his preexisting interest in software and the enhanced capacities of CCDs to peer ever deeper into the night sky, speaks to the power of new science born of necessity. The natural inclination of astronomers standing before the vastness of the universe is to seek imaging technologies offering

the widest field. But long before CCD mosaics made this possible, Djorgovski and others designed innovative software to extract quantitative information detectable by CCDs due to their sensitivity and low noise levels. Essentially, he pivoted away from one shortcoming of digital detectors to explore a potential asset: the relative smallness of a single CCD meant it could not image wide fields in a single exposure, but within a single, relatively narrow field, the depth of light it could capture, made usable by new software, opened new avenues of astronomical discovery. And the inefficiencies created by pointing telescopes at more discrete fields of view to compensate for the narrow frames of the early generation of CCDs were balanced by their built-in efficiencies in data transfer, dynamic range, and quantum sensitivity. It was an early and pivotal alliance between computation and astronomy, with CCDs serving as the cornerstone.

New possibilities in CCD imaging technology for sky surveys soon led to impossibilities in data management. Jim Gunn, who had by this time moved to Princeton, set to work building a new camera system for the Sloan Digital Sky Survey (SDSS) that combined the power of an enormous wide-field CCD and a spectrograph to image hundreds of spectra from a single exposure.[16] Commencing in 2000 with its capabilities in capturing large areas of the night sky at high efficiency and resolution, the resulting images from SDSS immediately launched astronomy into the era of gigabyte-level amounts of data, which soon made human-only analysis impossible.

More recently, the Zwicky Transient Survey (ZTF) at Palomar Observatory, outfitted with a 600-megapixel mosaic CCD covering the entire focal plane of the 48-inch Oschin Telescope, is capable of scanning the entire northern sky every two days.[17] Today, astronomy shows no signs of slowing in its pursuit of CCD capabilities. ZTF's successor, the Rubin LSST Camera in Chile, is the size of a car and contains a mosaic of 189 detectors for a total capability of 3.2 gigapixels. It is the world's largest digital camera. When the Vera Rubin Observatory is completed, it is forecast to produce fifteen terabytes of data every night, with an ultimate dataset in the range of 200 petabytes.[18]

Over the last quarter of the twentieth century, capabilities in machine learning and artificial intelligence arose separately but in parallel with those of CCD technology. The digitization of astronomical images transformed astronomy into a computationally intensive field, initially as a means to extract additional information from the limited fields of view that early CCDs were capable of capturing. As astronomers developed novel techniques so that CCDs could "see" the entire night sky quickly, repeatedly, and at levels of detail previously unimaginable, the computational challenge became one of data analysis, not extraction. Without astronomers' embrace of artificial intelligence and the dedicated infrastructure of organizations like the National Virtual Observatory to systematize the vast amount of data produced by the current generation of telescopes, too much valuable scientific information would be lost or hopelessly inaccessible. This in turn would throw into question the *raison d'être* of such advanced imaging technology.

Instead, the field finds itself at a happy, even exciting balance: sky surveys capable of capturing otherwise unmanageable amounts of data, computational and machine learning advances capable of identifying objects of astronomical interest, and ever more powerful telescopes both in space and on land capable of "zooming in" for additional analysis. The next great era of astronomical discovery proceeds along this sequence, with the possibilities of CCD capabilities as profound today as they were at their inception, 50 years ago.

1—For an overview of the impact of CCDs on astronomy, see Patrick McCray, "How Astronomers Digitized the Sky," *Technology and Culture* 55, no. 4 (October 2014): 908–44. A useful case study is Robert W. Smith and Joseph N. Tatarewicz, "Counting on Invention: Devices and Black Boxes in Very Big Science," *Osiris* 9 (1994): 101–23.

2—George E. Smith, "Nobel Lecture: The Invention and Early History of the CCD," *Reviews of Modern Physics* 82, no. 3 (2010): 2307–12.

3—Neil Savage, "Nobel Goes to Boyle and Smith for CCD Camera Chip." *IEEE Spectrum*, October 9, 2009, https://spectrum.ieee.org/nobel-goes-to-boyle-and-smith-for-ccd-camera-chip.

4—George E. Smith, interview by David Morton, January 17, 2001, Institute of Electrical and Electronics Engineers History Center, https://ethw.org/Oral-History:George_E._Smith.

5—Jeff Hecht, "Who Invented the CCD for Imaging?" International Society for Optics and Photonics, January 1, 2023, https://spie.org/news/photonics-focus/janfeb-2023/focusing-on-the-inventors-of-ccd-imaging.

6—Stewart Braun and Stuart MacDonald, *Revolution in Miniature: The History and Impact of Semiconductor Electronics* (Cambridge: Cambridge University Press, 1982), 7. See also Jon Gertner, *The Idea Factory: Bell Labs and the Great Age of American Innovation* (New York, NY: Penguin, 2012).

7—James R. Janesick, *Scientific Charge-Coupled Devices* (Bellingham, WA: SPIE Press, 2001), 11.

8—See Lyman Spitzer Jr., "Report to Project Rand: Astronomical Advantages of an Extra-Terrestrial Observatory," *Astronomy Quarterly* 7, no. 3 (1990): 131–42.

9—National Research Council, *Scientific Uses of the Large Space Telescope* (Washington, DC: National Academies Press, 1969), 6.

10—Robert Zimmerman, *The Universe in a Mirror: The Saga of the Hubble Space Telescope and the Visionaries Who Built It* (Princeton: Princeton University Press, 2010), 81.

11—Janesick, *Scientific Charge-Coupled Devices*, 7.

12—See G. Edward Danielson, "Obituary: James Adolph Westphal, 1934–2000," *Bulletin of the American Astronomical Society* 36, no. 5 (2004): 1687–88.

13—Charles Day, "Hatching Hubble," *Physics Today* 73, no. 4 (2020): c1.

14—The drama of this decision and the crushing personal blow to Spitzer is recounted in Zimmerman, *Universe in a Mirror*, 80–92.

15—S. George Djorgovski, interview by David Zierler, January 27, 2023, Caltech Heritage Project, https://heritageproject.caltech.edu/interviews-updates/s-george-djorgovski

16—For a technical overview, see James E. Gunn et al., "The 2.5 m Telescope of the Sloan Digital Sky Survey," *Astronomical Journal* 131, no. 4 (2006): 2332–59.

17—See Eric C. Bellm et al., "The Zwicky Transient Facility: System Overview, Performance, and First Results," *Publications of the Astronomical Society of the Pacific* 131, no. 995 (2019): 1–19.

18—See "Vera Rubin Observatory's Legacy Survey and Space and Time," Kavli Institute for Particle Physics and Cosmology, Stanford University, https://kipac.stanford.edu/research/projects/vera-rubin-observatorys-legacy-survey-space-and-time.

Shana Mabari
Spectrum Petal, 2024
Acrylic and mirror
Courtesy of Shana Mabari

James Nasmyth
"Back of Hand" and "Wrinkled Apple,"
in *The Moon: Considered as a Planet, a World, and a Satellite*, 1874
Photographs
Caltech Archives and Special Collections

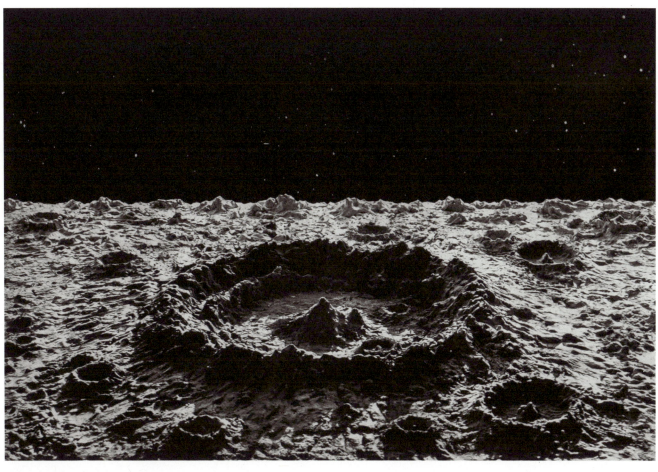

James Nasmyth
"Normal Lunar Crater," in *The Moon: Considered as a Planet, a World, and a Satellite*, 1874
Photograph
Caltech Archives and Special Collections

Unknown Photographer
Roger Hayward and moon model at Griffith Park, 1939
Photograph
Los Angeles Public Library

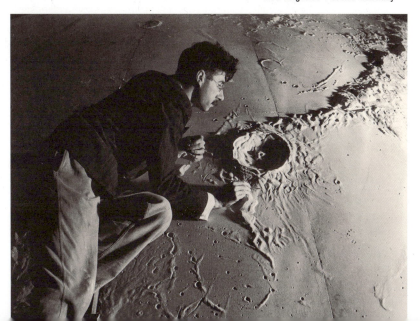

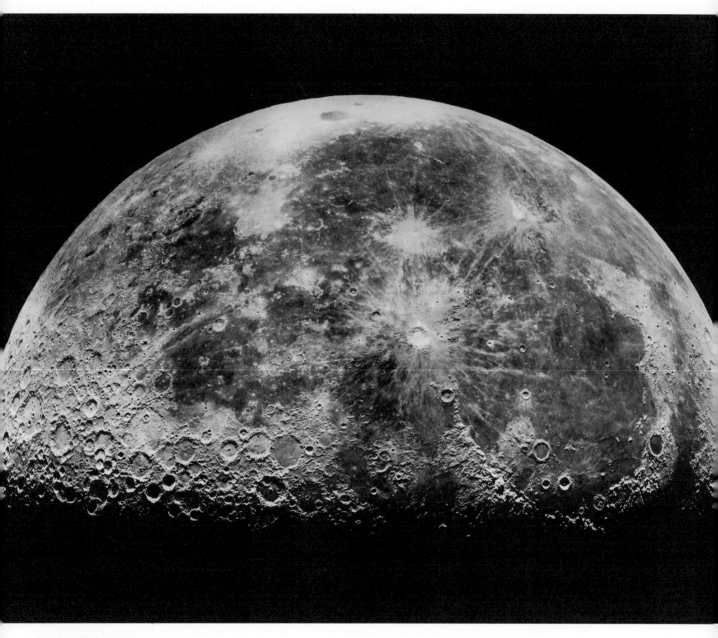

Unknown Photographer
Moon from Palomar Observatory, c. 1955
Photograph
Caltech Archives and Special Collections

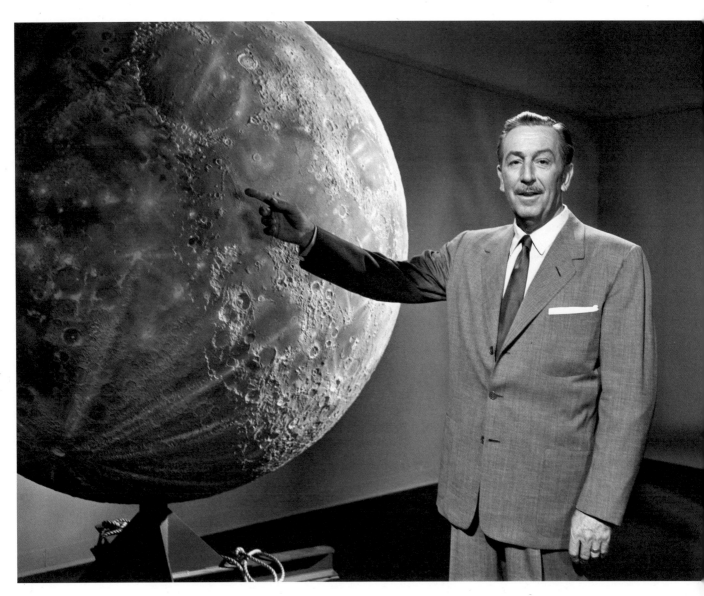

Unknown Photographer
Walt Disney with Roger Hayward's moon model, 1955
Photograph
© 1955 Disney

Maarten Schmidt, James Gunn, and Don Schneider
3C 273, the first quasar to be characterized, c. 1963
Photograph
Caltech Archives and Special Collections

Jean Mueller
Asteroid (12711) Tukmit, c. 2010
Photograph
Palomar Observatory

Lita Albuquerque
Helium Blaze, 2020
White gold leaf on resin and pigment on panel
Kohn Gallery

Unknown Photographer
James McClanahan and Hendrik Rubingh
file Sky Survey plates, 1955
Photograph
Caltech Archives and Special Collections

Unknown Photographer
Albert G. Wilson and Walter
Baade examine astronomical
photographs, 1949
Photograph
Caltech Archives and Special
Collections

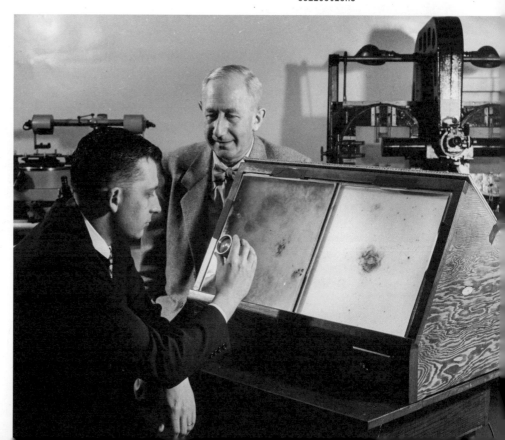

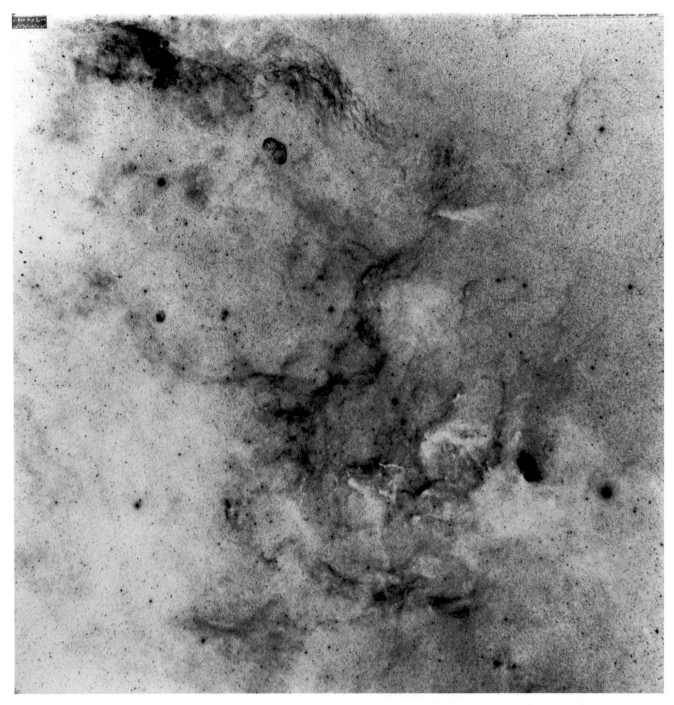

Palomar Observatory and National Geographic Society
One of 936 fields from the Palomar Observatory
Sky Survey, 1955
Photograph
Caltech Archives and Special Collections

TIME STREAM

I *must* go and look at the stars.
 —Italo Calvino, "The Contemplation of Stars," *Mr. Palomar*

The most beautiful thing we can experience is the mysterious. It is the source of all true art and science. He to whom the emotion is a stranger, who can no longer pause to wonder and stand rapt in awe, is as good as dead: his eyes are closed.
 —Albert Einstein, *Living Philosophies*

Gazing at the stars—"luminous bodies filled with uncertainty," as Mr. Palomar called them—has enthralled humans since time immemorial. Eternal, serene, and mysterious, the sky above compels exploration, offering a sense of exaltation and wonder in a rapidly changing world. This section draws on Caltech's substantial collection of rare first-edition books in physics and astronomy, including works by Nicolaus Copernicus, Galileo Galilei, Johannes Kepler, Johannes Hevelius, and many others. Augmented by photographs, a travel album, pulp science fiction books, and contemporary artworks, *Time Stream* explores how scientists and artists have imagined, observed, and studied the universe over the past five hundred years.

The display unfolds in the small historic library of Gates Annex, built in 1927 as an addition to Elmer Grey and Bertram Goodhue's 1917 Gates Laboratory of Chemistry. The intimate space, lined floor to ceiling with vintage books, evokes a late-Renaissance *studiolo* (Italian for little studio) dedicated to reading, writing, and contemplative study. Los Angeles artist Jane Brucker engages the private room for a meditation on the *Magnetic Attraction* between opposites while reflecting on the celestial theme of this section.

Time Stream concludes with Lita Albuquerque's monumental installation, *This Moment in Time*, spanning the reflecting pool outside Gates Annex. The artist's use of gold refers to the creation of the precious metal and other chemical elements through nuclear fusion reactions within stars. Known as stellar nucleosynthesis, this process was theoretically and experimentally studied in landmark research by Caltech physicist William A. Fowler and his colleagues in the 1950s and '60s. *This Moment in Time* was commissioned specifically for this exhibition and commemorates the fiftieth anniversary of Albuquerque's first exhibition at Caltech's Baxter Art Gallery in 1974.

Helen Pashgian
Untitled, 2019
Cast urethane
Courtesy of Helen Pashgian

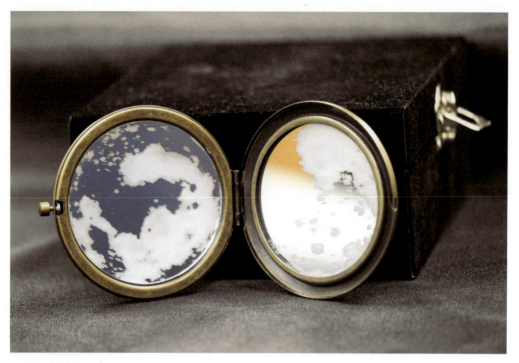

Jamie Molaro
Moon Compact, 2018
Etched glass and metal
Courtesy of Jamie Molaro

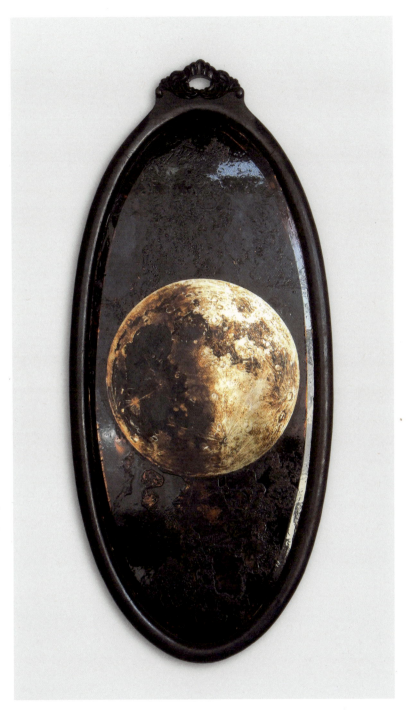

James Griffith
Moon, 2019
La Brea tar on late 19th-century mirror
Craig Krull Gallery

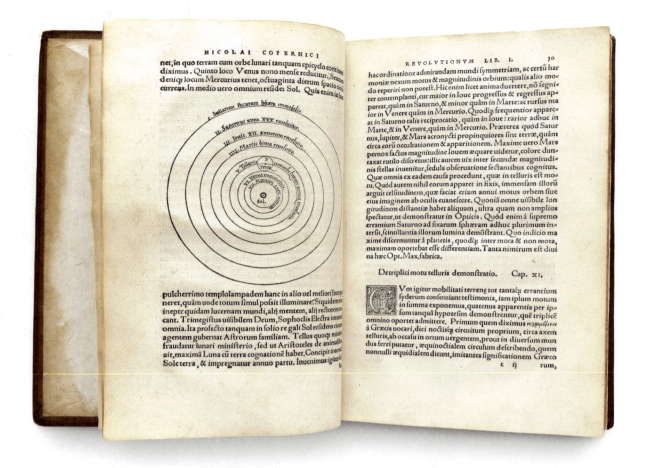

Nicolaus Copernicus
De revolutionibus orbium coelestium, 1543
Book
Caltech Archives and Special Collections

Johannes Kepler
Mysterium cosmographicum, 1596
Book
Caltech Archives and Special Collections

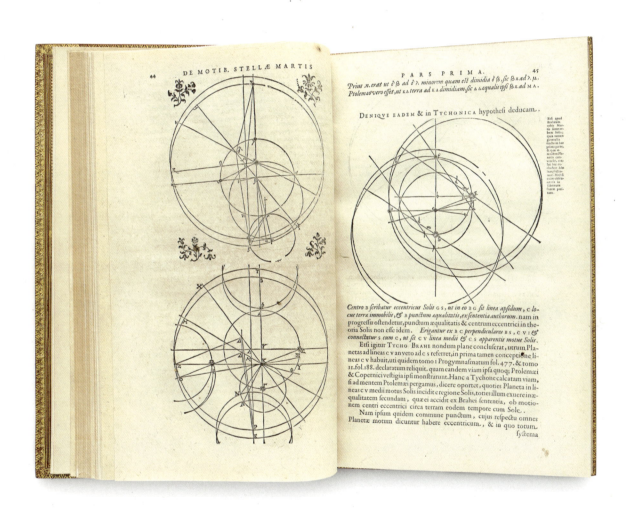

Johannes Kepler
Astronomia nova, 1609
Book
Caltech Archives and Special Collections

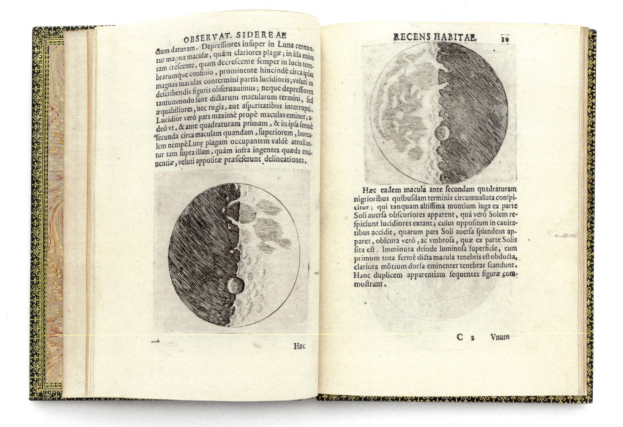

Galileo Galilei
Sidereus nuncius, 1610
Book
Caltech Archives and Special Collections

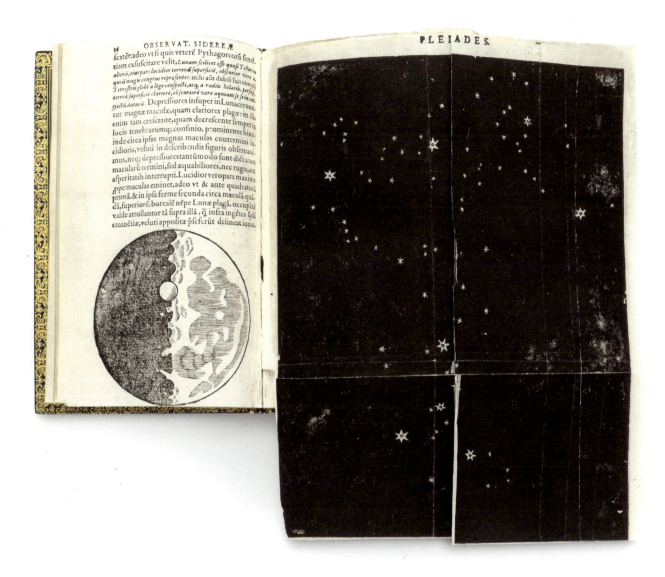

Galileo Galilei
"Pleiades," in *Sidereus nuncius*, 1610
Book
Caltech Archives and Special Collections

Bruce Conner
Two Mandala Circles, c. 1970–71
Lithograph
Michael Kohn Gallery

Vija Celmins
Untitled (Dark Sky), 2016
Mezzotint and drypoint on hahnemühle paper
Michael Kohn Gallery

Pages 80–81
Lloyd Hamrol
Situational Construction for Caltech, 1968
Digital print of nine tethered, illuminated,
18-inch helium-filled weather balloons
Lloyd Hamrol

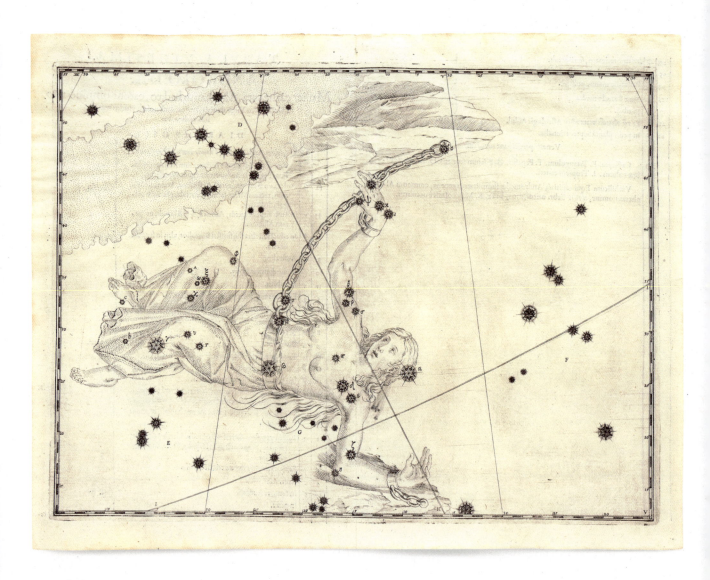

Johann Bayer
"Andromeda," in *Uranometria*, 1603
Book
Caltech Archives and Special Collections

Robert Cumming
The Big Dipper, 1978
Gelatin silver print
Robert Cumming Archive

JOANNIS KEPPLERI

		Longit.	Sagit.	Latit.		Magn.
In Isoscele spiræ Serpentis, apex	—	15.	3/	10.	25/ S.	4.
Prior basis	—	19.	26/	8.	4/ S.	4.
Posterior	—	20.	12/	10.	23/ S.	4.
Dextri Pedis { Tibia	—	15.	45/	1.	57/ S.	4.
Digitus	—	14.	10/	3.	27/ Au.	4.
Dorsum	—	14.	50/	1.	27/ A.	5.
Palmæ clara	—	15.	50/	1.	43/ A.	3.
Vola	—	16.	40/	0.	59/ A.	4.
Calx seu Talus	—	18.	8/	0.	57/ A.	4.
Quatuor informium in Rhombo ad humerum dextrum borealissima	—	25.	10/	28.	0/ S.	4.
Mediarum prior	—	25.	0/	26.	40/ S.	4.
Posterior	—	26.	53/	26.	28/ S.	4.
Infima	—	25.	43/	24.	45/ S.	4.
Duarum parvarum supra caudam, superior	29.	52/		26.	38/ S.	6.
Inferior	—	1.	42/ Capr.	23.	28/ S.	6.
Infra caudam clara	—	3.	3/	15.	49/ S.	4.
Post pedem dextrum, socia novæ	—	20.	7/ Sagit.	1.	22/ S.	4.
Trium minimarum inter ultimam & penultimam caudæ Serpentis, præcedens	2.	3/ Capr.		21.	29/ S.	6.
Media	—	4.	9/	22.	42/ S.	6.
Postrema	—	6.	43/	24.	52/ S.	6.
Proximè infra ultimam, infor.	—	10.	25/	25.	2/ S.	6.
Cuspis Sagittæ		25.	23/ Sagit.	6.	54/ A.	3.

Huc refer figuram ex Cupro, signo ✱ ✱ ✱, in qua Æ Q æquatorem notat; E C. Eclipticam; α & ⚹ Saturnum; π & ♃ Jovem; υ Martem; N Novam: hoc discrimine, ut α & π, circuli vacui, designent loca Saturni & Jovis conjunctorum die ¾ Decembris anni 1603. ⚹,♃,υ, significent situm Saturni Jovis & Martis die 30. Sept. vel 10. Octob. quo die Pragæ primùm visa est Nova stella. Reliquæ rectæ & curvæ lineæ paulò suprà sunt explicatæ. Stellarum verò cæterarum nomina patent ex imaginum membris, quibus inhærent.

✱ ✱ ✱

De loco

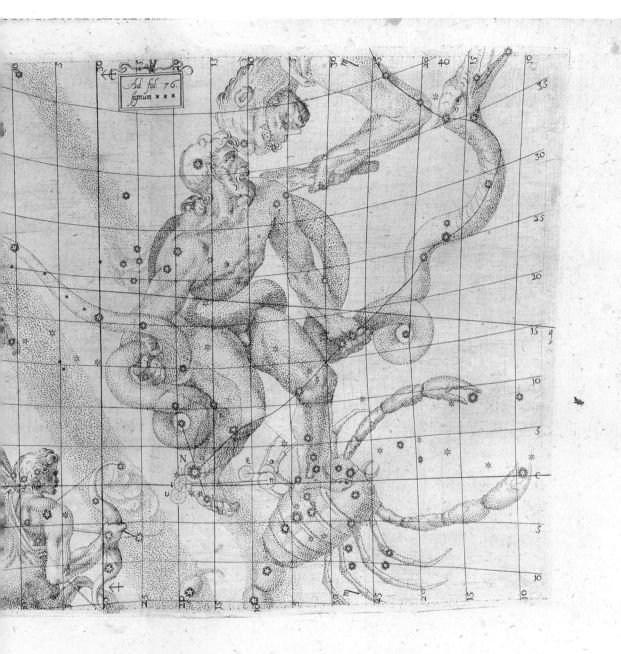

Chesley Bonestell
Astounding Science Fiction cover, January 1950
Magazine
Caltech Archives and Special Collections

John Taine (Eric Temple Bell)
The Time Stream, 1946
Book
Caltech Archives and Special Collections

Edwin Hubble
"Var Plate" of Andromeda Galaxy seen with the Hooker telescope, 1923
Glass plate photograph copy
Carnegie Observatories

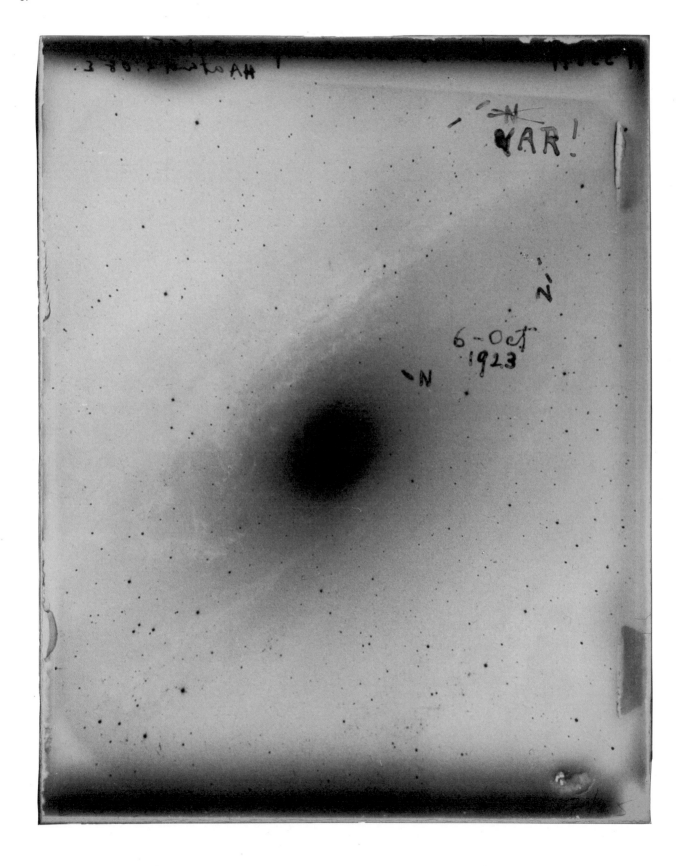

THE MINNEAPOLIS JOURNAL

Tuesday Evening, PAGE TWELVE

Astronomer Takes Five Month's Trip For 5 Minutes Work

TAKING a five month's trip for five minutes of photography was the experience of J. J. Johnson, astronomer at California Institute of Technology. He recently returned from Malay peninsula where he photographed an eclipse of the sun.

August 27, 1929.

Eclipse Trip, 1929

JOSEF J. JOHNSON

Josef J. Johnson
Eclipse expedition album, 1916–1933
Photo album
Caltech Archives and Special Collections

Jane Brucker
Magnetic Attraction, 1997
Compass, magnet, needles, and photographs
Courtesy of Jane Brucker

Karl Obert
Einstein on the beach in Santa Barbara, 1931
Photograph
Caltech Archives and Special Collections

Lita Albuquerque
This Moment in Time, 2024
Pigment print on archival paper
Courtesy of Lita Albuquerque

> Short man, large dream
> I send my rockets forth between my ears
> Hoping an inch of Good is worth a pound of years
> Aching to hear a voice cry back along the Universal Mall:
> We've reached Alpha Centauri!
> We're tall, O God, we're tall!
> —Ray Bradbury, "If Only We Had Taller Been"

Lia Halloran
How Can We Visualize Warping, The Warped Side of the Universe, 2019
Ink on drafting film
Lia Halloran

POWERS OF TEN

I stand at the seashore, alone, and start to think. There are the rushing waves, mountains of molecules, each stupidly minding its own business... trillions apart... yet forming white surf in unison. [...] Never at rest... tortured by energy... wasted prodigiously by the sun... poured into space. [...] Growing in size and complexity... living things, masses of atoms, DNA, protein... dancing a pattern ever more intricate. Out of the cradle onto the dry land... here it is standing... atoms with consciousness... matter with curiosity. Stands at the sea... wonders at wondering... I... a universe of atoms... an atom in the universe.
—Richard Feynman, "The Value of Science"

This third and largest section of *Crossing Over* is located in the historic Dabney Lounge, built in 1928 and home to many exhibitions and theater productions. Artist Lia Halloran's installation *You, Me, and Infinity*, created for this room, speaks to our fascination with the cosmic expanse and our minute place within it. Her work incorporates various levels of scale, ranging from the tiny human eye and body to the immense warping of space-time caused by gravitational waves.

Powers of Ten takes its title from a 1968 documentary by Los Angeles designers Charles and Ray Eames, who gave lectures at Caltech in the mid-1950s. Their eponymous film—which zooms in and out of the human body, into outer space, and back—depicts the relative scale of the observable universe in orders of magnitude based on factors of ten. Modeled after the 1957 book *Cosmic View: The Universe in 40 Jumps* by Dutch educator Kees Boeke, *Powers of Ten* provides the organizing principle for this section as it moves in scale from images of Earth, its organisms, cells, molecules, atoms, and subatomic particles to the visual culture of human spaceflight and exoplanets.

Discrete case studies center on imagery from seismology, genetics, chemistry, particle physics, nuclear weapons, data visualization, rocketry, and planetary science, attesting to the rich and mutually influential relationships between artists and scientists at Caltech. At the heart of *Powers of Ten* is an exploration of Caltech's relationship with the US military's World War II Manhattan Project, synonymous as it is with the single most iconic image of the twentieth century: the mushroom cloud. Together, the diverse works in this room represent an imaginary voyage both inward and outward, reflecting on the vastness of the universe, whose history and complexity humans are only beginning to comprehend.

EARTH

The journey begins on Earth, with imagery from Caltech's Seismological Laboratory. In the 1920s and '30s, Caltech scientists revolutionized earthquake research with the inventions of the torsion seismometer, which enabled some of the most precise recording to date of earthquakes near and far, and the Richter scale, which measures a quake's magnitude. The lab's development of a long-period seismograph in the late 1950s helped detect global oscillation (analogous to "bell ringing") generated by the Great Chilean Earthquake of 1960. Caltech and earthquake science have since become synonymous, transforming seismology around the globe and inspiring a unique genre of film, art, and literature that associates Los Angeles not only with earthquakes but also with other disasters and turmoil.

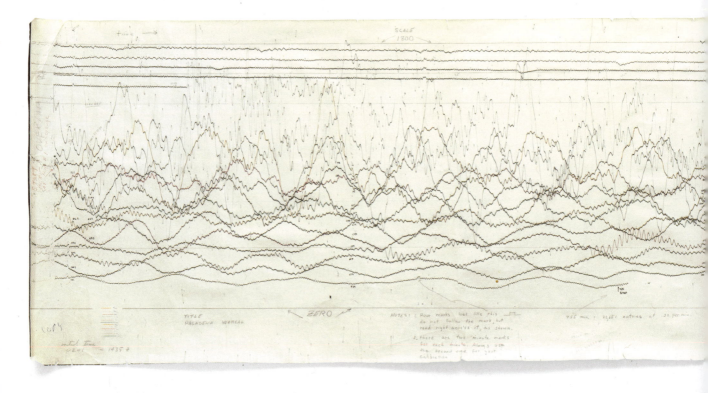

Frank Press and Martin Ewing
Seismogram of Chilean earthquake recorded at Caltech,
May 22, 1960
Ink on paper
Caltech Archives and Special Collections

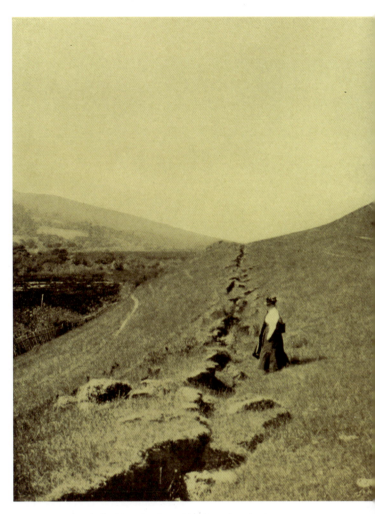

California State Earthquake Investigation Commission
"Fault trace a mile northwest of Olema,"
The California Earthquake of April 18, 1906
Photograph
Special Collections, Claremont Colleges Library

Unknown Printmaker
Untitled (Namazu-e, "Catfish Print"), 1855
Woodblock print
Caltech Archives and Special Collections

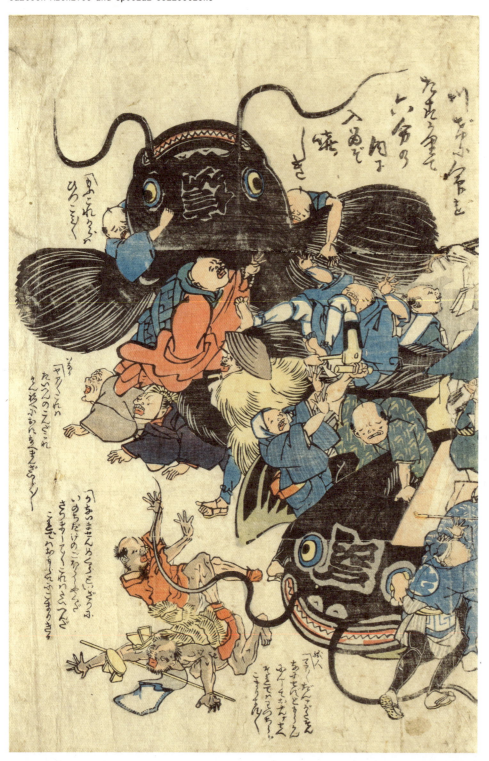

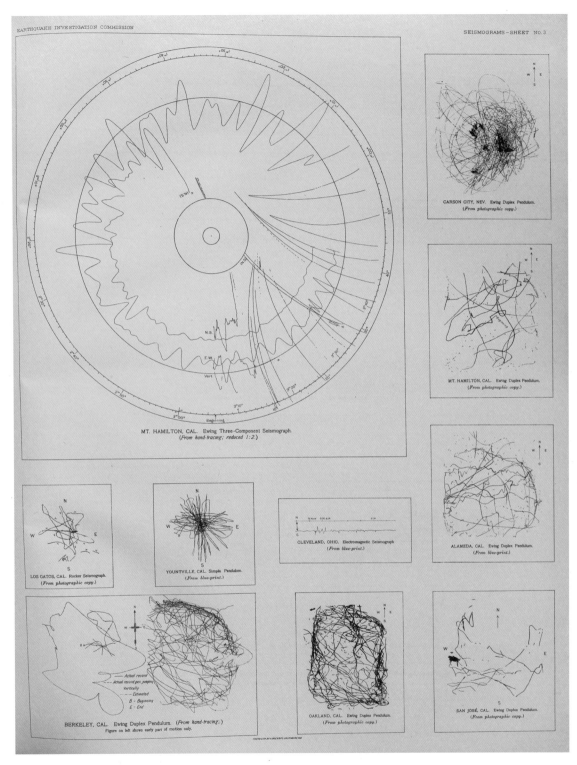

California State Earthquake Investigation Commission
The California Earthquake of April 18, 1906
Book
Special Collections, Claremont Colleges Library

Bailey Willis
Seismogram of earthquake in Chile made by a fruit dish scraping across a sideboard, November 11, 1922
Photograph
Caltech Archives and Special Collections

Unknown Photographer
Professors sing "The Richter Scale," 1969
Photograph
Caltech Archives and Special Collections

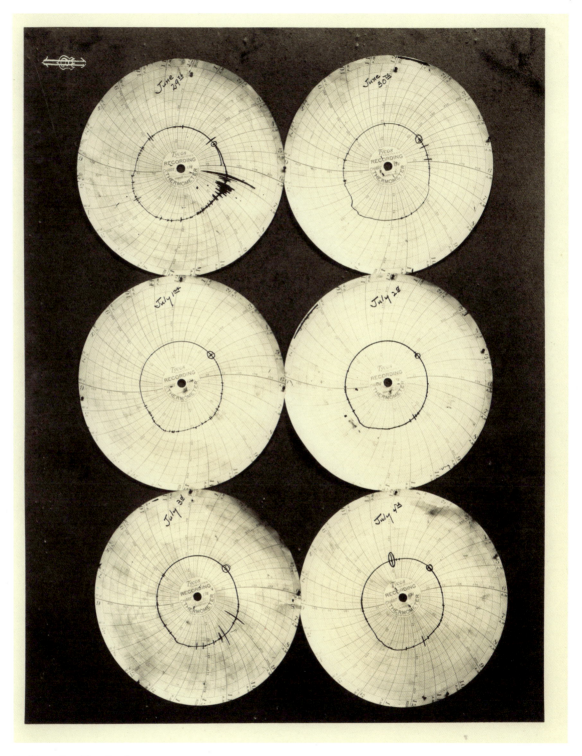

Southern Counties Gas Company
Accidental seismograms of the Santa Barbara
earthquake, June 25 – July 4, 1925
Photograph of paper discs
Caltech Archives and Special Collections

US Army
"Graphical Record of the End of the War,"
November 11, 1918
Photograph of print
Caltech Archives and Special Collections

Unknown Photographer
Frank Press with a seismogram of the Alaskan earthquake, 1964
Photograph
Caltech Archives and Special Collections

Victor Henderson and Terry Schoonhoven
Isle of California, 1973
Pencil and acrylic on photograph
Los Angeles County Museum of Art

Don Cormier
Actors dodging rubble during filming
of *Earthquake*, 1974
Film frame
UCLA Library Special Collections

Unknown Photographer
Charles Richter (right) and others view
buckled pavement, c. 1970
Photograph
Caltech Archives and Special Collections

ORGANISMS

This section focuses on how Caltech biologists used artistic illustrations to refine and share their research on individual lifeforms. From the 1910s to the '30s, Caltech geneticist Thomas Hunt Morgan worked with biologist and illustrator Edith Wallace, whose detailed drawings of *Drosophila melanogaster* enabled scientists to map fruit flies' chromosomes and the inheritance of genes. Biologist George Beadle enlisted architect and "Renaissance artist" Roger Hayward to illustrate his work on *Neurospora*, a common bread mold. Visual representations of complex biological processes by Hayward and others were crucial for communicating scientific breakthroughs to wider audiences.

Pamela Lewis
The Origin of Life, c. 1950
Watercolor on canvas
Caltech Archives and Special Collections

Alfred F. Huettner
Thomas Hunt Morgan, 1920
Gelatin silver print
Caltech Archives and Special Collections

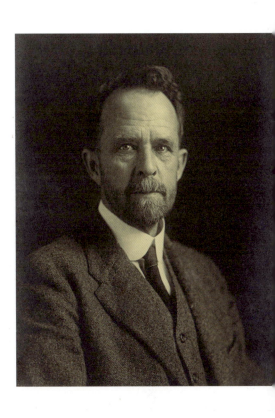

Unknown Photographer
Columbia University biology staff (Edith Wallace, center), 1918
Photograph
Caltech Archives and Special Collections

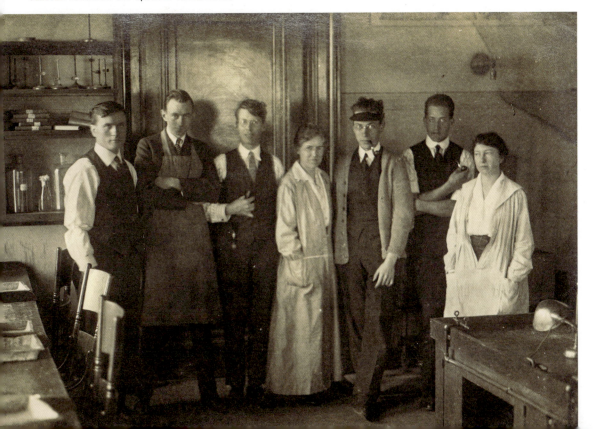

Edith M. Wallace
Fruit fly, 1920
Ink and watercolor on cardstock
Caltech Archives and Special Collections

Edith M. Wallace
Male and female fruit flies, 1934
Ink and watercolor on cardstock
Caltech Archives and Special Collections

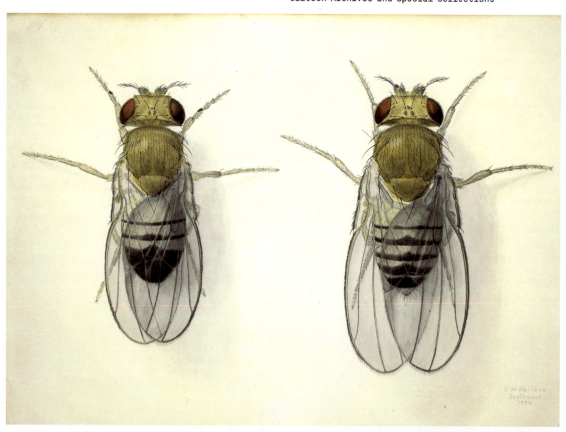

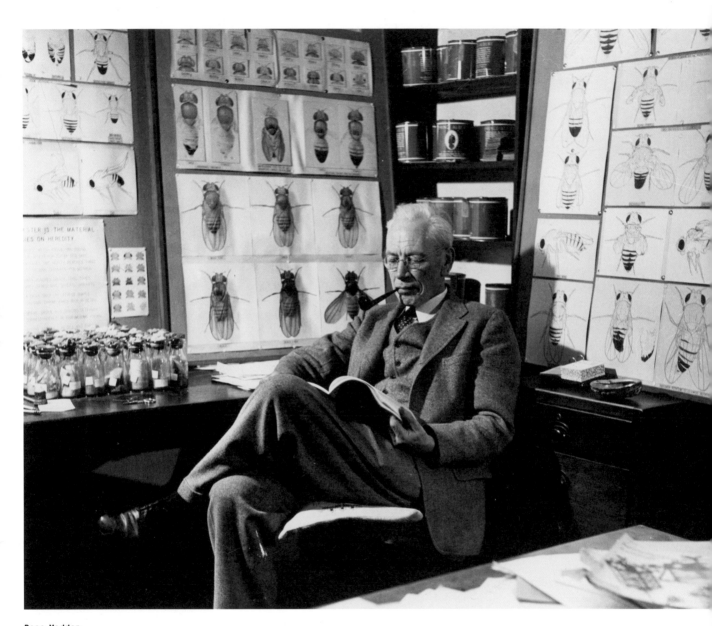

Ross Madden
Alfred H. Sturtevant, 1949
Photograph
Caltech Archives and Special Collections

Charles A. Kollmer

"OF MEN AND MOLDS": *Neurospora* and the Illustration of Nature's Molecular Order

Introduction

Opening a copy of the September 1948 issue of the popular science magazine *Scientific American*, readers encountered an article titled "The Genes of Men and Molds" by George W. Beadle, chair of the Division of Biology at Caltech.[1] The magazine had recently been purchased by a publishing company that had appointed a new board of editors. For over a century, an announcement explained, *Scientific American* had embodied a "journalistic tradition of reporting the practical applications of science."[2] However, the incoming editors insisted, "the men who are best qualified to write about science are scientists." Going forward, scientists themselves would pen stories about their own work, aided by "the resources of modern graphic art to extend the power of words in expressing the ideas of science."

Beadle's piece was exemplary of the direction of the "new *Scientific American*," introducing readers to the unlikely protagonist of his experimental work: "One of the most useful genetic guinea pigs is the red bread mold *Neurospora crassa*."[3] The mold, Beadle informed his readers, enabled researchers to trace how genetic mutations affected the activities of enzymes, thus establishing precise links between individual genes and the metabolic reactions they directed within cells. In short, *Neurospora* was a powerful instrument for probing "how the units of heredity determine the characteristics of all living things" (page 111).[4]

These sweeping statements were elaborated through diagrams prepared by Roger Hayward, an MIT-educated architect who had migrated to Pasadena in the late 1920s and begun hobnobbing with Caltech's faculty. Hayward's sketches for Beadle's article depicted the elaborate reproductive cycle of *Neurospora*, the laboratory procedures with which Beadle produced mutations in the fungus, and the metabolic pathways that he inferred from the mutants' behaviors. These figures guided a viewer's eye smoothly from an idealized laboratory filled with colorful test tubes into the imagined interiors of fungal cells, where bulbous molecules enacted a choreography regimented by genes (page 118).

Caltech provided a hospitable milieu for this abstract, stylized view of life. The biology division's founding patrons and its first chairman, famed *Drosophila* geneticist Thomas Hunt Morgan, shared a conviction that collaborations at the borderlands of biology, chemistry, and physics would ultimately demystify life.[5] Researchers like Beadle enacted this agenda by imbuing organisms like *Neurospora* with a near-talismanic power to elucidate living nature's molecular order. The dizzying diversity of living things, he presumed, obscured a more fundamental set of patterns at play in all organisms—fungi and animals alike. Behind Beadle's lofty equation "of men and molds" and Hayward's slick illustrations for *Scientific American*, however, lies a far more convoluted story, tying together industrial sugar mills, a voracious fungus with an obscure sex life, x-ray mutations, and a booming market for popular science magazines.

Mold Cultures

During World War II, the production of penicillin at enormous scales spurred a sea change in popular depictions of fungi. Engineers repurposed distilleries to grow vast quantities of *Penicillium* mold, purify the antibiotic molecules in its excreta, and parcel this substance into millions of doses of a substance celebrated as a wonder drug. It was in this context that readers of *Life Magazine* in 1944 encountered a different mold, belonging to the genus *Neurospora*, skillfully depicted by Arthur A. Jansson of Lederle Laboratories as a pink profusion wafting from a loaf of bread. A caption indicated that "bread

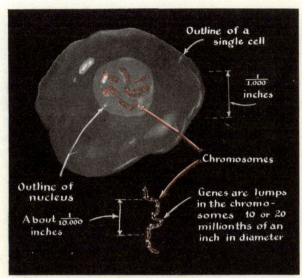

THE CELL is the site of nearly all the interactions between the gene and its environment. The genes themselves are located in the chromosomes, shown above in the stage before cell divides, duplicating each gene in the process.

THE GENES OF MEN AND MOLDS

The study of the red fungus Neurospora crassa sheds light on exactly how the units of heredity determine the characteristics of all living things

by George W. Beadle

EIGHTY-FIVE years ago, in the garden of a monastery near the village of Brünn in what is now Czechoslovakia, Gregor Johann Mendel was spending his spare moments studying hybrids between varieties of the edible garden pea. Out of his penetrating analysis of the results of his studies there grew the modern theory of the gene. But like many a pioneer in science, Mendel was a generation ahead of his time; the full significance of his findings was not appreciated until 1900.

In the period following the "rediscovery" of Mendel's work biologists have developed and extended the gene theory to the point where it now seems clear that genes are the basic units of all living things. They are the master molecules that guide the development and direct the vital activities of men and amoebas.

Today the specific functions of genes in plants and animals are being isolated and studied in detail. One of the most useful genetic guinea pigs is the red bread mold *Neurospora crassa*. Its genes can conveniently be changed artificially and the part that they play in the chemical alteration and metabolism of cells can be

Illustrated by Roger Hayward

analyzed with considerable precision. We are learning what sort of material the genes are made of, how they affect living organisms and how the genes themselves, and thereby heredity, are affected by forces in their environment. Indeed, in their study of genes biologists are coming closer to an understanding of the ultimate basis of life itself.

It seems likely that life first appeared on earth in the form of units much like the genes of present-day organisms. Through the processes of mutation in such primitive genes, and through Darwinian natural selection, higher forms of life evolved—first as simple systems with a few

mold, familiar to many housewives, is the cottony, quick-growing *Neurospora sitophila*. In this free-growing state the mold is of little use for mycological research because it may be contaminated."[6] While Jansson presented the moldy bread as a visual foil to the sanitary cultivation of *Penicillium*, by 1944, *Neurospora* had already made its own incursions into sterile glass containers in laboratories across the world (page 120).

In fact, the species that would feature centrally in Beadle's work had a bizarre provenance dating back to the mid-1920s, when researchers employed by the United States Department of Agriculture's Bureau of Chemistry and Soils in Arlington, Virginia, developed an interest in sugar mill waste. As mill workers transformed sugar cane into a stable, crystalline commodity, they were left with residual plant fibers, called bagasse. Typically, mill workers had burned bagasse to boil down cane juice, but as food processing firms grew, managers felt an imperative to repurpose manufacturing wastes in profitable ways. Celotex Corporation, a company in Chicago, began purchasing enormous quantities of bagasse from mills in Louisiana to make boards of "insulating lumber."[7] Celotex processed bagasse year-round, requiring storage of several hundred thousand tons of the stuff at its plant in Marrero, Louisiana—an accumulation of fibers liable to combust spontaneously and suffer damage from the region's formidable tropical storms. To address these risks, Celotex invited Department of Agriculture researchers to examine the bagasse.

According to their subsequent report, the researchers surveyed microbes residing in the piles, noting that "on the surface of the bales the first organism to develop was *Monilia sitophila*, which spread over the piles with great rapidity and draped them with festoons of orange fruiting masses."[8] The fungal cultures they brought back to Arlington piqued the interest of plant pathologists Cornelius L. Shear and Bernard O. Dodge. In their extensive readings of taxonomic literature, they were "[un]able to find ... mention of the findings of perithecia [i.e., fruiting bodies] of *Monilia sitophila* either in nature or in artificial cultures."[9] Intrigued, the duo solicited reference cultures collected in Berlin, Paris, Surinam, Tokyo, Ithaca, New York City, St. Louis, Ann Arbor, and Charlottesville for comparison.

When these samples arrived, Shear and Dodge systematically combined spores from different sources, finding that some combinations indeed produced fruiting bodies. These results suggested a case of heterothallism—a condition in which fungi that reproduced asexually also engaged in sexual reproduction, forming fruiting bodies but only in the presence of a complementary mating type. Publicizing their findings, Shear and Dodge concluded that *M. sitophila* was not only heterothallic but also a misnomer. Comparing the fruiting bodies, they argued that what had long passed as a single species instead comprised three: "As the result of the life history and morphological studies of the red bread-mold fungus and its near relatives a new genus, Neurospora, and three new species are described."[10] Breeding the mold in their laboratory, the phytopathologists teased out otherwise invisible taxonomic diversity.

Dodge soon left Arlington for the Bronx, where he was tasked with keeping the plants of the New York Botanical Garden free of disease and pests. Alongside his official duty of patrolling the garden's 200 acres for any sign of fungal infection, Dodge made use of its laboratory to improvise a series of genetic experiments. Working with limited resources, he successfully traced hereditary "factors" between stages of *Neurospora*'s life cycle, informing readers of the journal *Science* in 1929 that "Neurospora furnish[es] very desirable material for studies of inheritance in the fungi. Perhaps in no other place in the plant or animal kingdoms so far known can the progeny of a single mother cell be studied so readily and to such advantage."[11] In August 1930, he traveled to Cambridge, England, where he spoke about his findings to colleagues at the Fifth International Botanical Congress and exhibited vivid evidence of fungal heredity. Making the contrast between mutants clear to his audience, however, required a touch of artifice, which came courtesy of a New York Botanical Garden staff photographer, who had carefully painted each of the photos by hand (page 121).[12]

Dodge's vision of using Neurospora to investigate the mechanisms of heredity came to fruition, albeit after the fungus migrated across the

continent. In 1928, he had presented cultures of *Neurospora* to Thomas Hunt Morgan, who soon after left New York City for Pasadena, California, where he preceded Beadle as chairman of the biology division at Caltech. In Pasadena, Morgan struggled to make anything of the *Neurospora* cultures, as his notoriously filthy laboratory was rife with contaminants, making it impossible to repeat Dodge's careful crosses.[13] One of his graduate students, Carl C. Lindegren, drew on prior training in plant pathology to put Dodge's cultures to use, constructing a micro-manipulator to cross strains of the mold with unprecedented efficiency. He established lines of mutants with aberrations in color and texture, mapping distances between hereditary factors on their chromosomes. After a move to the University of Southern California, Lindegren and his spouse, Gertrude Lindegren, cultivated a menagerie of colorfully named mutants, including "peach," "pale," "dirty," and "crisp." The couple developed a procedure for inducing mutations by irradiating *Neurospora* with x-rays and ultraviolet light, reporting that "it was quite easy to distinguish the cultures from each other macroscopically because there were many other clear-cut differences in color, texture, distribution of hyphae [i.e., filaments produced by fungi as they grow], coloration of the substrate."[14]

In his retrospective telling of the story, Beadle adopted *Neurospora* as an experimental organism after a sudden epiphany in a Stanford University lecture hall. Yet he did not conjure the fungus *ex nihilo* into his laboratory. Rather, *Neurospora* made a lengthy journey, traveling from bagasse piles in Louisiana to laboratories in Arlington, Virginia, and on to the Bronx and Pasadena. In 1941, Beadle sent a letter to Dodge soliciting cultures of "wild-type" *Neurospora*, to which Dodge responded by suggesting, "Dr. Edgerton of the Agricultural Experiment Station at Baton Rouge certainly must have cultures from sugar-cane begasse [*sic*]."[15] The "genetic guinea pig" so central to Beadle's research was, as Dodge's recommendation suggests, itself shaped by circumstances as disparate as the industrial processing of sugar cane, government agricultural research, and a mounting interest among university geneticists in x-ray mutagenesis.

Depicting the Fundamental

After publicizing the success of his *Neurospora* experiments in scientific journals, Beadle spent the years immediately following World War II making an impassioned case to scientific audiences across the United States that the enzymatic reactions in all cells were controlled by genes. Images were essential to his elevation of a seemingly simple mold into an exemplar of life writ large. In February 1948, he addressed researchers at the Naval Medical Research Institute in Bethesda, Maryland, using hand-drawn glass slides to impart the significance of his work (page 114).[16]

In his talk, Beadle repeatedly referenced "protoplasm," a concept famously coined by British zoologist Thomas Huxley to refer to the substance of cells or, more dramatically, the "physical basis of life." As Beadle explained it, nutrition was best understood as "the process by which an organism obtains the raw materials out of which its protoplasm is elaborated." Organisms like *Neurospora*, he said, differed from animals merely in their ability to "build up the constituents of protoplasm from simpler starting material." Some of his slides showed straightforward diagrams of the production and crossing of mutants. Other slides brought the audience inside the protoplasm, populated with tidily labeled molecules linked through discrete reactions. One diagram showed the synthesis of the amino acid arginine, a process that unfolded identically in both *Neurospora* and mammalian liver cells. "Because of this basic similarity in the chemical properties of protoplasm," he concluded, "we are able to learn so much about the nutritional requirements of man by studying such organisms as yeast and bread mold."[17] A common visual idiom of simple lines and labels smoothly linked chemical and biological insights.

Returning to Pasadena, Beadle received a letter from Leon Svirsky, the new managing editor at *Scientific American*, who wrote that he had "heard from several people later that they thought it was by far the outstanding paper at the meeting." Svirsky solicited an adaptation of the talk for publication in *Scientific American*, noting however that, "since you talked from slides, presumably, some slight modifications

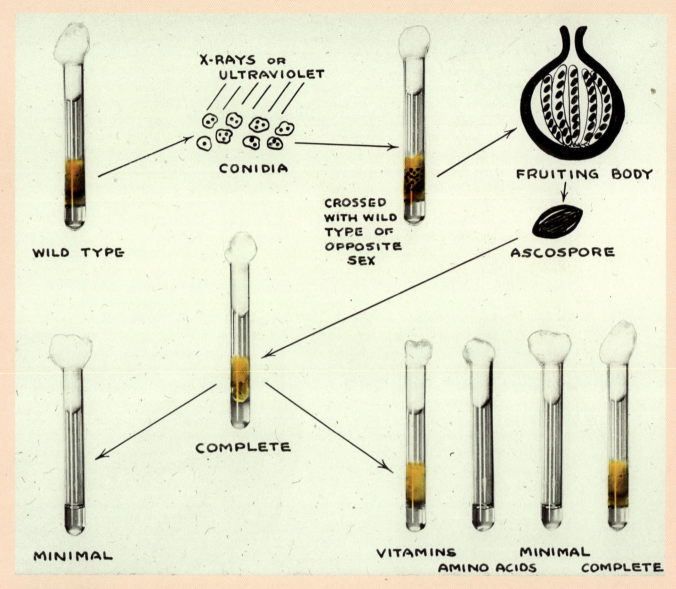

George W. Beadle
Neurospora research process, 1946
Hand drawn glass slide
Caltech Archives and Special Collections

would have to be made for reading purposes." With the magazine's readership in mind, Svirsky advised Beadle to write "in the language and manner one would use to explain the subject to a scientist in another field. The only concession one would need to make therefore is to avoid special terminology that a nonspecialist might not understand." Beadle responded warmly to the proposal, expressing one reservation, "I'm worried about illustrations. Those I used in Washington [sic] are no good except in color. That's probably too expensive to do—or is it? I could have Roger Hayward, who does fine drawings...do some but this would cost something." In his response, Svirsky reassured Beadle, "We can do them in two colors, something called Duotone. Would that be good enough? Having Roger Hayward do them sounds like a very fine idea."[18]

Architect and artist Roger Hayward had resided in Pasadena since 1929, when he won a million-dollar contract to design the Los Angeles Stock Exchange. During the 1930s, he became enthralled with science, seeking out remedial instruction at Caltech. He began to dabble in instrument-making and scientific illustration with John D. Strong, assistant professor of physics and astrophysics. Befitting their proximity to Hollywood, the duo designed a so-called "transparent projection screen" for projecting previously filmed background footage behind actors in a film studio. Hayward also illustrated a chapter of Strong's textbook *Procedures in Experimental Physics*. As the book's preface explained, "The ideal way to learn the procedures of experimental physics is by direct contact with them in the laboratory. Realizing this, we have endeavored to bridge the gap between laboratory demonstrations and experience on the one hand, and exposition on the other, by the liberal use of figures."[19] Following stints as a researcher for the National Defense Research Committee and an analyst with the US Army Air Forces during World War II, Hayward drew evocative tableaus of the microworld for Linus Pauling's *General Chemistry*, as Soraya de Chadarevian explores elsewhere in this catalog.[20] Across these eclectic projects, Hayward became a skilled facilitator of virtual witnessing, providing readers with vivid representations of science in action.

Beadle informed Hayward of Svirsky's proposition, and the duo got to work, which proceeded smoothly save for a kerfuffle after editor Dennis Flanagan suggested that the article incorporate a photograph of *Neurospora* taken at Yale. As Beadle explained, "I wouldn't feel right about using illustrations taken there in an article written here."[21] While Beadle and Hayward depicted *Neurospora* as placeless, surrounded only by glass tubes and monochrome backgrounds, Beadle was nonetheless wary of erroneously suggesting any involvement on his part with the work at Yale. Author and editor eventually compromised, including a single "photomicrograph" that Flanagan deemed necessary "for mechanical reasons."[22]

Flanagan, who had served as the science editor at *Life* before joining *Scientific American*, was acutely aware of the power of images in reaching an expansive readership. Thrilled by the outcome of the collaboration, he wrote Beadle that "your article and the Hayward illustrations... are superb." Furthermore, as Flanagan informed Beadle, "We are giving both you and Hayward a by-line on the article. This is the first time we have done this for an artist, but Hayward surely deserves it."[23] Beadle concurred, "I am very happy that you are giving Hayward a by-line.... Actually in addition to doing the illustrations, he made several useful suggestions on the text."[24] For both editor and writer, illustration was manifestly also a form of authorship.

The September 1948 issue of *Scientific American* reportedly flew off newsstand shelves, as the circulation of the magazine had nearly tripled under its new format.[25] Beadle wrote to Flanagan that he had "tried to pick up some extra copies here and was informed by the local magazine wholesaler...that unsold copies were very difficult to find."[26] Beadle also had Hayward's illustrations made into lantern slides that he projected during his ongoing lecture tour.[27] Four decades later, Hayward's striking drawings were reprinted when historian of science Lily Kay included them in a 1989 article about Beadle's savvy handling of patrons within the federal government and private pharmaceutical firms.[28]

In an ironic testament to Hayward's artistic abilities, Kay reused his illustrations to explain Beadle's *Neurospora* experiments while offering no acknowledgement that Hayward had produced the images. In this version of the story, the careful crafting of *Neurospora*'s iconography simply vanished.

Conclusion

As Charles Darwin once observed of his fellow researchers, "It is good to have hair-splitters & lumpers."[29] The annals of the life sciences are replete with both. Where the former emphasized the distinctive variations between living things, the latter sought to discern unity underlying this diversity. In the 1940s, Beadle, a lumper extraordinaire, made *Neurospora* a proxy for all living things, promoting the mold as a way of studying the gene as a "master molecule or template" responsible for "directing the final configuration of the protein molecule as it is put together from its component parts."[30] With their article in *Scientific American*, Beadle and Hayward transformed this view into a seductive visual argument, reaching audiences far beyond the ranks of professional scientists.

Yet where these images served to lump together "men and molds," other scientists, like Dodge, placed *Neurospora*'s peculiarities in the foreground, elucidating the features that set the fungus apart. As Dodge explained to Beadle in 1942, Beadle's nomenclature for fungal mating types misleadingly implied their equivalency with sexual dimorphisms in animals: "The whole trouble is that maleness and femaleness carry the idea of morphological differentiations while in the heterothallic fungi the races which will unite in sexual reproduction may be morphologically very much alike."[31] Here, "sex" did not translate neatly between animals and fungi. Rather, it required unique means of representation.

Beadle's experiments and Hayward's illustrations shaped a popular midcentury vision of *Neurospora* as "genetic guinea pig." Still, as microbial geneticist Rowland H. Davis remarked in 2003, models like *Neurospora* "were the last to offer (and only briefly) findings of universal relevance in biology."[32] Capturing the aura of certainty permeating Beadle's work, Davis wrote, "A faith prevailed that emergent properties and complex interactions could be resolved into straightforward diagrams."[33] By the end of the twentieth century, a molecular world once depicted with tantalizing clarity had become increasingly unruly.

Throughout the heyday of *Neurospora* research, scientific claims about nature's fundamental molecular order were marred by superficiality. Even as they promised glimpses into the interiors of living cells, researchers never escaped a world of appearances. Later in life, Beadle himself acknowledged the essential role of the human sensorium in his work, as well as the eye's fallibility. In an epigraph for a book on *Neurospora* that remained unwritten, he described a fraught encounter of scientist and fungus:

> Little spore, oh little spore, sitting so properly
> On your block of agar, I can't see you, but you, alas, can see me.
> …
> With misty eyes, how can I think
> To dig you out of the agary drink,
> To separate you one by one?
> In my condition it can't be done![34]

Only in bringing such human struggles to light can our picture of science's past begin to approach verisimilitude.

1—G. W. Beadle, "The Genes of Men and Molds," *Scientific American*, September 1948, 30–39.

2—"An Announcement to Our Readers," *Scientific American*, December 1947, 244.

3—Beadle, "Genes of Men," 30.

4—Beadle, "Genes of Men," 30.

5—Lily E. Kay, *The Molecular Vision of Life: Caltech, the Rockefeller Foundation, and the Rise of the New Biology* (New York: Oxford University Press, 1993).

6—F. W. Goro, "Penicillin: Mass Production of Drug Replaces Slow Laboratory Methods to Meet Military Needs and Provide a Limited Civilian Supply," *Life*, July 17, 1944, 60.

7—A. E. Buchanan, "An Industry That Was Made-to-Order," *Scientific American*, May 1931, 322–24.

8—Charles Thom and Elbert C. Lathrop, "Psilocybe as a Fermenting Agent in Organic Debris," *Journal of Agricultural Research* 30, no. 7 (1925): 625.

9—C. L. Shear and B. O. Dodge, "Life Histories and Heterothallism of the Red Bread-Mold Fungi of the *Monilia Sitophila* Group," *Journal of Agricultural Research* 34, no. 11 (1927): 1021.

10—Shear and Dodge, "Life Histories and Heterothallism," 1025.

11—Dodge, "Segregations Observed in Breeding the Monilia Bread Molds," *Science* 70, no. 1809 (1929): 222.

12—Dodge, "Inheritance of the Albinistic Non-Conidial Characters in Interspecific Hybrids in Neurospora," *Mycologia* 23, no. 1 (1931): 48, n. 1.

13—Judith R. Goodstein, *Millikan's School: A History of the California Institute of Technology* (New York: Norton, 2006), 138.

14—Carl C. Lindegren and Gertrude Lindegren, "X-Ray and Ultra-Violet Induced Mutations in *Neurospora* II. Ultra-Violet Mutations," *Journal of Heredity* 32, no. 12 (1941): 435–40.

15—Beadle to Dodge, February 27, 1941, folder 6, box 6, Bernard Ogilvie Dodge Records, LuEsther M. Mertz Library, New York Botanical Garden; Dodge to Beadle, March 5, 1941, Dodge, Bernard O. file, Correspondence series, George W. Beadle Papers, Caltech Archives and Special Collections.

16—Beadle, "Nutritional Aspects of the Science of Inheritance," c. 1946-1947, Manuscripts series, Beadle Papers; Neurospora slides, Biographical series, Beadle Papers.

17—Beadle, "Nutritional Aspects."

18—Svirsky and Beadle correspondence, February–March 1948, *Scientific American* file, Publications series, Beadle Papers.

19—John Strong, *Procedures in Experimental Physics* (New York: Prentice Hall, 1938), v.

20—Linus Pauling, *General Chemistry: An Introduction to Descriptive Chemistry and Modern Chemical Theory* (San Francisco: W. H. Freeman, 1947).

21—Beadle to Flanagan, May 29, 1948, *Scientific American* file.

22—Flanagan to Beadle, August 4, 1948, *Scientific American* file.

23—Flanagan to Beadle, August 4, 1948.

24—Beadle to Flanagan, August 10, 1948, *Scientific American* file.

25—Sean F. Johnston, "Vaunting the Independent Amateur: Scientific American and the Representation of Lay Scientists," *Annals of Science* 75, no. 2 (2018): 111.

26—Beadle to Flanagan, October 4, 1948, *Scientific American* file.

27—Beadle to Flanagan, September 7, 1948, *Scientific American* file.

28—Kay, "Selling Pure Science in Wartime: The Biochemical Genetics of G. W. Beadle," *Journal of the History of Biology* 22, no. 1 (1989): 73–101.

29—Charles Darwin to J. D. Hooker, August 1, 1857, Darwin Correspondence Project, https://www.darwinproject.ac.uk/letter/DCP-LETT-2130.xml.

30—Beadle, "Biochemical Genetics," *Chemical Reviews* 37, no. 1 (1945): 82.

31—Beadle to Dodge, February 11, 1942, Dodge, Bernard O. file.

32—Rowland H. Davis, *The Microbial Models of Molecular Biology: From Genes to Genomes* (New York: Oxford University Press, 2003), viii.

33—Davis, *Microbial Models*, viii.

34—Beadle, "Revenge on Agar," *Neurospora* Book file, Manuscripts series, Beadle Papers.

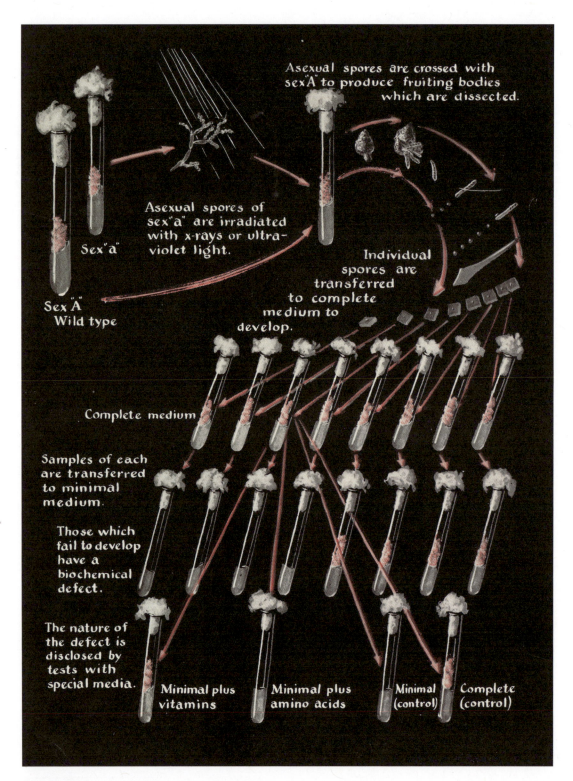

Roger Hayward
Illustration for George Beadle, "The Genes of Men and Molds," *Scientific American*, September 1948
Magazine
Caltech Archives and Special Collections

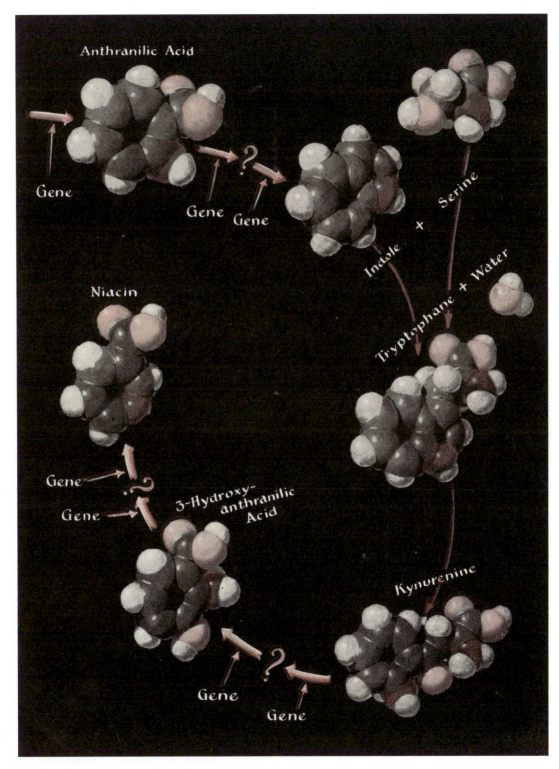

Roger Hayward
Illustration for George Beadle, "The Genes of Men and Molds," *Scientific American*, September 1948
Magazine
Caltech Archives and Special Collections

Arthur A. Jansson
Photographs for "Penicillin
Mass Production," *Life*,
July 17, 1944
Magazine

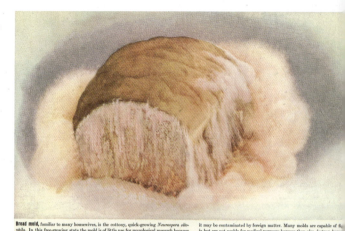
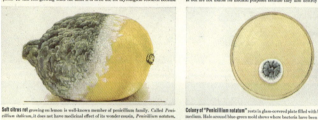

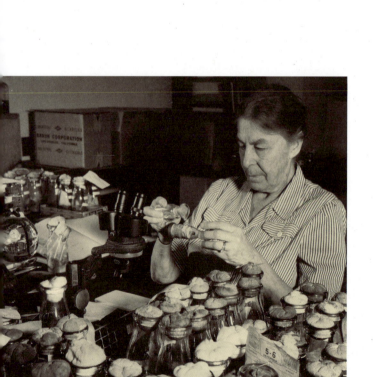

Ross Madden
Lilian Vaughan Morgan working
with fruit files, 1949
Photograph
Caltech Archives and Special
Collections

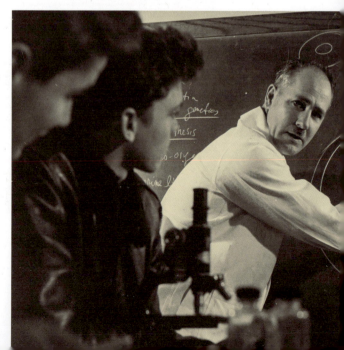

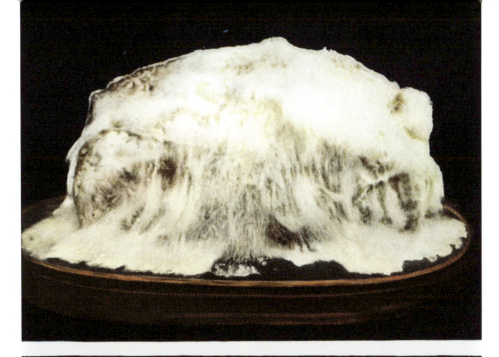

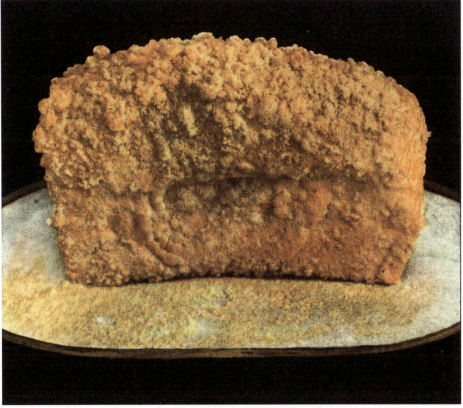

Bernard O. Dodge
"Inheritance of the Albinistic Non-Conidial Characters in Interspecific Hybrids in Neurospora,"
Mycologia, 1931
Journal
Linda Hall Library

Ross Madden
George Beadle, c. 1949
Photograph
Caltech Archives and Special Collections

MOLECULES

This section highlights Caltech's work in structural chemistry. Beginning in the 1930s, Linus Pauling conducted landmark research illuminating the nature of chemical bonds, which hold molecules together. Over the next three decades, Pauling and his colleagues used three-dimensional models when envisioning molecules and made them standard teaching tools in Caltech chemistry labs. Increasing the impact of their work, Pauling and fellow chemist Richard Dickerson collaborated with artists Roger Hayward and Irving Geis to create two-dimensional renderings of molecular architecture, synthesizing complex structures into renderings that made small-scale research visually accessible.

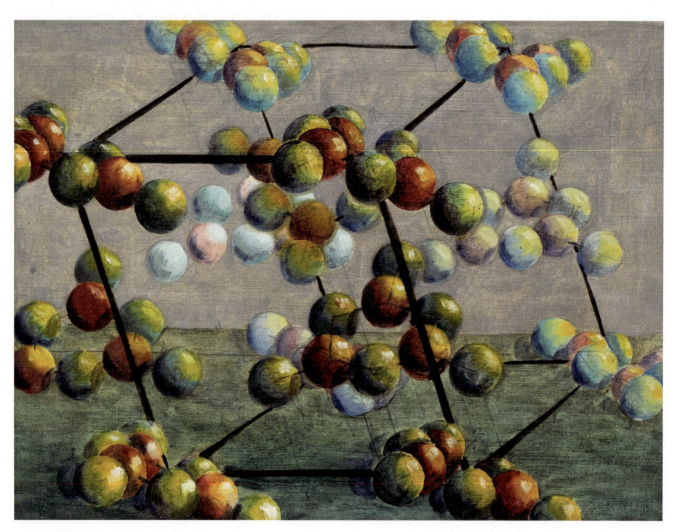

Dan McLachlan
The Structure of Melamine, c. 1941
Oil on canvas
Caltech Archives and Special Collections

Linus Pauling
Laue x-ray photograph, 1922
Photograph with pencil
Oregon State University Libraries

A Laue x-ray photograph. I made hundreds of them. LP

Unknown Photographer
Alexander Goetz with model of tin crystal, c. 1930
Photograph
Los Angeles Public Library

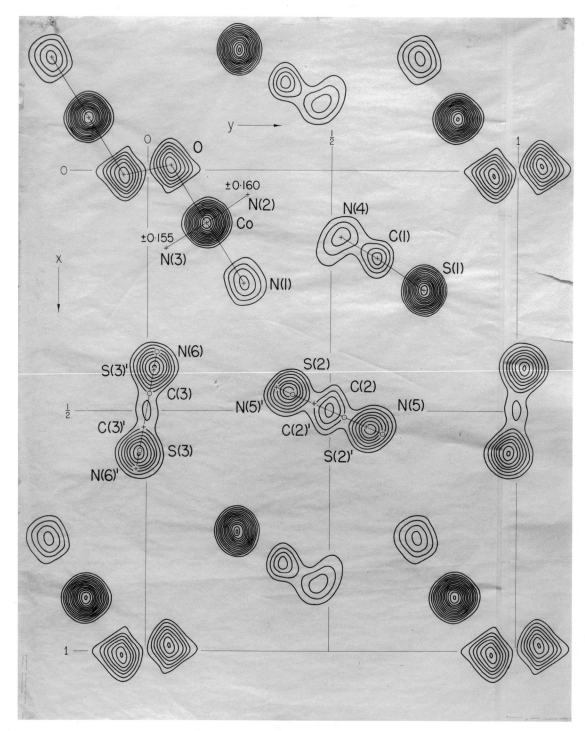

Unknown Maker
Electron density map of decammine, 1973
Ink on paper
Caltech Archives and Special Collections

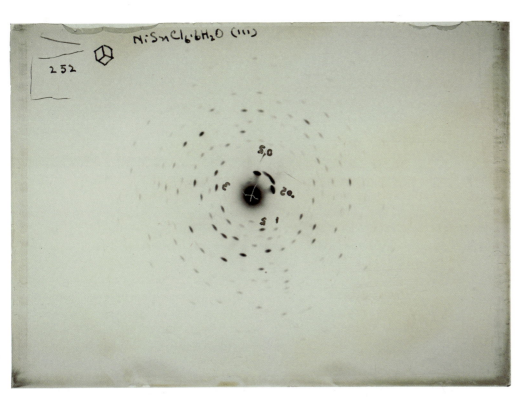

Linus Pauling
X-ray diffraction of nickel
chlorostannate hexahydrate crystal, c. 1929
Glass plate photograph
Caltech Archives and Special Collections

Unknown Maker
Three-dimensional Patterson map
of hydroxyproline, c. 1950
Plexiglass and ink
Caltech Archives and Special Collections

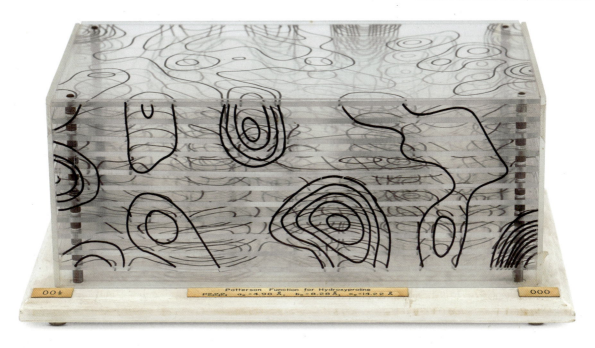

Soraya de Chadarevian

RENDERING THE MOLECULAR WORLD

The way in which lay people imagine the molecular workings of cells and living beings very much depends on the colored and vivid renderings of these processes in textbooks and popular media. Scientists, too, get caught up in the representations they produce. This essay illuminates this process in more detail by focusing on the pioneering work of two Caltech scientists and their close collaboration with artists in their efforts to capture the workings of the molecular world.

Not an Ordinary Illustrator
Starting in the 1930s, Caltech became a center for structural chemistry. Linus Pauling, who from the mid-1930s directed the Division of Chemistry and Chemical Engineering, first worked on the structure of small inorganic molecules. Using x-ray crystallography, he determined the atomic structure of hundreds of minerals and metal compounds. Yet increasingly, he shifted his interest to the structure of biological molecules, including especially the structure of the large protein molecules that are responsible for many chemical processes in the cell. He approached the problem from the "bottom up" by determining the structure of the amino acids, the building blocks of proteins. Using his extensive knowledge of inter-atomic chemical forces and chemical bonds, he then studied the way the single amino acids are linked together in long polypeptide chains. Building on this approach, in the early 1950s, he worked out the alpha- and beta-structure of proteins. These two structural formations of the polypeptide chain—one helical, the other sheet-like—form the basis of all protein structures. Famously, Pauling worked out the alpha-helix structure playing with paper models while he was ill in bed in Oxford, England.

Model building became a trademark approach of the Pauling group at Caltech. The practice built on a longstanding tradition in chemistry, and a variety of model building sets existed. Nevertheless, to help with their specific research effort, Pauling, together with his colleague Robert B. Corey, developed a set of purpose-built scale models. In these models, single atoms were not simply represented by small spheres as in other conventional sets but by stereo-chemically accurate space-filling model parts. Built in solid wood with internal clamps for fastening, they could be used "as substitutes for calculation in investigations of the probable configuration of the polypeptide chain in proteins." In parallel, the two chemists also developed a set of smaller scale models built in rubber-like plastic material that were lighter and easier to handle and thus useful for qualitative studies of protein structures. Both model sets used the same color scheme, broadly following convention: black for carbon, white for hydrogen, red for oxygen, blue for nitrogen, deep and light yellow for sulfur and phosphorus respectively.[1]

It took the Caltech researchers more than ten years of tinkering to develop the models that best served their research needs. Researchers at other institutions, trained in the same bottom-up method of structure determination, agreed that no other models were as good as the Caltech ones (page 136). In the late 1940s, staff technicians in the Caltech instrument shop started building model sets for off-campus scientists in their free time. It was a small-scale operation, and the models were sold at cost. Even then, because of the considerable labor involved, the price for a set ranged between $600 and $1000. Delays in production became an even more serious issue, and soon the instrument shop was unable to fill the orders that were coming in. In response Corey, who was most deeply involved with the model set operation, proceeded to develop precise drawings of the model parts and the steel molds in which the models were cast so that other laboratories could build their own sets. Efforts were made to patent the Caltech model design, but these were halted when Pauling decided that it would be unwise to move ahead with patenting. A decade later, Walter Koltun from UC Berkeley took out a patent on an improved version of the models, which since

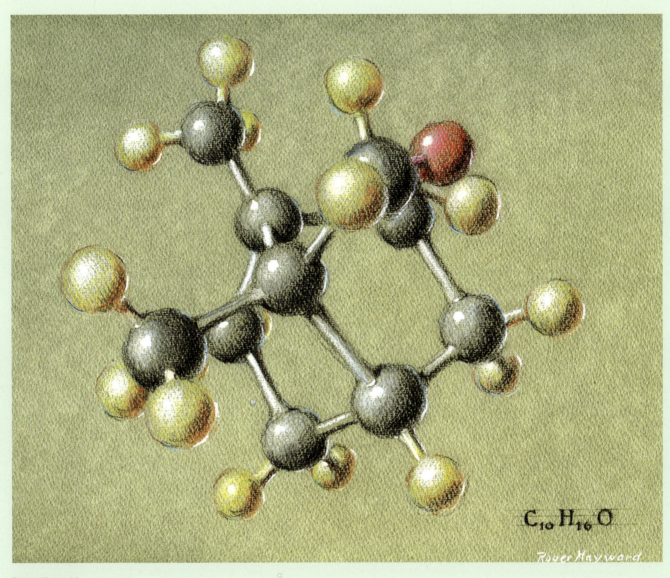

Roger Hayward
$C_{10}H_{16}O$ (camphor), 1964
Pastel on paper
Oregon State University Libraries

then have become known as CPK models after their three inventors—Corey-Pauling-Koltun.

The distribution of the Caltech models contributed to a specific tinker-toy aesthetic of the molecular world. As a fellow crystallographer and biographer later remarked, Pauling transformed "the chemical flatland…into a world of three-dimensional structures."[2] These models also defined the way scientists saw and understood the biological world.

Models were useful for testing different structures and for demonstrations, but there was a need to translate the 3D structures into 2D representations. To render the modeled structures on paper, Pauling developed an increasingly close relationship with Roger Hayward, a local architect, optical inventor, amateur astronomer, artist, and skilled draftsman, who worked with Pauling on a freelance basis. Their collaboration started in the early 1930s when Hayward, who had recently moved from the East Coast to Pasadena and increasingly shifted his attention from architectural practice to science, began drawing viewgraphs and other materials for Pauling's lectures. Later, Pauling collaborated with Hayward on the publication of his textbook *General Chemistry* and a number of other publications. Initially listed as "illustrator," Hayward soon appeared as coauthor, highlighting the importance of his contribution to the scientific work. This was also reflected in his more formalized institutional position of "artist consultant."[3]

Pauling published a first version of this textbook, reproduced from typescript with few explanatory graphs and drawings, in 1944.[4] Three years later, an expanded and richly illustrated first edition came out with William H. Freeman & Company, a new San Francisco-based publishing house. For this revised edition, Hayward provided vivid pen-and-ink drawings of experimental setups as well as multiple illustrations of atomic and molecular structures. Reflecting the space-filling model structures, the atoms and molecules were rendered by clouds of dots that provided both shading and the perception of depth, not unlike in pointillistic drawings.[5] The textbook's first illustrated edition, followed six years later by a second edition, became a classic in the field. It was translated into thirteen languages and introduced generations of students to the study of chemical principles and molecular structures, rendered in Hayward's signature style. It also helped Freeman & Co. become a powerhouse in textbook publishing.

Hayward went on to illustrate many of the firm's scientific textbooks, including the second edition of *General Chemistry*.[6] Both Freeman and Pauling agreed that Hayward was not "the ordinary illustrator" and that his drawings had "both soundness and a certain personality" that were irreplaceable.[7] Nevertheless, for the third edition of his textbook, published by Freeman in 1970, Pauling changed artists.[8] Following a more general trend, he now required a cleaner, more technical style for the illustrations in his textbook than Hayward was able or willing to produce. Mechanical drawings or computer graphics supplanted the hand-drawn line, although Hayward's composition of the images was often maintained. As a result, the textbook looked more "modern" but decidedly less distinctive.[9]

Pauling's eventual defection notwithstanding, the late 1940s to 1960s marked an intense period of collaboration between him and Hayward. An important paper he published on the formation of antibodies, just after the first edition of the textbook came out, carried striking images of knitted molecular structures, in which Hayward tried to transfer to paper Pauling's visual imagination of the process. The article garnered much attention, not least because of its memorable imagery. The drawings were reprinted on several occasions, in both the scientific literature and semi-popular scientific writings. On that occasion as on others, Pauling, who himself had a strong visual imagination and aesthetic sensibilities, provided Hayward with detailed sketches, instructions, and feedback on his drawings but relied on Hayward's own understanding of spatial relations and on his graphic and artistic skills to make the invisible molecular world visible.[10]

The most successful collaboration between Pauling and Hayward developed around the 1964 publication of *The Architecture of Molecules*. The slim volume, aimed at a broader public and timed for Christmas sales, featured a series of page-filling, delicate, and quite striking colored

pastel drawings of molecular structures (page 127).[11] Pauling intended the book as an introduction to the world of atoms and molecules—a basic knowledge of which he deemed essential in the atomic age and for understanding and appreciating new discoveries in the molecular field. Reflecting these goals, he wrote the book from the illustrations, with the text quasi-illustrating the drawings rather than the other way around.

The book received high praise. All reviews emphasized the drawings, "perhaps because this was among the first publications where art and science were so thoroughly blended."[12] Nevertheless, there was also some pushback against the emphasis on molecular drawings. In a pencil annotation next to one of the text panels in a library copy of *The Architecture of Molecules*, an annoyed reader remarked, "What is the purpose of this book?" The offending passage mentioned some chemical details that were omitted in the accompanying drawing, presumably to simplify the image and its message.[13] A present-day crystallographer, who was a student at Caltech at the time, echoed this sentiment, recalling that the book did not make an impression on him as a crystallographer in training. He viewed the volume as part of Pauling's effort to popularize science rather than as a real contribution to the field.[14] Such opinions do not of course make Hayward's contribution less meaningful and certainly do not do justice to it more generally. One reported episode makes this particularly clear.

In 1951 Pauling urgently requested a structural drawing of Na_2Cd_{11}, a sodium and cadmium compound. As usual, he provided detailed instructions. Hayward followed suit but soon let Pauling know that the drawings could not be executed as he had requested because of some problems with the spatial arrangement of the atoms as specified. Pauling went back to the drawing board and, sure enough, found an error in his calculations. This episode cemented Pauling's trust in Hayward's drawings and their accuracy. If there was any need, it also confirmed that Hayward's drawings were more than mere illustrations and instead served as a veritable test for the soundness of structural hypotheses (page 130).[15]

Despite this clear scientific and commercial value of Hayward's drawings, the relations between the scientist, the artist, and the publisher were not without tensions and had to be frequently reset. This dynamic reflected not only the peculiar professional relationship between Pauling and Hayward, but also the deeper-seated undervaluation of the role of visual representation in science, which Hayward in many ways aimed to reverse.

Molecular Vesalius

Pauling left Caltech in the mid-1960s, but the campus remained an important center for structural biology. Following in many ways in Pauling's footsteps was Richard Dickerson, who joined the Caltech group at just about the time that Pauling left. As a postdoctoral researcher at the Laboratory of Molecular Biology at the University of Cambridge, Dickerson had worked with John Kendrew on elucidating the structure of myoglobin, the molecule that stores oxygen in muscle. It was the first globular protein structure ever to be solved at an atomic level, work for which Kendrew would share the 1962 Nobel prize in chemistry. *Scientific American* published an article on the pioneering work in 1961 and hired Irving Geis, who had previously worked as a scientific illustrator for the magazine, to draw the complex molecular structure for the piece.[16] The editor, Dennis Flanagan, reportedly dismissed the drawing Geis presented after six months of intense work as a "mass of crumpled chicken wire."[17]

Despite this devastating critique, the drawing found its way into the magazine and laid the groundwork for Geis's subsequent career as a "molecular artist" (page 132).[18] A few years later, not long after Dickerson joined Caltech, he and Geis met, more or less by chance. When Geis asked whether Dickerson knew about Kendrew and his work on myoglobin, a thirty-year collaboration began.

Like Hayward, Geis had a background in architecture, which undoubtedly was important to his ability to grasp and visualize 3D structures. Both Geis and Hayward worked for *Scientific American*, a publication that played an important role in introducing a highly illustrated way of

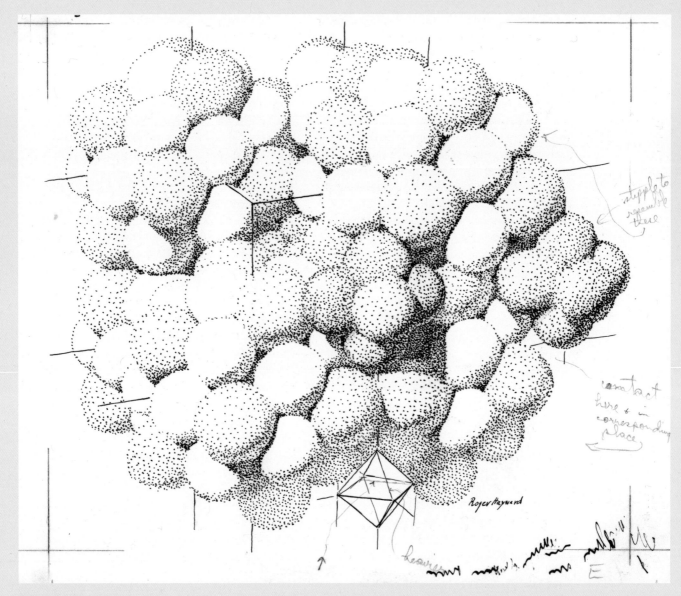

Roger Hayward
Architecture of Na_2Cd_{11}, 1951
Ink and pencil on paper
Oregon State University Libraries

communicating science to an interested lay public in the post-World War II era.[19] But while Hayward's most enduring passion lay with astronomy and optical instrumentation, Geis soon dedicated himself completely to molecular drawings.[20] Producing each picture was a laborious process: Geis would travel to the model, even if this included coming from his home in New York to Los Angeles, and study it intensely. He would sketch and photograph the model as a way to "conceptualize...and finally paint it."[21] This process was accompanied by intense conversation and much correspondence between the scientist and the artist.

Dickerson and Geis worked together on a textbook, *The Structure and Action of Proteins*.[22] For the book, which featured Geis as co-author, the pair developed a new style of representation that highlighted the structure and action of proteins. Stretches of alpha-helices were represented as "sausages." Lettered alphabetically, they provided an image of the general structure of the molecule and its active center. More detailed atomic drawings focused in on chemically important details. Every drawing was rendered in varying shades of turquoise, with atomic details drawn in black, making them highly recognizable.

Dickerson himself was artistically inclined and very good at drawing. Therefore, it is possible that he suggested the sausage element and that Geis was responsible for the final execution. As Dickerson saw it: "It was never clear whether Irv illustrated my books, or I wrote Irv's captions. In the end, it did not matter: together we could do more than either could have done alone."[23] Their readers seemed to agree. The copiously illustrated textbook was widely used and taught generations of students (including this author) how to think about proteins and biochemical processes more generally in structural terms. The illustrations were reproduced in many other biochemical textbooks, making this way of rendering molecular structures even more ubiquitous. According to Dickerson, who collaborated with Geis on two further book projects that included illustrations in a similar style, Geis "taught us all how to look, how to understand and how to show others what we saw."[24]

In his drawings, Geis would practice what he called "selective lying."[25] This meant he would introduce small distortions and exaggerations to resolve overlaps and create an understandable image of the complex structures. As he saw it, it was this capacity that distinguished the human artist and gave his drawings an advantage over a photograph of any given molecular model. In his later drawings, Geis shifted to an increasingly abstract and "artistic," although always stereochemically correct, rendering of molecular structures that highlighted the function of the molecule rather than the position of single atoms. He achieved this effect by working with striking colors and light effects (page 133). The shift in representation was Geis's response to the rise of molecular computer graphics programs that had borrowed from his ribbon-and-arrow style, further popularized by biophysicist and molecular illustrator Jane Richardson. Geis's later drawings also appeared in textbooks, now copyrighted by Geis.[26] According to Dickerson, Geis came to see himself as a "molecular Vesalius," who, as his Renaissance predecessor did for the modern study of human anatomy, used art to teach the lay public the new "molecular anatomy."[27]

From Physical to Digital and Back Again

Of course not all structural chemists or molecular biologists could avail themselves of artists of the caliber of Hayward or Geis. Many drawings appearing in publications and used in teaching were produced by illustrators working on multiple projects in the laboratory. Rules and how-to guides informed their work. By the 1980s, computer graphics programs started to supplant physical modeling and molecular artists. Imaging packages such as the model-making program FRODO, developed by Welsh structural biologist Alwyn Jones in the late 1970s, or MolScript, created by Swedish data engineer Per Kraulis in the early 1990s, offered standard tools to produce intricate molecular structures, floating in space, on the computer screen.

Yet looking online at a model developed with MolScript, it is immediately clear that the style of representation was borrowed from Geis's

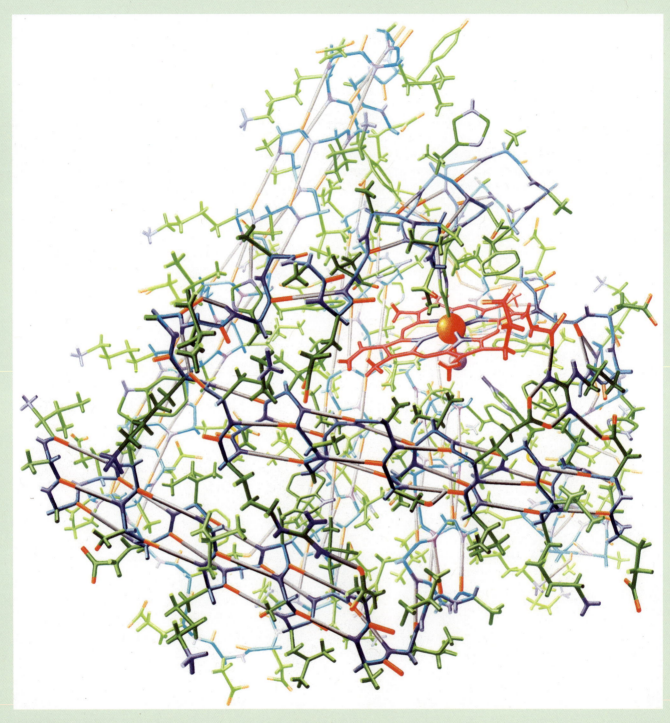

Irving Geis
Structure of Myoglobin, 1961
Watercolor on paper
Howard Hughes Medical Institute

Irving Geis
Myoglobin Fold, 1987
Acrylic on canvas
Howard Hughes Medical Institute

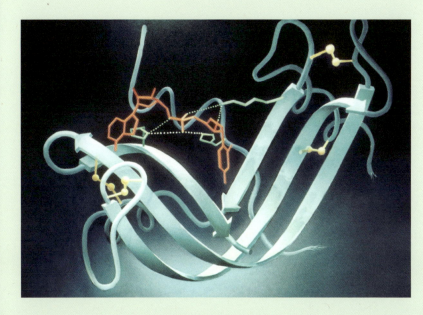

Irving Geis
Ribonuclease S, 1991
Acrylic on canvas
Howard Hughes Medical Institute

ribbon-and-arrow molecular drawings. This highlights the fact that many of the basic design features of modern modeling software rely on graphic choices made by Geis and other pioneers of molecular artistry. Indeed, as art historian Martin Kemp has observed, accustomed as we now are to representations of computer graphics, it is difficult to believe that Geis's drawings were drawn by hand.[28]

Initially, structural biologists wrote their own programs, and their specific needs drove developments in computer graphics, a field then still in its infancy. Yet, as computer graphics increasingly became its own independent field, driven as much by the film and gaming industry as by military and commercial interests, structural biologists were left to decide which tools to adapt for their ever more data-intensive science. VR (virtual reality) and AR (augmented reality) are also finding applications in the molecular structure field. Even so, next to animated, interactive, and simulated representations of "Hollywood quality," hand-drawn 2D representations remain an important tool for peer-to-peer communication, education, and publication.[29]

An interesting recent development is the move back to physical models, facilitated by the advent of 3D-printing. This technology makes it possible to produce highly accurate physical visualizations of complex molecular data sets. As practitioners in the field see it, all these methods serve to make the "unseen world of biology accessible, understandable, and beautiful." At the same time, they raise complex questions of artistic license, credibility, and visual literacy—all of which are necessary to discern what is known, what is hypothesized, and what is speculative.[30] In this process, scientists, artists, technologies, and lay people interact to produce the molecular world as we know it.

1—Robert B. Corey and Linus Pauling, "Molecular Models of Amino Acids, Peptides, and Proteins," *Review of Scientific Instruments* 24, no. 8 (1953): 621–27.

2—Max F. Perutz, "Linus Pauling (1901–1994)," *Nature Structural and Molecular Biology* 1, no. 10 (1994): 668.

3—Pauling, Robert B. Corey, and Roger Hayward, "The Structure of Protein Molecules," *Scientific American* 191, no. 1 (1954): 51–59.

4—Pauling, *General Chemistry* (Pasadena: 1944).

5—Pauling, *General Chemistry: An Introduction to Descriptive Chemistry and Modern Chemical Theory* (San Francisco: W. T. Freeman, 1947).

6—Pauling, *General Chemistry*, 2nd ed. (San Francisco: W. T. Freeman, 1953).

7—William H. Freeman to Pauling, January 12, 1953, quoted in Ina Heumann, "Linus Pauling, Roger Hayward und der Wert von Sichtbarmachungen," *Berichte zur Wissenschaftsgeschichte* 36 (2013): 313–33, on p. 315.

8—Pauling, *General Chemistry*, 3rd ed. (San Francisco: W. T. Freeman, 1970).

9—Heumann, "Linus Pauling," 325–27.

10—Pauling, "Antibodies and Specific Biological Forces," *Endeavour* 7, no. 26 (1948): 43–53; Alberto Cambrosio, Daniel Jacobi, and Peter Keating, "Arguing with Images: Pauling's Theory of Antibody Formation," *Representations* 89 (2005): 94–130.

11—Pauling and Hayward, *The Architecture of Molecules* (San Francisco: W. T. Freeman, 1964). For an example of Hayward's pastel drawings, see page 127. Unfortunately, the drawings included in *The Architecture of Molecules* cannot be reproduced here for copyright reasons.

12—"Roger Hayward and Linus Pauling," *Pauling Blog*, Oregon State University Special Collections & Archives Research Center, May 1, 2008, https://paulingblog.wordpress.com/2008/05/01/roger-hayward-and-linus-pauling/.

13—Pauling and Hayward, *Architecture of Molecules*, 57.

14—Personal communication to author.

15—"Roger Hayward and Linus Pauling." See also Heumann, "Linus Pauling," 319–20.

16—John C. Kendrew, "The Three-Dimensional Structure of a Protein Molecule," *Scientific American* 205, no. 6 (1961): 96–110.

17—Bruce Paul Gaber and David S. Goodsell, "The Art of Molecular Graphics. Irving Geis: Dean of Molecular Illustration," *Journal of Molecular Graphics and Modelling* 15, no. 1 (1997): 57–59.

18—R. E. Dickerson, "Irving Geis, Molecular Artist, 1908–1997," *Protein Science* 6, no. 9 (1997): 2483–84.

19—From the 1950s to the 1970s Hayward wrote a regular column, "The Amateur Scientists," for *Scientific American*. The publishing house Freeman and Co., which owed much of its initial success to the publication of *General Chemistry*, acquired *Scientific American* in 1964.

20—Trudy E. Bell, "Roger Hayward: Forgotten Artist of Optics," *Sky and Telescope*, September 2007, 30–37.

21—Sandy Geis to author, July 20, 1998.

22—Dickerson and Geis, *The Structure and Action of Proteins* (New York: Harper and Row, 1969).

23—Dickerson, "Irving Geis, Molecular Artist," 2483.

24—Dickerson, "Irving Geis, 1908–1997," *Structure* 5 (1997): 1249.

25—Dickerson, "Irving Geis, Molecular Artist," 2484.

26—See for example, Donald and Judith G. Voet, *Biochemistry* (New York: John Wiley & Sons, 1995).

27—Dickerson, "Irving Geis, Molecular Artist," 2484.

28—Martin Kemp, *Visualizations: The Nature Book of Art and Science* (Berkeley: University of California Press, 2000), 118–19.

29—Arthur J. Olson, "Perspectives on Structural Molecular Biology Visualization: From Past to Present," *Journal of Molecular Biology* 430, no. 21 (2018): 4002; Goodsell and Jodie Jenkinson, "Molecular Illustration in Research and Education: Past, Present, and Future," *Journal of Molecular Biology* 430, no. 21 (2018): 3979.

30—Olson, "Perspectives," 4009.

Molecules

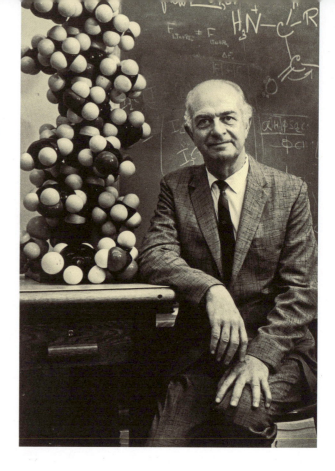

Mike Opalenik
Linus Pauling with CPK
molecular model, 1963
Photograph
Caltech Archives and Special
Collections

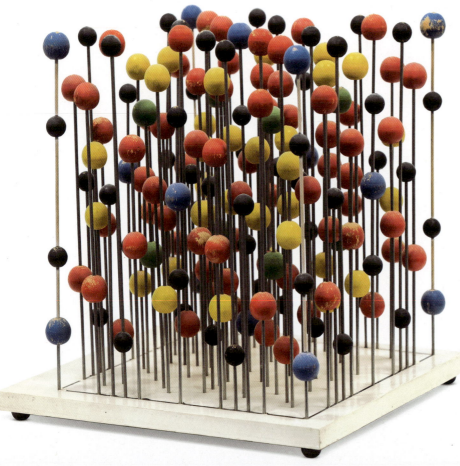

Unknown Maker
Model of crystal structure
of chromium carbon, c. 1950
Wood, styrofoam, paint, and metal
Caltech Archives and Special
Collections

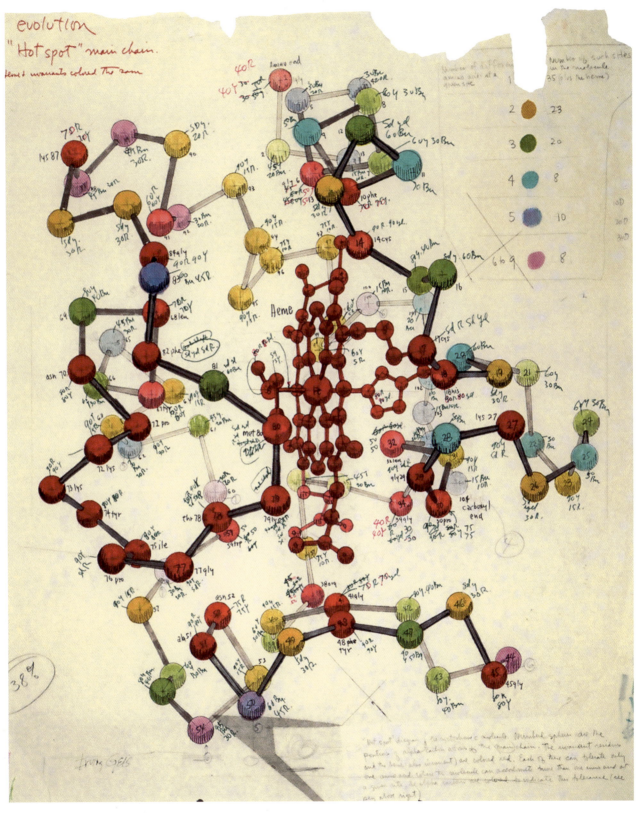

Irving Geis, comments by Richard Dickerson
Cytochrome-C Study, 1972
Marker, pen, and pencil on paper
Howard Hughes Medical Institute

Roger Hayward
Structure of ice, 1964
Pencil on paper
Oregon State University Libraries

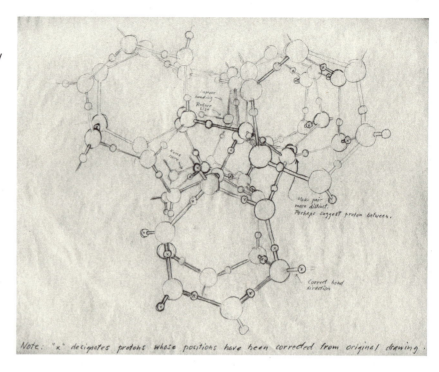

Roger Hayward
Untitled (Polypeptide Chain Coiling into a Helix), c. 1947
Pastel and pencil on paper
Caltech Archives and Special Collections

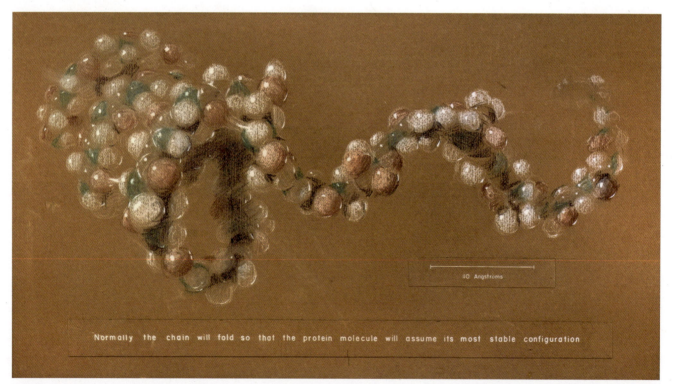

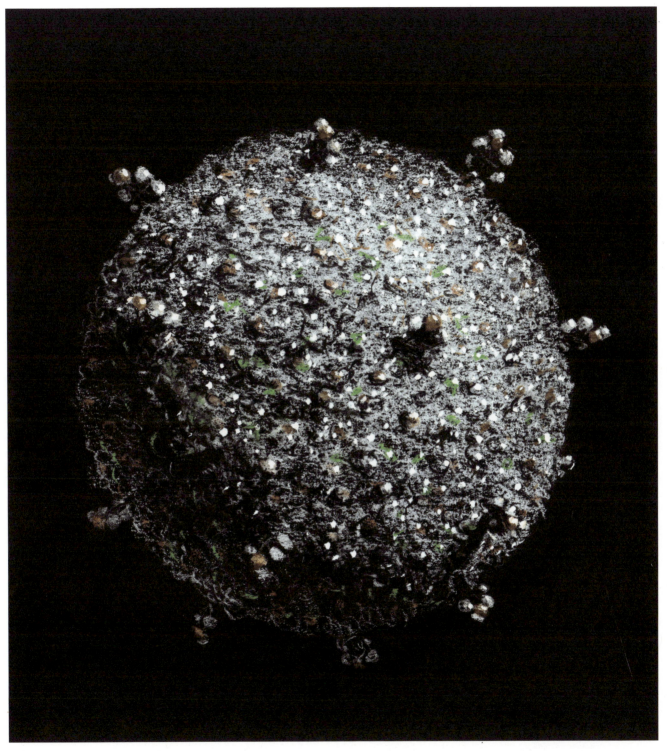

Roger Hayward
Untitled (Virus), c. 1947
Pastel and pencil on paper
Caltech Archives
and Special Collections

Molecules

Unknown Photographer
Richard Dickerson and Irving Geis look over layouts
for *Chemistry, Matter and the Universe*, 1970
Photograph
Courtesy of Sandy Geis

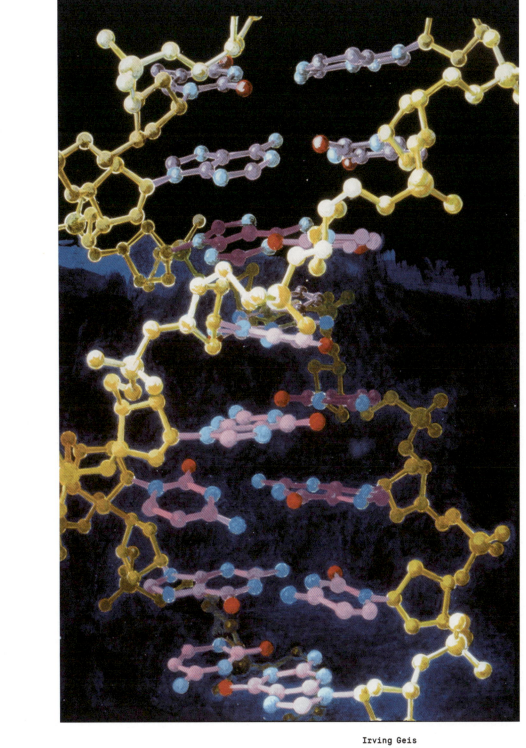

Irving Geis
B-DNA, 1984
Acrylic on canvas
Howard Hughes Medical Institute

PARTICLES

In the early and mid-twentieth century, Caltech physicists and engineers fascinated audiences with demonstrations of pioneering experiments in high-voltage electricity and visual evidence of exotic, previously unknown elementary particles. Records of these experiments include photographs of electrical sparks flying off a million-volt transformer, electron beams accelerated almost to the speed of light in Caltech's synchrotron, and, in 1932, the trail left by an antielectron, or positron, in a cloud chamber. In 1957, Carl Anderson, who made that photograph and thus discovered the positron, collaborated with Academy Award-winning film director Frank Capra. Together, they produced the TV program, *The Strange Case of the Cosmic Rays*, pioneering a new medium of entertainment that became a popular vehicle for communicating groundbreaking scientific ideas to lay audiences.

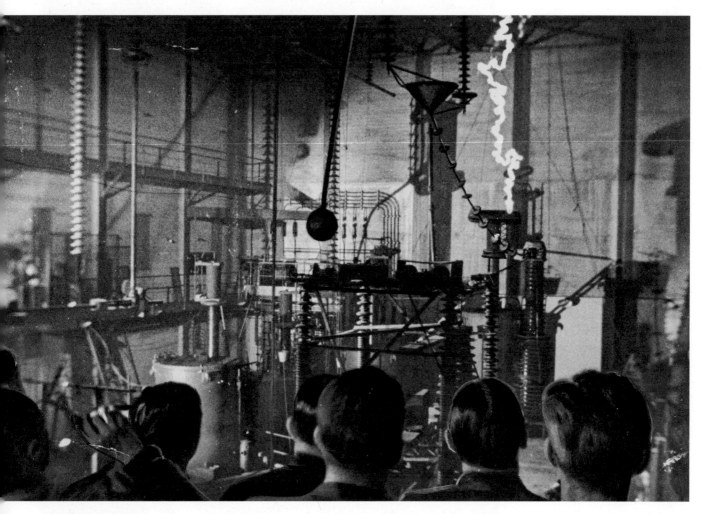

Unknown Photographer
High Voltage Research Laboratory demonstration,
c. 1930
Photograph with ink
Caltech Archives and Special Collections

John Taine (Eric Temple Bell)
Seeds of Life, 1951
Book
UCLA Library Special Collections

Unknown Designer, Story by John Taine
Marvel Science Stories, April 1939
Magazine
UCLA Library Special Collections

Page 144
Grace Milner
Sparking in High Voltage Research Laboratory, c. 1930
Photograph
Caltech Archives and Special Collections

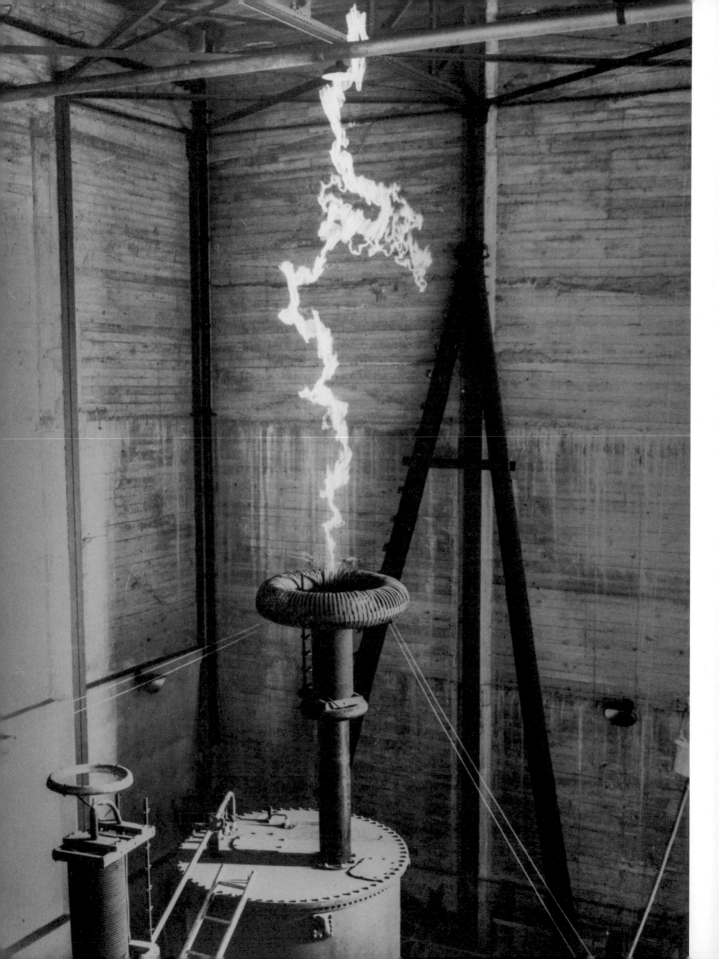

Eyre Powell Press Service
Robert A. Millikan and G. Harvey
Cameron with cosmic ray apparatus,
c. 1929
Photograph
Caltech Archives and Special
Collections

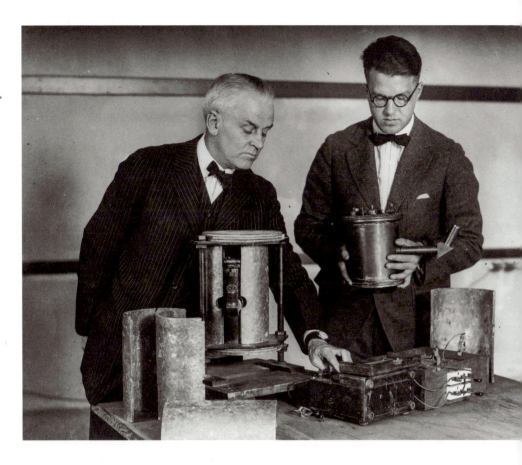

Unknown Photographer
Victor Neher with cosmic ray apparatus, c. 1933
Photograph
Caltech Archives and Special Collections

146 Particles

Carl Anderson
First cloud chamber photograph
of positron track, 1932
Photograph
Caltech Archives and Special
Collections

Unknown Photographer
Positron tracks in cloud
chamber, c. 1932
Glass slide photograph
Caltech Archives and Special
Collections

Unknown Photographer
Spiraling electron in bubble chamber, 1956
Glass slide photograph
Caltech Archives and Special Collections

Donald Cooksey
Particle pairs collide in bubble chamber, 1957
Glass slide photograph
Caltech Archives and Special Collections

Caltech Physics Shop
Ion chamber, c. 1930
Copper alloy
Caltech Archives and Special Collections

Christopher O'Leary
Air Shower, 2015
Digital print
Courtesy of Christopher O'Leary

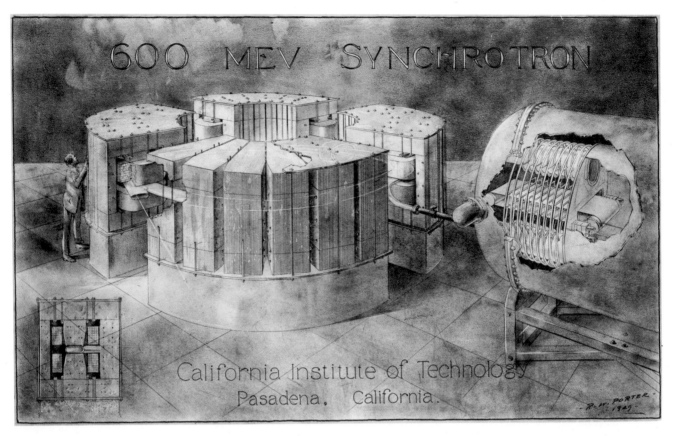

Russell Porter
600 MeV Synchrotron, 1949
Photograph of drawing
Caltech Archives and Special Collections

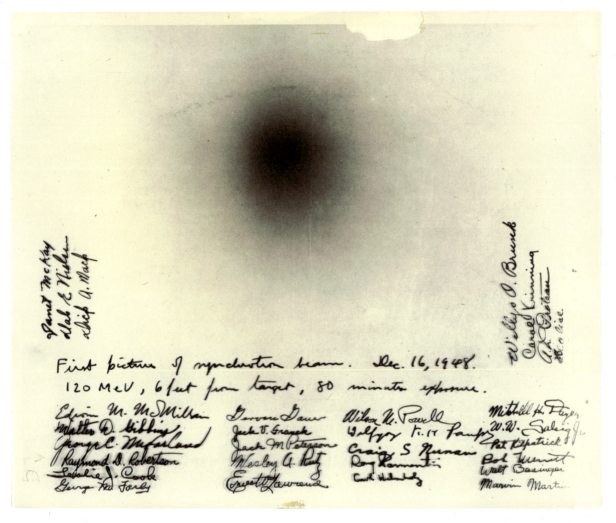

Caltech Synchrotron Laboratory
First picture of a synchrotron beam, December 6, 1948
Photograph with ink
Caltech Archives and Special Collections

Ernie Stout
Bruce Rule, Robert Bacher, Robert Langmuir, and Robert Walker (left to right) at Synchrotron Lab, c. 1952
Photograph
Caltech Archives and Special Collections

Caltech Synchrotron Laboratory
Synchrotron beam, 1952
Photograph with ink
Caltech Archives and Special Collections

SYNCHROTRON BEAM - JULY 1, 1952

Robert V. Langmuir
Robert L. Walker
Vincent Z. Peterson
Matthew Sands
Alvin V. Tollestrup
Paul V.C. Hough
Robert F. Bacher
Bruce H. Rule
John G. Teasdale
Bert J. Anderson

Brian R. Jacobson

GOLDEN EVENT SCIENCE IN THE GOLDEN AGE OF TELEVISION

In September 1918, future Hollywood icon Frank Capra graduated from the Throop College of Technology with a bachelor of science degree but no designated major subject.[1] Having failed too many chemistry courses, Capra could only receive a general education degree from Throop, which changed its name to the California Institute of Technology in 1920. Capra had entered with dreams of becoming an engineer and initially excelled in his courses, earning high marks and a travel scholarship that took him, among other places, to the Eastman film manufacturing plant in Rochester, New York. He ultimately found greater interest and success, however, in four years of English courses taken in what would become, in 1925, Caltech's Division of the Humanities. Writing in 1918 in the campus newspaper, *The Throop Tech*, Capra went so far as to insist that "the English language courses at Throop are ones for which we should have the deepest regard, otherwise we may tend to become mere thinking machines instead of warm, appreciative human beings."[2]

As an English student, Capra cobbled together the foundations for a film career. In addition to his literature classes, he began writing short stories, some of which appeared in the *Tech*. He learned photography from *Tech* staff photographer Edison R. Hoge, a movie buff who helped develop photographic plates at the Carnegie Institution's Mount Wilson Observatory and became a lifelong friend and collaborator. At Mount Wilson, Hoge introduced Capra to a newsreel cameraman who, in turn, initiated him into the art of motion picture photography.[3]

Twenty-five years later, Capra was one of Hollywood's most successful and influential directors, with six Academy Awards for Best Picture, Best Director, and Best Documentary as well as the Legion of Merit and Distinguished Service Medal for the films he produced for the US Department of War. Despite this success, Capra never quite got over his brush with science, even lamenting late in life that he had not followed in the footsteps of his early "idol," astronomer Edwin Hubble, who began working at Mount Wilson the year after Capra graduated from Throop. "A movie director is not as important as an astronomer," he told biographer Joseph McBride.[4]

Such statements obscure the degree to which Capra's career frequently—and perhaps always—operated at the juncture of science and motion picture art. Lost in his distinction between the "more respectable" path of science and the "warm, appreciative" humanistic route he found in his English studies is the significant role that visually oriented sciences like astronomy played in leading Capra into film. Hoge's work at Mount Wilson, for example, depended upon photography and the careful analysis of numerous photographic plates of images captured using the observatory's telescopes. It's no coincidence that Capra found common interest with Hoge— and from there a direct connection to film. Even more concretely, when Capra's Hollywood career faltered after World War II, he found work and new creative energy by shifting his attention explicitly back to science (page 155).

Between 1952 and 1958, Capra produced four one-hour television specials for AT&T's Bell System Science Series: *Our Mr. Sun* (1956), *Hemo the Magnificent* (about the circulatory system, 1957), *The Strange Case of the Cosmic Rays* (1957), and *The Unchained Goddess* (about weather, 1958).[5] Capra and AT&T developed the series during the peak years of American television's "Golden Age," when TV wielded arguably as much influence as any cultural form in the United States.[6] But the series also capitalized on what historian of science Peter Galison has termed twentieth-century science's "golden event"—a crowning form of evidence for a scientific tradition dependent upon "the production of images of such clarity that a single picture can serve as evidence for a new entity or effect."[7] For television and modern science alike, success depended

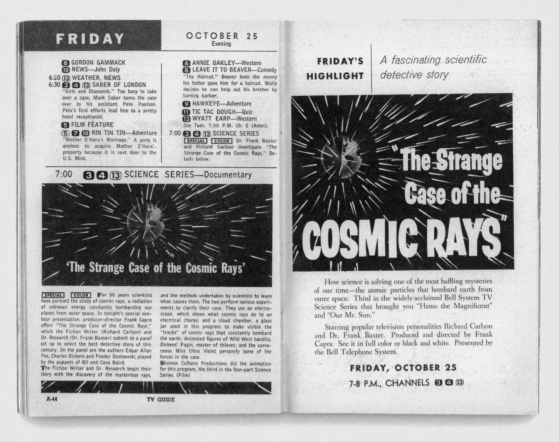

Unknown Designer, in *TV Guide*
The Strange Case of the Cosmic Rays
advertisement, October 19, 1957
Magazine advertisement

on generating images by recreating the world in controlled conditions: the studio in film and television, the laboratory in the sciences. Galison describes this lab-based representational practice—the basis for science's "mimetic tradition"—as the "attempt to imitate nature in the small," a description no less applicable to the "small screen" of television.

Science and television's connected mimetic, or "image," traditions converge in Capra's episode about cosmic rays, which uses still and moving science images as both educational evidence and entertaining spectacle.[8] Those images notably include a paradigmatic example of the image tradition's "golden event"—the 1932 photograph of the positron taken by Capra's future Science Series collaborator, the Caltech physicist Carl Anderson. After seeing Anderson's photo, no one could doubt the existence of a new and exotic subatomic particle—a positively charged electron—which provided the first stunning confirmation of the existence of antimatter.

Capra and Anderson's subsequent collaboration on the cosmic ray film illustrates the common ground between scientific and popular approaches to mimesis and world creation, each with its own visual language and analytic method but with shared assumptions about the evidentiary power of images. The intersection of science and science television, shaped by Capra and

Anderson's movement between science and art, illuminates both the degree to which so many branches of science became image-driven pursuits in the twentieth century and how that imperative lent itself to science's popularization in image culture. Their story also demonstrates how Caltech, though better known for the mimetic tradition and "golden event" images pioneered in its labs, also made such images the basis for less scientific but no less evocative forms of symbolic power.

...

After graduating from Throop, Capra had few job prospects. As late as 1927, he briefly considered a return to Caltech for graduate school—an impulse that included a speculative meeting with Caltech's de facto president, Robert Millikan. Instead, Capra found his way into Hollywood, scoring hit after award-winning hit with *It Happened One Night* (1934), *Mr. Deeds Goes to Town* (1936), *You Can't Take It with You* (1938), and *Mr. Smith Goes to Washington* (1939). During World War II, his *Why We Fight* film series reached some 54 million viewers, cementing his position as one of the most influential American filmmakers of the second quarter of the twentieth century.

After the war, however, Capra's career steadily ran aground—his production methods increasingly out of sync with the shifting film business, his movies out of touch with changing audience tastes, and his social networks and politics uncomfortably close to the targets of the House Un-American Activities Committee.[9] Even *It's a Wonderful Life* (1946), a holiday TV classic, failed at the box office despite critical praise. His independent studio, Liberty Features, also failed, leaving Capra to make his final Hollywood feature for rival Paramount. With major motion picture options dwindling, however, Capra found new life in his old interests. In 1952, AT&T and its research arm, Bell Telephone Laboratories, approached him to produce and direct a series of science films for television.

AT&T had become a leader in the development of educational film during the 1930s.[10] Its role in that industry rapidly grew so extensive that in 1937 the FCC, wary of a monopoly, forced the company to divest its motion picture interests. Notably, these included film production facilities at the headquarters of AT&T's experimental subsidiary, Electrical Research Products, Inc., where Bell executives and engineers sought new methods for popularizing scientific discourse.

Despite their forced divestment, AT&T and Bell Labs continued to invest in educational film. In the 1950s, they expanded into television, including the Bell System Science Series, which was envisioned as both entertaining education and good public relations. With this new venture, Bell joined a broader movement of institutions invested in making television a tool of scientific education and observation. Described in the language of science, their goal, as Lorraine Daston and Elizabeth Lunbeck have said about observation, was to "make the invisible visible, the evanescent permanent, the abstract concrete."[11] Or as Capra summarized his approach to the Bell films, "we reduced the complex to the simple, the eternal to the everyday," and thereby connected "scientist and commoner" by "making education as exciting and entertaining as any comedy, drama, or whodunit."[12]

It was Capra's ability to devise that approach that made him such a good choice for the job. As Capra scholar Eric Smoodin emphasizes, Capra had made a career precisely out of creating a didactic but still entertaining cinema.[13] He also had a background in science dating to his Throop days and ongoing contact with the highest levels of American scientific research, thanks to both social and business connections with Caltech.

In 1950, for example, Capra helped develop a Caltech student recruitment film with Charles Newton, an assistant to Caltech president Lee DuBridge. Newton wrote the film, eventually completed in 1954 as "Careers for Youth," and enlisted Capra's old Throop ally Edison Hoge to shoot it.[14] During that time, Capra also cowrote a script with another DuBridge assistant, Charles Stearns, for an earlier version of *The Strange Case of the Cosmic Rays*. Stearns, a 1924 Caltech graduate in engineering and economics, initially led the project and based the script on detailed scientific notes he recorded in 1950, when he

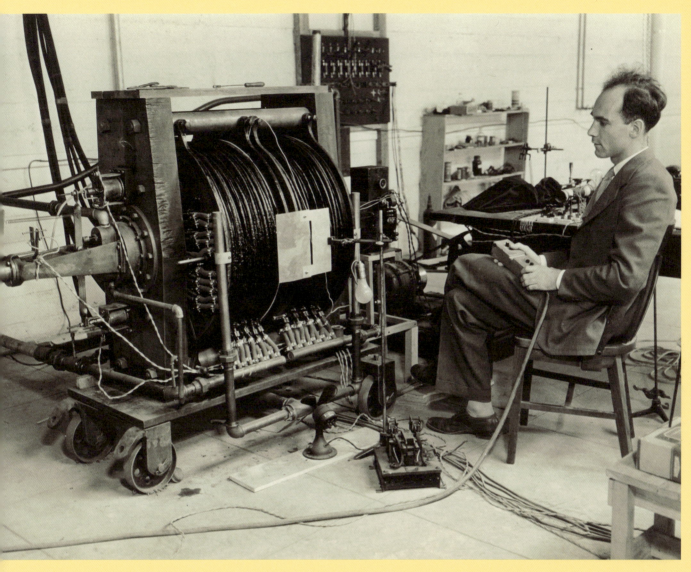

Unknown Photographer
Carl Anderson with cloud chamber, 1931
Photograph
Caltech Archives and Special Collections

also began assembling newsreels and other visual material. For reasons that are unclear, it was never produced, but with the Bell series in hand, Capra returned to it in 1954.

Carl Anderson, who had received both his undergraduate and graduate degrees in physics from Caltech and who won the 1936 Nobel Prize in Physics for his discovery in 1932 of the positron—arguably the most notable "golden event" in the decades-long sequence of cloud chamber cosmic ray experiments—became a key figure in the revised project. Now an eminent Caltech professor (Millikan, who had been his PhD advisor, promoted him after he won the Nobel Prize), Anderson seems to have become acquainted with Capra long before this time, possibly through Millikan, who knew Capra well enough to earn an invitation to the 1935 Academy Awards, which Capra hosted.[15] Anderson later recalled a visit to Columbia Studios that must have taken place around the same time, where Capra helped him acquire a motor-generator set that Anderson brought back to Caltech to power the magnets that were used on the cloud chamber to determine the charges of the particles passing through it.[16] Approached informally by Capra as well as formally by Bell vice president Ralph Bown and Warren Weaver, who headed the natural sciences division at the Rockefeller Foundation, Anderson agreed to join the film project as "advisor and consultant."[17]

Those titles understate Anderson's central role, which essentially was that of coproducer. By the end of August 1954, he had already drafted a four-page "outline of scientific material" that in other circumstances might be described as an early script.[18] Throughout the project's production phase, he read drafts and wrote letters soliciting feedback from leading physics colleagues, from whom he also solicited technical films and photographs.[19] He was also one of the film's important subjects.

Some of the most significant innovators in science's image tradition worked at Caltech, including Anderson and his mentor, Millikan. Their research focused to no small degree on taking photographs of phenomena made visible for the first time in the cloud chamber. Developed in the 1890s and completed around 1911 by Scottish physicist Charles Wilson, the cloud chamber, for which Wilson won the 1927 Nobel Prize, was, just as its name implies, a chamber for manufacturing clouds, or, put more broadly, "reproducing nature."[20] In more technical terms, it was a sealed container holding a supersaturated vapor of water and alcohol in which otherwise invisible, and occasionally very rare, subatomic particles, streaking through the chamber from the depths of space, leave visible trails of water condensation. (The cloud chamber served as an indispensable tool for experimental physics research until the 1950s, when it was largely supplanted by the more sophisticated bubble chamber and high-energy particle accelerators.) Like the film camera, which developed concurrently, the cloud chamber had its roots in such earlier devices as the camera obscura and camera lucida, both of which were used to reproduce aspects of nature in photographically recordable miniature form.[21] Anderson's modifications to the apparatus generated what the scientific community recognized as "much better photographs," the most iconic of which was his first image of the positron (pages 146 and 157).

Cloud chamber photography ushered in a new mode of observation and "a new visually based language" that scientists needed to analyze nothing less than a new class of visible evidence defined by a positivist visual epistemology—faith that images were a source of knowledge, and thus that seeing was believing.[22] With its capacity to capture this evidence, the cloud chamber extended human powers of observation and was thus not only a scientific instrument but also a modern form of mediation in the sense described by Marshall McLuhan and summed up in the subtitle of his 1964 book, *Understanding Media: The Extensions of Man*.[23] Though a different technology, it embodied and extended similar image-based methods emerging in disciplines that had defined Caltech's early history, including, significantly, the astrophysics work pioneered by solar astronomer George Ellery Hale, the founder of Mount Wilson Observatory and one of the builders of Caltech. Hale's image practice—that is, his use of imaging techniques in both conducting and presenting his research—was

based in part on his development of the spectroheliograph, an instrument for photographing the sun in monochromatic light, which appears in the first Bell film, *Our Mr. Sun*. Like the cloud chamber, the spectroheliograph created new visible evidence of intriguing natural phenomena, which drew on the photograph's power to depict solar activity with both stunning scientific clarity and a visual splendor readymade to move and persuade fellow scientists, wealthy donors, and—Capra and Bell Labs wagered—television audiences.

Educated in this image-focused scientific setting, Capra made its images the basis for his science films, with specific Caltech connections in *Our Mr. Sun* and *The Strange Case of the Cosmic Rays*. Both films mixed animation and live-action sequences, with the latter featuring two characters: "Dr. Research," played by Frank Baxter, a USC English professor whose 1954 *Shakespeare on TV* program had earned him an Emmy, and "Mr. Fiction Writer," portrayed in the cosmic ray film by actor Richard Carlson.

In *Strange Case of the Cosmic Rays*, Dr. Research and Mr. Fiction Writer must convince a panel of judges—marionette figures of Charles Dickens, Edgar Allen Poe, and Fyodor Dostoevsky, all renowned literary figures whose writings included detective stories—that the story of the discovery and characterization of cosmic rays should win an award for the best detective story of the century. Turning scientists into detectives and subatomic particles into furtive suspects, the episode's entertainment value rests largely on the animation. But it also relies heavily on the scientific and visual appeal of a wealth of newsreel and photographic material collected by Stearns and later Anderson and Capra's research team. That imagery gives the film its science-side "golden event" bona fides. Its indisputably factual images become the episode's evidentiary bridges between science and art, between reality and representation. Anticipating Galison's argument about the image tradition, Capra's "whodunit" turns science images into fictionalized versions of precisely what they had become in fact: "the final word in evidence."

...

The Strange Case of the Cosmic Rays aired on October 25, 1957. It received mixed, if generally positive, reviews from critics, many of whom noted the significance of the fact that the *Sputnik* satellite, launched three weeks earlier by the Soviet Union, was orbiting overhead. The Soviet connection gave Americans a chance to consider not only space travel and America's potential role in such an undertaking, but also how scientific research was being mobilized for Cold War military dominance and all its atomic-age risks.[24]

If science's image tradition succeeded in no small part because cloud chamber photographs made for good public relations—"decorative dominance," as Galison describes their appearance on the covers of physics textbooks—we find Capra, in his Science Series films, reaching back to his own science education, trading precisely on that same blend of scientific documentation and good PR.[25] Bringing the cloud chamber and the story and significance of its discoveries to the television studio and science photography to the small screen, Capra made one of Caltech's "golden events" a player in television's Golden Age and a lasting model for those interested in how scientific discourse becomes, with the shrewd, always self-interested, sometimes insidious oversight of powerful corporations, public knowledge.

As Capra's midcentury work for and with Caltech suggests, the Institute also understood good PR and its utility for promoting both science and its own reputation. Understanding the cloud chamber as a visual medium underscores how it functioned as an instrument not just for scientific inquiry but also simultaneously for visual communication—notably without any apparent need for inference or typical forms of interpretation, at least for scientists. But even if these images were scientifically self-evident, there's something much less transparent about how they were used, particularly as fodder for corporate advertising, as with AT&T.

Cloud chamber photographs also became a form of evidence in very different kinds of promotional images. Consider one final photo: Millikan and Anderson, sharing a moment after the announcement of Anderson's 1936 Nobel

Prize (below). Millikan, beaming at his newly honored protégé, poses casually, a cigarette dangling from one hand, while the other is pressed to the wall next to a particularly spectacular cosmic ray photo. On the wall behind them hang imposing portraits of Caltech trustees (and lumber barons) Arthur H. Fleming and Charles W. Gates, early Caltech supporters whose names still grace, respectively, a student residence and the campus's main administrative building, which began as a chemistry lab funded by Fleming and Gates to lure chemist Arthur Amos Noyes, friend and former classmate of Hale, away from MIT.

For Fleming, Gates, and especially Millikan, Anderson, the first Caltech student to win a Nobel Prize, was a deeply significant symbol of success—proof that their wager on turning tiny Throop into a major (if still relatively tiny) research institution had paid off. Their triumph is the photo's subtext, boosted by the symbolic value of wealthy trustees consecrated in oil paintings, and indexed in Millikan's wide grin. The creation of Caltech itself had been an experiment, an attempt to create, virtually from scratch, a new stage setting—an apparatus of laboratories, classrooms, libraries, conference rooms, and the campus's famous faculty club, the Athenaeum—for the most advanced scientific research. Like the cloud chamber, that apparatus was designed to create the conditions for discovery. As with Anderson's landmark photo of the positron, the photo of Anderson and Millikan made discovery visible, knowable, and valuable.

Capra's achievement represented a different version of Throop's success—one rooted in its modest humanistic corner but still engaged with its broader scientific ambitions. He was perhaps the most unlikely example of what Theodore Roosevelt, in a 1911 speech at Throop, had described as the "one-hundredth man," a student "with the kind of cultural scientific training that will make him and his fellows the matrix out of which you can occasionally develop a man like your great astronomer, George Ellery Hale."[26] Roosevelt's reference to "cultural scientific training" no doubt had little to do with the appeal to mass culture that dominated Capra's post-Throop career. But Capra, a proud product of the school's cultural side, shows what else the institutional experiment soon to be renamed Caltech could and sometimes did produce.

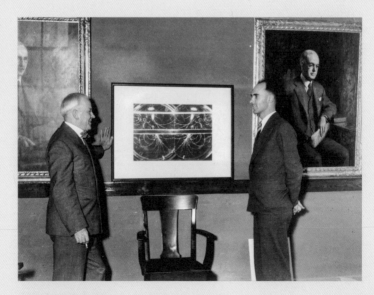

Unknown Photographer
Robert Millikan and Carl Anderson
with cloud chamber photograph, c. 1936
Photograph
Caltech Archives and Special Collections

For Capra, informed as he was by this mix of scientific and humanistic training, science and its images became the stuff of educational entertainment, where their value lay not simply in illustrating scientific phenomena but also in attracting the attention of viewers who might never understand the complex details of experimental physics but could nonetheless be moved and inspired by its visible evidence. But for Caltech as well as its trustees, the images were more than just science. They were persuasive public displays of the Institute's value and success. Capra's unusual relationship to Caltech and its image tradition does not merely illustrate a humanistic side of the Institute's history or the degree to which scientific practice is image practice. It also illuminates how scientific images have so often reached beyond the domain of evidence and of "pure science" to do other kinds of work, be it entertainment, persuasion, politics, or, as in photos like the one of Anderson and Millikan, institutional self-promotion and publicity.

1–Joseph McBride, *Frank Capra: The Catastrophe of Success* (New York: Simon and Schuster, 1992), 91–92.

2–Quoted in McBride, *Frank Capra*, 75.

3–McBride, *Frank Capra*, 98. See also "Wendell P. Hoge, An Astronomer, 72," *New York Times*, November 15, 1939.

4–McBride, *Frank Capra*, 182, 655.

5–Capra directed the first three.

6–See Kelly W. A. Huff, "Golden Age of Television," in *History of the Mass Media in the United States: An Encyclopedia*, ed. Margaret A. Blanchard (New York: Routledge, 2013), 241–43.

7–Peter Galison, *Image and Logic: A Material Culture of Microphysics* (Chicago: University of Chicago Press, 1997), 19, 22.

8–At the time of writing, the film is available on YouTube: https://www.youtube.com/watch?v=k_wt5AFjRQo.

9–For an account of audience responses to Capra's late films, see Eric Smoodin, *Regarding Frank Capra: Audience, Celebrity, and American Film Studies, 1930–1960* (Durham, NC: Duke University Press, 2005), 203–19.

10–This section is based on Heide Solbrig, "Dr. ERPI Finds His Voice: Electrical Research Products, Inc. and the Educational Film Market, 1927–1937," in *Learning with the Lights Off: Educational Film in the United States*, ed. Devin Orgeron, Marsha Orgeron, and Dan Streible (Oxford: Oxford University Press, 2012), 193–214.

11–Lorraine Daston and Elizabeth Lunbeck, "Introduction: Observation Observed," in *Histories of Scientific Observation*, ed. Lorraine Daston and Elizabeth Lunbeck (Chicago: University of Chicago Press, 2011), 1.

12–Frank Capra, *The Name Above the Title: An Autobiography* (New York: Macmillan, 1971), 443.

13–Smoodin, *Regarding Frank Capra*, 235.

14–Charles Newton, interview by Rachel Prud'Homme, January 1983, Caltech Archives Oral History Project, 13, 52–54. Details of the extended production are documented in the Frank Capra Collection, Ogden and Mary Louise Reid Cinema Archives, Wesleyan University. My thanks to Head Archivist Joan Miller for facilitating access to these materials.

15–McBride, *Frank Capra*, 338.

16–Carl Anderson, interview by Harriet Lyle, February 9, 1979, Caltech Archives Oral History Project, 41.

17–See Warren Weaver to Carl Anderson, July 22, 1954 and Carl Anderson to Ralph Bown, August 5, 1954, C. D. Anderson file, Robert Leighton Papers, Caltech Archives and Special Collections.

18–Anderson, "Preliminary Outline of Scientific Material for Cosmic Ray Film," August 1954, C. D. Anderson file.

19–C. D. Anderson file.

20–Galison, *Image and Logic*, 4.

21–Galison, *Image and Logic*, 32.

22–Galison, *Image and Logic*, 135.

23–Galison, *Image and Logic*, 67; Marshall McLuhan, *Understanding Media: The Extensions of Man* (New York: McGraw-Hill, 1964).

24–As Hal Eaton wrote for the Newhouse news service, "With Sputnik, flying saucers and rockets on the tip of practically every American's tongue, 'The Strange Case of the Cosmic Rays' gave NBC a highly informative and entertaining hour." See this and similar reviews in Press Reviews 1957 Nov. [N.W. Ayer & Son, 1957] file, box 26, Capra Collection.

25–Galison, *Image and Logic*, 38.

26–Theodore Roosevelt, "A Zoological Trip through Africa," *Bulletin of Throop Polytechnic Institute* 20, no. 51 (1911): 6.

THE ATOM

During World War II, Robert Oppenheimer and other Caltech scientists worked on the Manhattan Project to develop the atomic bomb, first detonated in the Trinity test in New Mexico and subsequently dropped on Hiroshima and Nagasaki in August 1945. The mushroom cloud, simultaneously devastating and redolent of sublime natural wonders, instantly became a visual icon so unprecedented and shocking that it continues to defy easy interpretation. Caltech's involvement with the Manhattan Project is juxtaposed with poignant images from Iri and Toshi Maruki's *Hiroshima Panels*—exhibited at Caltech's Baxter Hall in 1971—and by Caltech visiting artist elin o'Hara slavick, whose work offers powerful representations of the long-term effects of unbridled atomic science.

US Air Force
Nevada Proving Ground fall test, 1951
Photograph
Caltech Archives and Special Collections

Unknown Photographer
Los Alamos identity badges, c. 1943
Photographs
Los Alamos National Laboratory

Top left to bottom right: Richard Feynman, Robert Bacher,
Robert Christy, Charles Lauritsen, Robert Oppenheimer,
Edwin McMillan, Seth Neddermeyer

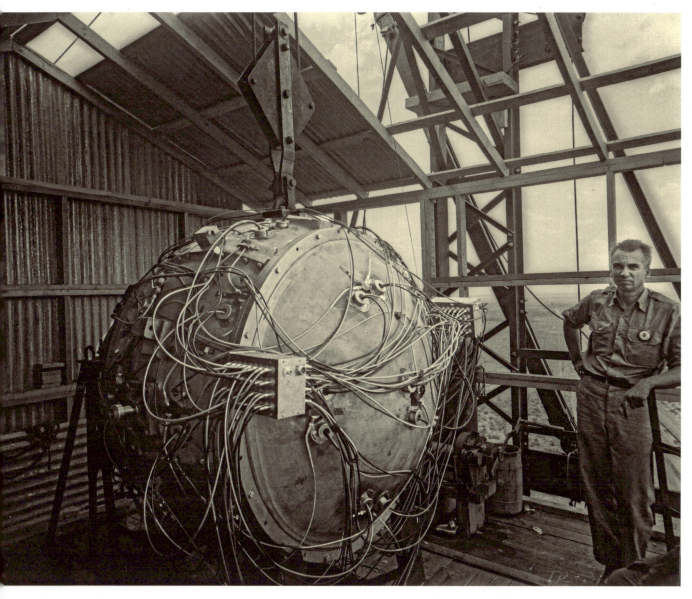

Unknown Photographer
Norris Bradbury with the "Gadget," 1945
Photograph
Los Alamos National Laboratory

Unknown Photographer
Delivery of plutonium core to White Sands Proving
Ground, 1945
Photograph
Caltech Archives and Special Collections

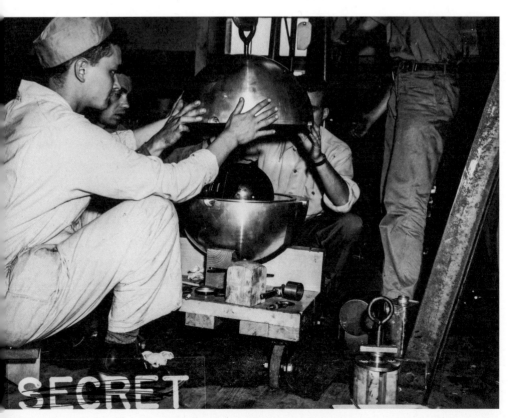

Unknown Photographer
Assembling the "Gadget," 1945
Photograph
Caltech Archives and Special
Collections

Unknown Photographer
Moving plutonium core
to Trinity Site, 1945
Photograph
Caltech Archives
and Special Collections

Unknown Photographer
Hoisting the "Gadget" into the
drop tower, 1945
Photograph
Caltech Archives and Special
Collections

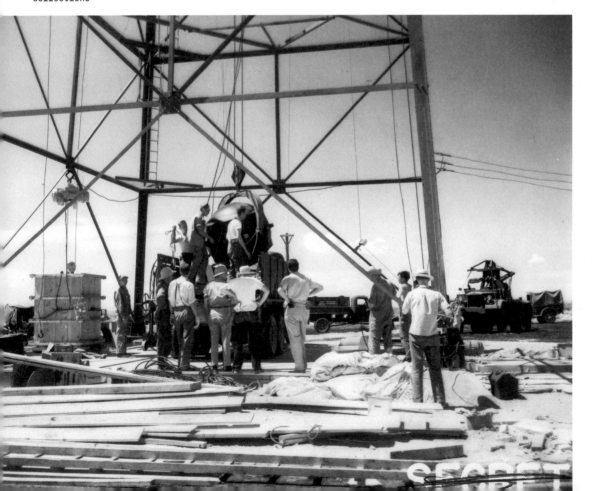

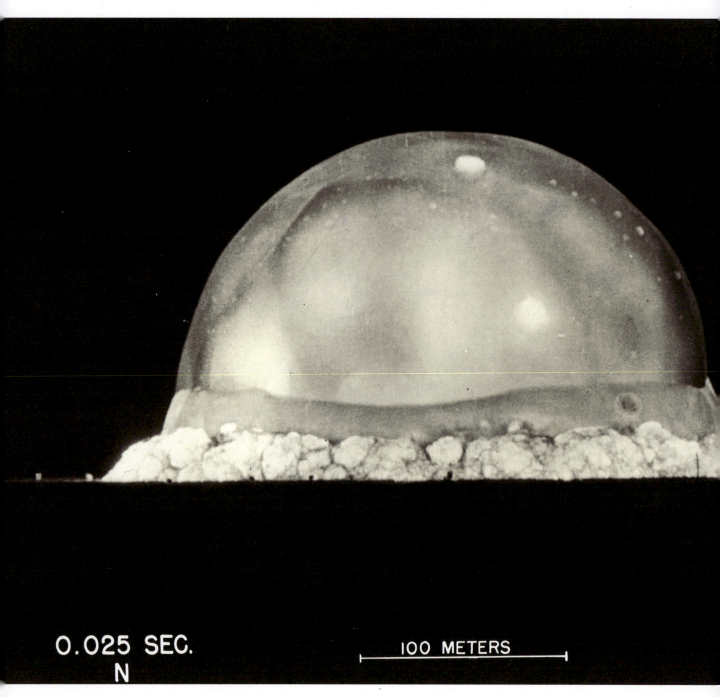

Unknown Photographer
Trinity detonation at 0.025 seconds, 1945
Photograph
Caltech Archives and Special Collections

Unknown Photographer
Gen. Leslie Groves (left), Caltech's Robert Bacher
and Richard Tolman (seated), and others, 1946
Photograph
Caltech Archives and Special Collections

170 The Atom

Unknown Photographer
Aerial view of Trinity Site, 1945
Photograph
Caltech Archives and Special Collections

Bruce Conner
BOMBHEAD, 2002/1989
Pigment on Somerset paper, acrylic (red)
Magnolia Editions, Oakland, CA

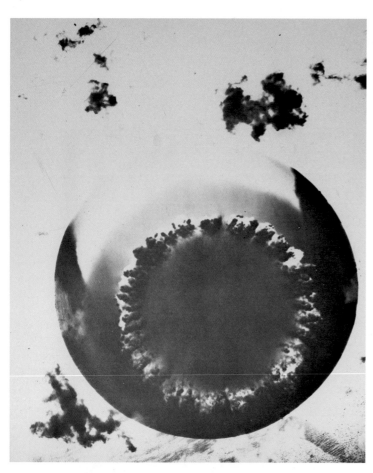

Unknown Photographer
Aerial view of Bikini Atoll nuclear test, c. 1950
Glass slide photograph
Caltech Archives and Special Collections

Unknown Photographer
Bikini Atoll nuclear test, c. 1950
Glass slide photograph
Caltech Archives and Special Collections

Unknown Photographer
Bikini Atoll nuclear test, c. 1950
Glass slide photograph
Caltech Archives and Special Collections

Unknown Photographer
Atomic Energy Commission, with Robert Bacher second from left, 1947
Photograph
Caltech Archives and Special Collections

Unknown Designer
The Hiroshima Panels exhibition poster, 1970
Ink on paper
New School Archives and Special Collections

Panel 2. *Fire* (detail)

Panel 4. *Rainbow* (detail)

Iri and Toshi Maruki
The Hiroshima Panels exhbition catalog, 1970
Book
Caltech Archives and Special Collections

elin o'Hara slavick
Lingering Radiation, 2008
Autoradiograph
Courtesy of elin o'Hara slavick

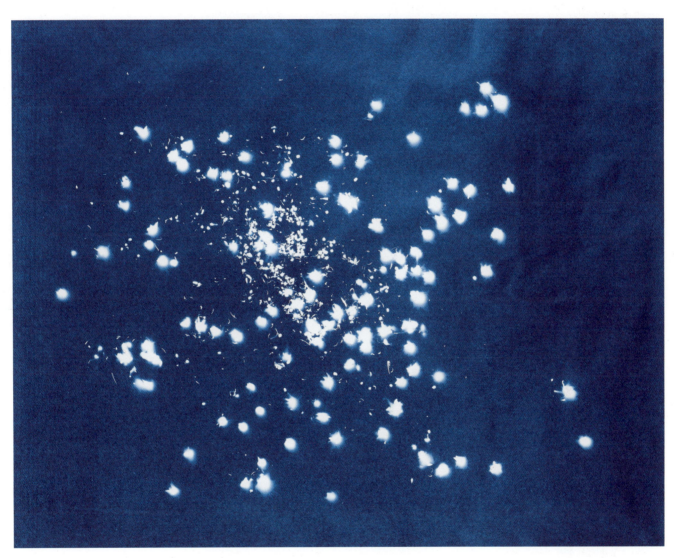

elin o'Hara slavick
Hiroshima Flowers, 2008
Cyanotype
Courtesy of elin o'Hara slavick

Leigh Weiner
William Fowler, 1951
Photograph
Caltech Archives and Special Collections

Ross Madden
Charles Lauritsen, 1948
Photograph
Caltech Archives and Special Collections

Russell Porter
Japanese Balloon Ballasting Control, 1945
Photograph of drawing
Caltech Archives and Special Collections

180 The Atom

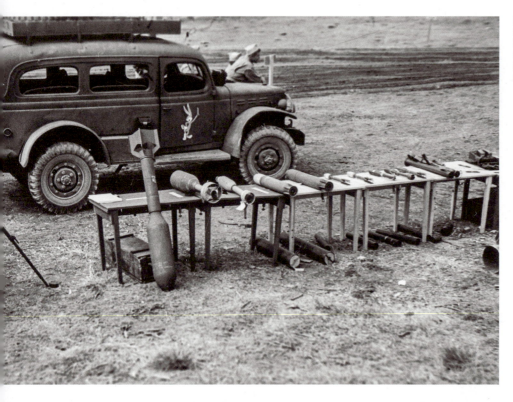

Unknown Photographer
Rocket demonstration in
New Caledonia, c. 1942
Photograph
Caltech Archives and Special
Collections

Unknown Maker
Rocket segments, 1940s
Metal
Caltech Archives and Special
Collections

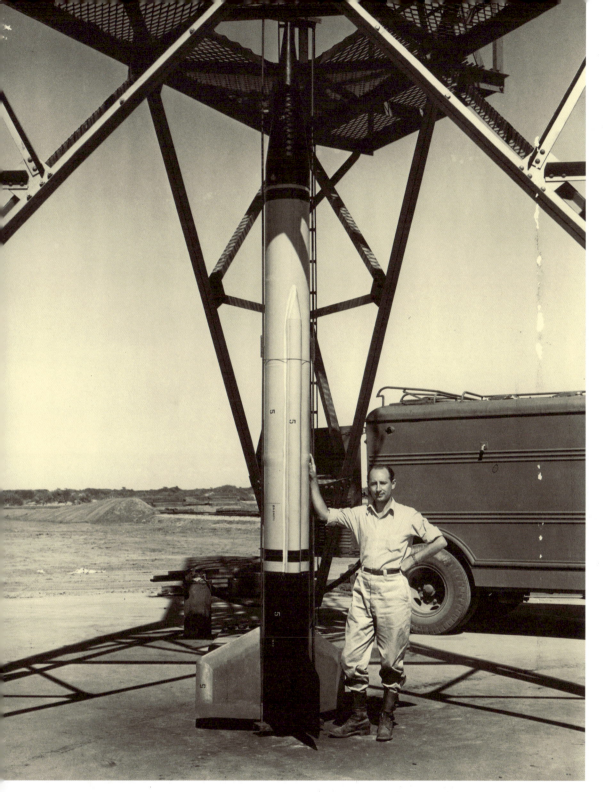

Unknown Photographer
Frank Malina with WAC Corporal at White Sands
Proving Ground, 1945
Photograph
Caltech Archives and Special Collections

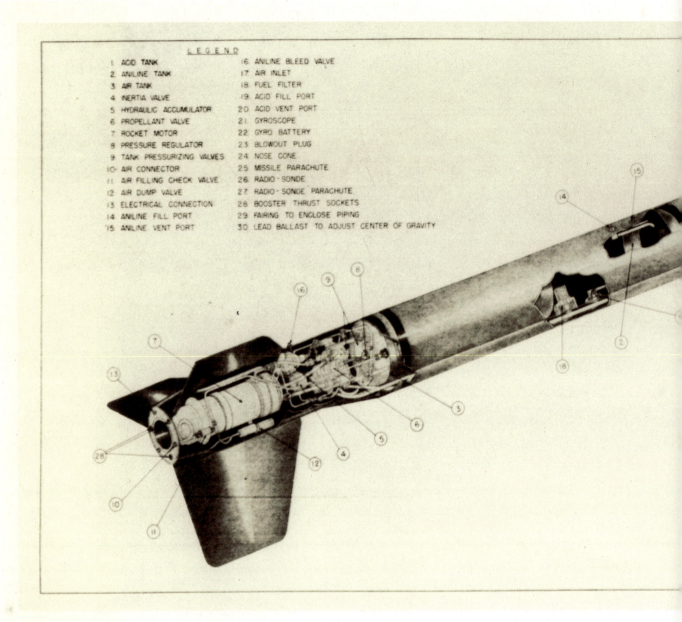

Roger Stanton
WAC Corporal, 1946
Photograph of drawing
Caltech Archives and Special Collections

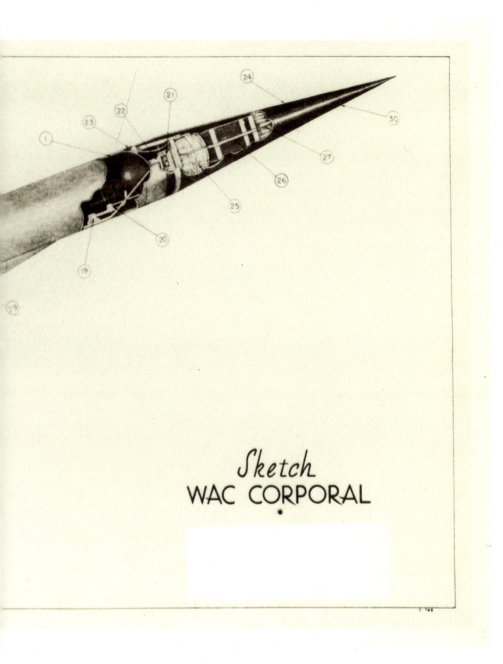

Unknown Photographer
Clark Millikan, Lee DuBridge, Richard Nixon,
and William Pickering with model of Explorer I,
the first space probe, 1958
Photograph
USC Digital Library

DATA

This section explores the visualization and sonification of abstract information. In the 1940s, physicist Richard Feynman invented Feynman Diagrams to depict the interactions between elementary particles, using a vivid visual imagination he later expressed in drawings and paintings. Today, *Data to Discovery*, a design research initiative involving Caltech, the Jet Propulsion Laboratory, and ArtCenter College of Design, creates interactive image systems in collaboration with scientists in fields ranging from astronomy to molecular biology. Blending science and aesthetics, visualization experts in astrophysics take data from powerful telescopes and transform them into dazzling images of the cosmos. Sonification turns astronomical data into sound, allowing users to listen to imaginary symphonies in space across distances spanning millions of light years.

Unknown Photographer
Richard Feynman juggling at the beach, c. 1940
Photograph
Caltech Archives and Special Collections

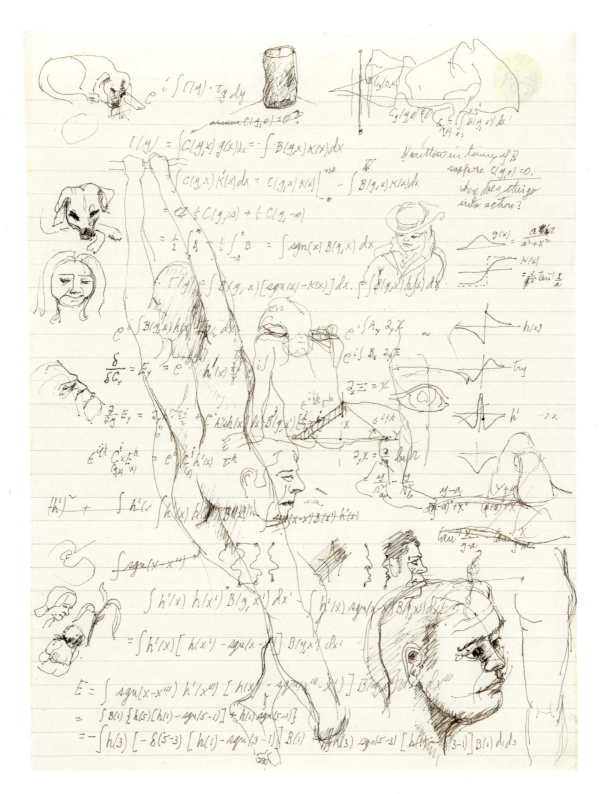

Richard Feynman
Equations and sketches, 1985
Ink on paper
Private collection

Richard Feynman
Sketches, c. 1970
Ink on paper
Caltech Archives and Special Collections

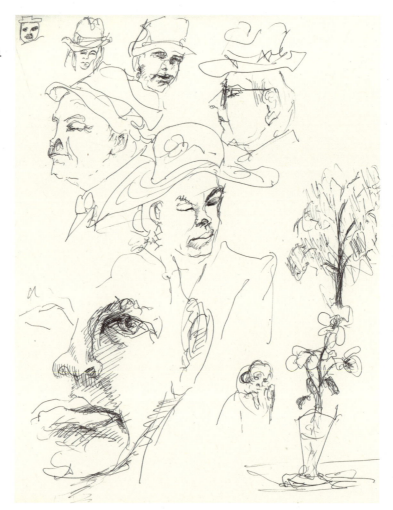

Tom Harvey
Richard Feynman lecturing, 1963
Photograph
Caltech Archives and Special Collections

Richard Feynman
Portrait of a woman, 1983
Pencil on paper
Courtesy of Michelle and Carl Feynman

Unknown Photographer
Jenijoy La Belle and Richard Feynman
in *Fiorello*, 1978
Photograph
Caltech Archives and Special Collections

Sylvia Posner
Untitled (Richard Feynman as a Monk with Diagrams), 1981
Photograph of paint on canvas
Caltech Archives and Special Collections

NASA, ESA, CSA, and Space Telescope Science Institute
"Webb's First Deep Field" (galaxy cluster SMACS 0723), 2022
Composite photograph

NASA, JPL, and Susan Stolovy
Center of the Milky Way from Spitzer
Space Telescope, 2006
Composite photograph

Data to Discovery and Guttman Lab
3D DNA, 2016
Interactive data visualization software
Caltech

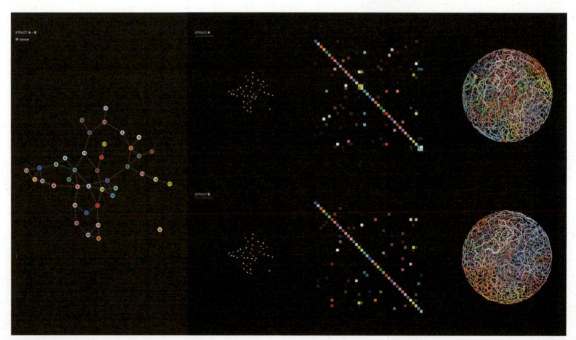

Pages 192–193
Data to Discovery and Infrared Processing and Analysis Center
N3D, 2015/2024
Interactive data visualization software
Caltech

NASA, ESA, and Joel Kastner
Butterfly Nebula, NGC 6302, 2020
Composite photograph

192 Data

Talia Shabtay Filip

THINKING WITH ART AND ENGINEERING AT THE JET PROPULSION LABORATORY: Learning From JPL's Visual Strategists

In 1613, when Galileo published the first telescopic observations of Saturn, word and drawing were as one. The stunning images, never seen before, were just another sentence element.

Saturn, a drawing, a word, a noun.

The wonderful becomes familiar and the familiar wonderful.
—Edward Tufte, *Envisioning Information*[1] (page 196)

When Dan Goods reflects on what it means to be a visual strategist at the Jet Propulsion Laboratory (JPL), a single image comes to mind. It's not one of the thousands of stunning, never-before-seen images that have come, during his twenty years at JPL, to computer screens and newsstands from the space-based telescopes and camera-equipped payloads scattered across our solar system. Nor is it any of the well-publicized artistic projects for which his JPL group, The Studio, has been responsible. Rather, this particular image beams like a distant star awaiting discovery within the institutional constellation that links JPL to Caltech to NASA, and to the way, way beyond.[2]

Earthen-colored bands of tiny, encoded inscriptions congeal to form an orb that hovers on the page. If you squint, the orb almost spins, the visual rhythm of its spaced and dotted striations performing for the mind's eye. A magnifying glass, clutched between a thumb and index finger, perches over the striated orb, decrypting and amplifying this snippet of the message inscribed there: "the history of our solar system is found in the formation of the planet Jupiter" (page 195).

That image graces the cover of JPL's *Juno Concept Study Report*, a proposal outlining the rationale for NASA's ninth mission to the largest planet in our solar system. Practically, the visual is the face of the document that JPL submitted to the NASA review board, which judges the feasibility (and fundability) of possible missions. It sits atop a thick stack of pages—a monolith of calculations, timetables, diagrams, and matter-of-fact descriptions, ranging from plots of the mission's thirteen proposed phases to accounts of the spacecraft's power, propulsion, and spinning, solar-powered structure. It would be easy for a general reader to get bogged down in any number of minutiae, however essential, to such a mission—the first to penetrate Jupiter's dense cloud cover to learn more about the planet's origin and evolution as a means of gaining insight into the early history of our solar system.

How does one summarize such a mission in a single picture? With this image, designed by Goods in 2003, the *Juno Report* might have been the first such proposal *not* to picture the proposed spacecraft on its cover. Such renderings might draw attention to a spacecraft's state-of-the-art design but convey little or nothing of a mission's scientific goals or objectives—*what do we want to know and how exactly are we going to find out?* What makes the *Juno* cover so striking is that it offers, through its form, a conceptual way of thinking about the mission. At a glance, it presents the mission, not as four tons of metal and instrumentation, but rather as the relationship humans—in this case scientists and engineers—develop with technological tools in their attempts to draw the wonderful near *and study and analyze it*.[3] In a single eyeful, it frames the scientific aims of the mission within the history of technology as both a concept and a working relationship between humans and their instruments—in this case, a single eyepiece. To those familiar with the history of observational astronomy, the image might even suggest that in some sense the Juno

Dan Goods
Cover of *Juno Report*, c. 2003
Digital illustration
Jet Propulsion Laboratory

Galileo Galilei
Istoria e dimostrazioni intorno alle macchie solari e loro accidenti, 1613
Book
Caltech Archives and Special Collections

mission began the moment Galileo trained his "spyglass" on Jupiter and became the first to discern, then plot, the orbits of the four largest Jovian moons.

While Galileo was able to engineer his own tools, perform his own scientific observations, record them by hand, and present his findings directly to the public and his patrons, the scale of scientific research today makes such tactile connections to data and technical control nearly impossible for any single individual working in astronomy and planetary science to cultivate. The intellectual feedback and imaginative stimulation that once came from holding a handmade telescope up to the heavens and charting by hand the movement of celestial bodies is difficult to achieve within large, nationally funded organizations like JPL. Yet, as historian Peter Westwick reminds us, the success of JPL, and the impact of its science and technology, still depend on personal creativity.[4] Like The Studio's work and, more broadly, visual strategy at JPL, the *Juno* cover creates an opening for its audiences to grab hold—to experience a moment of cerebral recognition that comes from the visceral impact of something wonderful brought close by one's own hand.

For the last twenty years, Dan Goods has built and led The Studio, a non-technical, creative team that includes his longtime collaborator David Delgado as well as six additional colleagues whose experience and training spans disciplines from industrial and graphic design to anthropology. Known as visual strategists, Studio team members operate almost as freelancers, joining brainstorming sessions to aid in concept development and proposal preparation for projects throughout the lab. In addition to their work inside JPL, these visual strategists have also conceived and created highly publicized works of art meant to capture and expand the public imagination about planetary exploration. The visual forms they produce function not as illustrations—a genre that has long been associated with imagining space travel—but rather as conceptual objects: tools for thinking and learning. Pinned to the wall of their workshop space on the JPL campus, just below a group portrait, are postcards bearing slogans that capture their design-based,

learning-model approach: "Helping People Think Through Their Thinking" and "Sneaking Up on Learning." These maxims, rooted in Goods and Delgado's education at Pasadena's ArtCenter College of Design, shape their practice of visual strategy at every level.[5]

To survey the entirety of The Studio's work would be beyond the scope of this essay. However, another early work by Goods that involved drilling a tiny hole in a grain of sand to illustrate the size of the solar system relative to the Milky Way Galaxy provides an apt metaphor for the present essay, whose purpose is to consider more closely what it means to do the work of "visual strategy," and, using examples of lesser-known works created by The Studio, analyze the aesthetic means by which these visual forms communicate conceptually through their grounding in design-based thinking and learning.[6]

The Familiar Wonderful: The Work of Visual Strategy

Galileo, of course, never had the opportunity to design, build, and launch a billion-dollar vehicle and send it to Jupiter. To conceptualize, propose, and realize a mission like Juno requires the collaboration of hundreds of scientists and engineers spanning multiple institutions and disciplines. In the 80 years since JPL was established, the lab has grown from a handful of Caltech students testing rocket motors in the Arroyo Seco, a dry stream bed in Pasadena, California, to a sprawling R&D complex that employs upwards of 5,000 "explorers," as former lab director Charles Elachi fondly called his colleagues. As sociologist of science Janet Vertesi notes, "It is not for nothing that spacecraft teams are called 'missions,' a word that orients their members toward a common purpose, uniting individuals across boundaries in a common site of focus, energy and negotiation."[7]

Still, denoting a project as a "mission" is not nearly enough to unite scientists and engineers in a diverse array of fields, communicate their thinking from concept to launch, and direct that thinking toward novel forms and discoveries. Moreover, as JPL engineer-turned-designer Tibor Balint has observed, rigid project management protocols within large governmental organizations such as NASA often have difficulty accommodating the type of flexibility and change needed to achieve success, organizational growth, and the development of new ideas. Balint and his JPL colleague Anthony Freeman have argued that "broadening the system's worldview is needed from the strategic level [and] it can be achieved by introducing novel languages, new perspectives, and adding new disciplines to existing ones. In effect, this helps to broaden the organizational paradigm, and subsequently influence its mission, impact the culture, and open up its core processes."[8]

Exactly if and how The Studio's design-based visual strategy opens these "core processes" has yet to be well studied. Meanwhile, the media has bestowed on the Studio team such monikers as "NASA's secret art studio," "a group of rocket-science misfits," or simply "artists hired by NASA to create space-inspired works."[9] They are certainly not the first artists to be employed by NASA: the space agency began its official art program in the 1960s working with the likes of Norman Rockwell, Lamar Dodd, Robert Rauschenberg, and Andy Warhol. However, neither Goods nor Delgado see themselves as inheritors of that particular legacy.[10] The Studio team has justly managed to dodge the title "artists in residence," a common categorization of creatives at big tech organizations. Here, the language used among The Studio team members to conceptualize their work is more useful. Visual Strategist David Delgado has remarked,

> The thing about visual art is that it brings the visual in…and that's…something that wasn't necessarily there [before] because you have a whole bunch of people who have gone through their careers not focusing on the visuals necessarily and thinking either abstractly or using engineering or scientific visualization tools like charts and graphs that they became very *familiar* with…. When somebody gives you back something… but it's…captured in a visual that…is poetic and concise and…poignant…it has this huge effect on them…. It brings a new freshness of life to their ideas and you can see them get excited.[11]

In these comments, Delgado characterizes the work of visual strategy as a kind of communication feedback loop that connects the visual strategist with engineers and scientists. In this arrangement, the visual strategist breaks apart the familiar forms by which scientific information is typically communicated and recasts them in a novel, visual form. In the words of Edward Tufte, "the wonderful becomes familiar and the familiar wonderful."

Delgado's characterization speaks to the intensely human-centered nature of this type of work. It also complements a broader discourse that has grown, in the last fifteen years or so, around aspects of JPL's organizational culture that focus on innovating concept formulation and design practices. Since 2011, JPL has operated a division known as the Innovation Foundry—a collaborative design environment for developing mission concepts, proposals, and strategy[12]—where visual strategists have helped give novel form to concepts that aid in thinking, learning, and communicating at every phase of the projects in which they are involved. It is within this context of expanding JPL's organizational paradigm that we should understand practitioners of "visual strategy," the visual forms they produce, and the modes by which they impact culture at JPL and beyond.

Storytelling in Space: The First Digital Image of Mars

In July 1965, JPL's Mariner 4 spacecraft made its historic fly-by of Mars, snapping 22 photographs of the Martian surface with the first digital imaging system used in outer space. The system combined a television camera with a four-track tape recorder to capture the first close-up views of another planet. Today, the very first digital image of the Martian landscape hangs on the wall of the second floor of Building 179—JPL's Spacecraft Assembly Facility—steps away from High Bay 1, the assembly and testing site for some of NASA's most celebrated unmanned spacecraft. At first glance, it might easily be mistaken for an abstract painting from the Mariner era.[13] It doesn't look like the gray scale, pixelated views of the cratered planet that NASA released to the print media. It doesn't even look like the vista of ones and zeros that artist Nam June Paik's *First Snapshots of Mars* (1966) presented a year after the Mariner 4 encounter.[14]

The first digital image of Mars, it turns out, was processed *in color, by hand*, on July 15, 1965, by engineers at JPL as television crews and scientists alike anxiously awaited the first close-up glimpse of our planetary neighbor. As the story goes, when the data began to trickle in, some engineers worried that Mariner 4's imaging system, like hardware on its twin, Mariner 3, had malfunctioned.[15] Unable to bear the suspense, engineer Richard "Dick" Grumm sprang into action, lighting upon 3-inch-wide ticker tape on which he and his fellow engineers printed the numeric data showing the brightness of reflected light across the Martian terrain and atmosphere. Once they had assembled and affixed these strips to a movable wall in his lab, they used oil pastels from a local art supply store to color-by-number the image, pixel by pixel.

As it became apparent that the Mariner 4 data were good, JPL's public engagement team could no longer hold off the media. As a result, the colored, handmade digital image became the very first close-up of Mars to appear on broadcast television—before any of the grainy black and white photos characteristic of NASA's early planetary missions were released. Nearly sixty years on, The Studio has kept the remarkable story behind the so-called "First TV Image of Mars" alive as part of the visual culture of JPL's campus. The framed image shares a wall with other notable artifacts: the color key drawn by Grumm and his colleagues, along with color close-ups of the Mariner 4 tape recorder and of the spacecraft itself being readied for launch. The original box of oil pastels is framed and mounted beside a still frame of Grumm and a colleague putting the finishing touches on their color-by-number creation (pages 199 and 218–19).

An example of how visual strategy affects the way scientists and visitors experience JPL's campus, the Mariner 4 installation transforms a small u-shaped rampway inside Building 179 into an emotive environment that tells a compelling story. Standing inches from the handmade digital image, stray smudges of orange pastel read alternately as noise in the data and the chance

touches of an engineer's pigment-covered fingertip. The photograph of Grumm and his colleague, and the well-handled sticks of oil pastels alongside it, lend the marks an air of freshness and immediacy. On the opposite wall hangs a copy of a late nineteenth-century map of Mars, hand drawn by amateur astronomer Percival Lowell. His drawing—the most updated map of Mars until the Mariner missions greatly revised scientific views of the Red Planet—helps frame the painstakingly hand-assembled and hand-colored Mariner 4 image and its related artifacts as part of the historically intertwined development of the tools of scientific observation and human perception. By positioning the handmade record on a continuum with the material arbiters of the remotely sensed data that informed it, the installation foregrounds the often-overlooked collaboration between the observing humans and the unmanned spacecraft that has been, and continues to be, central to the production of closeup views of our planetary neighbors.

On the transformative power of novel forms of storytelling, Goods observes, "When someone shows you a story in a way you've never seen it before, you're transfixed by it, and it changes you…. When there's a moment where you can show them the thing they've been working [on] their whole life in a way they've never seen it before. That's exciting."[16] More than a mere recounting of events, the Mariner installation expands the function of the historical artifact into a conceptual object: a tool with which present-day engineers and scientists who pass it on their way to assemble and test today's spacecraft might reimagine the joy—and excitement—that the Mariner 4 engineers felt, as they gazed upon this never-before-seen view of Mars, which *they* had created, and recognized that their technology had worked.

Unknown Photographer
Creating "The First TV Image of Mars," 1965
Photograph
Caltech Archives and Special Collections

Reaching Out

Juno principal investigator and space physicist Scott Bolton recalls gazing upon the night sky as a child: "I would look out there, and you couldn't touch it; you couldn't learn about it enough because you couldn't get there. And so, I have always had this yearning to want to reach out."[17] While visual forms like the *Juno* cover and the "First TV Image of Mars" installation are seen mainly by scientists and engineers, The Studio's more public-facing work creates openings for expanded audiences to "reach out" and engage with larger concepts that motivate planetary exploration. One such project, *Hi Juno*, extended a public invitation to anyone who wanted to "reach out" and make contact with the Juno spacecraft.

Launched in August 2011 from Kennedy Space Center, Juno made its five-year trip to Jupiter via a trajectory known as the slingshot maneuver. The spacecraft's flight path took it as far as the asteroid belt located between Mars and Jupiter, at which point the sun's gravitational pull flung it back toward Earth, where it received a "gravity assist" from its home planet to propel it back toward the Jovian system. As the spacecraft swung within 350 miles of Earth's surface on October 9, 2013, its radio receiver heard this message: "Hi."[18] Using Morse Code, the nineteenth-century precursor to modern telecommunications, more than a thousand volunteer ham radio operators around the globe signaled the four "dits," space, followed by two "dits" to broadcast the greeting from Earth. To transmit each "dit," participants signaled for thirty seconds in unison, taking six-and-a-half minutes to signal the full message: "Hi." Juno recorded the Morse Code message, which mission engineers subsequently received and processed into sound, confirming that the greeting had been "heard."

Taking the form of an orchestrated happening rather than a single graphic or finite object, *Hi Juno* nods to earlier waves of participatory art, which often celebrated technology as the basis for a new social paradigm comprising interactive communities rather than idle spectators.[19] *Hi Juno* also has elements of "citizen science," a feature of the Juno mission more broadly.[20] Yet the project succeeds in an area that has often been a stumbling block for both participatory art and citizen science. In slowing down the gesture of communication, *Hi Juno* allows people time and space to reflect on their own relationship to technology and the ways in which familiar gestures, when coordinated, configured, and amplified to cross the vastness of space and time, appear wonderful.

Since the dawning of the space age, humans have tried in various ways to make tangible this yearning to reach out. Such gestures often say more about life on Earth than about potential life beyond our planet. When the two Voyager spacecraft were launched in 1977, each carrying a copy of the Golden Record bearing sounds and images of life on Earth, the planetary scientist and science popularizer Carl Sagan remarked, "The spacecraft will be encountered and the record played only if there are advanced spacefaring civilizations in interstellar space. But the launching of this bottle into the cosmic ocean says something very hopeful about life on this planet."[21] Nearly four decades later, *Hi Juno* brought the moment of contact home. Civilization on Earth "encountered" Juno and transmitted a greeting in a conceptual form that transformed a familiar gesture into the most wonderful kind of meaning. Threaded throughout the work of JPL's visual strategy is a conviction that a novel approach to the most ordinary gestures—like saying hello—can lead to extraordinary ways of seeing and thinking about the universe and our own collective and individual purpose in it.

Conclusion

What distinguishes the work of visual strategy from many of the other entanglements of "art" and "science" represented in this catalog?[22] As I have tried to show in this overview, the work of The Studio gives scientists, engineers, and their publics novel forms with which to think and learn about our universe. These forms don't come in the usual language of scientific illustration, nor do they materialize in charts and diagrams. Whether it's encapsulating a mission in a single eyeful or reminding us of the remarkable coordination of human effort essential to robotic space exploration, The Studio creates forms that ultimately encourage better communication at every phase of a project. The Studio gives us tools for making the most remote or abstract data communicable, thinkable, sharable. Rather than giving us a conventional picture of space science, visual strategy empowers audiences to recognize and engage with the wonderful, not just "way out there," but within the most familiar forms, bodies, sounds, and gestures here on Earth.

1—Edward R. Tufte, *Envisioning Information* (Cheshire, CT: Graphics Press, 1990), 121.

2—Sincere thanks to Dan Goods and David Delgado for generously sharing their time and conversation with me. Dan Goods and David Delgado, author interview, April 17, 2023.

3—My language and argument build on Janet Vertesi's analytical framework *drawing as*, on which she elaborates in Janet Vertesi, "*Drawing As*: Distinctions and Disambiguation in Digital Images of Mars," in *Representation in Scientific Practice Revisited*, ed. Catelijne Coopmans et al. (Cambridge, MA: MIT Press, 2014), 15–36.

4. Peter J. Westwick, *Into the Black: JPL and the American Space Program, 1976–2004* (New Haven: Yale University Press, 2007), ix–x.

5—Goods and Delgado, interview.

6—Goods, *Big Playground: Seeing the Universe through a Hole Drilled into a Grain of Sand* (c. 2003). The installation included enormous mounds of sand with which people played as they imagined touching billions of galaxies.

7—Vertesi, *Shaping Science: Organizations, Decisions, and Culture on NASA's Teams* (Chicago: University of Chicago Press, 2020), 2.

8—Tibor Balint and Anthony Freeman, "Designing the Design at JPL's Innovation Foundry," *Acta Astronautica* 137 (2017): 182.

9—Sanden Totten, "AXS Festival: Meet the Artists Hired by NASA to Create Space-Inspired Works," LAist, September 23, 2014, https://laist.com/news/kpcc-archive/axs-festival-meet-the-artists-hired-by-nasa-to-cre; Erin Berger, "NASA's Secret Art Studio: How to Make Rocket Science Beautiful," *Guardian*, August 7, 2016.

10—Goods and Delgado, interview.

11—Goods and Delgado, interview.

12—See Balint and Freeman, "Designing the Design" and Brent Sherwood and Daniel McCleese, "JPL Innovation Foundry," *Acta Astronautica* 89 (2013): 236–47.

13—For example, Helen Frankenthaler's *Focus on Mars* (1976).

14—Paik's lithograph presented an allover composition of binary code with a caption that read in part: "The first 'snapshots' of Mars looked like this—because only 'zeros' and 'ones' could be transmitted to earth from Mariner IV. But IBM computers helped convert them into...close-up photographs."

15. Dan Goods has archived details of this story on his website: Dan Goods, "First TV Image of Mars," https://www.directedplay.com/first-tv-image-of-mars.

16. Goods and Delgado, interview.

17—Scott Bolton interview in "The Journey," Mission Juno, 2010, NASA/JPL, https://www.missionjuno.swri.edu/media-gallery/interviews.

18—This coordinated effort included The Studio and lead science investigators on the Juno mission, including research scientist Bill Kurth and research engineer Donald Kirchner.

19—For example, Allan Kaprow's *Hello* (1969). Kaprow saw the main message of his work as "oneself in connection with someone else." See Kristine Stiles and Edward A. Shanken, "Missing in Action: Agency and Meaning in Interactive Art," in *Context Providers: Conditions of Meaning in Media Arts*, ed. Margot Lovejoy, Christiane Paul, and Victoria Vesta (Bristol: Intellect, 2011), 31–54.

20—Juno's only camera, the JunoCam, is officially described as a public outreach tool rather than a science instrument. Its raw data are publicly accessible on the mission webpage and all images are processed by citizen scientists. See "JunoCam," Mission Juno, https://www.missionjuno.swri.edu/junocam/.

21—"What Are the Contents of the Golden Record?" Voyager, NASA/JPL, https://voyager.jpl.nasa.gov/golden-record/whats-on-the-record/.

22—For more on visual strategy at JPL, see Anne Sullivan's contribution to this catalog.

ROCKETS

Launching into rocketry and space exploration, this section focuses on early aeronautical innovation at Caltech. Led by Hungarian American physicist Theodore von Kármán, director of the Guggenheim Aeronautics Laboratory (GALCIT), graduate student Frank Malina, his friend Jack Parsons, and their "Suicide Squad" took to a dry stream bed, Pasadena's Arroyo Secco, to develop liquid-fuel rockets. Their daring experiments first drew inspiration from and then inspired depictions of missiles, spaceships, and scientists in 1930s science fiction, occult cosmology, advertisements, and radio. Emerging from the work of these unconventional young engineers, NASA's Jet Propulsion Laboratory continues to inspire contemporary visual culture through captivating images, both real and imagined, of our solar system.

Kelsey-Hayes Company
Advertisement in *Aviation Week*, July 13, 1959
Magazine (detail)
Prelinger Library

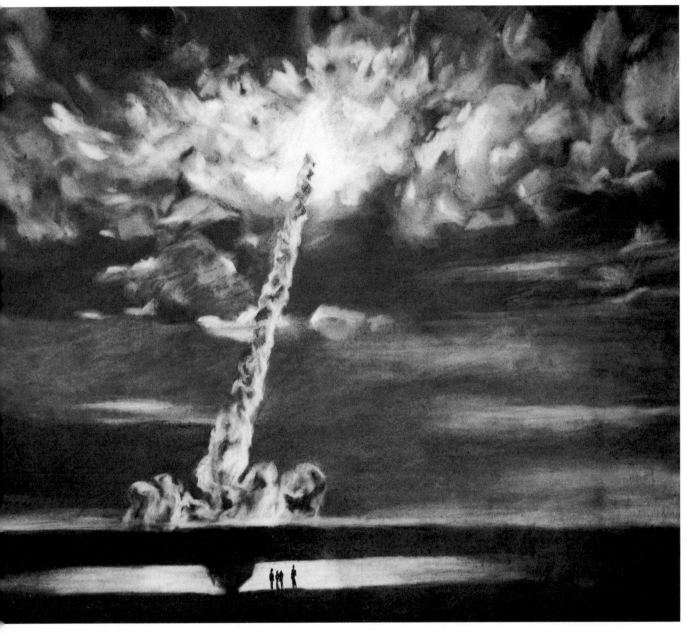

Lia Halloran
Night Launch, 2007
Charcoal on paper
Courtesy of Lia Halloran

205

Unknown Photographer
Caltech wind tunnel
Photograph
Caltech Archives and Special Collections

Hank Hoag
Henry Nagamatsu in wind tunnel, 1954
Photograph
Caltech Archives and Special Collections

Russell Porter
Southern California Cooperative Wind Tunnel, 1945
Photograph of drawing
Caltech Archives and Special Collections

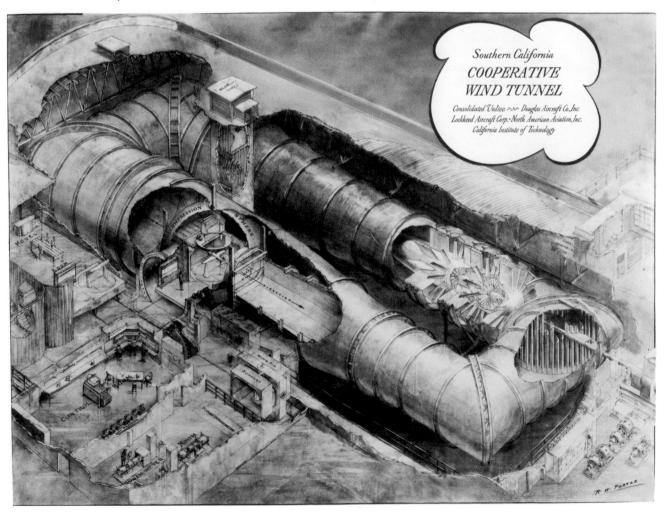

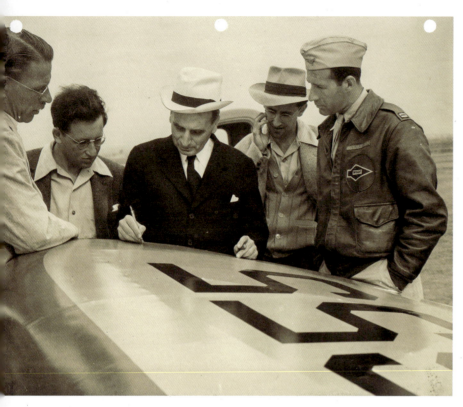

Unknown Photographer
Theodore von Kármán (center), Frank Malina
(also in fedora) and JATO team, 1941
Photograph
Caltech Archives and Special Collections

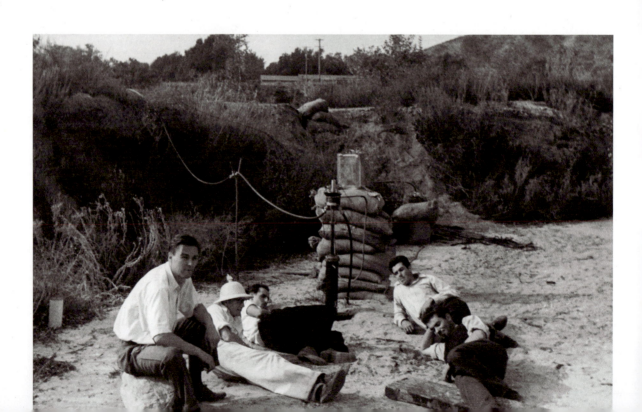

Unknown Photographer
First US rocket-assisted airplane flight, 1941
Photograph
Caltech Archives and Special Collections

Unknown Photographer
The "Suicide Squad" in the Arroyo Seco, 1936
Photograph
Caltech Archives and Special Collections

John "Jack" Parsons and Marjorie Cameron
Songs for the Witch Woman, c. 1952
Ink and watercolor in notebook
Cameron Parsons Foundation

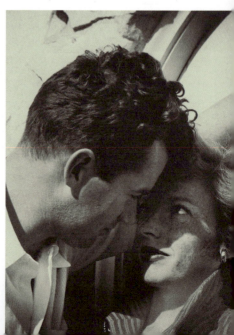

Unknown Photographer
Jack Parsons and Marjorie Cameron
wedding portrait, 1948
Photograph
Cameron Parsons Foundation

Marjorie Cameron
Dark Angel
Ink and paint on paper
Cameron Parsons Foundation

An idealized self-portrait

Aleister Crowley
The Confessions of Aleister Crowley
frontispiece, 1969
Book
UCLA Library and Special Collections

Ed Valigursky
Astounding Science Fiction cover, February 1950
Magazine
Caltech Archives and Special Collections

Paul Orban
Astounding Science Fiction cover, March 1951
Magazine
Caltech Archives and Special Collections

Alejandro Cañeda
Astounding Science Fiction cover, February 1948
Magazine
Caltech Archives and Special Collections

Ed Emshwiller
Galaxy Science Fiction cover, April 1954
Magazine
Caltech Archives and Special Collections

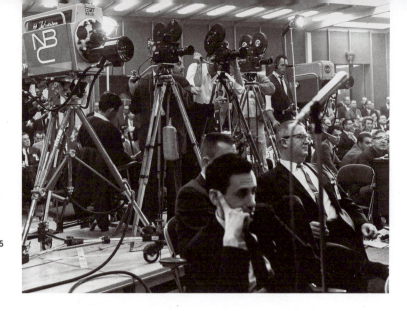

Unknown Photographer
Mariner 4 press conference, 1965
Photograph
Caltech Archives and Special Collections

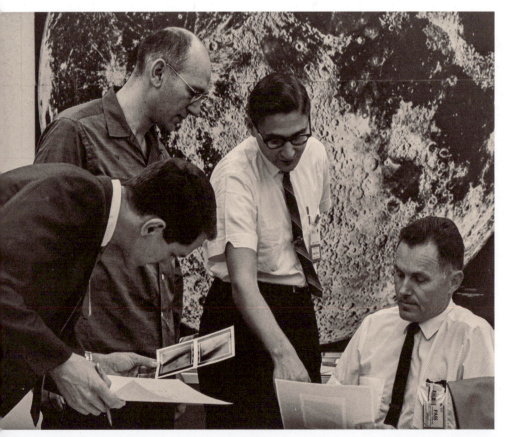

Unknown Photographer
Robert Leighton (seated), coinventor of Mariner 4 imaging system, reviewing Mariner 4 Mars images, 1965
Photograph
Caltech Archives and Special Collections

Unknown Photographer
JPL "computers," 1953
Photograph
JPL Archives

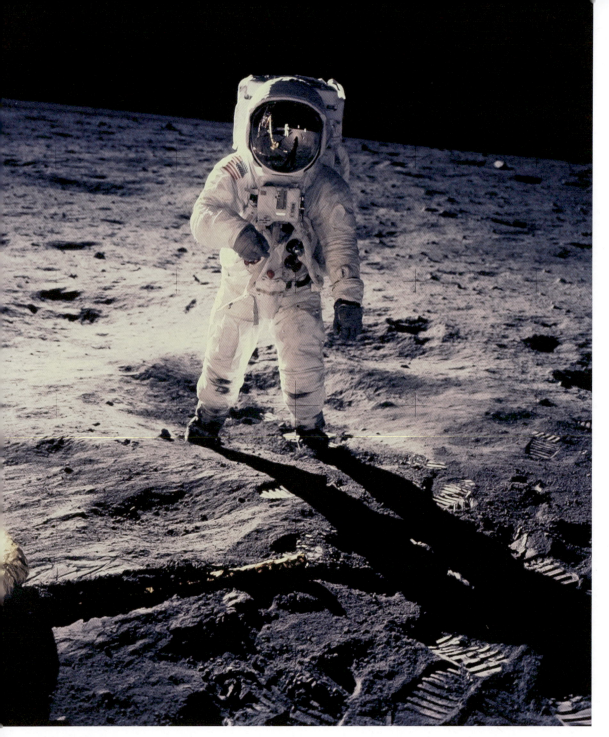

Neil Armstrong
Buzz Aldrin during the Apollo 11 moon landing, 1969
Glass slide photograph
Caltech Archives and Special Collections

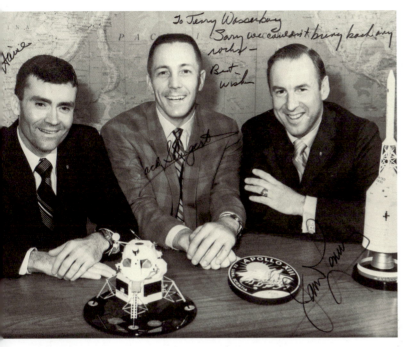

Unknown Photographer
Apollo 13 astronauts, 1970
Photograph with ink
Caltech Archives and Special Collections

Unknown Photographer
Microscopic moon dust, c. 1970
Glass slide photograph
Caltech Archives and Special Collections

Unknown Photographer
Moon rock, 1969
Glass slide photograph
Caltech Archives and Special Collections

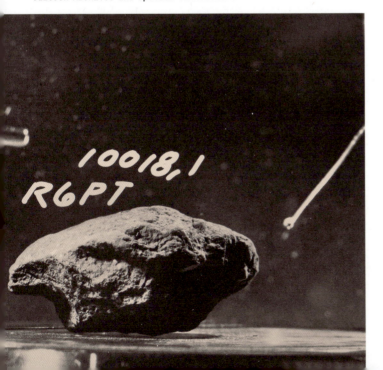

Unknown Maker
Lunar map with Ranger
7 camera views marked, 1964
Photograph
Jet Propulsion Laboratory

NASA, JPL, and University of Arizona
Octavia E. Butler Landing for Mars
Perseverance rover, 2020
Composite photograph

Stephen Nowlin
This Land (Rosetta/Bierstadt), 2022
Inkjet print
Courtesy of Stephen Nowlin

Richard Grumm
"The First TV Image of Mars," 1965
Pastel on paper
Jet Propulsion Laboratory

Jet Propulsion Laboratory
Mariner 4 Mars image #11
of Atlantis region, 1965
Photograph
Caltech Archives and
Special Collections

Unknown Photographer
Patsy Conklin assembles Mariner Mars
photomosaic, 1971
Photograph
Jet Propulsion Laboratory

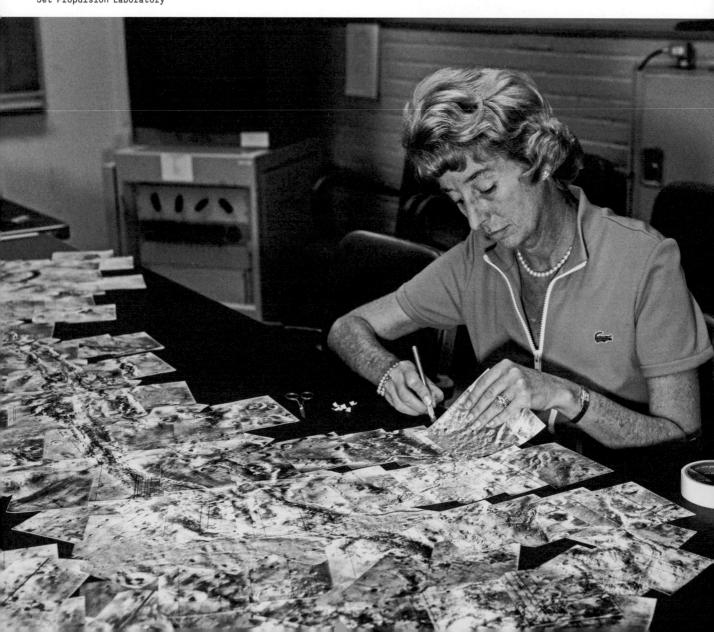

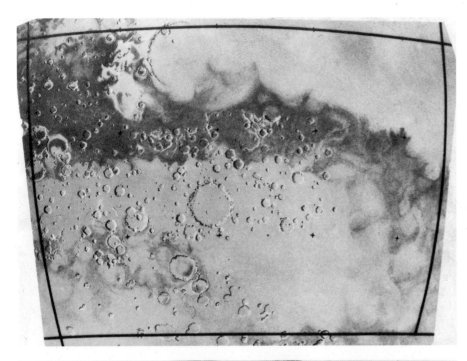

Donald E. Davis
Hand-painted Mars globe, 1969–71
Photograph
Courtesy of Donald E. Davis

Donald E. Davis
Mariner 9 photomosaic, c. 1971
Photograph
Courtesy of Donald E. Davis

NASA, JPL, and Malin Space Science Systems
Curiosity rover's view of dune with tracks, 2014
Composite photograph

NASA, JPL, and Malin Space Science Systems
Curiosity rover selfie, 2019
Composite photograph

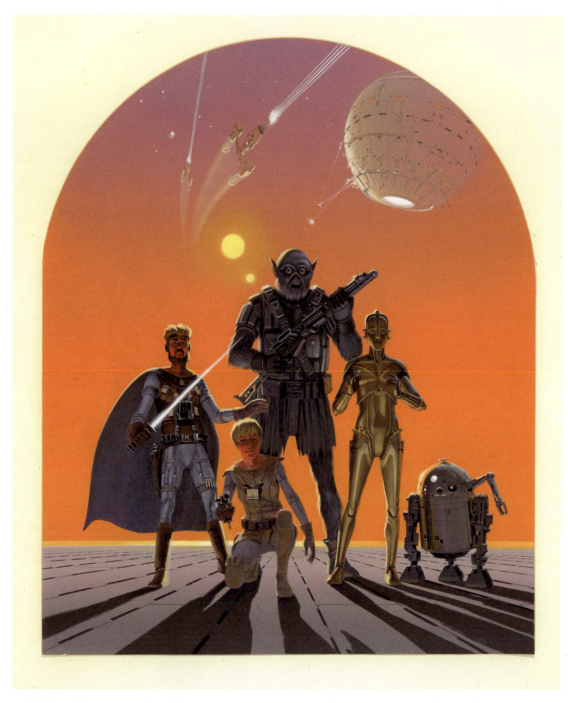

Ralph McQuarrie
Early concept poster for *Star Wars: A New Hope*, 1977
Gouache and graphite pencil on illustration board
Lucas Museum of Narrative Art, Los Angeles
© & ™ Lucasfilm Ltd.

SPACE

Articulating the distant frontiers of Caltech science, this final section of *Powers of Ten* envisions exoplanets, extraterrestrial life, and future space exploration. Using raw images from JPL missions like Mariner, Voyager, and Cassini, space artists render distant landscapes to help us visualize life beyond Earth. As depictions of the "final frontier," these images of imaginary journeys stimulate curiosity, echo Earth's histories of exploration and conquest, and serve as powerful reminders of the vast possibilities of space travel.

Unknown Creator
Imaginary Lifeform, 1975
Photograph of illustration
Jet Propulsion Laboratory

Bill Ray
Carl Sagan with a model of the Viking
lander in Death Valley, 1980
Photograph
National Air and Space Museum

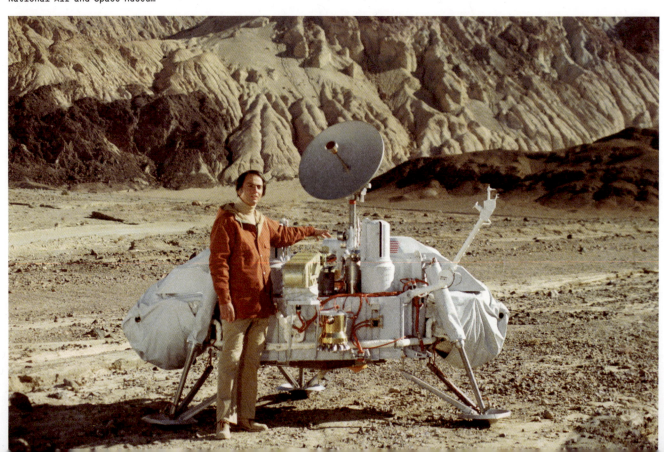

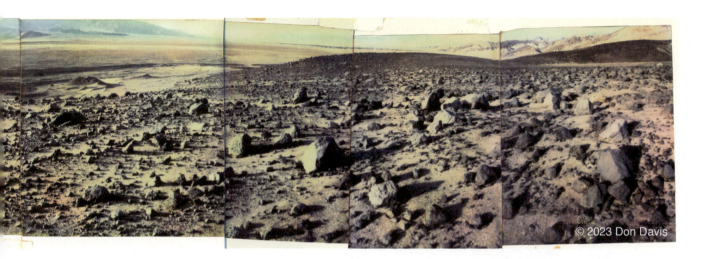

Donald E. Davis
Photo mosaic of Death Valley as stand-in for Mars, 1983
Polaroid prints
Courtesy of Donald E. Davis

NASA, JPL, and USGS
Valles Marineris seen from Viking 1 and 2, 1998
Composite photograph

Robert Hurt, NASA, and JPL
Black hole, 2013
Digital illustration

Jet Propulsion Laboratory
Jupiter's Great Red Spot seen
from Voyager 1, 1977
Composite photograph

229

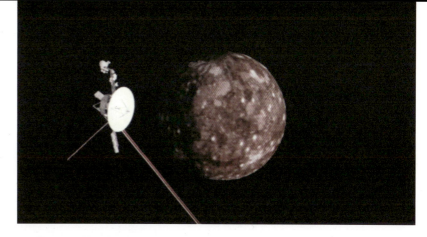

Jim Blinn and Charles Kohlhase
Voyager 2 flies by Jupiter's moon Callisto, 1979
Computer simulation still
Jet Propulsion Laboratory

Jet Propulsion Laboratory
Saturn's rings imaged using radio waves
from Cassini, 2005
Digital image from radio data

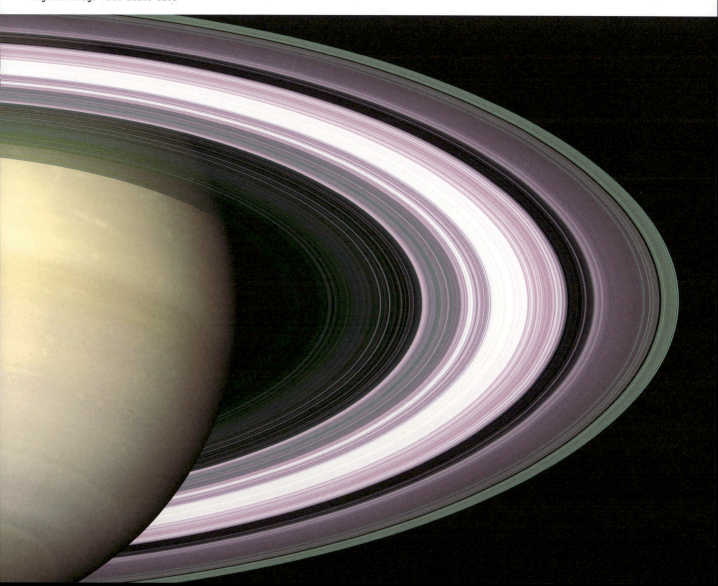

Anne Sullivan

JPL'S *VISIONS OF THE FUTURE* POSTERS AND THE IMAGINED FRONTIER

Introduction: JPL's* Visions of the Future *and Art x Science x LA

In 2016, the NASA-Jet Propulsion Laboratory (JPL) *Visions of the Future* travel posters debuted online and were downloaded 1.2 million times within the first week.[1] Created by JPL's in-house art and design team, The Studio, the retro-futuristic posters invite viewers to travel to destinations within and beyond the solar system. "Discover Life Under the Ice" on Enceladus, "Ride the Tides Through the Throat of Kraken" on Titan, "Experience the Gravity of HD 40307 g."[2] As the name of the series suggests, these illustrations present "impossible" views—landscapes from worlds that exist beyond the range of robotic rovers and human explorers. In designing posters for an imagined future, the Studio referenced a historic and enduring concept: the American frontier as synonymous with space exploration. The frontier appears explicitly in some posters—a silhouetted figure in a cowboy hat observes ocean worlds on the Enceladus poster—as well as implicitly through the suggestion that space is "ours" to explore and inhabit. As evidenced by the posters' popularity, the frontier iconography resonated with multiple audiences and provided a ready-made visual infrastructure to transport twenty-first century imaginations to distant celestial destinations.

Observing other planets and moons is difficult. Even within our solar system, the most intriguing features of relatively close neighbors, such as Jupiter's great red spot, remain mysteries. Exoplanets, the term used to describe planets lightyears outside of our solar system, are practically invisible. To date, only a few dozen have been observed through telescopes. But thousands of others have been detected through indirect methods, such as by studying dips in the luminosity of distant stars, variations that sometimes indicate the transit of an orbiting planet.[3]

Since the observations of exoplanets were first confirmed in the 1990s, JPL and Caltech have become central to exoplanet science. NASA's Kepler Telescope, developed by JPL and Ball Aerospace, is credited with the detection of more than 2,600 exoplanets between 2009 and 2018. In 2011, Caltech's Infrared Processing and Analysis Center (IPAC) launched NASA's online Exoplanet Archive, which reached a milestone of 5,000 confirmed exoplanets in March 2022.

JPL's retro-futuristic travel posters, purportedly created by the fictional "Exoplanet Travel Bureau," represent one initiative to share exoplanet data from research centers with scientists and non-specialists. According to the Visions of the Future website, an interdisciplinary team of scientists, artists, and visual communication specialists collaborated on and thoroughly vetted the poster designs from their inception to their published forms.[4] Their goal was to clearly and vividly communicate information about these alien worlds in order to advance scientific inquiry and to inspire the "architects of the future."[5]

What began as an internal project—three posters meant to stimulate scientific work within JPL—ramped up into a public campaign of sixteen posters designed for scientific communication. As NASA-JPL visual strategist David Delgado recounts, it was the then-JPL director's vacation at the Grand Canyon that propelled the initial travel poster idea into a fully-fledged concept. Specifically, a gift shop calendar of National Park posters, originally designed by the Works Progress Administration (WPA) in the 1930s and '40s and later revived in the 1990s, reinforced an idea that was already present in the

initial concept: the enduring appeal of imagining outer space as an extension of the American West. For Delgado, the posters are prompts to jog scientists' imaginations "out of the present" and to use "the future as a tool."[6] When we think of tools for cosmic observation, we may immediately think of objects such as binoculars and telescopes, but speculative illustrations also serve as tools for reaching beyond the range of imaging instruments.

The posters depict a future when human explorers will follow in the wake of the Voyager mission to the giant outer planets and beyond, a trajectory made explicit in the JPL "Grand Tour" poster. As works of art that also communicate scientific data, they highlight questions central to Caltech's *Crossing Over* exhibition: How do scientists observe the invisible? What does it mean to picture outer space from Los Angeles? What can we gain from understanding that JPL operates in a region partly formed by the mythos of the American frontier?

The practices of visualization and scientific communication utilized at JPL, an institution jointly operated by NASA and Caltech and located in Pasadena, California, are shaped by the geographies and histories of Southern California, a region where the American frontier and outer space as the "final frontier" frequently intersect. Both Caltech and JPL are located in the shadow of the Mount Wilson Observatory, where Edwin Hubble was the first to establish conclusive evidence of other galaxies. Both institutions are also geographical neighbors with Hollywood and Disneyland, popularizers of space as "the final frontier" in film, television, and theme park attractions. Scholars have analyzed the pervasiveness of frontier or colonialist frameworks in the history of astronomical science and exploration. Anthropologist Lisa Messeri has argued that we must abandon frontier terminology,[7] and astrophysicist Chanda Prescod-Weinstein has described how envisioning space exploration can conjure utopian futures while also threatening to repeat damaging modes of exploration here on Earth, where "our global ecosystem's ability to sustain life is collapsing under the weight of centuries of white supremacist, capitalist colonialism."[8] In this essay, I examine how frontier imagery in the *Visions* posters can inspire discovery and simultaneously threaten to distort imagined futures of outer space into exploitative relationships with lifeforms, lands, and resources.[9]

Illustrating the Invisible and Scientific Communication

JPL's *Visions* posters are acts of imagination that translate data from invisible exoplanets into immersive landscapes. Creating a more "emplaced vista" is crucial for scientists, Messeri explains, because planetary research requires "envision[ing] being somewhere humans cannot survive and cannot even reach."[10] She contrasts "emplaced" and "dynamic" perspectives with views obtained from Earth-bound and orbital telescopes, which tend to flatten three-dimensional places into two-dimensional aerial images that appear static.[11] To achieve these on-the-ground views, the JPL posters use astronomical illustration—a mode of visualization that hovers between art and science, invention and record—to bridge the gap between detectable data and otherwise impossible-to-achieve experiential research.[12] Astronomical illustrations can take many forms, but the *Visions* posters rely on the familiar and appealing genre of the travel poster to teleport twenty-first century imaginations to unfamiliar and invisible worlds.

Comparing the Titan poster's initial and published forms allows us to study the choices that were made when data from the surfaces of one of Saturn's moons were translated into an immersive viewing experience (page 232). The behind-the-scenes photo of the concept storyboards shows the original "science focus": "The narrow constriction in the Kraken sea termed the 'Throat of Kraken' is suggested to be a location of significant currents." A false-color radar image of the Throat of Kraken, taken during the Cassini mission to the Saturnian system in 2006, sits next to a mock-up of JPL's Titan poster.[13]

Joby Harris
Titan, 2016
Digital illustration
Jet Propulsion Laboratory

David Delgado
Storyboard for *Titan* poster, 2016
Digital illustration
Jet Propulsion Laboratory

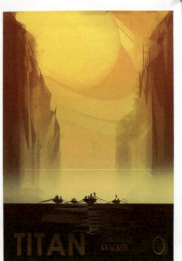

Joby Harris
Kepler-16b, 2016
Digital illustration
Jet Propulsion Laboratory

The mock-up renders radar-image information into towering cliffs that frame people boating on a methane lake in the poster's lower quadrant while Saturn looms on the horizon. In the published poster, the bordering cliffs have been eliminated. It is the rippling methane lake that commands attention, occupying three-quarters of the composition and rendered in greater detail, with multiple colors and textures. The impressive view of Saturn has been shifted, along with the boaters, to the poster's upper quadrant. In this final version, the viewer can imagine navigating strong currents from an "emplaced vista" on the surface of the lake—perhaps in a vessel just behind the group ahead.

While Cassini's radar image revealed some details from Titan's surface, confirming the existence of chemical seas that had been predicted twenty years earlier,[14] the poster extends our observations further. By imagining the act of river rafting, scientists and general audiences have access to an experiential means of discovery, albeit a virtual one. Viewers may not immediately realize that the lake is made of methane, but the rippling liquid rendered in otherworldly yellows and oranges helps them feel as though they are experiencing a dynamic world.

The dynamism of immersive views is crucial for understanding how frontier iconography in astronomical illustration generates overlapping and competing meanings. Such views can recapitulate imperialistic perceptions of planets as territories to colonize or commercialize. For example, by promoting adventurous travel, such as parasailing over "ocean[s] of lava" on exoplanet 55 Cancri e, the JPL posters could suggest a Disneyfied compression of terrains into commercialized experiences. The WPA National Park posters are another fraught source of design inspiration. As art historian Cory Pillen has explained, they presented the American western frontier as awe-inspiring natural spaces that must be preserved while also promoting tourism and recreation—activities that sometimes threatened to undermine the parks' ecological mission.[15]

However, the dynamism in JPL's posters also allows room for multiple interpretations. The posters' visual emphasis on this quality echoes efforts that scientists who study Mars are making to resist frontier paradigms and to foster more ecological imaginations by depicting the Red Planet as "a highly dynamic, lively dune world" instead of as a "lifeless" desert expanse.[16] By emphasizing dynamism, the posters can prompt viewers to imagine alternative futures and ethically informed modes of exploration. For example, the rippling methane currents are so active in the Titan poster that they suggest a much wider world. Instead of limiting the viewer to just one perspective, the poster encourages the viewer to speculate about the world beyond the composition's borders. The Titan image is one example of how the JPL posters strive to transform difficult-to-see moons and planets into worlds that are active, and perhaps these dynamic views can prompt us to resist an imperialistic exploration and exploitation of spaces that are perceived as empty.[17]

The Art of Picturing "Out There" from the American West to Outer Space

The *Visions* posters are part of the visual and material culture of Southern California, a region that has been shaped by the extension of American manifest destiny into outer space. Take, for example, Southern California's mountain-top observatories. In the late 1880s, representatives from the Harvard Observatory surveyed Mount Wilson in Pasadena before deciding to build their second observatory on a mountain in Peru, a location that would enable them to observe and photograph stars in the southern as well as the northern hemisphere. Both the Californian and Peruvian locations offered relatively dry climates with few weather disruptions and minimal atmospheric distortions.[18]

The perception that lands in the Americas with such ideal climates were ripe for development built upon nineteenth-century frontier expansion, a trajectory that continued throughout the twentieth century. George Ellery Hale,

a key figure in the early history of Caltech, founded Mount Wilson Observatory in 1924 and Palomar Observatory in 1928. Historian and astrophysicist Eun-Joo Ahn argues that Hale's vision for Mount Wilson's success relied on Pasadena's geographical and financial infrastructure, bolstered by twentieth-century boosterism and a desire to compete with East Coast scientific institutions.[19]

The visual iconography of the frontier as both the American West and outer space is also embedded in Southern California's entertainment institutions. In the 1950s, Walt Disney recruited rocket scientist Wernher von Braun to develop the aesthetics of "Tomorrowland" and intentionally set the space-faring adventure rides directly across the park from "Frontierland," so that guests could travel between one and the other, from the past to the future and back again.[20]

The *Visions of the Future* series presents multiple iterations of frontier imagery—from Earth as an Edenic homestead to picket fences on exoplanet Kepler 186-f and extreme gravity-defying skydiving on HD 40307 g. The Kepler-16b poster, one of the first that the Studio designed, is emblematic of how scientific exploration and communication are infused with the mythos of the American western frontier. The poster overcomes the observational challenges posed by the exoplanet's distance of 245 light years from Earth by translating data gathered from the Kepler Space Telescope into a striking, American southwestern landscape.[21] Two rock formations in the foreground position the viewer within the plane of the landscape, providing both a more familiar footing, as well as scale and perspective, for processing the otherworldly view on the horizon: purpled, rocky terrain that fades into a yellow sky dominated by two large suns, one orange and one pale yellow.[22] The setting suns silhouette a lone explorer in an astronaut suit, casting two shadows that stretch into the foreground (page 233).

While the occupant of the spacesuit is not necessarily identifiable by gender, ethnicity, or nationality, the scene's composition calls to mind numerous cinematic associations. This is Luke Skywalker on Tatooine. This is "The Man with No Name" and any other number of Hollywood cowboys or outlaws framed dramatically against an inhospitable desert. The poster's visuals and text also combine Hollywood Westerns with eerie science fiction: a lone explorer on an alien world and text reminiscent of *Twilight Zone* that reads "The Land of Two Suns: Where Your Shadow Always Has Company." On the *Visions of the Future* website, the poster's border text underscores the *Star Wars* allusion by announcing that the exoplanet's "discovery indicates that the movie's iconic double-sunset is anything but science fiction."[23]

In addition to film and television allusions, the Kepler-16b landscape likely feels slightly familiar due to the twentieth-century travel poster genre and its use of nineteenth-century visual traditions. One such tradition is the sublime, which is often associated with nineteenth-century landscape paintings that instill awe in viewers through scale, depth, and dramatic lighting. Art historian Elizabeth Kessler has demonstrated that the use of the sublime in these paintings informed the many decisions scientists made concerning color, composition, and orientation when they converted data from the Hubble Space Telescope into published images.[24] For Kessler, the visual tradition of the sublime when activated in a Hubble image transforms an unfamiliar and potentially overwhelming visual into a more familiar composition that "encourages exploration and excites a sense of curiosity."[25]

The WPA posters also incorporated strategies from nineteenth-century landscape paintings of the American West to encourage viewers to experience sublime views of the nation's national parks in person. Since the posters were prepared for mass production, the iconography and color palettes were simplified compared to realist paintings. This distillation enhanced the posters' success as vehicles for visual communication, but the simplified images also contributed to what Cory Pillen describes as recurring critiques of the sublime as "abstracted"

or "romanticized" portrayals of places that remove Indigenous peoples as well as evidence of infrastructure.[26] These historical contexts inform how the *Visions* posters use the sublime to transform data from invisible worlds into landscapes, a transformation that can inspire exploration while also threatening to repeat the colonization of the American western frontier on other planets.

Conclusions: Activating Pasts and Imagining Futures when Picturing the Invisible

The JPL *Visions* posters highlight how artists and scientists have borrowed strategies from each other's disciplines to advance a shared, interdisciplinary project: exploring distant reaches of space and time and translating data from far-off worlds into visual forms. By situating the posters within the geographies and histories of Los Angeles, we can understand why the frontier remains such an active metaphor for space exploration and begin to analyze the histories it revitalizes, as well as the futures it inspires.

Understanding the tools we use to transform invisible planets into visual forms will remain an essential and ongoing project. In the years since the *Visions* posters' debut, NASA's Exoplanet Exploration Program Office has begun to expand the posters' two-dimensional scenes into even more immersive virtual experiences online.[27] Experiments with virtual exploration are also developing alongside advances in telescope imaging. The James Webb Space Telescope, launched in 2021, promises to discover more exoplanets and to observe the "deepest reaches of space, where the first stars and galaxies formed more than 13 billion years ago." In August 2023, Caltech hosted a discussion about a potential new telescope called the Habitable Worlds Observatory (HWO) that would be "capable of detecting life on planets." We must continue to analyze the tools we use, including telescopes and astronomical illustrations, as we continue to expand our observational reach into the invisible and unknown.[28]

1—David Delgado, "Using the Future at NASA," interview by Stuart Candy, *Design and Futures*, ed. Stuart Candy and Cher Potter (Taipei: Tamkang University Press, 2019), 145.

2—"Visions of the Future," Jet Propulsion Laboratory, December 24, 2020, https://www.jpl.nasa.gov/galleries/visions-of-the-future. Unless otherwise noted, this website is the source for all references to the *Visions* posters.

3—Lisa Messeri describes how astronomers detect dips in luminosity to turn "invisible planets" into worlds. *Placing Outer Space: An Earthly Ethnography of Other Worlds* (Durham: Duke University Press, 2016), 111–115.

4—Talia Shabtay Filip examines the culture and development of visual strategy at JPL in her essay, also in this catalog.

5—"Visions of the Future."

6—Delgado, "Using the Future," 146–148. For the revival of the WPA National Park posters, see Erin Berger, "Meet the National Parks' 'Ranger of the Lost Art,'" *New York Times*, August 25, 2020.

7—Messeri, "Why We Need to Stop Talking About Space as a 'Frontier,'" *Slate*, March 15, 2017, https://slate.com/technology/2017/03/why-we-need-to-stop-talking-about-space-as-a-frontier.html.

8—Chanda Prescod-Weinstein, "Becoming Martian: Space Travel through the Middle Passage," *Baffler*, January 2022, https://thebaffler.com/salvos/becoming-martian-prescod-weinstein.

9—It is important to distinguish between intention and reception when analyzing how the frontier exploration is invoked to describe outer space. See, for example, Messeri's description of her method in *Placing Outer Space*, 17–19.

10—Messeri, *Placing Outer Space*, 88, 110.

11—Messeri, *Placing Outer Space*, 99–110.

12—Lois Rosson explores similarly dueling dynamics of astronomical illustration in her essay, also in this collection.

13—For details about the Titan poster, see Kristen Walbot, "The Exploration Behind the Inspiration at NASA," NASA Exoplanet Exploration, October 19, 2021, https://exoplanets.nasa.gov/news/1689/the-exploration-behind-the-inspiration-at-nasa/.

14—Walbot, "Exploration Behind the Inspiration."

15—Cory Pillen, *WPA Posters in an Aesthetic, Social, and Political Context: A New Deal for Design* (New York: Routledge, 2020), 80, 101.

16—Istvan Praet and Juan Francisco Salazar, "Introduction: Familiarizing the Extraterrestrial / Making Our Planet Alien," *Environmental Humanities* 9, no. 2 (2017): 314, 317–18.

17—For a review of scholarship on "space" and "place" and their theorized relationships to emptiness, see Messeri, *Placing Outer Space*, 13.

18—For a summary of the Harvard team scouting California and Peru, see Dava Sobel, *The Glass Universe: How the Ladies of the Harvard Observatory Took the Measure of the Stars* (New York: Penguin Books, 2016), 31–34.

19—Eun-Joo Ahn, "The University in Space: Regional Development, Boosters, and Southern California of Early 20th Century" (lecture, Caltech, May 20, 2022).

20—Catherine L. Newell, *Destined for the Stars: Faith, the Future, and America's Final Frontier* (Pittsburgh: University of Pittsburgh Press, 2019), 6–10.

21—Walbot's article clarifies that further observation after the poster was published now suggests that the planet is mostly gaseous.

22—The *Visions* posters borrow strategies for creating scale, perspective, and drama from nineteenth-century visual culture. See Rachel Teukolsky, *Picture World: Image, Aesthetics, and Victorian New Media* (Oxford: Oxford University Press, 2020), 289–92.

23—"Kepler-16b JPL Travel Poster," Jet Propulsion Laboratory, December 24, 2020, https://www.jpl.nasa.gov/images/kepler-16b-jpl-travel-poster.

24—Elizabeth Kessler, *Picturing the Cosmos: Hubble Space Telescope Images and the Astronomical Sublime* (Minneapolis: University of Minnesota Press, 2012), 19–68.

25—Kessler, *Picturing the Cosmos*, 193.

26—For an overview of some of these critiques, see Pillen, *WPA Posters*, 76–80, 96–101.

27—Calla Cofield, "Take a Virtual Trip to a Strange New World with NASA," NASA Exoplanet Exploration, May 24, 2018, https://exoplanets.nasa.gov/news/1508/take-a-virtual-trip-to-a-strange-new-world-with-nasa/.

28—I am grateful to students from my "Picturing the Universe" classes that met at Caltech between 2020 and 2022, and I want to thank Isabel Swafford for preparing a class presentation that compared the JPL posters with the WPA National Park posters. Conversations from these classes helped me form ideas about the JPL *Visions of the Future* posters.

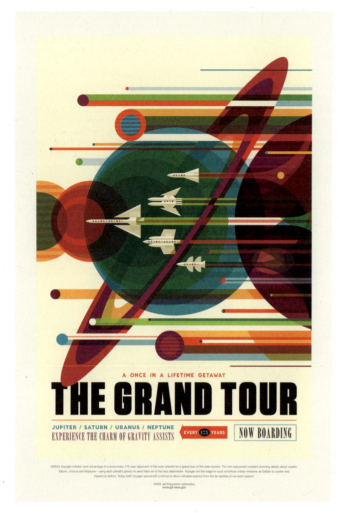
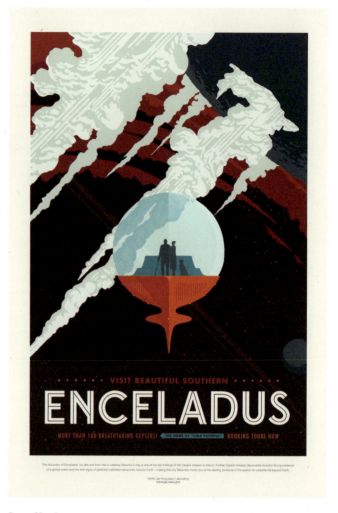

Don Clark
The Grand Tour, 2016
Digital illustration
Jet Propulsion Laboratory

Ryan Clark
Enceladus, 2016
Digital illustration
Jet Propulsion Laboratory

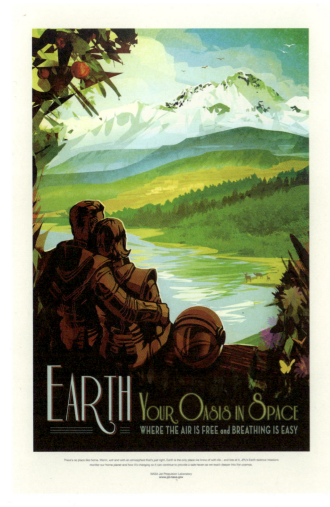

Joby Harris
Earth, 2016
Digital illustration
Jet Propulsion Laboratory

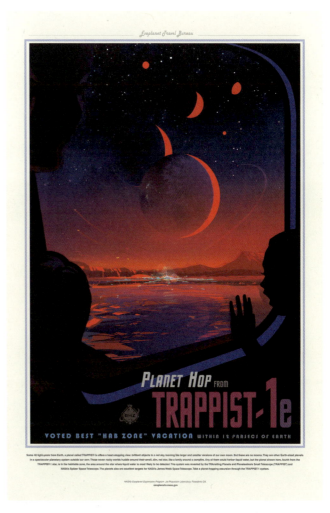

Joby Harris
Trappist-1e, 2016
Digital illustration
Jet Propulsion Laboratory

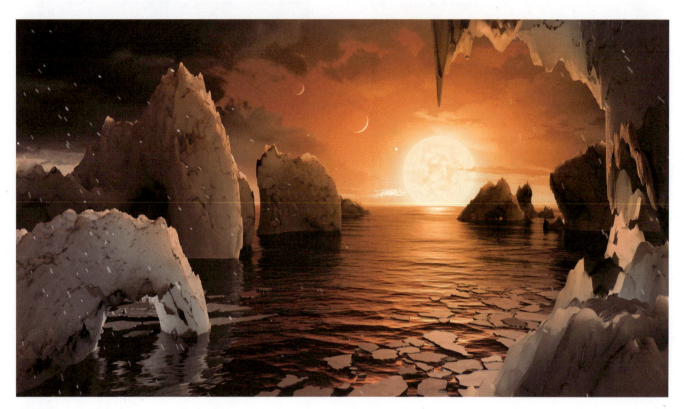

Tim Pyle
Trappist-1, 2017
Digital illustration

Terry Braunstein
Nuclear Summer #1 (background image by Chesley Bonestell), 1986
Photomontage
University of Michigan Museum of Art

Ralph McQuarrie
A Rebel Sentry on the Fourth Moon of Yavin,
Star Wars: A New Hope, 1977
Gouache on board
Lucas Museum of Narrative Art, Los Angeles
© & ™ Lucasfilm Ltd.

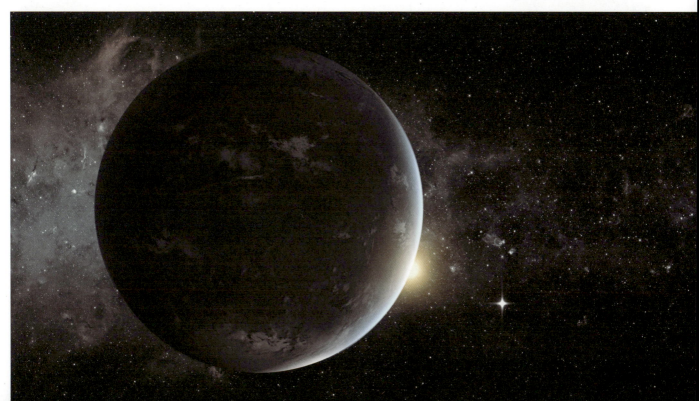

Tim Pyle
Morning Star (Kepler-62f), 2013
Digital illustration

Robert Hurt and Robert Benjamin
Annotated Roadmap to the Milky Way, 2008
Digital illustration
Caltech

Joby Harris
NASA Astronaut on Mars, 2020
Digital illustration
Jet Propulsion Laboratory

Bertram Goodhue
Untitled (Caltech Campus Plan), 1920
Watercolor and ink on paper
Caltech Archives and Special Collections

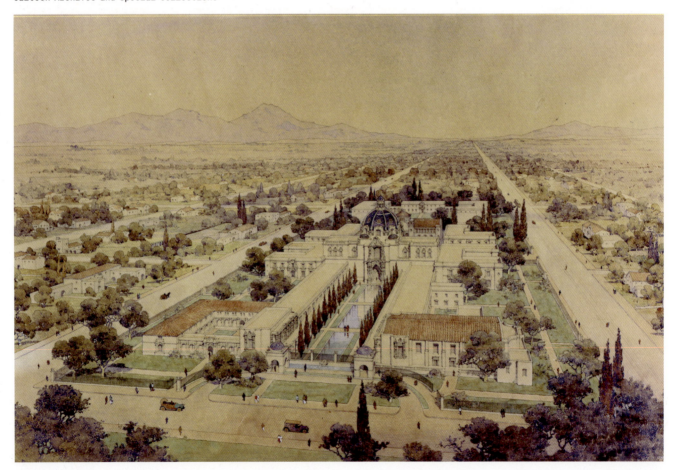

AESTHETIC VIRTUE

I'm very moved by the beauty of your campus.
 —Vincent Scully, inaugural James Michelin
 Distinguished Visitor at Caltech

One must move around to observe changes: coming and going, appearing and receding, visible and invisible—a phenomenon of constant movement. It touches on the mysterious, the place beyond which the eye cannot go.
 —Helen Pashgian

The final section of this catalog goes beyond the exhibition. Here, we explore the evolving ecology of Caltech itself, its campus art and architecture, its first artist-in-residence program (1969–1971), and Baxter Art Gallery (1970–1985), an influential but short-lived showcase for contemporary art. Featuring architectural drawings, watercolors, sculptural programs, and original artworks, this section probes Caltech's aesthetic self-image over the past century when the institution envisioned itself as "a theater for human action," in the words of visiting architectural historian Vincent Scully.

The term *Aesthetic Virtue* describes how science organizations in the 1960s embraced the visual arts to restore the reputation of a discipline that, in the eyes of contemporaries, had been severely tarnished by its contributions to nuclear weaponry, the Vietnam War, and the era's rapacious consumerism. In 1969, Caltech—then still a male-dominated school focused almost exclusively on science and engineering—tenuously joined calls for participatory multimedia projects like Experiments in Art and Technology or MIT's Center for Advanced Visual Studies, founded in 1967. Baxter Art Gallery, whose formation was spearheaded by members of Caltech's humanities faculty to present cutting-edge works by artists like John Altoon, Peter Alexander, Hans Haacke, and Lita Albuquerque, among many others, was shuttered just as it garnered greater critical acclaim—a testament to the ultimately limited reach of contemporary art at Caltech.

One of only two female members of the famed California-based Light and Space movement, Los Angeles artist Helen Pashgian was also the lone woman to join Caltech's artist-in-residence program in 1969. Her radiant *Lens* reflects her longstanding interest in the effects and perception of light while attesting to the significance of her path-breaking experiments with polyester resins at Caltech more than fifty years ago.

Unknown Photographer
Gates Annex north entrance with relief sculpture
by Lee Lawrie, c. 1927
Photograph
Caltech Archives and Special Collections

James W. McClanahan
Faculty in front of Throop Hall
and the Calder arches, 1952
Photograph
Caltech Archives and Special Collections

250 Aesthetic Virtue

Unknown Photographer
Dismantled Calder arches in Pasadena
storage yard, c. 1973
Photograph
Caltech Archives and Special Collections

Austin Studios
Cosmopolitan Club (Grant Venerable, center), 1932
Photograph
Caltech Archives and Special Collections

Unknown Photographer
Arthur Amos Noyes, George Ellery Hale,
and Robert A. Millikan (left to right), 1917
Photograph
Caltech Archives and Special Collections

Unknown Photographer
West entrance of Kerckhoff Laboratory, c. 1930
Photograph
Caltech Archives and Special Collections

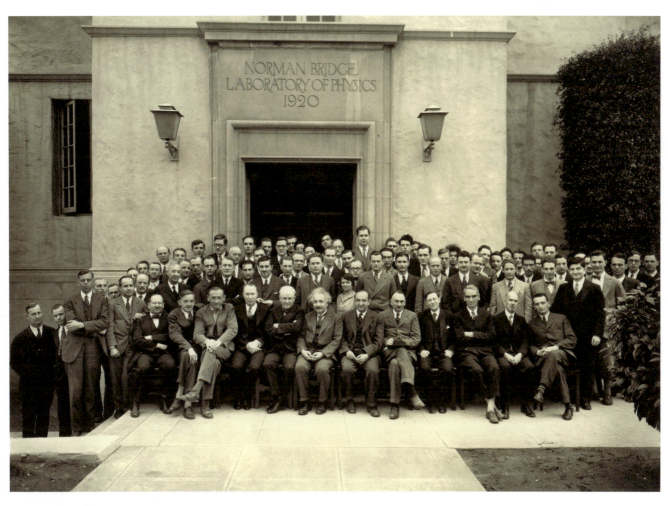

Keystone Photo Service
Physics Department, 1931
Photograph
Caltech Archives and Special Collections

Unknown Photographer
Throop Glee Club (Frank Capra, top left), 1916
Photograph
Caltech Archives and Special Collections

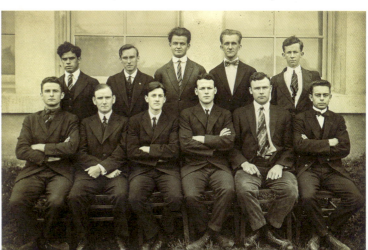

254 Aesthetic Virtue

Unknown Photographer
Apollo statue on Throop Hall landing, c. 1910
Photograph
Caltech Archives and Special Collections

Unknown Photographer
Demolition of Lee Lawrie sculpture, 1959
Photograph
Caltech Archives and Special Collections

Unknown Photographer
Entrance to High Voltage Research Laboratory with relief sculpture by Lee Lawrie, c. 1923
Photograph
Caltech Archives and Special Collections

Myntverket
George W. Beadle Nobel Prize Medal, 1958
Gold
Caltech Archives and Special Collections

Godefroid Devreese
California Institute of Technology seal, 1926
Bronze
Caltech Archives and Special Collections

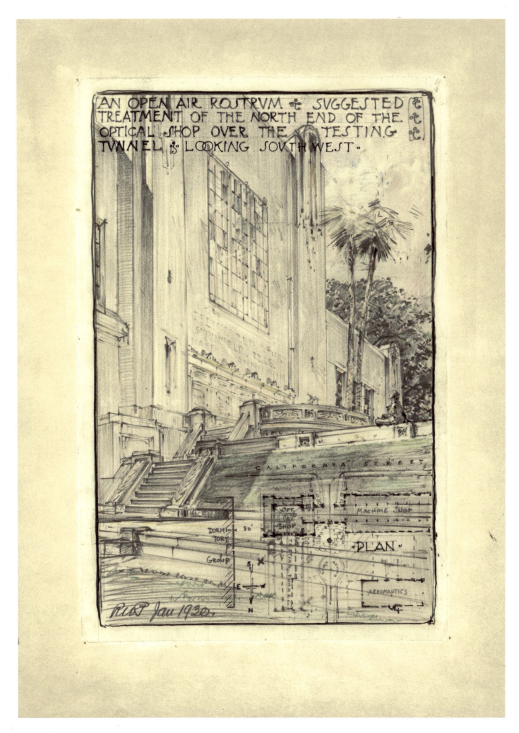

Russell Porter
Optical Shop, 1930
Pen, pastel, and pencil on paper
Caltech Archives and Special Collections

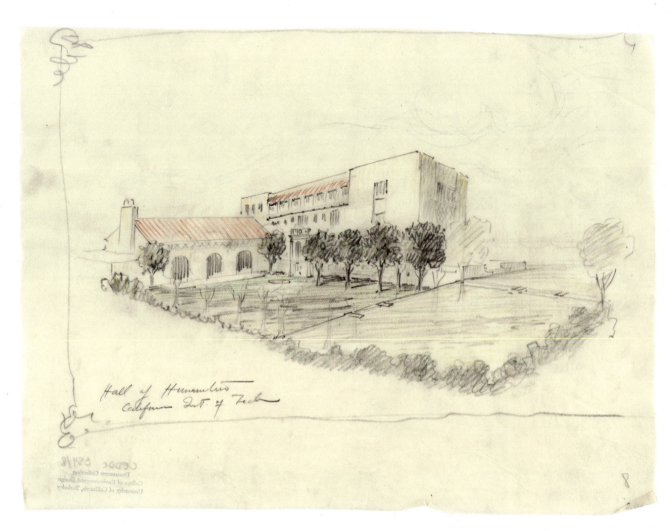

Beatrix Farrand
Hall of Humanities (Dabney courtyard), c. 1930
Pencil and pastel on paper
Environmental Design Archives, University
of California, Berkeley

Morphosis Architects
Model of Cahill Center for Astronomy and Astrophysics, c. 2005
Plastic
Morphosis Architects

Christopher Hawthorne

FIGURES AND GROUNDS:
A Critical History of the Caltech Campus and Its Architecture

In the fall of 1992, the Yale architectural historian Vincent Scully arrived at Caltech as the school's inaugural James Michelin Distinguished Visitor. The honor, which would later go to the novelist Walter Mosley, the soprano Beverly Sills, and the poet Seamus Heaney, among others, had one primary requirement: to give a lecture promoting "creative interaction between the arts and sciences."[1] Scully's talk focused on the work of the American architect Louis Kahn, exploring echoes in Kahn's work of the ruins of classical Rome.

Scully opened his remarks with a few observations about the architecture of Caltech, which he was visiting for the first time. "I'm very moved by the beauty of your campus," he said, adding:

> I think that it's only on the college campus, and especially on the American college campus, that architecture exists in its proper scale. Not in terms of individual buildings trying to outdo others, but in terms of the creation of an environment as a whole in which buildings are designed to get along with the others to shape a space—a theater for human action.[2]

Scully, who would return to Caltech three years later as a Mellon Visiting Professor, wasn't praising the architecture of the campus where he'd been invited to speak merely to ingratiate himself to a local audience. He was also leading his listeners toward an argument about the limits of International Style modernism (and why Kahn's architecture, with its unusual and forceful blend of the contemporary and the archetypal, was worth holding up as an alternative model). "Along about World War II something happened," Scully told his Caltech audience:

> Perhaps it was the Depression and then war, and, I think, also the victory of the modernist idea itself, but all of a sudden we seemed to forget what architecture was all about. We began to forget that architecture consisted of buildings that were supposed to get along with one another, and modern architects wanted to do things that had never been done before. Buildings began to appear as attempts at the most original, the most unusual, the most exotic, the most decorative imaginable. Caltech has its examples of these too.

This is a useful contention as far as it goes. Even visitors to Caltech without much knowledge of architectural history can sense a fissure between the consistency of its oldest buildings, with their shaded arcades and streamlined spin on the Spanish Colonial, and the diversity of architectural expression elsewhere on campus, where what predominates are "individual buildings trying to outdo others." Yet the particular history of Caltech and its architecture breaks from the tidiness of that narrative in certain fascinating ways. The architectural sensibility of the campus has been shaped not so much by competing styles as by the complex and sometimes unpredictable interaction of people and place: of leaders and landscape, of figures and grounds.

This essay will focus on three of those leaders in particular: one an architect, one a donor, and one a Caltech president. These overlapping histories have left us with the Caltech campus we have today—generally of an enviably consistent piece yet studded with singular architectural departures, some more successful than the others. It is only after sorting through and making sense of those histories that we can articulate a clear set of ideas about how Caltech's scientific achievements, and its institutional ambition, have been rendered in visual and physical form, and where campus planning might turn next.

Goodhue

To a degree unusual in the history of American higher education, it is possible to trace the look and feel of the Caltech campus to a single moment: when solar astronomer George Ellery Hale, the founder of Mount Wilson Observatory and a crucial figure in the transformation of Throop College of Technology—as the school was then known—

into Caltech, decided in 1915 to travel to San Diego's Balboa Park to visit the Panama-California Exposition.[3] The Expo's architecture was the work of a 46-year-old New York architect named Bertram Grosvenor Goodhue, who would later design the state capitol in Lincoln, Nebraska (1922–1932) and the main branch of the Los Angeles Public Library (1925). In 1915 Goodhue, then a year into running his own office following a two-decade collaboration with the New York architect Ralph Adams Cram, was still little known on the West Coast.

When Hale visited the Expo, he later wrote, he realized "at once that its creator was a pure genius," and urged the Throop trustees to hire Goodhue. The architect was in place at Throop by summer of 1915.[4] Goodhue found it a rather bare site, but far from a tabula rasa. The architects Myron Hunt and Elmer Grey had proposed a campus plan in 1908, featuring Mission-style buildings in a U-shaped configuration, open to the west around a central open space. In the end, however, the only building the pair contributed was Pasadena Hall, later called Throop Hall. It was completed in 1910 and for a time was the sole academic building on campus.

Goodhue's first task was to collaborate with Hunt—who had dissolved the partnership with Grey after their collaboration on Pasadena Hall—on the campus's second building, Gates Laboratory of Chemistry. Its construction had been promised to the esteemed chemist Arthur A. Noyes to convince him to leave MIT to take up a permanent position at Throop.[5] Throop's trustees then asked Goodhue to develop a new plan for the campus to replace Hunt and Grey's proposal of 1908. Working quickly, he produced three variations by September 1915. The trustees responded enthusiastically but also made the specific request that Goodhue be sure to make his campus plan, to the degree possible, "elastic."[6]

The architect worked through at least three more versions of the plan before the trustees settled on a final version in early 1917. Denser and more urban than the Hunt and Grey plan, it envisioned a height of four stories, rather than two, for most structures and called for a series of buildings executed in a relatively stripped-down version of the Spanish Colonial style. These would be linked by a series of arcades inspired by the San Juan Capistrano Mission and would feature walled courts and gardens between buildings. Those open spaces allowed for future expansion, and the arcades gave the whole a uniform look. The heart of the plan was a strong axis running just north of California Boulevard and connecting Wilson Avenue, on the western edge of campus, with Hill Avenue on the east (page 246).

After commissioning several buildings from Goodhue Associates, the architect's successor firm, the school turned to Gordon Kaufmann to fill in the empty spaces on the eastern end of the main Goodhue axis, first with the grand Athenaeum faculty club of 1930 and then with a series of elegant dormitories, wrapped around central courts, moving back toward the center of campus. Though Kaufmann brought his own particular approach—an eclectic kind of Mediterranean Revival closer to the so-called California Style, as defined by the architect and critic Harris Allen, than Spanish Colonial—his architecture folded easily into the larger conceptual whole suggested by the Goodhue plan (page 262).

Beckman

Even the most generous reading of the Goodhue plan would acknowledge that its influence had fully waned by the 1960s. Cold War politics and the intensifying space race helped guarantee that funding for many Caltech programs, and for both facilities and research at the Jet Propulsion Laboratory, which Caltech manages for NASA, remained strong. On campus, expansion hopes shifted in three important ways. First, Caltech planners emphasized a new north-south axis cutting through the heart of the school and flanked by three large new buildings. Second, they erected a starkly modernist library tower, named for Caltech's founding leader, Robert A. Millikan, and now called Caltech Hall,[7] where Goodhue's library was once meant to go; rising nine stories and designed by the firm Flewelling & Moody, it was completed in 1967. (This is the campus building Caltech students and faculty have always most loved to hate.) Third, and perhaps most significant of all, Caltech began granting individual donors a new level of power and prominence on campus.

No single donor epitomized this change more than the Orange County industrialist Arnold O. Beckman (1900–2004). Beckman had earned a PhD from Caltech in chemistry in 1928 before joining the faculty and subsequently inventing the pH meter and the so-called DU spectrophotometer, a device for measuring ultraviolet light. In 1934, he founded National Technical Laboratories, later renamed Beckman Industries, eventually earning a fortune

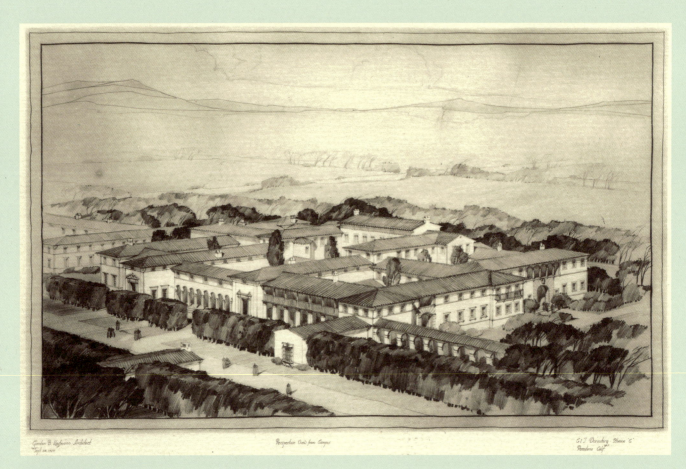

Gordon Kaufmann
Perspective View from Campus (of student houses), 1929
Pencil and ink on paper
Caltech Archives and Special Collections

Julius Shulman
Beckman Auditorium, 1964
Gelatin silver print
Getty Research Institute

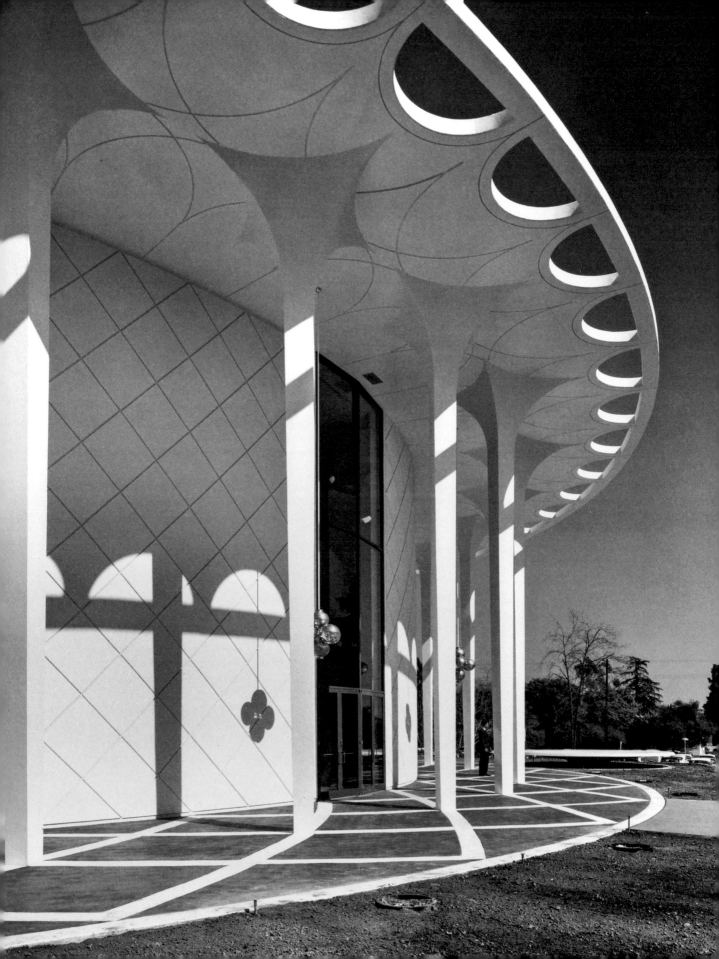

large enough to allow him and his wife, Mabel, to endow facilities at UC Irvine and Stanford. He lavished special attention on his alma mater, serving as chairman of the Caltech Board of Trustees for a pivotal decade of expansion, from 1964 to 1974, and helping to fund three buildings on campus that still carry the Beckman name. Each of them—long among the largest on campus—solidified Caltech's evolution away from the Goodhue plan in its own way.

The first and most architecturally significant was Beckman Auditorium, designed by the prolific New York architect Edward Durell Stone and completed, as an early West Coast example of the New Formalism, in 1964. Caltech's major performing-arts venue, it stands at the northern end of what is now the major north-south axis on campus. In silhouette the auditorium resembles a carousel, a big-top, or, as it is often called, a wedding cake, its circular base topped by a conical roof (page 263). In the early 1970s two sizeable shoebox-like classroom and lab buildings went up just south of the auditorium, on either side of a large mall. Both were designed by Robert Alexander in a bureaucratic version of the Brutalist style, rather without the courage of their hulking convictions. The first, in 1971, on the mall's east side, was Baxter Hall,[8] followed in 1974, on the mall's west side, by the Mabel and Arnold Beckman Laboratories of Behavioral Biology.

As far as Caltech's architectural progression is concerned, the Beckman Labs are most significant as a linchpin or pivot between the auditorium and the third building to carry the donor's name, the Beckman Institute. In 1986 the Beckmans announced that they would donate $50 million to establish a new institute for chemical and biological research; in keeping with Beckman's expertise, it would place a premium on accommodating the latest in scientific instruments—which would be available for use to scientists across Caltech. The prolific Los Angeles architects AC Martin Partners were hired to design the building, which is directly west of Beckman Auditorium—the space between them would be filled with a new reflecting pool— and northwest of the Beckman Laboratories. Unlike the other campus structures that bear the Beckman name, Beckman Institute is draped in references to the Spanish Colonial that are almost cartoonishly over-scaled. It revives the Goodhue arcades but pulls them into the volume of the building, so they are flush with the façade on both the east and west side rather than extending in front of the façade, as with the Goodhue buildings. Instead of connecting one building to the next, and supporting a continuous pedestrian passage, they operate self-referentially, as an extension of the Institute's own internal court.

Baltimore

Caltech leaders might have drawn certain architectural lessons from the period when Beckman led the board of trustees. They might have reflected on the easy sophistication of the Goodhue buildings and looked to return to a kind of campus planning that emphasized the balance between architecture and landscape, inside and out, rather than the prominence of increasingly larger standalone structures. Instead, by the time David Baltimore was inaugurated as Caltech's sixth president, in 1997, they were poised to extend the go-it-alone architectural approach for a new era.

A biologist, Baltimore was 37 when he shared the 1975 Nobel Prize in physiology or medicine with Renato Dulbecco and Howard Temin for research into the genetic makeup of viruses. One of his early decisions as president was to reject a master plan that would have made an explicit return to the Goodhue and Hunt approach.[9] Next, Baltimore enlisted firms led by I. M. Pei (Pei Cobb Freed), Rem Koolhaas (Office for Metropolitan Architecture), and Thom Mayne (Morphosis), among others, to design new facilities for Caltech. It is likely no coincidence that each of those three architects are winners of the Pritzker Prize, often called the Nobel of architecture.

The Koolhaas project fell through, ultimately going in slightly modified form to the Los Angeles architect Frederick Fisher and becoming the Walter and Leonore Annenberg Center for Information Science and Technology, completed in 2008. But the Pei and Mayne projects, realized largely as Baltimore first envisioned them, brought a brash new architectural presence to campus. They also reflected the influence of Eli Broad, who joined the Caltech Board of Trustees in 1993 and, across Los Angeles County, practiced a brand of philanthropy that gave preference to blue-chip, big-name architects.[10] He and Caltech's new president got to know each other during discussions about the building that would become the Broad Center for the Biological Sciences. As Baltimore remembers it, "Eli said to me, in our final negotiation over his

funding the building, 'One of the requirements is that we get a notable architect.' And I said, 'That's fine; I think that's what the campus needs anyway.'" 11

It was Pei Cobb Freed's James Ingo Freed, lead architect on the United States Holocaust Memorial Museum in Washington, DC, who took charge of the design team; Pei, born in 1917, had stepped back from day-to-day leadership of the firm by the time the project was initiated. Completed in 2002, with the help of a $20 million gift from Broad and his wife Edythe, the building was the first to give physical shape to Baltimore's vision for the campus. A collection of piled rectilinear forms that from certain angles suggests a hill town, it has two distinct personalities. The southern façade, facing the Goodhue section of campus, is faced in travertine, while the northern side is covered in panels of etched stainless steel. This is one of the building's few gestures in the direction of contextualism; on the whole it appears proud of its rather imposing bulk. It also, importantly for the future direction of the Caltech campus, anchors the southwestern edge of a second east-west axis that has gained prominence in recent decades.

Fisher's ultimate design for the Annenberg Center, a rectangular box of green glass, is a thoughtful and elegant work of architecture, if surely more reticent than what Koolhaas would have produced for the site. That left the Cahill Center for Astronomy and Astrophysics, designed by Morphosis, to fulfill Baltimore's architectural vision for Caltech. The site was on the south side of California Boulevard, marking the first time a prominent Caltech building rose in that part of the campus. As Baltimore recalled, "There's huge traffic on California. So this was going to be sort of the defining image of Caltech, and I thought it ought to be really special." 12

The "defining image of Caltech" is a three-story building, completed in 2009, whose façade along California, made of terracotta-colored cement-board panels, seems to be breaking apart under some great twisting pressure. Inside, the central stair is

Yazdani Studio of Cannon Design
Resnick Sustainability Center, 2021
Digital rendering
Yazdani Studio of Cannon Design

similarly dramatic, torquing its way from the lobby upward through the heart of the building. In nearly every other way the architecture is generic. The plan of the building reveals a predictable grid of traditional office spaces and conference rooms. Here, finally, was the perfect inversion of Caltech's original approach to designing buildings for scientific research. In the Goodhue plan, laboratories for cutting-edge scientific work were cloaked in consistent and coherent architectural dress. In the Cahill Center, self-consciously experimental, highly mannered architectural forms were attached like appliqué to an otherwise unremarkable building. [Refer to plate with checklist number 358]

In the fifteen years since the Cahill Center was built, Caltech architecture has returned to a more even keel, with sizable but measured designs by ZGF (Bechtel Residence, 2018); SmithGroup (Chen Neuroscience Research Building, 2021) and Yazdani Studio of Cannon Design (Resnick Sustainability Center, 2024) pushing the center of campus farther to the west, along Wilson, and north, toward Del Mar Boulevard. At the same time, these projects have extended some of the trends set by Beckman and Baltimore, with each new building expressing its own architectural sensibility and existing to a large degree within its own sphere of influence (page 265).

Elsewhere in this volume, J. V. Decemvirale argues forcefully that Caltech has been slow to grapple with the "white imaginary entangled within the visual order" of its Spanish Colonial and Mission Revival architecture. The more pertinent concluding questions for this essay have to do with the ways Caltech has used architecture to promote its own institutional ambitions as well as ideas about the role of scientific research in the larger culture. Here it may be helpful to return to Vincent Scully's notion of the university campus as a "theater for human action." The first decades of Caltech's expansion relied heavily on a commitment to Goodhue's spin on the Spanish Colonial, an architecture that conceived of campus buildings as constituting a coherent stage set, with scientific and engineering research as the subject matter for the script, and the researchers themselves as the players on the stage.

The shift that began with Beckman and accelerated with Baltimore turned the campus buildings and then their architects into far more prominent actors on campus than at any time in the past. This approach turned up the spotlight on new buildings themselves with a brightness and intensity that essentially made the stage set—the backdrop formed more by connections among works of architecture than by the individual works themselves—fade nearly to the point of invisibility. One way forward would be to imagine Caltech returning, in its campus planning, to an architecture of connection that privileges human scale and pedestrian movement without feeling the need to cloak those connections in revivalist or otherwise self-consciously contextual dress. Given the climate crisis and rising temperatures across Southern California, this approach might also revive an emphasis on shade—whether architectural, produced by arcades or other built elements, or enabled by planting and landscape design.

This would be perhaps the only way to successfully reinvent some appropriate version of the Goodhue sensibility for the twenty-first century at Caltech. Style and colonialist baggage aside, the key element of that sensibility worth rescuing is its ability to be elastic and coherent, flexible and grounded, at the same time: to pull new buildings, for new uses, and even by new architects, into its larger embrace, while once again treating researchers and students, rather than architects, donors, or administrators, as the key protagonists of the Caltech drama.

1—Vincent Scully, "Louis I. Kahn and the Ruins of Rome," *Engineering & Science*, Winter 1993, 2.

2—Scully, "Louis I. Kahn," 2.

3—Alice Stone and Judith R. Goodstein, "Windows Back of a Dream," in *Caltech 1910–1950: An Urban Architecture for Southern California* (Pasadena: Baxter Art Gallery, 1983), 9.

4—Richard Oliver, "Bertram Goodhue," in *An Urban Architecture*, 17.

5—"Noyes would come in exchange for a new laboratory" in Judith R. Goodstein, *Millikan's School: A History of the California Institute of Technology* (New York: W. W. Norton, 2006), 55.

6—Oliver, "Bertram Goodhue," 18.

7—Millikan's name was removed in 2021, after a campus-wide debate on his history of support for eugenics.

8—Jennifer Watts chronicles the history of the art gallery housed in the Baxter basement elsewhere in this volume.

9—David Baltimore, interview by Sara Lippincott, November 25, 2009, Caltech Archives Oral History Project, 87.

10—For more on Broad's architectural track record beyond Caltech, see Christopher Hawthorne, "Eli Broad: L.A.'s Peripatetic Patron," *Los Angeles Times*, June 20, 2010.

11—Baltimore, interview, 86.

12—Baltimore, interview, 94.

J. V. Decemvirale

ARCHITECTURES OF EPISTEMIC MASTERY ON THE CALTECH CAMPUS, 1915–1930

I have proposed two sphinxes... with a little Angeleno wink in their otherwise Egyptian eyes.
—Bertram Goodhue[1]

From the tiled Spanish Mission Revival archways to the international modernist style laboratories, the architecture of Caltech presents a powerful narrative of European civilizational progress.[2] This narrative is forcefully anchored in architect Bertram Goodhue's plan for the campus. One of Goodhue's last projects before his unexpected death in 1924, the unfinished Caltech master plan was a culmination of the architect's grand civilizational eclecticism. The "California" style he invented went on to influence architecture throughout Southern California, the US West, and Australia.[3] In no small measure, Goodhue's Southern California architectural work defined the new Anglo settler-colonial landscape of the twentieth century.

Most of Caltech's architecture reflects the Euro-American forms of knowledge it was designed to house. In a few fascinating late 1920s exceptions, though, Caltech's early architects also incorporated non-European iconography and architecture into their buildings. In this essay I focus on how buildings of this era made claims on the land and its people, leaving behind ahistorical and contradictory architectural narratives that continue to influence campus life and architecture. As architectural critic Joseph Giovannini reminds us, Caltech's campus is "a highly interpretive environment—one of values."[4] In case studies of Dabney Hall of the Humanities, Gates Laboratory of Chemistry Annex, and the Athenaeum, I attempt to understand how architecture, painting, and sculpture were used by campus architects and visionaries to naturalize European knowledge supremacy in the historic campus, at times assimilating alternative knowledge traditions and at other times silencing and ignoring them by privileging architecture that had no connection to the land or its histories beyond colonial conquest.

From Expositions to Outposts

The development of the historic heart of the Caltech campus began in San Diego, at the Panama-California Exposition of 1915, one of many world's fairs that put European and Euro-American modernity on display in the nineteenth and twentieth centuries. Part of a broader geopolitical campaign to make San Diego the first port of entry for the forthcoming bounty of international trade opened by the Panama Canal, the exposition was a laboratory of white colonial development of California that propelled local movements in architecture, anthropology, immigration policy, labor politics, and museum practice.[5]

New York architect Bertram Goodhue, most famous for his Gothic Revival architecture, designed many of the fair's important buildings. The Spanish Colonial Revival style he premiered at the exposition was widely lauded for its references to California's history and for articulating a uniquely Southern Californian modernism. The exposition launched Goodhue's career on the West Coast and made him a clear favorite among Los Angeles elites searching for a monumental architecture announcing Los Angeles' place on the world stage.[6]

When eminent astronomer and Caltech trustee George Ellery Hale visited the exposition, he was, as historian Romy Wyllie describes, "particularly impressed with the Spanish spirit and exoticism expressed in Goodhue's exposition buildings."[7] On returning to Pasadena, Hale lobbied for the young Institute to scrap the more modest plans of architect Myron Hunt for Goodhue's unique fusion of the world's architectural traditions. Indeed, Goodhue's master plan was a continuation of the Panama-California Exposition's colonial narrative for a new settler audience (page 246).

The exposition focused on the "humanization of science," in which anthropologists and exposition planners constructed elaborate exhibitions promoting evolutionary and civilizational narratives based in racialized science. As historian of world's fairs Robert Rydell details in his classic study, the exposition's "elaborate racial fantasies about California's history were intertwined with predictions of continuous national progress."[8] As a test site for white world building, the Panama-California Exposition showed how visual technologies such as ethnographic exhibitions and architectural structures could affirm class and racial hegemony when buttressed by science.

Of the many architectural details shared by Caltech and the exposition, it was Spanish mission arches that became iconic. The exposition's white historical fantasies were premised on the belief that progress was a continuation of the Franciscan "priest-civilizers" who arrived in Alta California in the eighteenth century.[9] Spanish Colonial Revival architecture not only fostered romantic visions of an untouched land worked by Spanish priests and settlers, but served as a narrative stepping stone between Spanish conquest and Anglo imperialism's nation building in the southwest, speaking just as much about white anxieties as about visions of progress.

The Spanish Catholic missions, or outposts of Christendom as they were sometimes called, were part of the white spatial imagination of Caltech leadership and framed how they understood their own mission.[10] The image of the outpost was revived in a planning document from 1922, most likely by eminent physicist Robert Millikan, outlining the Institute's future. Among several bullet points regarding world events, the allusion to a racial outpost as central to a civilizational narrative reappears: "California marks now, as England did three centuries ago, the farthest western outpost of Arian civilization. It is here that East and West meet. This is the region which is most favorably located for assisting in the solution of the world's most pressing problems of the next three or four centuries, problems which will have to do with the relations of eastern and western races."[11] This telling spatial metaphor summarized a core belief of the white imperial project: progress was built and was to be maintained across North America one racially specific outpost at a time. The goal was to continue pushing boundaries and recalibrating in response to local conditions.

The Catholic mission arches are one example of how a visual technology of mastery made its way beyond the boundaries of the exposition. As Alexandra Minna Stern details in her groundbreaking work on the role of eugenics in modern American life, the California expositions functioned as test sites and meeting places for likeminded elites to think through the problems confronting white civilizational progress. They were also important places for California's eugenicists to sell their vision of "better breeding," which in practice prevented those they deemed unfit from reproducing, often poor and disabled people and people of color, including by sterilizing them without their consent. As Stern's work makes clear, "Eugenicists shaped modern California—its geography, inhabitants, and institutions."[12] The expositions were places where space was racialized through visual technologies premised on the scientific credibility of racial thinking.

The 1915 Panama-Pacific International Exposition in San Francisco, where "the eugenics movement coalesced," would also play a role in campus history. It was here that biologist Paul Popenoe cemented his place among the developing network of California eugenics leaders through both a well-received speech and popular exhibition booth devoted to race betterment. When Pasadena lawyer and rancher Ezra Gosney sent out a call for nominations for his own eugenics foundation, Popenoe's plan for action detailed in his 1915 speech brought him to the forefront.[13] Together, he and Gosney would create one of the world's most effective eugenics advocacy groups, the Human Betterment Foundation (HBF), and contribute enthusiastically to California's prominence as the largest practitioner of forced sterilizations in the United States. The HBF counted several Caltech professors and trustees as its members, but most important for this essay is the work of humanities professor William B. Munro, who was also an HBF member, trustee, and vice president.

Unknown Photographer
West entrance of Dabney Hall, c. 1930
Photograph
Caltech Archives and Special Collections

Catching the Tail of the Plumed Serpent: Dabney Hall of the Humanities and Gates Laboratory of Chemistry Annex

William Munro was a distinguished professor of history and government among a faculty that consisted largely of scientists, but his role as arbiter of history and taste in Southern California has gone mostly unacknowledged. Hale and Millikan recruited the well-connected Munro from Harvard, to move to Caltech in 1926. The importance of Munro as a leader of the humanities was explicit in his appointment to the Institute's governing committee—the Executive Council—and his chairmanship of the Trustee Committee on Buildings and Grounds from 1929 to 1953.[14] His vision and ability to raise funds were widely admired throughout Southern California, as he sat on the boards of many nonprofit organizations and banks, and even worked as a key advisor in the construction of Scripps College in nearby Pomona.[15] In Millikan's speech at Munro's party for his retirement portrait, he described Munro as "one of the most important builders of the California Institute of Technology," for no single other person had played such an enormous role "in making the plans, letting contracts, and supervising the construction of most of the buildings on the campus."[16]

At Caltech, Munro's first major project was the 1928 Dabney Hall of the Humanities (page 270). According to Caltech's 2020 report exploring the legacy of the HBF, he "helped secure endowment for, and establish the construction of, Dabney Hall, a building devoted exclusively to the study of the humanities. It was at this time, in 1928, that Munro became a founding member and original Trustee of the HBF."[17]

By the time Munro took charge of the Trustee Committee on Buildings and Grounds, there was strong disagreement around the aesthetic avenues Goodhue and Associates were pursuing. As architectural historian Richard Oliver and Wyllie describe, campus leaders were "especially frustrated over deviations from the original Spanish character of the master plan." Oliver notes that, according to trustee meeting minutes of 1928–1929, a "strained atmosphere" developed between Hale and the architects.[18] This was in part due to the architectural firm's distant location in New York, but it was also a response to their explorations of non-Western iconography and architecture in their first buildings, Gates Annex and Dabney Hall of the Humanities.

In Dabney Hall, Goodhue and Associates kept Goodhue's minimalist adobe planes, but where Goodhue (who had died in 1924) would have worked with colonial-themed decorative elements along windows and door frames, his successors instead broadened their range to include the peripheral cultures of the Spanish Catholic empire. Elements of Dabney include a Mesoamerican temple entryway, a Pueblo-inspired southern façade flanked by mission arches, and even a North African garden, tapping into Catholic Spain's own appropriation of Islamic architecture.

For a building with such symbolic importance as the place where students would be "humanized" on campus, Dabney's "non-Western" architecture is dissonant and disorienting within the master colonial aesthetic on campus. The main western entrance is adorned in the symbols of the plumed serpent, the ancient Mesoamerican god of technology, culture and agriculture: step frets on the imposing blue metal entry gate, three stone chevrons on the western balcony, and single-line stylized serpent heads along the staircase. Dabney speaks in a muted visual language on all sides, offering white-washed and fragmented pieces of non-Western cultures that are unified by an unnamed authority. Instead of appropriating local Gabrieleño/Tongva/Kizh, Fernandeño Tataviam, and Chumash histories, Dabney's historical legitimacy is most visibly grounded in the ahistorical premise that Mesoamerican cultures were the modern Los Angeles basin's historical antecedents.

The purpose was not to construct a Hall of Humanities for the people of this land or a place to share the collaborative work of defining the human. Dabney would be devoted to the study of European and Euro-American literature, history, and philosophy, not non-Western cultures.[19] These architectural enclosures created, as decolonial theorist Rolando Vazquez describes the vistas of modernity, as places where the "subject is produced in its constitution as the center, as the gaze that owns world-historical reality."[20] The building's aesthetic function was not to perform a public pedagogy elucidating non-white knowledge traditions, but to provide those identified with European culture a sense of global ownership that authorized the appropriation of non-white peoples' lands and cultures.

Smaller in scale but comparable to the construction of the Cathedral of Mexico City out of the ruined

Mexica Templo Mayor, Dabney's architecture of assimilation makes spiritual and epistemic colonization starkly visible. Munro's role in the HBF's advocacy of forced sterilizations, which disproportionately affected Latinas/os in California, makes the building's stylistic dissonance even more striking.[21]

The intention to include non-white cultures so as to reassert white dominance was also expressed in the largest sculptural program on campus, on Gates Laboratory of Chemistry Annex (pages 248 and 273). Emigre German artist and longtime Goodhue collaborator Lee Lawrie sculpted this work, most likely based on the research of Hartley Burr Alexander, a University of Nebraska philosopher who served as Goodhue's "iconologist." These men collectively and individually defined Los Angeles' knowledge landscape through narrative architectural programs on the Los Angeles Public Library, the old *Los Angeles Times* building, and nearby Scripps College.

Lawrie sculpted a large-scale imitation Mesoamerican sculptural program based on the universality of serpent and dragon symbols around the world, with the four central pillars devoted to the plumed serpent god. This Mesoamerican deity has a contested history, and historians have worked diligently to disentangle the historical figure/ mythical god from the wholesale appropriation of the myth by Spanish conquistadors in their own mythologizing of the conquest.[22] Each plinth represents a manifestation of the plumed serpent: as morning star, as bearded white conquistador, as Quetzalcoatl (Mexica), and as Kukulkan (Maya). The panels on the inside of the pillars depict serpents in Asian and Assyrian traditions.

One of Lawrie's great masterpieces, the thematic was most likely based on Alexander's research on the universality of the serpent and dragon symbols across world cultures. In his essay "The Serpent Symbol and Maize Culture," Alexander explains the myth of the plumed serpent:

> The most famous and picturesque of New World mythic figures is that of Quetzalcoatl, although primarily his renown is due less to the undoubted importance of his cult than to his association with the coming and the beliefs of the white men.... When Cortez landed, the Mexicans were expecting the return of Quetzalcoatl.... The white men... were inevitably assumed to be the deity.[23]

Scholars now question this account of Mexico's Indigenous people associating white men with the plumed serpent. While sympathetic to the Indigenous histories and people he researched, Alexander was particularly interested in the myth of the white savior, as it gave white people a mythical nativist claim on the land. Programs like Dabney Hall and Gates Annex represented sophisticated efforts to unify fragments of non-white cultures into a universe of knowledge founded on the mythologies of European colonial rule.

In 1931, three of the core architects of Goodhue and Associates rebranded to become Mayers, Murray & Phillip (MMP). Sorely under-researched, MMP was one of the major architectural firms responsible for designing federally funded buildings on Native American reservations.[24] According to art historian Lillian Makeda, MMP was commissioned by the Roosevelt administration, under Commissioner for the Bureau of Indian Affairs John Collier, whose own beliefs about appropriating Indigenous architecture into federal projects made the MMP's approach appealing.

In her in-depth study of one of these buildings, the Navajo Mountain Day School in Utah, Makeda describes the MMP design as "unusual in the extreme." Exhibiting a perverse visual logic, the MMP instrumentalized Diné architecture to disconnect the Diné from one another, from their land and knowledge. As Makeda describes on the architects' role in epistemicide, what resulted was a "liminal place where Diné children began the transition from their own culture to the culture of the dominant society. As the sanitized imitation of a Diné outfit, the school can be likened to a Potemkin village, stripped of any features that might make a Euro-American audience question the efficacy of a mainstream American education."[25]

Predating the MMP's work in Utah by a few years, Dabney and Gates Annex are part of this architectural lineage, early prototypes for an architecture that naturalized the white civilizational project in the non-white world's architectural garb, often placing whiteness as the center or as an invisible binder holding together a fantasy world of its own

Lee Lawrie
Gates Annex north entrance column, 1927
Architectural relief sculpture (detail)
Caltech Archives and Special Collections

making. Here, the Dabney Hall of Humanities is draped in the fragmented culture of the conquered other to promote a new vision of white civilizational progress in Southern California.

The Athenaeum: Mapping a World of White Knowledge

The attempt to address "regional" histories created a unique moment in campus history, and the anxiety around this exploration is readable in the campus itself. Goodhue and Associates completed eleven more buildings as part of Goodhue's master plan, but the firm was bypassed for the most prized projects, which were spaces for socializing. Instead, the building committee chose Gordon Kaufmann's strictly Spanish-Italianate architecture for the faculty club, the Athenaeum, and the South Student Houses.

At this point Caltech abandoned regional architecture altogether, and structures on campus over the next hundred years would come to be defined by an internationalist modernist style with no relationship to the land or its history. As Stefanos Polyzoides and Peter de Bretteville, architects and architectural historians of Caltech, explain, its postwar period "has been characterized by the triumph of an international technoculture over regional cultures which would otherwise be based on the traditions, history and romance of particular places."[26] The gradual progression toward an international modernist architecture began with the declarative architectural statement of the Athenaeum, a reaffirmation of the European tradition as the campus' visual order.

As important as any laboratory, the Caltech Athenaeum has offered accommodation for decades to eminent visiting scholars and other guests and served as a gathering place for a wide range of social and academic activities. Widely considered an architectural jewel, the Athenaeum relies on a classical European spatial archetype, best exemplified by the Italian Renaissance painter Raphael's 1511 *School of Athens* in the Vatican. In an idealized Greco-Roman setting, the great able-bodied men of arts and science gather to think and converse with one another and with the philosophers of European antiquity. This vision of the proper space for thinking has dominated the European tradition since the Renaissance, appearing as the architectural lingua franca of museums and universities across

the world.[27] Deploying these visual vocabularies creates a stage to perform social scripts, as well as to affirm authority and grant legitimacy. As such, the visual culture created by the white imaginary on campus does much more than decorate; it places subjects within an ordered and racialized world.

One mapping of this world is to be found in the largest and most complete painting program on campus, in the Athenaeum's Hall of the Associates. Named after an important group of philanthropists, the hall is decorated in an Italianate Baroque style with lush painted ceiling detailing. A row of university seals runs right below these ornate decorations, creating a panoramic mapping of human knowledge as seen from Pasadena. Painted by Italian painter Giovanni Battista Smeraldi, this room curiously contains Caltech's greatest concentration of Judeo-Christian religious imagery, as many seals reference institutions' foundational religious histories.

According to Wyllie, professors Munro and Paul Epstein and trustee Hale selected the seals of universities that "made the most significant contributions to the progress of learning through research and discoveries."[28] Here the mapping creates a compelling geographical narrative of Western modernity, as the imagined viewer can move from the oldest European and North African universities to the Ivy League of the East Coast, the University of Chicago in the Midwest, and finally California.

This mapping of knowledge is not entirely European or Euro-American as it also includes the Alexandria School with depictions of the Lighthouse of Alexandria and the Arabian School with an astrolabe, both outliers from the European incorporated university tradition. These are important to note because visual strategies of knowledge supremacy are nuanced in their capacity to assert dominance through selective inclusion. Decolonial theorist Linda Tuhiwai Smith speaks of the imperialist strategies of the Western project of knowledge as highly adept at this claiming, particularly as a deterrent to counter alternative epistemic claims. As she explains, "For this purpose, the Mediterranean world, the basin of Arabic culture and lands east of Constantinople are conveniently appropriated as part of the story of Western civilization, Western philosophy and Western knowledge."[29]

Such a painted knowledge constellation is enormously powerful precisely because, as Smith explains, it "reaffirms the West's view of itself as the center of legitimate knowledge, the arbiter of what counts as knowledge and source of 'civilized' knowledge."[30] This highly selective mapping not only asserts dominance, but puts Caltech, and in particular those who stood in this room, at the center of the management of world knowledge. It is a worldview echoed in various scales across campus.

What promises can a campus make about democratic ways of thinking or cohabitating the landscape when its own vistas are based on myths of epistemic conquest and historical narratives that make cultural assimilation appear inevitable? The dangers lie in the disconnection between land and thinker that presumptions of mastery engender, particularly in the creation of a landscape in which Indigenous knowledge is deployed to articulate white knowledge's mythical supremacy. To imagine what a more epistemically diverse campus might look like, or better, what an institute of technologies could be, we must first reckon with the white imaginary's entanglements within the visual order.

1—Hartley Burr Alexander, "The Nebraska Capitol," in *Bertram Grosvenor Goodhue: Architect and Master of Many Arts*, ed. Charles Harris Whitaker (New York: Press of the American Institute of Architects, 1925), 44.

2—Caltech's master visual narrative is summarized in the subtitle of a comprehensive study of campus architecture: Romy Wyllie, *Caltech's Architectural Heritage: From Spanish Tile to Modern Stone* (Los Angeles: Balcony Press, 2000).

3—Genevieve Carpio, "Zorro Down Under: Settler Colonial Architecture and Racial Scripts |en Route from California to Australia," *Aztlán* 46, no. 1 (2021): 111–42.

4—Joseph Giovannini, "Gordon Kaufmann," in *Caltech 1910–1950: An Urban Architecture for Southern California* (Pasadena: Baxter Art Gallery, 1983), 34.

5—For more on the Panama-California Exposition see Robert W. Rydell, *All the World's a Fair: Visions of Empire at American International Expositions, 1876–1916* (Chicago: University of Chicago Press, 1984) and Alexandra Minna Stern, *Eugenic Nation: Faults and Frontiers of Better Breeding in Modern America*, 2nd ed. (Oakland: University of California Press, 2016), 28–56.

6—Romy Wyllie, *Bertram Goodhue: His Life and Residential Architecture* (New York: W. W. Norton, 2007).

7—Wyllie, *Caltech's Architectural Heritage*, 31.

8—Rydell, *All the World's a Fair*, 5.

9—Rydell, *All the World's a Fair*, 213.

10—On Indigenous histories in the modern-day Los Angeles basin see Damon B. Akins and William J. Bauer, *We Are the Land: A History of Native California* (Oakland: University of California Press, 2021) and Deborah A. Miranda, *Bad Indians: A Tribal Memoir* (Berkeley: Heyday, 2013). For details on the violence of the missions see Yvette Saavedra, *Pasadena Before the Roses: Race, Identity, and Land Use in Southern California, 1771–1890* (Tucson: University of Arizona Press, 2018).

11—"California Institute of Technology: Its Directions, Aims, Accomplishments, Needs and Financial Condition," c. 1922, Arthur H. Fleming Papers, Caltech Archives and Special Collections. See also Mike Davis's characterization of Millikan's mixing of science and business as "reproducing Aryan supremacy on the shores of the Pacific," in *City of Quartz: Excavating the Future in Los Angeles* (New York: Vintage Books, 1992), 57.

12—Stern, *Eugenic Nation*, 83.

13—Stern, *Eugenic Nation*, 83, 105.

14—Harvey Eagleson, "William Bennett Munro 1875–1957: A Memoir," William Bennett Munro papers, Huntington Library.

15—Helen Lefkowitz Horowitz, "Designing for the Genders: Curricula and Architecture at Scripps College and the California Institute of Technology," *Pacific Historical Review* 54, no. 4 (1985): 439–61.

16—Eagleson, "William Bennett Munro."

17—Committee on Naming and Recognition Final Report, California Institute of Technology, December 17, 2020, https://inclusive.caltech.edu/documents/18182/CNR_Report_FINAL.pdf. For further details see the groundbreaking work of the Black Scientists & Engineers of Caltech, who brought attention to these histories.

18—Wyllie, *Caltech's Architectural Heritage*, 68.

19—*Bulletin of the California Institute of Technology* 37, no. 121: 219–31.

20—Rolando Vásquez, *Vistas of Modernity: Decolonial Aesthesis and the End of the Contemporary* (Prinsenbeek, the Netherlands: Jap Sam Books, 2020), 26.

21—Nicole L. Novak et al., "Disproportionate Sterilization of Latinos under California's Eugenic Sterilization Program, 1920–1945," *American Journal of Public Health* 108, no. 5 (2018): 611–13.

22—For more on the debates over the legend and realities of the plumed serpent, see Alfredo López Austin, *The Myth of Quetzalcoatl: Religion, Rulership, and History in the Nahua World* (Boulder: University Press of Colorado, 2015); Enrique Florescano, *The Myth of Quetzalcoatl* (Baltimore: Johns Hopkins University Press, 1999); Karl A. Taube, "The Temple of Quetzalcoatl and the Cult of Sacred War at Teotihuacan," *Res* 21 (1992): 53–87; Camilla Townsend, "Burying the White Gods: New Perspectives on the Conquest of Mexico," *American Historical Review* 108, no. 3 (2003): 659–87.

23—Hartley Burr Alexander, *The Mythology of All Races: Latin-American* (Boston: Marshall Jones, 1920), 66–67.

24—Lillian Makeda, "Baca/Dlo'ay azhi Community School," *SAH Archipedia*, ed. Gabrielle Esperdy and Karen Kingsley, https://sah-archipedia.org/buildings/NM-01-031-0152.

25—Lillian Makeda, "Visions of a Liminal Landscape: Mythmaking on the Rainbow Plateau," *Journal of the Southwest* 58, no. 4 (Winter 2016): 675–76.

26—Stefanos Polyzoides and Peter de Bretteville, "The Caltech Campus in the Twentieth Century," in *An Urban Architecture*, 59.

27—Paula Findlen, *Possessing Nature: Museums, Collecting, and Scientific Culture in Early Modern Italy* (Oakland: University of California Press, 1996).

28—Wyllie, *Caltech's Architectural Heritage*, 139.

29—Linda Tuhiwai Smith, *Decolonizing Methodologies: Research and Indigenous Peoples* (London: Zed Books, 1998), 63.

30—Smith, *Decolonizing Methodologies*, 61.

William B. Dyer
Greta Millikan, c. 1925
Gum-bichromate print
Caltech Archives and Special Collections

Clara P. Ewald
Olga Taussky-Todd, 1939
Oil on canvas
Caltech Archives and Special Collections

Jon R. Friedman
David Baltimore, 2006
Oil on canvas
Caltech Athenaeum

Lloyd Hamrol
Moore's Stone Volute (sculpture rubbing), 2008
Pencil on paper
Courtesy of Lloyd Hamrol

Richard Serra
Vectors, 2002
Model of proposed sculpture
Courtesy of Richard Serra

Jud Fine
Tripoli, 1978
Sculpture, proposed for Caltech
Caltech Archives and Special Collections

John Altoon
Untitled (Sunset Series #31), 1965
Oil on canvas
Kohn Gallery

Frank Malina
Sans titre, 1956
Mixed media on cardstock
RCM Galerie

Incendiary Traces at Caltech
Accordion books of graphite, colored pencil, and watercolor on paper
Courtesy of Hillary Mushkin

Top: Richard Abbott, Jim Barry, Hillary Mushkin, and Jennah Colborn (left to right)
Guggenheim Aeronautical Laboratory

Middle: Hillary Mushkin, Nina Mohebbi, Sahangi Dassanayake, Hillary Mushkin, John Pederson, Alejandro Stefan-Zavala, and Jacqueline Tawney
Northrop Grumman Reading Room

Bottom: SooJean Han, David Kremers, Hillary Mushkin, Jena Lee, Richard Abbott, and David Kremers
Center for Autonomous Systems and Technologies

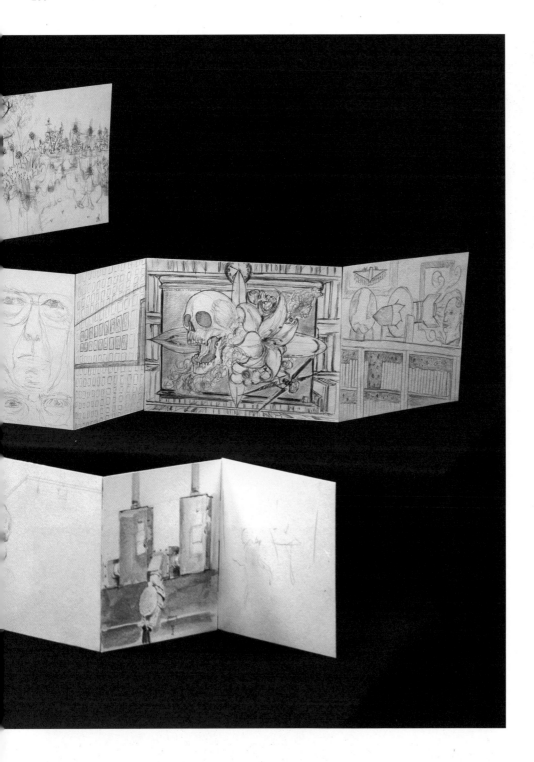

John Whitney
Matrix, 1971
Film still
©John Whitney, Whitney Editions™, Los Angeles CA

Lillian Schwartz
Pixellation, 1970
Film still
©The Henry Ford

Peter Alexander
Untitled, 1968
Cast polyester resin
Los Angeles County Museum of Art

Peter Sachs Collopy

PASSING IN THE HALLWAY:
Art and Technology at Caltech, 1968–1972

In 1969, Caltech converted seven rooms in its defunct Earhart Plant Research Laboratory into an art studio.[1] Only twenty years earlier, Earhart had been the world's first phytotron, a climate-controlled botanical research facility. As botanists left, retired, and died, the field vanished at Caltech, an institution always selective about the subdisciplines in which it was active. In the building's last years—it was demolished in 1972—it was home to Caltech's effort to synthesize art and science.[2] In addition to art classes, the building hosted artists-in-residence: painter Lukas van Vuuren used holograms and mirrors, while sculptors Helen Pashgian, Robert Bassler, Peter Alexander, and David Elder worked in polyester resins. Across campus in the Booth Computing Center, computer animator John Whitney produced his influential abstract film *Matrix*.[3]

In the period dubbed the long 1960s (from roughly the mid-1950s to the early 1970s), artists and scientists embraced each other's professional practices, and universities institutionalized interdisciplinary efforts in new centers for art and technology. As Matthew Wisnioski argues in an analysis of MIT's Center for Advanced Visual Studies, established in 1967, scientists and engineers were drawn to the art world by their pursuit of aesthetic virtue—a synthesis of the transdisciplinary ideals of collaboration and creativity that promised to "rehabilitate the image of science and technology" in an era when intellectuals and activists critiqued them for their contributions to capitalism, consumerism, and the Vietnam War.[4] At the same time, artists sought out new media that could be found only in wealthy, research-oriented corporations and universities.

Artists and scientists, that is, did not come to these new programs with the same motivations and expectations. Around 1970, the young artist Stephen Nowlin encountered the esteemed theoretical physicist Richard Feynman, who had himself begun exchanging weekly lessons in drawing and physics with artist Jirayr Zorthian in 1962, on Caltech's campus. "We passed in a hallway and nodded a mutual hello," Nowlin recalls, "me on my way to write code in the computing center, he on his way to draw like Degas in the live-model class."[5] This was how artists and scientists often encountered each other at Caltech, walking or talking past each other as each embraced the resources traditionally held by the other. Many artists were indeed interested in synthesizing art with science and engineering in some way—Nowlin was writing code for computer animation—but most scientists and engineers who engaged in art were seeking a break from their technical work rather than a different mode of it, making genuine collaboration the exception rather than the rule.

The founders of Caltech's art program were a third group, though: faculty in English literature. At an institution without art programs or art history professors, it was these scholars and teachers of another art form who first took on the responsibility for visual art as well. In 1967, lecturer Charles Newton and professor J. Kent Clark formed a new art committee, which came to include Feynman, fellow literature professor David Smith, and trustee and renowned industrial designer Henry Dreyfuss. They also began seeking funding for an art program, and in the initial years of 1968 to 1971 received $62,000 from local electric motor heiress Virginia Steele Scott and $50,000 from the Mellon Foundation. The Earhart studio was one of three branches of this program, along with acquisitions and exhibitions.[6]

The committee hired 30-year-old white South African painter Lukas van Vuuren, then an instructor at Scripps College, as the art program's first director and artist-in-residence. His arrival was announced by one of the program's first exhibitions, consisting of Van Vuuren's landscapes painted with acrylic on metal and David Elder's sculpture in materials such as fiberglass, resin, and acrylic lacquer. Although Van Vuuren's training was, in Smith's words, "thorough, classic, and academic," he had turned from painting on canvas to "transferring photographic images to metal,… copolymers,… metal plating techniques, and… even… lasers."

"Art and Science Wed at Caltech," proclaimed the alumni publication *Caltech News*.[7]

Van Vuuren was, Clark later recalled, "a fine artist, and perhaps the world's worst PR man."[8] Smith regarded Van Vuuren's leadership as the least satisfactory element of the art program. The artist did not raise money and devoted little effort to administration other than hiring instructors and recruiting artists-in-residence, leaving the management of exhibitions, for example, to Smith. Worse, according to Smith, Van Vuuren used his hiring authority to coerce art models to have sex with him, behavior that the art committee discussed but didn't actually do anything about. At precisely the historical moment when Caltech began to hire women as professors and admit them as undergraduate students—events that took place in 1969 and 1970—the institution remained deeply patriarchal.[9]

With the sole exception of Pashgian, the artists whom Van Vuuren brought to Caltech were all men. Several taught non-credit courses: Paul Darrow and Connor Everts successively taught printmaking, Ferenc Csentery and David Elder taught sculpture, and Van Vuuren himself taught drawing and painting. "We were swamped with the registration," wrote Van Vuuren, of about 75 students and 25 faculty. He also taught "art and technology," not in a formal course but as an advisor to those engaged in independent study—but "for the students or faculty members that feel that they wish to break away from technology altogether," reported the student newspaper, the *California Tech*, "it is suggested that they sign up for one of the other classes."[10]

Indeed, Van Vuuren wrote, one of the surprises of the program "was the comparative lack of interest in technological applications to creating art." One of the promises of art at Caltech was an opportunity to engage in modes of creativity different from those of science and engineering. "Many faculty members and students," Van Vuuren continued, "did not want to approach art from a technical viewpoint; they wished to approach the subject traditionally and academically as a change from their daily occupation in technology and science." Similar challenges arose in sculpture, where, again, students expected a more traditional approach. "A great number of students came to class expecting to work with wood, clay, and plaster," wrote Van Vuuren. "Although Mr. Csentery is competent in these media, he preferred to emphasize metal and plastics. This choice alienated many students and the class diminished to five."[11]

Even when students were interested in technological art, Caltech did not provide the resources to realize their projects, which, Van Vuuren wrote, "on average...would have cost more than $1000 each." They were also unable to use "light sources, lazers [sic], and other technical equipment," which were already allocated to research. Similarly, lab manager Desmond Armstrong's collaboration with chemical engineering professor Fred Shair and artists Melvin Liaw and Caroline Hinkley to construct glow discharge plasma sculpture ended when they couldn't raise $5000 or more. And Van Vuuren himself collaborated with electrical engineering professor Nicholas George to produce the largest holograms ever constructed, with images of "outdoor or live subjects," but stopped the project when the two of them were unable to raise $9000 to purchase "lasers, hologram tables, and optical equipment."[12]

More fundamentally, some students were less attracted to new technologies as media for making art than to new technologies as already accomplished aesthetic achievements themselves. "They seemed to feel," wrote Van Vuuren with frustration, "that a lazer beam, an electrical discharge, or a computer image is itself a work of art. This mistake is roughly analogous to considering the oil used in oil paintings as art."[13]

Artists, on the other hand, were drawn to Caltech during this period precisely by the opportunity to use new science and technology. Nowlin, who had dropped out of art school in Oakland, California, was among them. "Science was emerging," he later wrote, "as the symbol for a more complex kind of beauty in nature, one without authorship." In order to participate in the art program, Nowlin got a job as a drafter in Caltech's Astro-Electronics Laboratory. Working on campus, he "became increasingly aware that many of the Caltech folks did not share this sense of romance about science," and some indeed found it in art.[14]

For artists at Caltech, technology mostly connoted two media in particular: plastics and digital computers. "Earhart," wrote Van Vuuren, "provided... the accurate temperature control which work in plastic demands," so, "using this facility as a strong inducement I invited Helen Pashgian and Robert Bassler to join our group," and later Peter Alexander as well.[15] (Caltech did not pay Pashgian and Bassler

but did pay salaries to Alexander and John Whitney, who each joined later.[16])

Sculptors were also attracted by the opportunity to learn from Caltech's chemical engineers, but both Pashgian and Bassler found that experience frustrating. Professor Nicholas Tschoegl, recalled Pashgian in a 2014 interview, "was an expert in the world of polymers, but he was an expert in the *theoretical* world of polymers." When she presented her techniques for casting polyester resin to his research group, a graduate student became angry that her success contradicted the theory he was advancing in his dissertation. With the exception of that encounter and a friendship she developed with Feynman around art, "there was no interaction" with scientists or engineers (page 309).[17]

Similarly, Bassler wrote that "collaboration with scientists and engineers at the Institute, although interesting, was essentially fruitless to me as an artist.... My needs were basically of a practical nature. I was not particularly interested in a theoretical understanding of the molecular chemistry of the material I was using.... I continued applying empirical methods, as habitually done by artists."[18] Using these methods, said Pashgian in another interview, "the working (scientific) knowledge came quickly, mostly in the multiple failures that piled up. If the material was over-catalyzed, there were cracks. If it was under-catalyzed, it was gooey and runny."[19] In these artists' accounts, art and engineering were competing modes of knowledge, with art the more hands-on and practical of the two, and chemical engineering hopelessly conceptual.

In 1968, abstract computer animation pioneer John Whitney had lectured on his artistic uses of computers at Caltech, "attempting," he later wrote, "to draw the scientist into vigorous rapport with the art and technology issue." He was more successful than the sculptors. The following year, Frederick Thompson, professor of applied science and philosophy, invited Whitney—who had grown up in Pasadena, and whose brother and collaborator James had worked as a drafter at Caltech during World War II—to join the art program. Thompson was developing a programming language called REL, or Rapidly Extensible Language, and Whitney began programming computer graphics in it.[20]

Stephen Nowlin became Whitney's assistant, and they each produced a film. "We always filmed in the middle of the night, which were the only hours during which we could schedule computer time," recalled Nowlin, "a reflection of our status in the overall Caltech hierarchy." Nowlin's film was *NNON*, an algorithmically generated pattern of "rotating kaleidoscopic lines" (left). Whitney's was *Matrix*, "a sequence of events of clustering and dispersal of the lines, squares and cubes" following the Lissajous geometries that Whitney had previously explored using analog computers built out of World War II gun directors—massive mechanical devices for aiming antiaircraft guns. According to Clark, Whitney regarded *Matrix* as his best work, and it featured prominently in his book *Digital Harmony* a decade later (page 286).[21]

In 1970, "Whitney's work at Caltech was halted," wrote Clark, "by the shift in computer center policy"—perhaps a replacement that year of IBM 7094 computers with IBM System/360 models—"which phased out the equipment which he and Dr. Thompson were working on."[22] Even otherwise successful collaborations between artists and engineering faculty—Whitney's with Thompson, Van Vuuren's with George, and Liaw and Hinkley's

Stephen Nowlin
NNON, 1970
Still frame from 35 mm computer-generated film
Stephen Nowlin

Robert Bassler
Two Piece Enclosure, 1971
Polyester resin
Courtesy of Robert Bassler

with Shair—were stymied by limited resources, as Caltech as an institution prioritized more conventional science and engineering research over that involving artists.

The crescendo of the art and technology movement at Caltech came on May 21, 1971, with an exhibition of sculpture by artists-in-residence Pashgian, Bassler, Alexander, and Elder—the second exhibition in the new Donald E. Baxter, M.D., Hall of the Humanities and Social Sciences' dedicated gallery—and an accompanying evening festival celebrating the opening of the building. Showcasing work they had created in Earhart, the four sculptors each exhibited polyester resin objects that refracted light to generate prismatic color spectra. Pashgian showed five circular lenses, "concentric targets of color" in the words of *Los Angeles Times* reviewer William Wilson; the largest, five feet in diameter, was stolen a week into the exhibition and never recovered. Bassler's six curvy columns, wrote Wilson, conveyed "intimations of abstract sexuality" and "sensations of flowing water" (left). Elder placed abstracted landscapes of "pink, see-through hills" within eight trapezoidal shapes. Alexander, whom Wilson deemed most successful in transcending the "sticky, Jell-O like origins of polyester sculpture," showed five thin vertical rectangles of plastic hanging on the wall, tinted with shades of purple that appeared and disappeared with the viewer's focus.[23]

The Baxter Festival served as an opening for the exhibition but also featured other art inside Baxter and performances outside. In addition to student art and the 24-foot-long painted *Hiroshima Panels*, the celebration incorporated the new media of lasers, light projection, electronic music, fog, computer graphics and films, and poetry accompanied by slides. These works' creators included physicist and research fellow Elsa Garmire, who developed laser patterns in her Caltech lab and commercialized them as Laserium laser shows, and undergraduate Gary Demos, who was inspired by Whitney to embark on an Oscar-winning career in computer animation.[24]

In fall 1971, Caltech's art studio moved into a single room in Baxter, and the curriculum narrowed to drawing and painting.[25] With diminishing funding and without the Earhart facility, which was being prepared for demolition, the artist-in-residence program wound down. The last event of this phase of Caltech's entry into the art world was an exhibition of Van Vuuren's own art. Van Vuuren worked with several technicians at the Jet Propulsion Laboratory and the lab's large vacuum chamber to turn sheets of glass and plexiglass into mirrors. A thin layer of aluminum, explained David Smith in the accompanying catalog, could be "simultaneously transparent and reflective," but it could also refract light, producing color. Photographs in the catalog show sheets of plexiglass with patterns of reflective and transparent dots or lines. In the cover photo, a topless young woman faces the camera through one of Van Vuuren's pointillist mirrors. In its reflection we see Van Vuuren himself, gazing with the camera at her and enlisting his

Control room of space simulator.

**BAXTER ART GALLERY
CALTECH PASADENA
27 April 1972 June 10**
GALLERY HOURS: TEN TO FIVE MONDAY THROUGH FRIDAY

Walter Walker, Eugene Noller, Lukas Van Vuuren preparing plexiglas for simulator.

Floyd Clark, Photographer
CIT JPL Van Vuuren invitation, 1972
Poster
Caltech Archives and Special Collections

experiment with mirrors in her objectification (above and page 306).[26]

Years after Caltech's initial art program ended, those involved had disparate appraisals of it. "This was one of the finest experiments Caltech ever did," declared Clark eighteen years later.[27] "The Caltech experiment—two years—was an entire debacle, it was a great failure," lamented Pashgian in 2014.[28] Ultimately, these conclusions reflected wildly varying expectations for the role and purpose of art at Caltech. The humanists who did much of the organizational work to bring the program to life aimed to enrich the cultural life of the campus, a goal they believed they met. For most scientists and engineers, the art program was, as Nowlin later wrote, a means of "escaping the isolation of their labs and notebooks by pursuing a kind of bohemian stereotype."[29] But for artists, it meant an opportunity to enter those labs and draw on the apparatus and expertise contained within—and, except for Earhart, Caltech's prioritization of science and engineering research above all else seldom let them in. Artists and scientists both wanted to cross over to the other side, but institutional priorities facilitated crossing in one direction more consistently than in the other.

1—Lukas van Vuuren, "Two Year Report on the Development of the Workshop and Gallery," April 19, 1971, 1; J. Kent Clark, "Report on the Caltech Art Program, 1968–1971," 6; both in Art Program file, Historical Files, Caltech Archives and Special Collections.

2—David P. D. Munns, *Engineering the Environment: Phytotrons and the Quest for Climate Control in the Early Cold War* (Pittsburgh: University of Pittsburgh Press, 2017), 5, 100–101.

3—Stephen Nowlin, "@Caltech: Art, Science and Technology, 1969–1971," *Leonardo* 50, no. 5 (2017): 445.

4—Matthew Wisnioski, "Why MIT Institutionalized the Avant-Garde: Negotiating Aesthetic Virtue in the Postwar Defense Institute," *Configurations* 21, no. 1 (2013): 91.

5—Nowlin, "@Caltech," 444; Richard P. Feynman, *The Art of Richard P. Feynman: Images by a Curious Character* (Basel: Gordon and Breach, 1995), 17–18, 60.

6—David Smith, interview by Jay Belloli, May 29, 1985, audiocassette, Baxter Art Gallery Records, Archives of American Art, Smithsonian Institution; Clark, "Report," 1–2, 21. For more on exhibitions at Caltech, see Jennifer Watts' essay in this volume.

7—*Caltech News*, March 1969, 2; David Smith, *David Elder, Lukas van Vuuren* (Pasadena: California Institute of Technology, 1969).

8—J. Kent Clark, interview by Shelley Erwin, February 13, 1989, Caltech Archives Oral History Project, 36.

9—Smith, interview.

10—Van Vuuren, "Report," 1–2, 4, 11; Clark, "Report," 7; "Earhart Lab Now Studio," *California Tech*, September 25, 1969.

11—Van Vuuren, "Report," 2, 4.

12—Van Vuuren, "Report," 2, 7–8, 12.

13—Van Vuuren, "Report," 2–3.

14—Nowlin, "@Caltech," 443–44.

15—Van Vuuren, "Report," 6, 11.

16—Clark, "Report," 19.

17—Getty Conservation Institute, "Helen Pashgian in Conversation," June 2014, YouTube, https://www.youtube.com/watch?v=Loppy74-Z0I.

18—Robert C. Bassler, "Lenticular Polyester Resin Sculpture: Transparency and Light," *Leonardo* 5, no. 3 (1972): 194–95.

19—Carol S. Eliel, *Helen Pashgian* (Los Angeles: Los Angeles County Museum of Art, 2014), 19.

20—John Whitney, *Digital Harmony: On the Complementarity of Music and Visual Art* (Peterborough, NH: Byte Books, 1980), 170, 197; Tom Sito, *Moving Innovation: A History of Computer Animation* (Cambridge, MA: MIT Press, 2013), 23; Zabet Patterson, "From the Gun Controller to the Mandala: The Cybernetic Cinema of John and James Whitney," *Grey Room*, no. 36 (2009): 39.

21—Nowlin, "@Caltech," 445–46; Whitney, *Digital Harmony*, 171, 197; Clark, "Report," 10.

22—Clark, "Report," 10; *California Institute of Technology 1970 Financial Report*, 6.

23—*Artists in Residence* (Pasadena: Baxter Art Gallery, 1971); William Wilson, "Caltech Gallery Inaugurated," *Los Angeles Times*, June 7, 1971; Helen Pashgian, interview by Michael Strauss, *Brooklyn Rail*, February 2020, 20–21.

24—Greg Simay, "Baxter Opening to Feature Many Cultural Exhibitions," *California Tech*, May 20, 1971; W. Patrick McCray, *Making Art Work: How Cold War Engineers and Artists Forged a New Creative Culture* (Cambridge, MA: MIT Press, 2020), 207, 271–72; Liz Rauer, "Gary Demos," 2018, Caltech Alumni Association, https://www.alumni.caltech.edu/awardees/2018-5-27-gary-demos-bs71.

25—"millikan troll," "Summar Summery," *California Tech*, September 23, 1971.

26—*CIT JPL Van Vuuren* (Pasadena: Baxter Art Gallery, 1972).

27—Clark, interview, 35.

28—Getty, "Helen Pashgian."

29—Nowlin, "@Caltech," 444.

Jennifer A. Watts

AN EXPERIMENT IN ART:
Baxter Gallery at Caltech

Experiment n. An action or operation undertaken in order to discover something unknown, to test a hypothesis, or establish or illustrate some known truth.
—Oxford English Dictionary

On a cloudy afternoon in May 1971, Caltech faculty, staff, trustees, and dignitaries gathered on a campus lawn. They had come to inaugurate the Donald E. Baxter M.D. Hall of Humanities and Social Sciences, a different type of laboratory at this institute of scientific renown. Speakers extolled the building's architectural beauty and hexagonal design. They praised Baxter's angled hallways, special libraries, state-of-the-art auditorium and the power of its spaces to shape young minds. During the event, as thunder rumbled overhead, one experiment received no comment, no praise. As the last speaker took his seat, the emcee rushed the podium for a final word. There was an art gallery on the ground floor and a "superb showing of African art." Some were no doubt perplexed. A gallery? African art? Caltech? He urged a visit as the crowd dispersed.[1]

Baxter Art Gallery was the realization of an idea that began in 1967 when an ad hoc faculty group surveyed national initiatives in science and art.[2] High-profile art and technology projects, including one at rival MIT, captured the public eye. A cohort of Caltech humanists wanted to follow suit. "We want to bring scientists and artists together in a dynamic, informal relationship and see what happens," proclaimed English professor J. Kent Clark, head of the art committee. "What we're *not* going to have is a lot of hifalutin' seminars on the nature of art and science."[3] Introducing visual arts to Caltech, Clark argued, offered aesthetic benefits, created essential community ties and, most importantly, offered students a pathway to knowledge beyond science. The committee proposed a tripartite plan: art acquisitions to beautify the campus; student workshops led by resident artists; and a public exhibition and lecture program.[4] After the committee secured $65,000 in outside funding, Caltech president Lee Dubridge approved a "Caltech Art Program" for a three-year trial.[5]

The first exhibition—a show of five local sculptors—took place for one week in May 1968. Between 1968 and 1970, the art committee sponsored approximately twenty exhibits featuring lithographs, drawings, paintings, sculpture, and artifacts in two locales. The basement of the Athenaeum, Caltech's faculty club, hosted casual showings, and a student lounge in the Dabney Hall of the Humanities featured larger, more consequential displays. A nebulous policy of showing "high-quality art" became the programmatic guide.[6]

South African Lukas van Vuuren became Caltech's first artist-in-residence in 1969, a position that included overseeing exhibitions.[7] Within the year, however, David Smith, a literature professor and master of student houses, took the lead in curating exhibits that lasted, on average, several weeks during the school year.[8] Eclectic offerings included pen and pencil drawings by physicist Richard Feynman; screen prints by artist, educator, and activist Sister Corita Kent; student workshop art; and Native American petroglyph rubbings lent by local collector and heiress Virginia Steele Scott. (For a comprehensive list of exhibits sponsored by the art program please see page 314 of this catalog.)

In Dabney, Smith and historian Robert Rosenstone—with help from industrial designer and Caltech trustee Henry Dreyfuss—created a flexible wall system with integrated lighting. "Four Printmakers" opened in February 1969 with an invitational "meet the artists" champagne event. It was a roaring success. "This exhibition proved the attractiveness of the new gallery arrangements," reported Van Vuuren, "and set a standard of tone for future exhibitions." Six exhibitions followed through 1970, most accompanied by elegant little catalogs with minimal text.[9]

Dabney shows privileged those in Caltech's orbit: resident artists, workshop instructors, and

local collectors. Loans included works by artists dominating the Pop Art and Light and Space scenes, among them Robert Irwin, Jasper Johns, Roy Lichtenstein, Ed Ruscha, and Andy Warhol. Many of those same artists reappeared in a show of 50 lithographic works created at Los Angeles's Gemini G.E.L. studio. The press took note. "Art at Caltech is a humanizing move, an appeal to the senses, a jutting out from the sciences to bring beauty to one of the world's great science institutes," enthused a *Los Angeles Times* reporter.[10]

As the trial period neared its end, the experiment's future came under review. Clark and Smith secured additional funds, making the effort self-sustaining for another year or two. While the workshop and artist-in-residence programs foundered, exhibitions thrived. Van Vuuren identified several rooms in Baxter's unfinished basement for a gallery and offices. Smith, the program's most passionate advocate, became director of exhibitions. Caltech's new president, Harold Brown, placed the initiative under the purview of the Humanities and Social Sciences Division (HSS), which provided administrative legitimacy.

With the opening of Baxter in 1971, the exhibitions found a permanent, albeit inconspicuous, home. At 2,000 square-feet, the gallery's four adjoining rooms and outdoor patio sat below-ground and down two flights of stairs, making the space not easy to find. Even so, Smith scheduled an ambitious roster of group and monographic shows with works across all media, ranging from the historical to the contemporary. Using the experimental phase as a template, he planned each season to include a private collection, often of artifacts or objects from abroad; contemporary work by living artists based in Southern California; and original and touring shows, with themes exploring ecology and the environment, regional architecture, and art and science.

Smith understood that success with students depended on keeping science, broadly conceived, at the forefront of his schedule. A "Baxter Festival" in May 1971 celebrated the art-science dyad through a series of performances, film screenings, artwork, and technological wizardry in various forms.[11] Smith also emphasized community outreach. "We have here a means of interesting people in the Institute who otherwise are in no way committed to support of science," he wrote to President Brown. Exhibits during his tenure highlighted art and artists from South America, Asia, and Africa and showcased numerous female artists, many of them in conjunction with 1975's UN-designated International Women's Year.

Operation of the gallery proved tumultuous. As early as 1972, Caltech's student newspaper reported financial difficulties. The administration expected Baxter to be self-supporting, with funds raised outside its usual channels. An art support group—consisting of local art enthusiasts and some members of the Caltech community—supplied about $3,000 per year, in addition to an annual gift of $12,000 from Virginia Steele Scott. Caltech supplied the space and occasional amounts of $2,000 or less.

Some insiders fretted that art diluted the Institute's core mission and siphoned off resources better used elsewhere. "In expanding Caltech's activities in art," wrote trustee Arnold Beckman to President Brown, "I have worried...about a conflict of interest with respect to Caltech's primary objectives in science and engineering."[12] Student attitudes ranged from apathetic to combative to irreverent, particularly toward contemporary art. In 1973, when a large octagonal sculpture by Tony DeLap appeared on campus, responses were swift and scathing. Calling it the "uglygon," students likened it to a "giant diffraction grating" and papered it over to resemble a huge stop sign.[13]

The local art community and press proved more enthusiastic, if not always complimentary. *LA Times* critics Henry Seldis and William Wilson consistently reviewed Baxter shows, with Wilson the crankier of the two. He reserved his harshest critiques for artists whom he considered in thrall to science and technology, often dismissing the outcomes as dreary, sophomoric, obtuse, and terminally hip.[14] Even so, openings drew sizable crowds, and art patrons, curators, and working artists across Southern California made visits to Baxter routine. Smith realized that students responded best to surrealism and science-themed shows (page 296). Spectacle also helped. He installed "Sandy," a 40-foot-long concrete whale on the lawn outside Baxter and featured electric and kinetic art.

Accolades alone could not keep Baxter afloat. The gallery's frenetic schedule kept Smith from devoting time to its financial predicament and impacted his scholarly career. More galling still, after supporter Virginia Steele Scott died in 1975, President Brown refused to direct any of her $100,000 bequest to the gallery. "I would not mind

Craig Grigsby
Untitled, 1971
Photograph of pencil on paper
(detail), on poster
Caltech Archives and Special
Collections

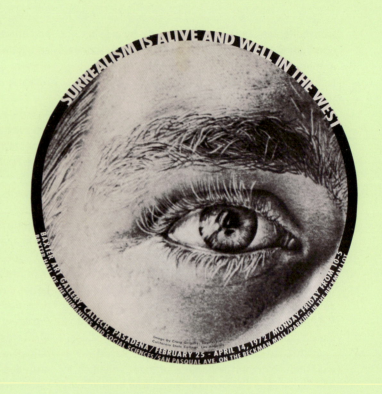

Sol LeWitt
Wall Drawing No. 285 in progress
for *The Poetry of Systems*, 1978
Photographs
Caltech Archives and Special
Collections

spending it on HSS Division (*not* the art program)," Brown scribbled in the donation letter's margin.[15] In 1976, Smith resigned as Baxter's director, and the administration announced the gallery's impending closure, due to "lack of funds."[16] Caltech's art experiment appeared to have reached its end.

Despite their seeming indifference, students rallied around the Baxter cause. Ninety percent of respondents to a survey favored keeping the gallery alive, and a student-led fundraising effort brought in $3,000. HSS chairman Robert Huttenback entered into talks with the Pasadena Art Alliance (PAA), a women's philanthropic organization that supported local arts. Having raised over a million dollars for the Pasadena Art Museum, the group found itself without an institutional affiliation when PAM merged with the Norton Simon Museum in 1974. Sensing opportunity, Huttenback negotiated a plan: PAA would give a substantial part of its funds—$55,000 per year—in exchange for three seats on the six-person Baxter Art Gallery board.[17]

In early 1977, the revived board hired Michael H. Smith as Baxter's first professional director. A 31-year-old Pasadena native with commercial gallery as well as museum experience, Smith entered Caltech on a part-time, one-year contract with the possibility of renewal for a second year, pending funds. The lack of an art history curriculum, acquisitions mandate, or clearly defined vision allowed Smith to shape a program with minimal restraints. One imperative from the hiring committee: the Caltech community, particularly students, came first.

Smith's inaugural exhibition, "Watercolors and Related Media by Contemporary Californians," tipped the new director's hand. The show brought together luminaries like Richard Diebenkorn, Bruce Nauman and Kenneth Price with lesser-known artists, 21 in all. Abstraction prevailed. An illustrated, loose-leaf catalog contained an interpretive essay by Smith, a format he vowed to repeat. *LA Times* critic Suzanne Muchnic lauded the gallery's forward-thinking approach while noting the exhibit's "art insider" intellectual demands.[18]

Smith made "art in the present tense" his guide. "The criterion...is relevance within today's aesthetic and intellectual society," he explained.[19] For Smith this meant one thing: Conceptual Art. Its practitioners privileged theory over craft, process over outcome, and "the idea itself." This was art less about pleasuring the eye and more about stimulating the brain.

Smith followed "Watercolors" with a show of two "acoustic sculptures" by Michael Brewster. The artist's sonic works, *Inside, Outside, Down* and *Soliloquies,* projected a 134-hertz tone and asynchronous clicking noises into the empty galleries and patio. Both works, explained Brewster, relied on one's willingness "to engage in a dynamic, sculptural form of behavior, moving down, in, around, and out while probing...these acoustically excited spaces."[20] Sol LeWitt, Conceptualism's eminence gris, appeared in "The Poetry of Systems," a 1978 group show. LeWitt sent instructions for *Wall Drawing No. 285* in which volunteers chalked lines at random on a black wall divided into 28 equal squares (page 296).

The exhibits based on theories and systems—heady, minimalist, often abstruse—kept coming. William Wegman and Robert Cummings, long-time art school friends, exhibited doodles, photographs, and films, with Cummings the "straight man" to Wegman's jokester. A Wegman video in which he attempts to teach his Weimaraner, Man Ray, to smoke a cigarette elicited laughs in the gallery but attracted few visitors.[21] Hans Haacke, the German provocateur, critiqued corporate public relations campaigns, presenting a silver-plated *New York Times* advertisement in a bespoke velvet-lined box. Feverish media attention surrounding Haacke's campus lecture drew an audience, but fewer than 800 people saw his show.[22]

Caltech and Baxter saw a changing of the guard in 1978 when Marvin L. "Murph" Goldberger, a theoretical physicist, was installed as president, and economist Roger Noll became the new HSS chair and thus the gallery's administrative head. Meanwhile, Michael Smith pressed ahead with ever-grander plans that included seeking a larger, more visible space. This new Institute for Visual Art, as he called it, would be a campus hub presenting exhibitions of "national significance." Caltech's vice president of financial affairs, after speaking with Goldberger and Noll, wrote that "some action is needed to rein in Michael." Noll agreed.[23]

A controversial 1980 exhibition by Richard Tuttle exacerbated an increasingly fraught situation for Smith. Tuttle, whose practice involved spare installations of everyday materials such as string, wire, and wood, was easy to mock. "When it comes to giving ammunition to Philistines," wrote one critic, "Richard Tuttle has few peers."[24] At Baxter, Tuttle hung 50 sketchbook pages from his 1977

"collage-drawings" series at a precise mid-point of 64½ inches from the floor. Folded cut-paper shapes formed tiny, cryptic abstractions floating in a single line. The show drew passionate, mostly negative responses, and students were particularly hostile.[25]

By now Smith was complaining to Rosenstone, the board chairman, about lack of guidance and fundraising support. "Perhaps you are doing a good job in the wrong place," Rosenstone replied.[26] Other board and PAA members objected to Smith's minimalist focus, and the Tuttle show fueled accusations that he did not take students seriously.[27] Concerns heightened when *Horizontal Pillar*, a 100-yard, site-specific straw and grass sculpture by Jud Fine, was spirited away from a central lawn and briefly set on fire. In an open letter to *California Tech*, Smith excoriated an "irresponsible" and "selfish" few whose actions both he and the artist now considered integral to the work. Student detractors reacted. "I hate to disillusion Mr. Smith," wrote "Sid," "but I believe it is he and his world of so-called art-appreciators who are by far the minority in this case."[28]

With PAA's financing of Baxter at its four-year mark, the organization asked Noll to lay out Caltech's future plans. Noll wanted Baxter to succeed and had already urged Smith to take a more student-centric approach. He had expanded the six-person board, placing Baxter's first director, David Smith, at its helm. He also assured PAA that Caltech would assist in raising funds for a new gallery. Even so, Noll cautioned, Caltech would *not* assume more of Baxter's operating costs, citing an already "substantial" outlay of space, utilities, and staff time.[29]

Michael Smith talked up his track record, and why not? He could boast of fifteen exhibitions; write-ups in *ArtForum* and *Art News*; a suite of catalogs; and a long list of artist films and lectures (page 299). Still, some felt that he valued art world approval over campus-wide appeal. Privately he fumed about the board. "How much fundraising does the director of the Getty Museum do?"[30] The questions of who should pay for the gallery and who should raise funds for it led to finger-pointing and recriminations all around. A consensus emerged: Smith had to go.[31] Caltech did not renew his contract and he left in the fall of 1982.

The hiring of Jay Belloli as director later that same year appeared to signal a desire for Baxter's success. Belloli, a contemporary curator with extensive museum experience, understood that raising money came with the job. "It's tough to reach students and even tougher to reach faculty," he admitted in an early interview with the press.[32] He responded by developing exhibits with wide appeal, featuring figurative and landscape art, seminal local collections, hometown artists like John Altoon, and regional architecture, including the Caltech campus. In an inspired move, he brought in artist Rockne Krebs to create *Caltech and the Argon Comet*, an installation that pointed a helium argon laser from atop Mount Wilson down to campus, its dazzling green beam visible for miles. The accompanying exhibit, a retrospective of Krebs's drawings, traveled to the Corcoran Gallery in Washington, D.C., a feat Belloli managed by securing a grant.[33]

Many in Baxter's sphere saw a reenergized gallery and applauded Belloli's vision and drive. Behind the scenes all was not well. PAA and the Baxter Board kept pushing to move the gallery from its inconspicuous, makeshift basement to a new purpose-built space. President Goldberger agreed to a feasibility study for a fundraising campaign but was emphatic that no faculty, staff, alumni, or current Caltech donors could be approached for money and that PAA be held in check.[34] The new provost, physicist Rochus "Robbie" Vogt, opposed the idea of a new building for Baxter and became particularly vexed at overreach by the "meddling women" of PAA. He noted the existence of two illustrious neighboring museums—The Huntington and Norton Simon—and asked, "Is it really Caltech's mission to create another gallery?" Goldberger pondered his options. The answer was "no."[35]

In June 1984, Goldberger wrote PAA that an "art gallery is not something the Institute can continue to maintain."[36] Confusion and outrage ensued. Letters and editorials in both campus and local newspapers decried the closure, and a "Save Baxter" campaign got under way. Over summer and into fall, Goldberger defended his decision. Baxter sat at the *periphery* of Caltech's research and teaching commitments, he said. Student and faculty interest remained low. Moreover, Baxter had become "a victim of its own success" during Belloli's brief tenure, and Caltech could not continue supporting the program at a cost of $50,000 a year.

Unknown Photographer
Installation view, *of no particular theme*,
artworks by Woods Davy (*Trancas*, 1982) and Laurie
Brown (*Land Site Displacements*, 1982), 1982
35 mm slide
Caltech Archives and Special Collections

(Records from the period indicate that the gallery itself was debt free, and that Caltech's actual outlay was closer to $35,000 annually.)[37]

This assertion drew incredulity, sparking gossip and speculation, the most outlandish being that Mildred Goldberger, the president's wife, helped kill off Baxter. "No faculty or administrative wife has any influence [at Caltech]," she shot back.[38]

On July 31, 1985, Baxter Art Gallery closed its doors for good. Belloli's final show, a critically acclaimed exhibit on 25 years of space photography, would subsequently travel to 50 venues in the United States and abroad. From its debut in 1971 to its closing, Baxter presented more than 85 exhibitions, published 43 catalogs, and featured hundreds of emerging and established artists. The Smithsonian requested Baxter's archive, an acknowledgment of its standing, even if brief, in the art world. Caltech turned the gallery into faculty offices. All that remains today is a motley assortment of posters and artworks scattered throughout Baxter's halls.

Baxter Art Gallery put a vaguely conceived hypothesis to the test: exposure to art could enhance the Caltech experience and open minds. Across fourteen years, three Caltech presidents and as many directors, the gallery's purpose remained amorphous and ill-defined. Attendance ebbed and flowed. Exhibitions received mostly positive coverage in regional and national press. The one consistent variable over the gallery's short life was Caltech's refusal to supply permanent budgetary or curricular support.

What made a Caltech art gallery untenable at the highest institutional ranks? And why the sudden closure just as Baxter appeared on the verge of greater visibility and success? Internal politics played an outsized role as faculty, influential administrators, and the provost insisted that Caltech had more urgent priorities to address. Across memos and behind closed doors, objections mounted as an extracurricular experiment threatened to become more than initially promised. More visible. More prominent. Most damning of all, more financially burdensome at an institute dedicated to science, not the arts. Even Roger Noll, one of Baxter's few faculty champions, viewed the gallery as an attractive bauble, "a pleasant, useful frill."[39]

The evidence suggests that Goldberger, and Goldberger alone, impetuously made the decision to close Baxter Gallery. Between PAA's relentless demands and an interfering provost's insistence that the gallery should not exist, Goldberger threw up his hands. Years later, he admitted his mistake, calling the decision the biggest gaffe of his career.[40] Not because he valued contemporary art per se. Baxter Art Gallery, he came to realize, drew a community of cultured art lovers and supporters to, of all places, Caltech.[41]

1—"Baxter Hall—A Laboratory for the Humanities and Social Sciences," *Engineering and Science*, May–June 1971, 12–18; audiocassettes, May 10, 1971, Baxter Hall Dedication file, Historical Files, Caltech Archives and Special Collections.

2—J. Kent Clark to Faculty Board, October 1, 1968, Art Program file, Marvin L. Goldberger Papers, Caltech Archives; Clark, interview by Shelley Erwin, January 24, 1989, Caltech Archives Oral History Project, 36.

3—"Art and Science Wed at Caltech," *Caltech News*, March 1969, 2.

4—Clark, "Report on Caltech Art Program, 1968–1971," Art Program file, Historical Files, Caltech Archives.

5—David Smith, interview by Jay Belloli, May 29, 1985, audiocassettes, Administrative Records series, Baxter Art Gallery Records, Archives of American Art, Smithsonian Institution (hereafter AAA); Lee A. DuBridge memo, November 7, 1968, Art Program file, Goldberger Papers.

6—*Contemporary Sculpture*, May 1–6, 1968, Various Exhibitions file, box 5, folder 3, Exhibition Files series, AAA; Clark, "Report," 6.

7—For insight into Van Vuuren's tenure at Caltech, see Peter Sachs Collopy's essay in this volume.

8—David Smith, interview.

9—David Smith, interview; Robert A. Rosenstone, interview by Shirley K. Cohen, June 27, 2005, Caltech Archives Oral History Project, 12; Lukas van Vuuren, "Two Year Report on the Development of the Workshop and Gallery," April 19, 1971, Art Program file, Historical Files, 8–9.

10 Christy Fox, "Art Amenities at Caltech Think Tank," *Los Angeles Times* (hereafter *LAT*), April 19, 1970.

11—"Baxter Festival," Art Program file, Historical Files.

12—Arnold Beckman to Harold Brown, August 4, 1971, Art Program file, Goldberger Papers.

13—Many opinions and cartoons about campus art appear in *The California Tech* between 1971 and 1975.

14—William Wilson, "Science-Fiction Art at Caltech," *LAT*, May 22, 1972.

15—Richard Steele to Harold Brown, September 2, 1975, Baxter Art Gallery and Administrative Committee on Art file, Goldberger Papers.

16—Gregg Brown, "Into the Sunset," *California Tech*, April 23, 1976.

17—Sandy McCorquodale, "A Verdict of Sorts," *California Tech*, April 30, 1976; Henry Fuhrmann, "Baxter Art Gallery Reopens," *California Tech*, March 4, 1977.

18—Suzanne Muchnic, "Caltech Gallery is Reopened," *LAT*, October 10, 1977.

19—Michael Smith, "Personal General Overview of...Baxter Art Gallery," Biographical Material on Michael Smith file, Administrative Records series, AAA.

20—*Michael Brewster* (Pasadena: Baxter Art Gallery, 1977), 11.

21—Muchnic, "Conceptualism Spans the Gulf," *LAT*, May 1, 1978.

22—Muchnic, "Creative Questioning," *LAT*, June 5, 1978; Attendance, Board of Governors file, Baxter Art Gallery Records, Caltech Archives.

23—Greg Van Der Werff to David Morrisroe, September 5, 1979, Baxter Art Gallery and Administrative Committee on Art file, Goldberger Papers.

24—Muchnic, "Unassuming Expressions," *LAT*, February 17, 1980.

25—Bruce Miller, "Miller's Highlife," *California Tech*, February 22, 1980; Guest Book, 1980, box 2, folder 14, Administrative Records series, AAA.

26—Michael Smith, "Notes of Meeting," February 13, 1980, Roger Noll file, Baxter Records, Caltech Archives.

27—Michael Smith, "Notes," Art Alliance file, Baxter Records, Caltech Archives.

28—Michael Smith and Sid, "Commentary," *California Tech*, October 17, 1980.

29—Pasadena Art Alliance (PAA) to Roger Noll, June 16, 1980, Art Alliance file; Noll to PAA, January 20, 1981, Board of Governors file.

30—Michael Smith, "Proposal for Continued Support," Board of Governors file; Michael Smith, "Description of Director Duties," Caltech Y file, Baxter Records, Caltech Archives.

31—Rosenstone, interview, 17.

32—Melody Malmberg, "Q&A: Jay Belloli," *Pasadena Weekly*, May 31–June 4, 1984.

33—*Rockne Krebs* file, box 9, folder 4, Exhibition Files series, AAA.

34—Dwain Fullerton, January 26, 1984, Baxter Art Gallery file, Goldberger Papers.

35—Rochus Vogt to Goldberger, February 13, 1984; unsigned memo, April 11, 1984; both in Baxter Art Gallery file, Goldberger Papers.

36—Goldberger to PAA, June 19, 1984, Baxter Art Gallery file, Goldberger Papers.

37—Daily attendance averaged 14 visitors for 1982–83 and 32.2 for 1983–84. Baxter Art Gallery file, Horace Gilbert Papers, Caltech Archives.

38—Larry Wilson, "The Politics of Art," *Pasadena Weekly*, June 27–July 3, 1985.

39—Noll, interview by author, April 8, 2022.

40—Annette J. Smith, interview by Heidi Aspaturian, December 11, 2010, Caltech Archives Oral History Project, 62; Noll, interview.

41—Noll, interview.

Claudia Bohn-Spector

"A CONSPIRACY OF BACHELORS": Caltech and the Visual Arts at Mid-Century

Goodbye! In fact, we will meet again. On one condition: we have to separate.
—Friedrich Nietzsche to August Strindberg[1]

In the early 1960s, the California Institute of Technology found itself at a crossroads. Established on the foundations of the coeducational Throop Polytechnic Institute in Pasadena, Caltech had emerged as a world-renowned science and engineering school, tightly aligned with the powerful interests shaping Southern California's ascendant techno-sphere. Boasting a state-of-the-art campus and an all-star faculty with a growing stable of Nobel laureates, the overwhelmingly male institution suddenly faced an internal reckoning: a 1963 Caltech survey revealed that a significant sector of alumni believed, as historian Amy Sue Bix notes, "that the absence of co-eds had 'limited or interfered' with the quality of their education."[2] Worse, both alumni and students regarded the Institute as a creative wasteland in need of social opportunities and meaningful institutional engagements with art and culture.[3] In 1966, a blistering editorial in the student newspaper openly blamed single-sex education and an overly narrow scientific focus for this glaring deficiency, noting that "the brutal facts are that the basic, 'skewed' nature of Caltech's population...tends to foment boorishness and anti-intellectualism."[4] Caltech, the editorial writer lamented, created intellectually and emotionally stunted "Eunuchs of Science"—ill-equipped products of "a perfectly functioning machine," as one respondent to a 1968 student questionnaire noted, that "turns out very bright fellows with a lot of precision, but *no soul*."[5]

Over the next decade, pressured by its undergraduates, Caltech worked to moderate its reputation as a sterile and sequestered bachelor factory.[6] Despite the dogged resistance of some of its senior faculty, the school opened its doors to both the visual arts and women in consecutive years—1969 and 1970, respectively—pledging support for the new-fangled ideal of "creative collaboration" then sweeping postwar American science institutions.[7] While Caltech eventually integrated women into its privileged ranks successfully, its institutional embrace of the visual arts was at best lukewarm and unambitious.[8] A short-lived art program and a campus gallery both folded ingloriously, leaving Caltech without a serious investment in the visual arts that could have rivaled institutional efforts elsewhere, such as MIT's Center for Advanced Visual Studies (CAVS), created in 1967 by the Hungarian-born artist and educator György Kepes.

It is a peculiar coincidence that not far from Caltech, at the Pasadena Art Museum on Colorado Boulevard, a 1963 exhibition illuminated precisely what ailed the powerful institution in the eyes of its students. Just as disaffected students jolted Caltech into taking a series of unprecedented steps, the great French modernist and artist-engineer Marcel Duchamp staged a spectacular comeback after decades in hiding, showcasing a replica of his celebrated masterpiece *The Bride Stripped Bare by Her Bachelors, Even*, also known as the *Large Glass* (page 303). The enigmatic work, created nearly half a century earlier, is a witty and cerebral allegory on the fraught relationship between the sexes and the impossibility of transcending fixed boundaries. Displayed just blocks away from Caltech, the *Large Glass* offers a surprising but oddly appropriate metaphor for Caltech's contemporaneous struggles. At mid-century, the school's longstanding commitment to single-sex education and prioritizing science and engineering research above all else proved a fateful legacy that prevented it, at a pivotal moment in its history, from "crossing over" and embracing the visual arts as a meaningful, and indeed desirable, complement to its academic endeavors. Locked into its hermetic seals and administrative divisions, Caltech missed an important opportunity: to harness the full range of the burgeoning Los Angeles avant-garde

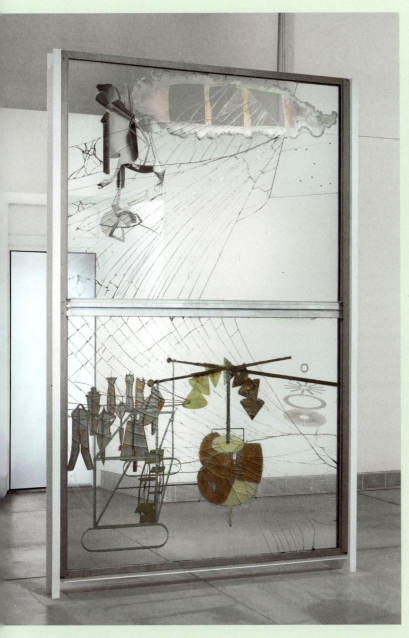

Marcel Duchamp
The Bride Stripped Bare By Her Bachelors, Even (The Large Glass), 1915–1923
Oil, varnish, lead, and dust on glass panels
Philadelphia Museum of Art

to forge a lasting union between art and science that could have spawned a new, uniquely Southern Californian brand of techno-aesthetic collaboration.

For an exploration of the visual arts and Caltech in the 1960s, Duchamp's *The Bride Stripped Bare by Her Bachelors, Even* offers an oblique but intriguing object lesson. Created between 1915 and 1923 in New York, the *Large Glass* is a humorous, conceptual statement on erotic desire cast in the scientific-technological idiom of late nineteenth-century ether physics.[9] Based on hundreds of notes and preparatory drawings, the work has been described as a "unique image-text system," a fascinating but largely incomprehensible pictogram of the suspended attraction between opposites.[10] The size of a tall, single-hung window, the *Large Glass* depicts the collision of two separate but interrelated realms: in the upper half of the *Glass*, a four-dimensional, biomechanical Bride floats weightlessly like an amorphous apparition, entrancing a group of mechanical Bachelors in the three-dimensional, gravity-bound section below.[11] The relationship between suitors and bride is complicated, attended by strange sparks and illuminating gases, electromagnetic waves, and wireless telegraphy—the tantalizing alchemy of an impossible union. Accidentally damaged in transit in 1927, the *Large Glass* and its 1960s replica show a network of cracks rippling across the transparent picture plane like an electrostatic discharge, underscoring the dynamic nature of the ill-fated encounter.

Duchamp rarely copied real scientific imagery; instead, he invented complex imaginary constructions filled with breathtaking intellectual complexity and humor. As art historian Linda Dalrymple Henderson has noted, he used "visual and verbal metonymy to encode his scientific content and usually layered one meaning over another in individual components of the *Large Glass*."[12] Duchamp famously called the Bachelor panel at the bottom of the *Large Glass* a *machine célibataire*, a fictitious male apparatus forever detached from communion with an ethereal female other.[13] The French writer Michel Carrouges, in his 1954 analysis of mechanistic ideas about society, eroticism, and religion in the late nineteenth and early twentieth centuries, seized on the Duchampian image as a pervasive literary and artistic leitmotif that fascinated authors as diverse as Bram Stoker, Franz Kafka, Raymond Roussel, and Sigmund Freud.

He called the "celibate machine" and its life-defying solipsism "a fantastical image that transforms love into a technique of death"—a closed system at once improbable and based on mathematical logic, less a love bed than a dissecting table upon which the dualism of opposing realms could be played out.[14] In the early 1970s, the Swiss curator Harald Szeemann organized an entire exhibition, *The Bachelor Machines*, around this surrealist theme, focusing on notions of "transcendence, horror, anthropomorphism of the machine, irony, autism, and speculation," as the critic Barbara Flynn noted in her 1976 review, provocatively entitled "A Conspiracy of Bachelors." "Bachelor machines," she added, "are statements...on the male's aspiration for something beyond himself; masturbation and artistic creation are shown to be activities that work like machines,...[symbolizing] the futility, lack of function, and incomprehensibility alluded to by Duchamp's ensemble."[15]

With its obscure alchemical figurations and splendid ambiguity, Duchamp's masterpiece was the *pièce de resistance* of his Pasadena retrospective, fawned over by the cognoscenti of the Los Angeles art world. Installed in the center of the main gallery, surrounded by objects that figured in its making, the work also served as the backdrop for an iconic stunt: a staged chess match between the aging Duchamp and a voluptuous nude, the 22-year-old Los Angeles writer Eve Babitz. Their performance echoed the *Large Glass*, elevating its narrative of desire and delay to the realm of voyeuristic theater.[16] Together, the *Large Glass* and the impromptu chess match it inspired harkened back to earlier eras of Freudian psychoanalysis, sexualized machines, and pre-Einsteinian physics that, in late nineteenth and early twentieth century America, had coincided with militant doctrines of "Bachelordom."[17] These doctrines, a sign of their time, would also profoundly shape the newly founded California Institute of Technology.

Caltech was primarily the brainchild of astrophysicist George Ellery Hale, who in 1908 hired the Lutheran minister James A. B. Scherer as the president of Throop Polytechnic Institute. In 1910, Scherer gutted Throop's vibrant art and vocational programs and decreed single-sex education.

"We have no women at all," he gleefully wrote to Hale. "I found that there would be so few that it would not be just to themselves to come here. Probably this settles the question of co-education, and I trust, without exciting the militant suffragettes."[18] Hale welcomed the news: "I was much pleased to hear of the registration at Throop," he wrote back, "and especially of those who didn't get in."[19]

Under Hale's aegis, Scherer quickly refocused the nascent school toward engineering. In 1916, two years after World War I broke out in Europe, he added national defense work and "patriotic preparedness" drills to the curriculum. When America's entry into the war seemed increasingly likely, Hale quickly shifted his attention to Washington, spearheading the founding of the National Research Council, tasked with mobilizing American science to support the war effort. Back in Pasadena, campus exercises in trench warfare signaled Caltech's Bachelor machine-in-the-making. In 1918, Hale added two renowned scientists—the MIT chemist Arthur Amos Noyes and physicist Robert A. Millikan from the University of Chicago—to his leadership team, forging the formidable "triumvirate" that would guide Caltech into the future (page 251).

As Caltech's imperious chairman, Millikan substantially shaped the character of the Institute, proselytizing a uniquely West Coast blend of science, corporate interests, and then-popular notions of Aryan supremacy. "In an important sense," historian Mike Davis has noted about Millikan, "this utter reactionary, who was totally out of step with younger, more progressive scientific leadership in places like Berkeley and Chicago, defined the parameters—illiberal, militarized, and profit-driven—for the incorporation of science into the economy and culture of Southern California."[20] Echoing Los Angeles' most ardent civic boosters and the progenitors of the California eugenics movement, whose programs of forced sterilization he supported by serving on the board of Pasadena's Human Betterment Foundation, Millikan wrote that "Southern California is today, as was England two-hundred years ago, the western-most outpost of Nordic civilization." "If [it] is to continue to meet the challenges of her environment," he added, "her supreme need...is for able, creative, highly

endowed, highly trained men in science and its applications."[21] About contemporary artistic expression, Millikan predictably had little positive to say, lamenting "the thoroughly diseased state of mind that is found so often in modern art."[22]

Caltech's military engagements reached their apex during World War II, when Millikan's "men of research" aided in developing the atomic bomb and other top-secret ordnance systems funded by 80 million dollars in federal support.[23] Under the new, postwar leadership of physicists Lee Alvin DuBridge and Robert Bacher, who had directed the Manhattan Project's infamous "G" Division ("G" stood for "the gadget," the implosion plutonium device first detonated in the Trinity test in New Mexico and subsequently dropped on Nagasaki in August 1945), Caltech's blueprint for a masculine, science-and-engineering-dominant institution was complete.[24] The school then hitched its fortunes to the U.S. government's Cold War struggle against communism and California's quest for dominance in jet aviation, electronics, and space exploration, cementing its role as the central hub in the "vast wheel" of Southern California's academic-military-industrial complex.[25] However, as faculty members of the Ad Hoc Committee on the Freshman and Sophomore Years would soon warn, according to Bix, "Caltech's insistence of technical precision harmed students by stifling creativity and social consciousness," leaving their lives, as one visiting professor noted, "gray" and "de-humanized."[26]

Throughout much of Caltech's history, the visual arts at "Millikan's monastery" led a shadow existence. Relegated to the fringes of academic life, they quietly flourished in the work of individual scientists who turned to the arts to help solve their pressing research questions. When evolutionary biologist Thomas Hunt Morgan joined the faculty in 1928, he brought along the accomplished illustrator Edith Wallace, whose detailed drawings of *Drosophila melanogaster* are among the earliest depictions of the common fruit fly then circulating among scientists (pages 4 and 108). They enabled scientists to map its chromosomes and the influences of genetic mutations.[27] In 1927, George Ellery Hale recruited the brilliant architect Russell Porter to aid in the design of the 200-inch Hale telescope at Palomar Observatory, then the largest on Earth (page 35). The partnerships of Nobel laureate Linus Pauling and Los Angeles Renaissance man Roger Hayward in the 1940s and 1950s and the work of Caltech biochemist Richard E. Dickerson with New York artist Irving Geis in the 1960s substantially aided twentieth-century understanding of molecular architecture (pages 127 and 137–41).[28] Likewise, Carl Anderson's groundbreaking 1932 discovery of the positron led to a collaboration with Academy Award-winning film director Frank Capra, himself a graduate of Throop.[29] Richard Feynman's depictions of quantum electrodynamics, known as Feynman Diagrams, sprang from his extraordinary gift for visualization, which found new creative expression in the 1960s and '70s through his friendship with the Pasadena artist Jirayr "Jerry" Zorthian, from whom he took drawing lessons (pages 185–87). These and other creative alliances attest to the rich and mutually influential connections between individual artists and scientists that blossomed below the surface of Caltech's larger hegemonical enterprise.

While individual scientists may have had an abiding interest in the visual arts, Caltech, as an institution, was slow to catch on. In the summer of 1969, prompted by widespread interest in aesthetic-technological collaboration, the visual arts made their first official appearance on campus with a carnival-like "cyber celebration" of the Apollo 11 moon landing, organized with the local chapter of the critically acclaimed Experiments in Art and Technology organization in New York. To this day, it remains the most magical art event Caltech has ever hosted, featuring imaginative space constructions, bouncy lunar dances, and a helium-filled membrane to simulate zero gravity for its moon-struck participants.[30] Physicist Elsa Garmire, one of Caltech's relatively few female research fellows, built an interactive laser wall exploring art and science's "third culture" intersections.[31]

That same year, a group of Caltech humanities professors led by literature professor J. Kent Clark inaugurated an official art program to bring scientists and artists into closer conversation with one another. "Art and Science Wed at Caltech: Long Campus Honeymoon Begins," *Caltech News* enthused about

"A Conspiracy of Bachelors"

Lukas Van Vuuren, R. M. Barnett, E. Noller, N. R. Morgan in front of space simulator at J.P.L.

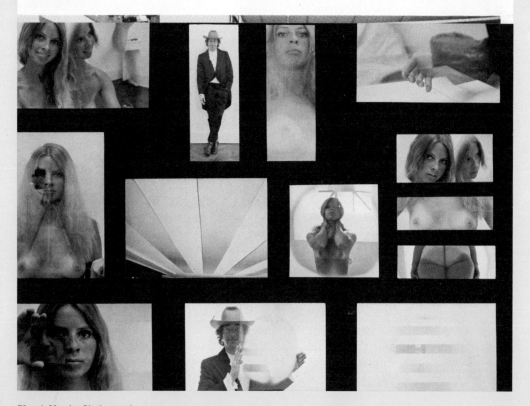

Floyd Clark, Photographer
CIT JPL Van Vuuren invitation, 1972
Poster
Caltech Archives and Special Collections

the new union, which promised to make "the creative sparks fly" with regular exhibitions, art acquisitions, and an artist-in-residence program.[32] The London-trained artist Lukas van Vuuren was hired from nearby all-female Scripps College to direct the initiative. The marriage was to be consummated at the defunct Earhart Plant Research Laboratory, which had been hastily converted into studios and darkrooms to accommodate the visiting artists.

This push for intellectual diversity coincided with students' urgent demands for coeducation and cultural programs that enabled "participation by the men and obtaining women with whom the men can 'participate,'" as one candidate for student-government social chair put it.[33] However, rather than fruitfully marrying art and technology by pollinating the new program with a rich blend of female perspectives, Caltech—in a metaphorical "Conspiracy of Bachelors"—jumped into bed with that other great Bachelor machine of the day, the art world, which was as at ease with discrimination and exclusion as the school itself. Between 1969 and 1971, Van Vuuren hired only one woman, Helen Pashgian, for the fledgling program, attesting to Caltech's—and the art world's—enduring patriarchy.

Caltech's short-lived art program concluded with a 1972 solo exhibition of Van Vuuren's work, consisting of large, simultaneously transparent and reflective plexiglass sheets coated in the Jet Propulsion Laboratory's vacuum chamber by electron beam-heated vapors. He issued a small fold-out brochure to accompany the show, which prominently featured a nude young woman posing with his work (left).[34] Like Duchamp's famous *Large Glass*, which Van Vuuren seems to reference, the leaflet is split into two juxtaposed realms, presenting the Bachelor-artist and his all-male collaborators in various high-tech settings, enraptured by a sun-kissed blonde stripped bare to model their alchemical creations. A far cry from Duchampian intelligence, wit, and originality, Van Vuuren's one-dimensional display misleadingly hitched the arts to the availability of unclad women, likely disappointing the hopeful bachelors attending his exhibition.

That the beautiful young woman in these pictures may have been Van Vuuren's wife made her blatant objectification all the more astonishing.[35]

With the demise of the art program, attention shifted to the newly inaugurated Baxter Art Gallery, tucked away in the Donald E. Baxter Hall for the Humanities and Social Sciences basement.[36] Among the gallery's first exhibitions was a show of innovative resin works by artists-in-residence Robert Bassler, Peter Alexander, David Elder, and Helen Pashgian. The accompanying brochure showed its four emerging artists "at work" (pages 308–9).[37] Sculptor Peter Alexander, sporting a crisp tuxedo, lounges in an ornate hotel suite with fellow artist Billy Al Bengston dozing nearby— two Bachelors luxuriating after a night of glamourous exploits. While Alexander languidly reaches for his martini, the lone woman in the program, Helen Pashgian, is seen actually *working*, finishing a large translucent polyester lens of the kind that eventually secured her fame as one of Southern California's foremost Light and Space artists. Similarly, Baxter's 1974 exhibition *A California Turn On: Electric and Kinetic Art* included but a single woman, Loretta Keller, whose husband taught mathematics at Caltech. Its suggestive brochure cover featuring a joystick conveys the challenges that beset the few women who joined the Institute in the mid-century.[38] "I have nothing but bitter hatred for all of Caltech," Elsa Garmire recalled in 1985 about the hostile environment she faced at the male-dominated school. "Most women I know that have been at Caltech feel that same way. ... It was just the entire aura of male bastion ... that was just incredibly difficult to take."[39] In 2021 she added that she had felt tremendously powerless at Caltech: "Couldn't get my name on a proposal. Everything I did had to be thanks to some man who was allowing it to happen. ... There were no women, except under positions where they were working for men."[40]

In 1970, Caltech finally admitted its first class of undergraduate women, bringing Caltech's exclusive Bachelor machine to a richly deserved end. In 1976, following the first International

"A Conspiracy of Bachelors"

David Smith
"[Peter] Alexander at Work," *CIT Art Program*
invitation, 1971
Photograph
Caltech Archives and Special Collections

David Smith
"[Helen] Pashgian at Work," *CIT Art Program*
invitation, 1971
Photograph
Caltech Archives and Special Collections

Women's Year, Baxter Art Gallery devoted an entire exhibition to *Four Women/Four Cultures*, opening at least a temporary pathway for more female artists of diverse backgrounds to engage with the Institute's scientific mission. With funding running out, Caltech's tentative embrace of the visual arts finally collapsed in 1985 with the closure of Baxter Art Gallery, largely at the behest of then-president Marvin Goldberger, who predictably considered the enterprise a distraction from the Institute's primary mission. The termination of the gallery, then at the cusp of greater recognition, constituted a monumental failure of the imagination, as Goldberger himself would later recognize. In the end, the imperial legacy of "Millikan's monastery," with its rigid boundaries and demographic exclusions, proved impossible to overcome, just as Duchamp's *Large Glass* and its emphasis on frustration and delay had so poignantly foreshadowed.

It would take a new era of multi-disciplinarity, diversity, and collaboration for the visual arts to take a deeper hold at Caltech. Today, the Institute's Data to Discovery initiative, created in collaboration with the Jet Propulsion Laboratory and ArtCenter College of Design, and its Visual Culture program, founded in 2019 in partnership with Huntington Library, are but two examples of new offerings that blend science and the visual arts at the Institute (pages 190 and 192–93). Likewise, at JPL's The Studio, a team of visual strategists help scientists imagine the future (pages 238–39 and 245).[41] With this multimedia exhibition, springing from PST ART's unprecedented region-wide exploration of art and science's myriad intersections, new institutional opportunities beckon to forge the kind of lasting creative connections that have eluded Caltech in the past.

1—Herman Scheffauer, "A Correspondence between Nietzsche and Strindberg," *North American Review* 198, no. 693 (1913): 204, cited in François Lyotard, "Consideration of Certain Partition-Walls as Potential Bachelor Elements of a Few Simple Machines," in *Le Macchine Celibi = The Bachelor Machines*, ed. Harald Szeemann (Venice: Rizzoli, 1975), 98.

2—"Alumni criticized fellow graduates as socially unaware, a defect that they blamed on the Institute's 'over-emphasis on technical subjects, a need for more liberal arts, and for more attention to...values.'" Amy Sue Bix, *Girls Coming to Tech! A History of American Engineering Education for Women* (Cambridge, MA: MIT Press, 2014), 195.

3—Bix, *Girls Coming to Tech!* 195–97.

4—John Middleditch, "'Eunuchs of Science,'" *California Tech*, October 6, 1966.

5—Bix, *Girls Coming to Tech!* 211. Emphasis in the original.

6—Bachelors and Brides are capitalized in keeping with Linda Dalrymple Henderson's usage in her work on Duchamp.

7—Matthew Wisnioski, "Why MIT Institutionalized the Avant-Garde: Negotiating Aesthetic Virtue in the Postwar Defense Institute," *Configurations* 21, no. 1 (2013): 91; Anne Collins Goodyear, "From Technophilia to Technophobia: The Impact of the Vietnam War on the Reception of 'Art and Technology,'" *Leonardo* 41, no. 2 (2008): 169–73.

8—For detailed information on Caltech's artist-in-residence program and Baxter Art Gallery, see Peter Collopy and Jennifer Watts' essays in this volume.

9—Henderson, "The Large Glass Seen Anew: Reflections on Contemporary Science and Technology in Marcel Duchamp's 'Hilarious Picture,'" *Leonardo* 32, no. 2 (1999): 113–26.

10—Henderson, "Large Glass Seen Anew," 113; Harald Szeemann, "How to Identify Bachelor Machines," *Le Macchine Celibi*, 23.

11—Henderson, "Large Glass Seen Anew," 113.

12—Henderson, "Large Glass Seen Anew," 113.

13—Arturo Schwarz and Marcel Duchamp, *Marcel Duchamp: Notes and Projects for The Large Glass* (London: Hudson and Thames, 1969), 209.

14—Michel Carrouges, "Directions for Use," *Le Macchine Celibi*, 22.

15—Barbara Flynn, "A Conspiracy of Bachelors," *Artforum* 15, no. 2 (1976): 44.

16—Dickran Tashjian, "Nothing Left to Chance: Duchamp's First Retrospective," in *West Coast Duchamp*, ed. Bonnie Clearwater (Miami Beach: Grassfield Press, 1991), 74.

17—Michael Kimmel, *Manhood in America: A Cultural History* (New York: Free Press, 1996), 89.

18—Quotes in Judith R. Goodstein, *Millikan's School: A History of the California Institute of Technology* (New York: W. W. Norton, 1991), 31.

19—Goodstein, *Millikan's School*, 113.

20—Mike Davis, *City of Quartz: Excavating the Future in Los Angeles* (London: Verso, 1990), 57.

21—*The Autobiography of Robert A. Millikan* (New York: Prentice-Hall, 1950), 242.

22—Robert H. Kargon, "The Conservative Mode: Robert A. Millikan and the Twentieth-Century Revolution in Physics," *Isis* 68, no. 244 (1977): 526.

23—Goodstein, "History of Caltech," The Nobel Prize, June 29, 1998, https://www.nobelprize.org/prizes/themes/history-of-caltech.

24—See Patrick McCray, "Project Vista, Caltech, and the Dilemmas of Lee DuBridge," *Historical Studies in the Physical and Biological Sciences* 34, no. 2 (2004): 339–70.

25—"Nowhere else in the country did there develop such a seamless continuum between the corporation, laboratory and classroom as in Los Angeles, where Caltech...became the hub of a vast wheel of public-private research and development." Davis, *City of Quartz*, 57.

26—Bix, *Girls Coming to Tech!* 200.

27—Susan Hardy, "Drosophila Drawings," *Endeavors*, Spring 2009, https://endeavors.unc.edu/spr2009/endview.php.

28—See Soraya de Chadarevian's essay in this volume.

29—See Brian Jacobson's essay in this volume.

30—William Wilson, "Lunar Walk Hailed at Art-Science Fete," *Los Angeles Times*, July 22, 1969.

31—McCray, "Art at the Speed of Light," December 26, 2014, https://www.patrickmccray.com/leaping-robot/2014/12/26/art-at-the-speed-of-light.

32—"Art and Science Wed at Caltech," *Caltech News*, March 1969.

33—Bix, *Girls Coming to Tech!* 196.

34—*CIT JPL Van Vuuren* (Pasadena: Baxter Art Gallery, 1972).

35—David Smith, interview by Jay Belloli, May 29, 1985, audiocassette, Baxter Art Gallery Records, Archives of American Art, Smithsonian Institution.

36—For a complete list of Baxter Art Gallery exhibitions, please see page 314.

37—*Artists in Residence* (Pasadena: Baxter Art Gallery, 1971).

38—*A California Turn On: Electric and Kinetic Art* (Pasadena: Baxter Art Gallery, 1974).

39—Elsa Garmire, interview by Joan Bromberg, February 4, 1985, Niels Bohr Library and Archives, American Institute of Physics, https://www.aip.org/history-programs/niels-bohr-library/oral-histories/4621.

40—Elsa Garmire, interview by David Zierler, December 21, 2021, Caltech Heritage Project, https://heritageproject.caltech.edu/interviews-updates/elsa-garmire.

41—See Talia Shabtay Filip's essay in this volume.

Helen Pashgian
Untitled, 2023
Cast urethane
Helen Pashgian

Tim Durfee

EXHIBITS A & B
Notes for an Exhibition of Science and Art

01 Science and art, it is said, are domains of truth.

One seeks pure objectivity, free of value. The other is a currency of the subjective (even at its most objective). Both truths, but often different truths.

Except that humans are involved. And humans are not that different from one another. They are makers and thinkers and observers and ruminators. Science and art require peak versions of these types.

So, how to exhibit the work of scientists and the work of artists together, in the same space? While comparisons can be illuminating, they can also be misleading. There may be art in science, and science in art, but they are not the same.

Perhaps the answer is to present the work as evidence: exhibits A and B. Articles of proof for the works' respective revelatory agendas. Leaving the connections to be defended, deliberated, and discovered by the audience.

02 Both science and art swerve between competing sensibilities: Do we believe the eye or the mind? Should we be Aristotelian describers of the world, or Platonic searchers for structure? Should we pursue pictorial models or functional ones? Do we represent or simulate?

Or could it be these seemingly divergent modes are actually the same thing? If we could only observe the world closely enough, would a pure, scalable logic reveal itself? If we could climb a tree of logic to the tips of each branch, would we build the universe?

03 As a formal discipline, geometry is at home in the contexts of science and art. Perhaps this is because of its many dualisms. It is objective and inevitable, but also its use is willful, artificial. It is universal and heroic, but equally mundane and generic. Its unique descriptive transparency makes it the meeting place of concept and material.

These qualities have long prompted awe in the imaginations of both scientists and artists. But more than anything, perhaps it is that geometry embodies the elusive natures of both fields. It is unattainable in its pure form, yet its harmonics echo throughout the universe. It is simultaneously nowhere, and everywhere.

04 Strange and intriguing structures are found in labs and studios. These systems enable the real work to happen. They are armatures, frames, rigs, stretchers, bucks, and jigs. They are the 99.99 percent necessary to produce the 0.01 percent effect, the mountain of structure needed to produce the tiny gem. The form of this apparatus is rarely pre-ordained. Instead, it is the residue of a pragmatic pursuit: to condition the environment for a particular result. Sometimes, from within these systems, a super-logic emerges from the service logic. A specific architecture at the intersection of structure and subject.

05 There is something compelling about buildings within buildings. Perhaps it is the appeal of the classic *Matryoshka* doll. In this case, however, the nested elements are aliens— reactive rather than sympathetic to their host. They are autonomous, self-contained and self-supporting. And hosts to their own nested— and alien—worlds.

06 Pursue something that is simultaneously at the service of a subject, as well as being a subject itself. Cultivate a specific language of accommodation. A pragmatism so literal it becomes its own thing.

07 In architectures of information—like exhibitions—the agenda of the structure is to provide suitable exposure to content. It is a surface-area problem. The project of the architectural plan is less about definitions of functional volume than about the direction of movement and time.

08 For temporary construction: fastening over fusing.

09 And that is, after all, what an exhibition is: a momentary connection—a fastening—of elements borrowed from their original context. It is an artificial and temporary fusion that allows us to encounter evidence we would otherwise miss. Will it yield something new? Or will it be something we have always known?

Tim Durfee
Preliminary exhibition design for *Crossing Over*, 2024
Digital renderings
Tim Durfee Studio

CALTECH ART EXHIBITIONS, 1968–1985

SELECTED EXHIBITIONS, 1968–1970
Dabney Hall and Athenaeum Basement

1968

Contemporary Sculpture
Aldo Casanova, Edward Dron, David Gray, James Strombotne, Jack Zajac

Tamarind Lithography Workshop

1969

First Graphics Exhibition
Paul Darrow, James Fuller, Douglas McClellan, Paco A. Lagerstrom Collection

Four Printmakers
Leonard Edmondson, Shiro Ikegawa, Ynez Johnston, Ben Sakoguchi

Modern Tapestries from the Hurschler Collection

The Art of Richard Feynman

David Elder / Lukas van Vuuren

Paintings by Corda Zajac, Sculpture by Jack Zajac

1970

Paul Darrow / Ferenc Csentery

Chinese Painting, Calligraphy, and Art Objects

Corita Kent: Serigraphs

Early Sculpture in India

James Jarvaise: Paintings from Spain

The Thomas Terbell Family Collection

A Selection of Gemini Graphics from the Collection of Mr. and Mrs. David Gensburg

Petroglyph Rubbings from the Collection of Mrs. Virginia Steele Scott

BAXTER ART GALLERY EXHIBITIONS, 1971–1985

1971

Treasures of West African Art: The Victor Du Bois Collection

The Hiroshima Panels
Iri and Toshi Maruki

CIT Art Program
Robert Bassler, Peter Alexander, David Elder, Helen Pashgian

Lithographs: Daumier to Gemini

Tapestry West

1972

Aldo Casanova: Recent Sculpture

Affiches De La Belle Epoque: Turn-of-the-Century Posters from the Mr. & Mrs. Robert P. Meyerhof Collection

James Steel Smith: Drawings and Paintings

Surrealism is Alive and Well in the West
Terry Allen, Robert Arneson, Juan Badia, Bruce Connor, Vija Celmins, Ciba, Cynthia Corngold, George Herms, Edward Kienholz, Jerry McMillan, Cheri Pann, Sasson Pearl, Paul Ré, Edward Ruscha, Paul Sarkisian, Benjamin Serrano, Joe Steuben, William Tunberg, Stephan von Heune, Paul Wonner, et al.

CIT JPL Lukas van Vuuren

Robert E. Dewar: Computer Halftones

Contemporary Tapestries: The Hurschler Collection

Asian Art: Selections from the Eisenberg Collection

1973

California's Representation: Twelve Painters and the Human Figure
James Bolton, Susan Brenner, Joan Brown, Frank Cyrsky, Mark Greenwold, Richard Joseph, Ralph Morocco, Keisho Okayama, Gary Pruner, Lance Richbourg, Barbara Rogers, James Valerio

Three Californian Artists
Walter Askin, Max Finkelstein, Ben Sakoguchi

Tijuanatomia: Five Tijuana Artists
Felipe Almada, Juan Badia, Danielle Gallois, Guillermo Mellado, Benjamin Serrano

Ruth Asawa: A Retrospective View

Rhoda Kellogg Child Art Collection

1974

Marvin Lipofsky: Glass Sculpture

In the Japanese Tradition
Shiro Ikegawa, Matsumi Kanemitsu, Takeshi Kawashima, Shiko Munakata, Sueo Serisawa, Masami Teraoka

ca. 90291
Jon Abbot, Lita Albuquerque, Loren Madsen, Marc Masse, Kelly Hames, Nina Sobell, John Sturgeon, Jolynn Suzar

Selections from Mrs. Virginia Steele Scott's Knoll House Collection

A California Turn On: Electric & Kinetic Art
Larry Albright, Anait, Dwight Carey, Robert Durst, Robert Gilbert, Loretta Keller, Charles Mattox, Claes Oldenburg, Charles Prentiss, William Ransom, Benjamin Serrano, Jean Tinguely, Stuart Ziff

General Whale

1975

McCafferty DeLap
Jay McCafferty and Tony DeLap

Elyn Zimmerman / Alan Scarritt

ARTHUR AMES paintings / DOUGLAS MCCLELLAN collage

Greene and Greene: Architects in the Residential Style

Erosions & Other Environmental Changes: Carl Cheng

Michael McMillen: Environments

Hogarth, Lissaman, Morris, Rapoport, Zaima
Michael Hogarth, Nancy Lissaman, Ann Morris, Sonya Rapoport, Stephen Zaima

1976

Kinetic Sculpture
George Baker, Frank Malina, George Rickey

The Many Arts of Science Festival: Music, Poetry, and the Visual Arts from Bell Labs, Cal Comp, Caltech, Cranbrook
John Chowning, Gary Demos, John Pierce, John Whitney, et al.

Lawton S. Parker: An American Impressionist (1868–1954)

In Search Of…Four Women / Four Cultures
Judithe E. Hernández, Donna Nakao, Cheri Pann, Betye Saar

1977

Art Alliance Collects

Watercolors and Related Media by Contemporary Californians
Terry Allen, Billy Al Bengston, Natalie Bieser, Tony DeLap, Richard Diebenkorn, William Dole, Sam Francis, Charles Garabedian, Jud Fine, Matsumi Kanemitsu, Don Kaufman, Bruce Nauman, Nathan Oliveira, Terry O'Shea, Kenneth Price, Joseph Raffael, Bruce Richards, Edward Ruscha, Ann Thornycroft, William T. Wiley, Tom Wudl

Michael Brewster

1978

Geoff Winningham and Jacqueline Thurston: Photographs

The Poetry of Systems
Peter Fend, Channa Horwitz, Sol LeWitt, Joyce Lightbody, Karen Shaw

Robert Cumming and William Wegman

Hans Haacke

Laddie John Dill: A Survey of Work, 1971–1978

Making Senses: A Proposal for a Children's Museum

1979

Bryan Rogers: Timepieces

A Painting Installation by Donald Kaufman

Bruce Richards: A Selection of Paintings and Watercolor

Nathan Oliveira: A Survey of Monotypes, 1973–1978

Visionary Drawings of Architecture and Planning: 20th Century through the 1960s

Trains and Boats and Planes
Nigel Cooper, William Goodan, Edwin Janss, Noel Korten, Paul B. MacCready, Jr., David Maxim, John Roloff

1980

Richard Tuttle: From 210 Collage-Drawings

James Reineking

Jack Brogan: Projects
Lynda Benglis, Ron Cooper, Tony DeLap, Guy Dill, Frank O. Gehry, Joe Goode, Robert Irwin, Helen Pashgian

Architectural Sculpture
Marsia Alexander, Michael Davis, Jud Fine, Bruce Nauman

Terry Allen: part of and some in betweens

1981

SITE: Buildings and Spaces

Anti-Static
Lita Albuquerque, Jo Ann Callis, Dan Douke, Ned Evans, Mark Lere, Jay McCafferty, Nancy Monk, Gifford Myers, Jay Willis, Connie Zehr

Jerry McMillan: Recent Work

Peter Lodato: Dust

Barry Fahr, Tom Jenkins, Paul Ré

Doo Dah Parade
Chris Gulker, Spike Loveland, Denise Lawrence, Walt Mancini, Norman Maukopf, Joe Messinger, Robin Mueller

Berenice Abbott: Images of Physics and Faces of the '20s

1982

Siah Armajani: A Poetry Lounge

of no particular theme
Laurie Brown, Nancy Buchanan, Woods Davy, Brian Forrest, Tom Holland, Bruce Houston, Robert Rauschenberg, Raymond Saunders

Matter Memory Meaning
Neda Al-Hilali, Janet Boguch, Robert Brady, Tony Costanzo, Stephen De Staebler, Anita Fisk, Marcia Floor, Charles Christopher Hill, Debra Rapoport, John Roloff, Mary Shaffer, Barbara Thompson, Peter Voulkas

Reliquaries: Richard Turner, Architectural Sculpture / Narratives

1983

Rockne Krebs: A Retrospective of Drawings, 1965–1982

Molly Burgess

Patsy Krebs

Caltech 1910–1950: An Urban Architecture for Southern California

The Nicholas Del Pesco Collection

The Nancy Yewell Collection

Fluxus Etc. / The Gilbert and Lila Silverman Collection

The Common American Bungalow

Tile, Stucco Walls and Arches: The Spanish Tradition in the Popular American House

1984

Contemporary Ceramic Vessels: Two Los Angeles Collections
Betty Asher Collection, Howard and Gwen Laurie Smits Collection

Five Artists: Southern California
Don Gregory Antón, Stephen L. Berens, Grey Crawford, Stephanie Sanchez, Jon Swihart

John Altoon: 25 Paintings, 1957–1969

Myron Hunt, 1868–1952: The Search for a Regional Architecture

1985

Arroyo Seco Release: A Serpentine for Pasadena
Helen Mayer, Newton Harrison

Painting as Landscape: Views of American Modernism, 1920–1984

25 Years of Space Photography: Jet Propulsion Laboratory

CONTRIBUTORS

Claudia Bohn-Spector is the curator of *Crossing Over*. She has served in positions at the Museum of Modern Art in New York, the Getty Research Institute, and the National Gallery in Washington, DC. Her publications include *The Great Wide Open: Panoramic Photographs of the American West* (Merrell, 2001); *This Side of Paradise: Body and Landscape in Los Angeles Photographs* (Merrell, 2008); *Speaking in Tongues: Wallace Berman and Robert Heinecken, 1961–1976* (Armory Center for the Arts, 2011); and *American Aleph* (Kohn Gallery, 2016).

Peter Sachs Collopy is University Archivist and Head of Archives and Special Collections at Caltech, and director of *Crossing Over*. His recent publications include "Video and the Self: Closed Circuit | Feedback | Narcissism," in *Video Theories: A Transdisciplinary Reader* (Bloomsbury, 2022); "'Video Is as Powerful as LSD': Electronics and Psychedelics as Technologies of Consciousness," in *Expanding Mindscapes: A Global History of Psychedelics* (MIT Press, 2023); and "Between Paradigms: Video and Art Therapy," in *Modernism, Art, Therapy* (Yale University Press, 2024).

J. V. Decemvirale is Assistant Professor of Art History and Global Cultures at California State University, San Bernardino and an Angeleno of Italian and Peruvian descent. His research focuses on community art politics in the Americas. Decemvirale recently published a chapter in the anthology *Self Help Graphics at Fifty* (University of California Press, 2023). He is currently writing *Keeping Fires in the Hinterlands,* a decolonial untwining of art's hidden histories as a tool of epistemic conquest and resistance. His research has been supported by the American Council of Learned Societies, Caltech, the Smithsonian American Art Museum, the Social Science Research Council, and the Terra Foundation for American Art.

Soraya de Chadarevian is Professor of History at UCLA. Her publications include the coedited volume *Models: The Third Dimension of Science* (Stanford University Press, 2004), as well as *Designs for Life: Molecular Biology after World War II* (Cambridge University Press, 2002; paperback, 2011) and *Heredity under the Microscope: Chromosomes and the Study of the Human Genome* (University of Chicago Press, 2020).

Tim Durfee is Professor of Media Design Practices at ArtCenter College of Design, Principal of Tim Durfee Studio, and designer of *Crossing Over*. His publications include *Made Up: Design's Fictions* (Actar, 2018).

Talia Shabtay Filip is Postdoctoral Research Fellow in Art History at the University of Chicago. Her publications include "The Art and the Politics of *The Forgotten Space*," *Oxford Art Journal* (2015) and "Goldsholl Vision: Systems of Display, Technologies of Design" in *Up Is Down: Mid-Century Experiments in Advertising and Film at the Goldsholl Studio* (Mary and Leigh Block Museum of Art, 2018).

Judith R. Goodstein is an American historian of science and mathematics, archivist, and book author. She worked for many years at Caltech, where she is University Archivist Emerita. Her publications include *Millikan's School: A History of the California Institute of Technology* (W. W. Norton, 1991), *The Volterra Chronicles: The Life and Times of an Extraordinary Mathematician, 1860–1940* (American Mathematical Society and London Mathematical Society, 2007) and *Einstein's Italian Mathematicians: Ricci, Levi-Civita, and the Birth of General Relativity* (American Mathematical Society, 2018).

Christopher Hawthorne is Senior Critic at Yale School of Architecture, with a secondary appointment in Yale's English department. He is the former Chief Design Officer for the city of Los Angeles, a position appointed by Mayor Eric Garcetti, and the former architecture critic for the *Los Angeles Times*. His 2024 publications include a chapter in *Housing the Nation: Social Equity, Architecture, and the Future of Affordable Housing*, edited by Alexander Gorlin and Victoria Newhouse (Rizzoli), and the foreword to India Mandelkern's *Electric Moons: A Social History of Street Lighting in Los Angeles* (Hat & Beard Press).

Brian R. Jacobson is Professor of Visual Culture at Caltech. His publications include *Studios Before the System: Architecture, Technology, and the Emergence of Cinematic Space* (Columbia University Press, 2015), *In the Studio: Visual Creation and Its Material Environments* (University of California Press, 2020), and *The Cinema of Extractions* (Columbia University Press, forthcoming).

Charles A. Kollmer is Visiting Researcher in History at Caltech, where he was previously Ahmanson Postdoctoral Instructor in History of Biology, and teaches history at an independent school outside of Los Angeles. He has published peer-reviewed articles in the *Journal of the History of Biology* and *Engaging Science, Technology and Society*. His research has been sponsored by the Mellon Foundation and the American Council of Learned Societies; the Consortium for History of Science, Technology and Medicine; and the German-American Fulbright Commission.

Lois Rosson is Octavia E. Butler Fellow at the Huntington Library, and a former Berggruen Institute Fellow at the University of Southern California's Center on Science, Technology, and Public Life. Her work has also been supported by NASA, the Smithsonian's National Air and Space Museum, and Lawrence Livermore National Laboratory.

Anne Sullivan is Lecturer in the University Writing Program at University of California, Riverside, and was recently Anne Rothenberg Postdoctoral Scholar in Visual Culture at Caltech. Her publications include "Animating Flames: Recovering Fire-Gazing as a Moving-Image Technology," *19: Interdisciplinary Studies in the Long Nineteenth Century* (2017).

Jennifer A. Watts is Senior Curator for Library Special Projects at the Huntington Library. Her publications include *This Side of Paradise: Body and Landscape in Los Angeles Photographs* (Merrell, 2008), *Maynard L. Parker: Modern Photography and the American Dream* (Yale University Press, 2012), *A Strange and Fearful Interest* (Huntington Library, 2015), and *Nineteen Nineteen* (Huntington Library, 2019).

Bailey Westerhoff is Exhibition Coordinator for *Crossing Over*, and a doctoral student in Cultural and Museum Studies at Claremont Graduate University.

Kara Whatley is University Librarian at the California Institute of Technology, a position she has held since 2019. Her recent publications and invited talks include "Say You Want a Revolution: Digital Initiatives, Digital Futures (You Know It's Gonna Be Alright)," at the Digital Initiatives Symposium 2023; "Psychological Safety and Building Effective Teams," at Brick and Click Libraries in 2020; and "Virtual Reference/Query Log Pairs: A Window onto User Need," *Reference Services Review* (2011).

David Zierler is Director of the Caltech Heritage Project and Senior Strategist at Caltech. His publications include *The Invention of Ecocide: Agent Orange, Vietnam, and the Scientists Who Changed the Way We Think about the Environment* (University of Georgia Press, 2011).

IMAGE CREDITS

Kaiser Aluminum Corporation (6); Carnegie Observatories (20, 45, 87); Carnegie Institution for Science Collection, Huntington Library (30, 36, 68); Smithsonian Institution Archives (31 top); National Air and Space Museum, Smithsonian Institution (31 bottom); Southern California Edison (40); LIFE Picture Collection, Shutterstock (43); Archives and Special Collections, Vassar College Library (44); Rick Sternbach (47); Jim Janesick (56 top); Shana Mabari (61); Works Progress Administration Photo Collection, Los Angeles Public Library (63 bottom); Disney (65); Lita Albuquerque (67, 92–93); Helen Pashgian (70, 311, 320); Jamie Molaro (72); James Griffith (73); © 2024 Conner Family Trust, San Francisco / Artists Rights Society: ARS, New York (78); © Vija Celmins, Courtesy Matthew Marks Gallery (79); Lloyd Hamrol (80–81, 279); Robert Cumming Archive, LLC (83); Jane Brucker (90); Lia Halloran (94, 202–203); © Los Angeles Fine Arts Squad, © Terry Schoonhoven Estate, © Victor Lance Henderson (104 top); Regents of the University of California, CC BY 4.0 (104 bottom); Lewis Family Trust (106); Marine Biological Laboratory Archives, CC BY (107 top); Estate of George W. Beadle (114); Ava Helen and Linus Pauling Papers, Oregon State University Libraries (123 top, 127, 130, 138 top); Security Pacific National Bank Photo Collection, Los Angeles Public Library (123 bottom); Geis Archives, Howard Hughes Medical Institute (132, 133, 137, 141); Sandy Geis (140); Christopher O'Leary (150); Los Alamos National Laboratory (164); Magnolia Editions, Oakland, California (171); Los Angeles Examiner Photographs Collection, USC Digital Library (183 bottom); New School Archives and Special Collections (174); elin o'Hara slavick (176, 177); Michelle and Carl Feynman (185, 186 top, 187 top, 188); Cameron Parsons Foundation (208, 209); Ordo Templi Orientis Archives (210); Estate of Ed Emshwiller (211 bottom right); Stephen Nowlin (217, 290); Lucas Museum of Narrative Art, Los Angeles © & ™ Lucasfilm Ltd. All rights reserved. Used under authorization. (224, 236); Donald E. Davis (226–227 top); Seth MacFarlane Collection of the Carl Sagan and Ann Druyan Archive, Library of Congress (226); Terry Braunstein (241); Nobel Foundation (256 top); Beatrix Farrand Collection, Environmental Design Archives, University of California, Berkeley (258); Morphosis Architects (259); © J. Paul Getty Trust, Getty Research Institute, Los Angeles (263); Yazdani Studio of Cannon Design (265); Jon R. Friedman (278); Richard Serra (280); Collection of Charles Hack, image courtesy of Jud Fine (281); Estate of John Altoon (282); RCM Galerie (283); Hillary Mushkin (284–285); © John Whitney, Matrix I, 1971, Whitney Editions™, Los Angeles CA (286 top); © The Henry Ford (286 bottom); Los Angeles County Museum of Art, Gift of Elliott and Adrienne Horwitch (287); Robert Bassler (291); © 2024 LeWitt Estate / Artists Rights Society: ARS, New York (296); Woods Davy (299); © Artists Rights Society: ARS, New York / © Association Marcel Duchamp / ADAGP, Paris and DACS, London 2021 / Courtesy of Philadelphia Museum of Art, ADAGP and DACS (303); Tim Durfee Studio (313).

Every effort has been made to contact the owners and photographers of illustrations reproduced here whose names do not appear above. Anyone having further information concerning copyright holders is asked to contact Caltech Library so this information can be included in future printings.

Page 1
Josef J. Johnson
"Ninafou Eclipse," October 21, 1930
Photograph
Caltech Archives and Special Collections

Page 2
Willi Baum
Space Probe advertisement for Martin Company, 1960
Magazine (detail)
Prelinger Library

Page 4
Edith M. Wallace
Male fruit fly with *Ebony* mutation, 1920
Watercolor and ink on cardstock
Caltech Archives and Special Collections

Opposite page
Allyn B. "Hap" Hazard
Mock-up of lunar exploration suit, c. 1960
Photograph
Jet Propulsion Laboratory

Page 320
Helen Pashgian
Untitled, 2023
Cast urethane
Helen Pashgian

Back Cover
Terry Braunstein
Nuclear Summer #1 (background image by Chesley Bonestell), 1986
Photomontage
University of Michigan Museum of Art

Published in conjunction with the exhibition

CROSSING OVER
ART AND SCIENCE
AT CALTECH
1920–2020

September 27—December 15, 2024

Published by
Caltech Library
Pasadena, California
library.caltech.edu

Distributed by
Getty Publications
Los Angeles, California
www.getty.edu/publications

Available as a free PDF from CaltechAUTHORS:
https://doi.org/10.7907/6v5rz-dkg58

Principal Investigators
Peter Sachs Collopy and Kara Whatley
Curator
Claudia Bohn-Spector
Exhibition Coordinator
Bailey Westerhoff

Edited by Heidi Aspaturian
Proofread by Hillary Bhaskaran
Photography by Ling Lim, Asta Thrastardottir, and Jeff McLane
Design by Lorraine Wild and Xiaoqing Wang of Green Dragon Office, Los Angeles
Color separations by Echelon Color, Los Angeles
Printing and binding by Burger-Druck GmbH, Waldkirch, Germany

Typefaces
Gill Sans, Sentinel, IBM Plex Sans, and Maison Mono

Section introductions by Claudia Bohn-Spector.
Powers of Ten subsection introductions by Bailey Westerhoff.

This publication is made possible with support from Getty through its PST ART: *Art & Science Collide* initiative.

Text, design, and layout copyright © 2024 California Institute of Technology.
Images copyright © their respective copyright holders; see opposite page.

All rights reserved. This book may not be reproduced, in whole or in part, including images, in any form (beyond that copying permitted by Sections 107 and 108 of the US Copyright Law), without written permission from the publisher, except by a reviewer, who may quote brief passages.

Library of Congress Control Number: 2024936153

ISBN: 978-1-60606-942-4 (paperback)